BEYOND GRIEF

SCULPTURE AND WONDER IN THE

GILDED AGE CEMETERY

CYNTHIA MILLS

A SMITHSONIAN CONTRIBUTION TO KNOWLEDGE

Smithsonian Institution
Scholarly Press
WASHINGTON, DC
2015

Published by
SMITHSONIAN INSTITUTION SCHOLARLY PRESS
P.O. Box 37012, MRC 957
Washington, D.C. 20013-7012
www.scholarlypress.si.edu

Front cover image: Augustus Saint-Gaudens, Adams Memorial, Rock Creek Cemetery, Washington, D.C. Photo by George Collins Cox. Photographic History Collection, Smithsonian National Museum of American History.

Library of Congress Cataloging-in-Publication Data:

Mills, Cynthia J.
 Beyond grief : sculpture and wonder in the Gilded Age cemetery / Cynthia Mills.
 pages cm
 Includes bibliographical references and index.
 1. Sepulchral monuments—United States—Themes, motives. 2. Sepulchral monuments—Psychological aspects. 3. Art and society—United States—History—19th century. 4. Art and society—United States—History—20th century. I. Title.
 NB1803.U6M55 2014
 731'.76—dc23

 2014004894

ISBN: 978-1-935623-37-3 (cloth)
ISBN: 978-1-935623-79-3 (pbk)
ISBN: 978-1-935623-38-0 (ebook)

Printed in the United States of America

♾ The paper used in this publication meets the minimum requirements of the American National Standard for Permanence of Paper for Printed Library Materials Z39.48–1992.

CONTENTS

INTRODUCTION

On a chilly Sunday morning in December 1885, Henry Brooks Adams pulled on his winter coat and stepped out onto the front portico of his home on Lafayette Square across from the White House. Perhaps he was feeling some discomfort, for by all accounts Adams, the well-known descendant of two presidents, was on his way to visit a dentist. Before he had ventured far on the tree-lined street, however, he encountered an acquaintance arriving to see his wife. Adams turned back, reentering the three-story stone house on H Street to call her. Met by silence, he climbed the stairs to an upper room. There he found forty-two-year-old Marian Hooper Adams slumped unconscious on a rug in front of a fireplace. The celebrated Washington hostess, a talented amateur photographer, had poisoned herself by drinking potassium cyanide, a toxic chemical used in developing film. A doctor, hastily summoned, could do nothing to revive her. Her body, still warm to Henry's first anxious touch, grew cold and rigid—an insensate corpse replacing the vibrant woman he had loved.[1] Thus began for a shaken Henry Adams the unrelenting cycle of grief, remorse, questioning, self-doubt, anger, and psychic exhaustion that haunts the survivors of suicides.

Adams equated his experience with "Hell"—describing himself as unsteady, not "calm," and not "myself" in days to come. "Life could have no other experience so crushing," he wrote one friend. "This wretched bundle of nerves, which we call mind, gives me no let up," he told another. "All my energy is now turned to the task of endurance," he confided in a letter to Oliver Wendell Holmes two weeks later.[2] At the same time, he realized that others shared a similar sorrow, reporting, "My table was instantly covered with messages from men and women whose own hearts were still aching with the same wounds, and who received me . . . into their sad fraternity."[3]

Adams's search for release from ceaseless waves of dark and troubling thoughts became a consuming obsession but also a generative force with an impact beyond his own great loss. For this personal tragedy led him on a quest for a consoling, cathartic beauty that he hoped would ease his mental torment and restructure others' perceptions. The result, more than five years later, was the Adams Memorial, designed by sculptor Augustus Saint-Gaudens in a setting by Beaux-Arts architect Stanford White.

One of the most extraordinary American funerary monuments of the nineteenth century, the bronze figure sits meditating on a granite seat in a quiet Washington, D.C., cemetery. Called a modern "sphinx" for its quality of shrouded mystery, it became the most widely

known and influential of a number of figurative grave memorials—including the moving Milmore monument in Boston—that were completed by some of the nation's finest artists in the 1890s (Plates 1, 2).

These memorials were sometimes created in highly personal relationships between survivor and sculptor. Artists like Frank Duveneck and the elderly William Wetmore Story made memorials to their wives after suffering loss (Plates 3, 4). Models, photographs, or replicas of the new "high-style" sculptural monuments were later displayed in arts exhibitions and in such elite venues as the Metropolitan Museum of Art in New York as well as in the precincts of death, inspiring other patrons, artists, and artisans to imitate or attempt to rival these achievements. The new memorials, frequently undertaken in partnership with architects and landscapers, helped to change the face of the American cemetery, already in the process of transformation in the decades following the Civil War. Among patrons and fine artists a great interest was developing in beautifying the cemetery following the deaths of 620,000 in the war. The land, pierced by shovels and turned repeatedly to make way for the casualties of military battles, was being heaved and hewn into the foundation for a new aesthetic, a more unified and centrally managed landscape of sensations. New attitudes toward mortality and mourning were emerging alongside a growing industry manned by deathways professionals ranging from undertakers to cemetery managers.

The artists who created this generation of private memorials avoided older sentimentalism and often modified or cast aside standard elements of religious symbolism and the reassuring inscriptions about the afterlife that had characterized many earlier monuments. They turned their sculptures into statements about modern life and death by seeking to meld grief and wonder in a nonverbal form. Death, their cemetery sculptures still tell us today, remains an event beyond human comprehension, even for faithful Christians. Survivors must learn to value their inability to explain it and turn its mournful riddle into a positive power that stimulates the imagination and the heart. They must come to revere its sheer mystery, cloaked in an aura of beauty in the cemetery, where an awe of nature and art can spur meditation on universal questions.

The monuments were intended to be vessels for catharsis, meant to console, but they also served other purposes. They could manipulate and mask, becoming vehicles for instilling an emotional and social legacy, or for denial of such negative emotions as guilt and excessive grief by individuals who above all feared loss of control over their feelings and reputations—turn-of-the-century Americans who lived with a dread of ridicule and shame.

Elite patrons and artists hoped that reverent and respectful spectators would find in their sculptures suggestions of dignity, nobility, serenity, order, and refinement—forms of beauty and peaceful stability in a situation that by its very nature was full of trauma and uncertainty. The artworks often denied or veiled the ugliness of death and the fragility or baseness of human motives. They participated in a struggle for grace amid wrenching societal change in the postwar era and, eventually, in a post-Darwinian age, when elites such as Boston's Brahmin class sensed a fracturing of life's wholeness. Placed in lovely outdoor garden settings, the

memorials linked death with the processes of nature's sensuous cycle of lush foliage, entropy, changing seasons, and renewal. But in their silence about deep human fears surrounding the pain and gruesomeness of death—taboo topics—they left a residual trace about the real meanings of grief. "Silence itself—the things one declines to say, or is forbidden to name . . . functions alongside the things said," the philosopher Michel Foucault noted.[4]

Evolving in dialogue with older, more highly ornamented forms of sepulchral sculpture and with the rise of American art museums, these exceptional 1890s cemetery monuments were reinterpreted in the early twentieth century. A generation of Americans discovered them through personal pilgrimage or, more often, through widely distributed reproductions and illustrated popular magazines and newspapers. But these diverse "outsider" audiences viewed the monuments through the lens of an increasingly urbanized consumer society now influenced by mass media, advertising, varying forms of public spectacle, specialization and professionalization of labor, and new modes of mass manufacture and replication. With the rise of motion picture technology, the multiple funeral processions for assassinated President McKinley were captured by Thomas Edison's cameras in 1901, for example, after a little-known commercial sculptor named Eduard Pausch had carefully measured the president's features and preserved them in the form of a plaster death mask that could be the basis for memorial statues.

By 1900 Sears Roebuck & Co. and Tiffany, among others, offered alternative choices for memorialization, raising questions about what standards an individual should apply in choosing a grave marker and what constituted "value" in this realm. Against all this, the public received turn-of-the-century classicizing renderings of restrained emotion with new understandings of the boundaries between high taste and low farce, social distance and intimacy, and the refined longing to encounter alien and exotic forms versus an almost gleeful pleasure in the grotesque, the excessive, and the weird. The Adams Memorial became popularly known as *Grief*, a title hinting at passion uncontrolled—far from the peaceful meditation about the mystery of death, the representation of a psychic state beyond mere grief that Henry Adams had sought. Meantime, Pausch and other sculptor-artisans "pirated" its design for the graves of people who had never known the Adamses.

This book attempts to set out at least part of the story of how high-style funerary sculpture functioned at the turn of the twentieth century and in the decades immediately after, a subject little investigated to date by scholars. These monuments have not been considered in terms of their wider context and shifting use as objects of consolation, power, and multisensory mystery and wonder. Rather, they have mostly been considered as oddities, a part of an individual artist's oeuvre, a detail of a patron's biography, or as local civic cemetery history. Why did new forms—many of them now produced in bronze rather than stone and placed in architectural settings—arise just at this time, and how did they mesh or clash with the sensibilities of their era? Why was there a gap between the intention of these elite patrons and artists, whose lives were often intertwined in a closed circle, and the way some public audiences received them through the filter of the mass media?

The book seeks to address these issues in part through the medium of individual lives. It accepts that many aspects of memorialization overlap, with outdated styles living on even until today beside new ones—baby lambs and crosses carved in stone next to laser-etched portraits of the deceased on polished black granite. It in no way claims to cover the entirety of this rich area. Many intersections with issues of gender, ethnicity, and regional differences, among other topics, remain for future scholars to explore. For this project is ambitious enough. Some of the tales it relates turn out to be stranger than fiction, venturing into the realm of a variety of private understandings that largely went unspoken.

Death is above all about absence and emptiness. It is often met with public silence, and this makes difficult going for historians. This narrative thus begins with four intertwined tales of personal loss in the 1880s for which a significant record remains. Then it places the key players' decisions in a wider social, historical, and artistic context and traces their monuments' creation, influence, and reception in the hope that they will help us to understand the larger story: how survivors used cemetery memorials as a vehicle to mourn and remember, and how their meaning changed over time.

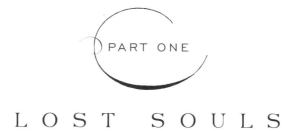

PART ONE

LOST SOULS

ONE

ADAMS'S QUEST
FOR CONSOLATION

Survivors are faced with many questions and choices after the loss of a close relation. For them, death is no longer an abstraction but a reality that has caused a loved one to vanish; they must try to extract meaning from this seemingly senseless event. Their responses are highly personal yet they are also shaped by the context of their era. Most Americans who lived through the Civil War had experienced death in multiple ways. The story of Marian Adams's suicide and her husband's quest to survive this sudden, mind-ravaging act provides an apt beginning for exploring the new patterns of memorialization that appeared.

The life of Henry Brooks Adams (1838–1918) has often been described as a tale of high expectations dashed. Indeed, when the couple married in June 1872, Henry and Marian Hooper Adams (1843–1885) both moved easily in Boston's circles of privilege. He was the great-grandson of President John Adams, the grandson of President John Quincy Adams, and the son of Charles Francis Adams, U.S. envoy to England, and Abigail Brooks Adams, heiress to one of Boston's great fortunes. After graduating from Harvard University and serving as a private secretary in the London legation that his father, a strong opponent of slavery, headed during the Civil War, Henry pursued journalistic ambitions for a time in Washington, D.C. He then taught medieval history at Harvard, where he also edited the prestigious *North American Review*.[1]

Marian, known as "Clover" to her friends, was the dark-haired, free-spirited daughter of physician Robert W. Hooper and Transcendental poet Ellen Sturgis Hooper. Based on the surviving correspondence, her life emerges as a story of lively talents and a fragile ego frustrated and constrained. Although she had lost her mother to tuberculosis when she was five years old, Clover was raised amid many caring relations who numbered among Boston's cultural elite. She was educated at the progressive school for young women run by the wife of Harvard naturalist Louis Agassiz in Cambridge. There she studied Latin and German, the art of conversation, poetry and good manners, piano and the waltz. During the Civil War,

Figure 1.
"Henry Adams with Dog Possum, Seated in Profile." Photograph by Marian Hooper Adams, 1884. From the Marian Hooper Adams Photographs. Photograph number 50.118. Courtesy of the Massachusetts Historical Society.

Clover and her sister Ellen seized every opportunity to work at the Sanitary League, the Civil War equivalent of the Red Cross, where female volunteers rolled bandages, stamped blankets, and visited wounded soldiers. Her cousin Robert (Bob) Gould Shaw wrote of "a very pleasant" party she hosted in early 1863 as he was preparing to assume command of the Fifty-Fourth regiment of African Americans, the pride of Boston's abolitionist circles; that summer she mourned his death in the assault on Fort Wagner in South Carolina.[2] Clover penned a vivid account of her trip to Washington to witness the grand review of the victorious Union armies—columns of troops clad in blue stretching for twenty-five miles—at the close of the Civil War, to see the blood-soaked pillow in the room where Abraham Lincoln died, and to stop in at the trial of the conspirators charged in the president's death.[3] She apparently met Henry Adams at a legation dinner in London after the war.

By the time of their marriage in June 1872, Clover was twenty-eight and Henry five years older (Figures 1, 2). He was already balding, a condition that drew increased attention to his high, serious forehead, long straight nose, and the somewhat impish ears that signaled a droll private humor behind his reserved, often blunt or prickly public manner. The bearded, mustachioed Adams was slight of build, just an inch taller than five-foot-two Clover, whom he had characterized on the occasion of their engagement as "not handsome" but not "quite plain" either, with her own decided wit and loquaciousness. It was difficult, he wrote his brother, to "resist the fascination of a clever woman who chooses to be loved."[4] Clover apparently was sensitive about her appearance, and few photographs of her survive. In the best-known picture of her as an adult, she holds her small, well-formed body perfectly erect and looks away from the camera as she sits sidesaddle on an alert, well-groomed horse. Riding was a beloved pastime she and Henry shared. With her eyes shaded by a light-colored bonnet, her mouth closed, and her riding habit buttoned firmly to the neck, she reveals little of the lively character friends described. Another undated tintype hints at her irreverence toward convention, however, as she conceals her face behind a large

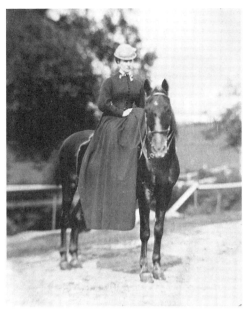

Figure 2.
"Marian Hooper Adams on Horseback at Beverly Farms." Tintype by unknown photographer, 1869. From the Marian Hooper Adams Photographs. Photograph number 50.131. Courtesy of the Massachusetts Historical Society.

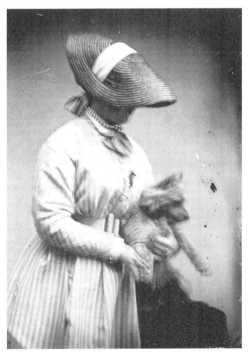

Figure 3.
"Marian Hooper Adams, Holding Dog, Face Obscured by Bonnet." Tintype by unknown photographer, ca. 1875–85. From the Marian Hooper Adams Photographs. Photograph number 50.137. Courtesy of the Massachusetts Historical Society.

straw hat while attempting to hold her fidgeting pet terrier up for display (Figure 3). Henry wrote affectionately of her eccentricity and resolute naughtiness in making judgments about people. Clover, he said, "takes malicious pleasure in shocking the prejudices of the wise and the good."[5]

The couple eventually settled in Washington, which was taking its place among the most fashionable cities in the nation. In 1880 they moved into 1607 H Street, an elegant residence on the north side of Lafayette Square that featured thirteen-foot ceilings and a view of the White House.[6] Adams found his niche in the capital city as historian, writer, and observer of society and government. While the path to national political power no longer seemed open to members of his family, he could follow the traditions of Boston intellectualism and idiosyncrasy. He completed biographies of Albert Gallatin and John Randolph, and began a nine-volume *History of the United States during the Administrations of Jefferson and Madison*. He has also been credited with writing two novels, *Democracy* (some said Clover was the actual author because of its stinging satire) and *Esther*, but he concealed his authorship of these works of fiction from all but a few close friends by publishing the first anonymously and the second under a pseudonym. Marian Adams, whose animated wit could be piercingly candid, presided over an exclusive salon of political, literary, and artistic notables at their well-situated home.

With statesman John Hay and his wife, Clara, and geologist Clarence King, the Adamses formed an even more impenetrable inner stratum, an intimate quintet

of friends they called the "Five of Hearts." Their transatlantic network of personal acquaintances included writers Henry James (who once referred to Clover as the "incarnation" of her native land and at another time as a Voltaire in petticoats), Edith Wharton, Bret Harte, William Dean Howells, and Matthew Arnold; historians George Bancroft and Francis Parkman; Oliver Wendell Holmes Jr.; politician Henry Cabot Lodge; and architect Henry Hobson Richardson. Clover Adams took up photography in 1883 and made camera portraits of a number of these friends, eventually filling three leather-bound albums with her pictures.[7] The Hoopers were great art lovers and, with the help of Clover's brother Edward (Ned), the couple formed a significant collection of British watercolors and drawings including works by John Constable, J.M.W. Turner, Richard Parkes Bonington, and William Blake (whose strange productions were especially beloved) as well as a less securely attributed array of old master drawings and curios from Asia. Her father gave them a painting by Winslow Homer. Clover, who Henry had once quipped "dressed badly," acquired a cosmopolitan taste for gowns from the famously expensive Paris couturier Charles Frederick Worth. At home the couple doted on a succession of pet terriers named Boojum, Marquis, Possum, Scalawag, and Waggles. In nostalgic hindsight that denied any evidence of the couple's marital tensions or cares, Henry Adams spoke later of the "twelve years of perfect happiness" he and Clover spent together.[8]

The thirteenth year, however, began an extended season of mourning. The death on April 13, 1885, of Dr. Hooper, at age seventy-five, was the first of a chain of personal tragedies. Within a few years, Adams would see his wife, both his parents, a sister-in-law, and a brother-in-law pass away.

Having lost her mother early, Marian Adams had always maintained a close relationship with her father, who raised her, her sister, and her brother. She managed his household before marrying and afterward faithfully wrote lengthy letters to Dr. Hooper each Sunday from Washington. She and Henry also usually summered in the cottage they had built near Hooper's Beverly Farms residence on the North Shore of Massachusetts. She helped to care for her father at her sister's house in Cambridge during his final six weeks of life—a wearying, emotionally draining experience. "The poor old doctor is fading away like a Stoic; without a murmur of complaint," Henry Adams told a friend. "I wish we might all face death as coolly and sensibly; but the process is harsh and slow."[9]

Adams shuttled back and forth to Washington, where the couple and the Hays were building attached houses designed by Richardson, a Harvard classmate. When at last Marian could write that her father "went to sleep like a tired traveler," Henry joined her for the funeral services and interment at Mount Auburn Cemetery in Cambridge. By all accounts, Clover was profoundly affected by this loss. She was now an orphan who had failed to become a mother herself; her marriage had produced no children. Henry worried about her health after "a long and hard spell of nursing at her father's bedside."[10] Scholars have also speculated that her depression and nervousness related to the restrictions placed on women of her high intelligence and education in this period, even at her level of society. They point

to evidence that her husband could be distant and difficult: he refused, for example, to allow her to publish one of her photographs, saying it was inappropriate for his wife to expose her talents publicly in that way and that it was best for the family to guard its privacy. Writer Natalie Dykstra has described her life as "gilded and heartbreaking." The constraints Adams insisted upon, his natural reserve, and his occasional outbursts of impatience must all have exacerbated his own grief afterward, when he reconsidered his sometimes ungenerous words and actions.[11]

By November, Adams was mentioning in letters that Clover was "unwell," a polite term that sanitized his increasing concern about her state of deepening depression. She "has been, as it were, a good deal off her feed this summer," he told one friend, "and shows no such fancy for mending as I could wish."[12] Marian in general shunned company, but neighbor Rebecca Dodge took her for regular drives in an attempt to lift her gloomy mood. She described how Clover wore as mourning garb "a little black net bonnet," and then later, "I got her a black silk one" as the weather turned cooler.[13]

Henry's older brother, Charles Francis Adams II, recalled that Clover appeared lethargic and severely depressed when he met the couple on the train between Boston and New York a few days before her death. "She sat there, pale and care-worn, never smiling, hardly making an effort to answer me, the very picture of physical weakness and mental depression," he wrote. "Physically and mentally, she was, during the months preceding her death, an object for the most profound compassion."[14]

On December 6, 1885, Henry set out to visit Dr. Edward Maynard, a dentist who lived just four blocks away on F Street. As he was leaving home, however, he encountered "a friend of Mrs. Adams who had come to pay her a visit," according to one newspaper report.[15] Adams returned to the house and found his wife's unresponsive form. Astonishingly, her heart had stopped; she breathed no longer, and her eyes appeared glazed. She had crossed the line between life and death as the poison did its work within a matter of minutes.

Adams later noted that Clover's death split his life into two. Time stopped, and he began a new life that he measured from the moment of her departure. His emotional reserve low, he warded off others' efforts to reach out to him, saying he could not speak about the tragedy. "Wait til I have recovered my mind," he wrote Dodge, who sent word to him on the day of Clover's death. "I can see no one now. . . . Don't let anyone come near me." To his close friend John Hay, he wrote of "the first feeling of desperation" and his sense that the struggle would not soon end. "Never fear me," he said in closing his short note, however. "I shall come out all right from this—what shall I call it—Hell!"[16] Adams knew that through his wife's death his own life had been changed forever.

To make matters worse, the newspapers revealed that Marian Adams had taken her own life, and some reports questioned her character, adding to the family's maelstrom of emotions the shadow of public scandal in the upper echelons of Washington and Boston

society. "Was It a Case of Suicide?" the Washington *Critic* asked in the headline over its brief report on the coroner's visit. "The late Mrs. Henry Adams," it reported later, had "a reputation of saying bitter things of men and measures, and of her fellow women too, and although an entertaining talker, was generally distrusted and failed to become socially popular."[17] Her suicide was seen as another form of ungenerous self-indulgence, perhaps, or at least a form of moral or psychic frailty. Writer Henry James, in a letter from London to Clover's young acquaintance Elizabeth Boott, confirmed that all society was talking about the scandal, saying, "I suppose you have heard the sad rumours as to poor Clover Adams' self-destruction. I am afraid the event had everything that could make it bitter to poor Henry."[18]

Clover's brother Ned Hooper and sister Ellen Gurney arrived from Massachusetts the day after her death, when, Ellen wrote, Henry was "almost like a child in his touching dependence."[19] Ellen described the private trials he and other family members had been going through while trying to pull Clover out of her depression. Clover, well aware that two of her aunts had suffered frail mental health and that one had committed suicide, had feared institutionalization in one of the new asylums, expansive, publicly funded structures with lush grounds built as part of the mid-nineteenth-century movement to reform "lunatic" care in America.[20] Her father was a trustee of the Worcester Asylum for the mentally ill and, according to one account, had sometimes taken his daughters with him on his visits to see patients there.[21] One of Clover's childhood friends had been hospitalized at the McLean Asylum near Boston.[22] Henry had firmly rejected that course, however, and the family "had been consumed with anxiety," Ellen Gurney wrote an acquaintance afterward:

> Probably others think if we had only done this or that. I have no such feeling. We did the best we knew how, and . . . I think any other course [institutionalizing Clover] would have been cruelty. The courage and manliness and wisdom and tenderness, and power of meeting so intense a strain, for days and nights—months and months—at first looking for the cloud to lift within a few months—finally satisfied that it might be years before it did—which Henry Adams went through we only knew—his family were wholly ignorant of it—and we felt it might kill him or worse. . . . He went out to the Dentist's for a short time Sunday morning and when he returned—she was at peace. God knows how he kept his reason those hours.[23]

The death of a spouse is one of life's most difficult experiences, and a sudden or violent death extends and deepens the grieving process. Psychiatrists have described these typical responses to loss: denial and isolation, followed by anger at abandonment, guilt and concern that the survivor is responsible for what happened (mentally replaying the circumstances over and over), depression, and, ultimately, some form of resolution or acceptance.[24] Henry Adams, a widower at forty-seven, can be expected to have gone through such stages, although he attempted to tightly control and conceal his emotions in public. While many Americans at this time suffered diseases such as tuberculosis that caused a lingering death and gave relatives time to prepare for loss and to resolve conflicts, Clover's death was sudden—shockingly so. Not only was Adams denied the notion of death as a passage

through an illness, but his wife's action of self-destruction (suicide was often referred to as "self-murder" at this time) also denied survivors the consolations of a "good death." The commemorative tablets in the church in Quincy, Massachusetts, where the Adams presidents are buried describe the enduring dedication of his grandmother and great-grandmother to stoic duty and to their appropriate supportive gender roles despite all life's challenges. His wife had not mustered that same strength and courage in the face of the trials and assaults of modern times, and by her act she had further violated Christians' responsibility to accept their life through faith instead of surrendering to despair. Through her lack of self-restraint, which could be interpreted as a form of moral weakness or cowardice, she also disrupted the polite surface harmony imposed by societal forces.

The need to notify others, to relate the story of what happened, to organize a service and burial, and to decide on an appropriate memorial are initial steps in the long process of changing grief to nostalgia; it can eventually bring some closure to survivors. Adams held a solitary vigil over Clover's body until relations could arrive. A neighbor recalled seeing him at one point alone at the window.[25] In the following weeks he tried to move swiftly, however, to return order to his life. For example, he invited State Department librarian Theodore F. Dwight to move into the new house with him as a companion and assistant. Adams never discussed in public his feelings after his wife's sudden death, maintaining a famous self-imposed silence about Clover and her demise for most of his remaining years. In his world-weary third-person autobiography, *The Education of Henry Adams*, he famously left blank the period from their marriage to her passing, simply entitling the next chapter "Twenty Years After." But he did recall in detail in that book his feelings after his sister Louisa Kuhn's tortured death at age forty in the summer of 1870. She developed lockjaw following a carriage accident in Italy and expired in convulsions with Adams helplessly looking on. He must have been combining his thoughts about the loss of these two important women in his life when he described how he felt about Louisa's struggle. Adams wrote that he knew "by heart the thousand commonplaces of religion and poetry" about human mortality intended "to deaden one's sense and veil the horror." Yet these did not comfort him as he watched Louisa die amid the beauty of the Tuscan countryside. "Impressions like these are not reasoned or catalogued in the mind; they are felt as part of violent emotion; and the mind that feels them is a different one from that which reasons; it is thought of a different power and a different person."[26] For Adams, the usual anodynes of society seemed mere artifice in the face of a close family member's tormented death. "The idea that any personal deity could find pleasure or profit in torturing a poor woman . . . could not be held for a moment. . . . God might be, as the Church said, a substance, but He could not be a person."[27]

In the days immediately after his wife's passing, Adams told his closest friends, "I have got to live henceforward on what I can save from the wreck of her life," and "I am going to keep straight on, just as we planned it together and, unless I break in health, I shall recover strength and courage before long."[28] Adams soon adopted a more guarded stance though, allowing only subtle, indirect allusions to his emotional state and preferring to make

a genteel stoicism and silence his outward response to this personal tragedy. His inability to stop dwelling on his loss linked him to the nineteenth century's grand, ritual obsession with death, which came to its climax amid the aestheticism of the Gilded Age. At the same time, his silence linked him to newer trends and to the future, when talk of grief and death would become a great societal taboo. Clover's suicide occurred at a time when highly regulated mourning customs were being questioned and the period of a mourner's seclusion from the world was being reduced.[29]

A brief funeral service was held December 9 at the rented house, presided over by the Reverend Edward Henry Hall of First Church (Unitarian) of Cambridge, a minister sent for by the Hoopers.[30] While no transcript of Hall's remarks remains, the fifty-four-year-old minister might well have struck a theme he favored in another sermon about death, urging survivors to reject "idle grief" and focus instead on how the life of the deceased could make the path of the next generation "richer in meaning and fuller of possibilities. . . . Our best homage is paid in calm recognition of what the departed have been and done."[31] Hall, like other progressive clergymen of his time, was wont to celebrate the life just ended rather than dwell on visions of hellfire for the errors of a woman who had suffered mental distress.[32] A greater simplicity in funerals—especially in the case of a suicide—was deemed in good taste as the century came to a close. Sentimental expressions of faith were giving way to a growing emphasis on the mysteries of death and the duties of the living.[33]

In his search for an understanding that extends beyond the rational and a form of consolation that goes beyond the sentimental, Henry Adams turned away from his family's Unitarian heritage and explored alternative concepts outside conventional Western Protestant understanding. In June 1886, six months after his wife's suicide, he set out on a trip to Japan with the older Roman Catholic painter John La Farge in search, they joked, of "Nirvana."[34] The two men shared an interest in religious philosophy, especially at this time Buddhism and its concept of nirvana, which they saw as complete release from the cycles of life and death, desire and pain—a final extinction of the passions resulting in inner quietude, a kind of psychic serenity. Adams hoped the trip might bring him peace. Like Clover's cousin William Sturgis Bigelow, who lived and studied in Japan for seven years, connoisseur Ernest Fenollosa, collector Isabella Stewart Gardner, and others of Adams's set, the pair participated in an elite interest at century's end in Asia and Buddhism. Their trip was partly a curious quest for exoticism and adventure and partly a serious search for new means and rituals to restore life's wholeness in a changing world. With Bigelow acting as their "master of ceremonies," Adams and La Farge visited temples, shrines, and markets, "read Buddhism" and Taoism, and viewed Mount Fuji and the Giant Buddha of Kamakura (which Adams photographed for La Farge) during a five-month stay (Figure 4).

Aboard ship on the trip home, they hashed over their reactions with Fenollosa and a Japanese colleague, Okakura Kakuzo. La Farge had collected Japanese prints since the 1850s and sought to make and understand art as a prophetic force that could help viewers to see beneath the mere surface of things; his work had been admired and respectfully collected by

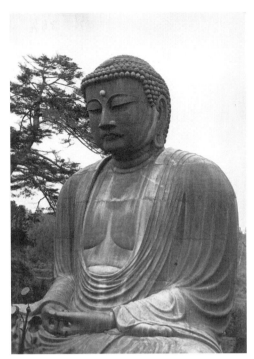

Figure 4.
"View of Daibutsu. Kamakura." Photograph by Henry Adams, 1886.
From the Henry Adams Photographs. Photograph number 40.282.
Courtesy of the Massachusetts Historical Society.

Clover's cousin Alice Sturgis Hooper and by her brother Ned.[35] Fenollosa preached a doctrine of artistic and cultural pluralism, attacking Western art's literary or storytelling heritage. Art had "several languages," and no "single set of laws" should dominate it, he insisted.[36]

Upon their return, Adams, with La Farge's help, set events in motion for the creation of a sculptural memorial to his wife that shared many of these same ideas and goals. He referred to the work in progress as "my Buddha" in his diary but later simply called the resulting bronze figure, with chin resting on hand, "the Peace of God."[37] It would serve to give shape to absence and to the continuing relationship with a lost spouse—with her unsettling, and then perhaps more wistful and nostalgic, hauntings as the decades unfolded.

TWO

THE MILMORES
AND THE SPHINX

To begin considering another family's story of loss, step back in time to August 16, 1871. On that day residents of Cambridge, Massachusetts, witnessed a strange spectacle, a stone sphinx wrapped in a protective tarp advancing toward Mount Auburn Cemetery on a cart pulled by a single workhorse. The clip-clop of the sturdy horse's hooves and the grating sound of the cart's wheels on the road accompanied its stately progress. Along the way, small groups of passersby stopped to gawk at the creature, which had been carved from a huge block of granite (Figure 5).

"The Bigelow Sphinx, the fabulous feminine monster, designed and executed by Martin Milmore, is now slowly moving from McDonald's shop to its place of destination in front of Mount Auburn Chapel, its weight is not far from thirty tons," the *Boston Evening Transcript* reported. "Her ladyship is deeply veiled."[1] Shrouded in its winding sheet, the sculpture presented an enticing contemporary riddle.

The sphinx, created as a memorial to the Civil War dead, was in fact a final gift to the cemetery from Jacob Bigelow, a physician and cultural theoretician who had helped to found Mount Auburn forty years earlier on an old estate a few miles from Harvard University. In the decades since the garden cemetery's consecration in 1831, Bigelow had taken a leading role in shaping its development as an influential landscape dedicated to burial and commemoration in a picturesque rural setting that contrasted with the grim appearance of earlier urban graveyards. Now he had commissioned Milmore, a young sculptor working with two of his brothers, to make the ten-foot-long stone creature, melding a lion's body and a woman's face.[2]

Milmore (1844–1883) came from Irish immigrant origins, far removed from the Boston Brahmin roots shared by Bigelow, Bigelow's niece Marian Hooper, and her husband, Henry Adams. But Milmore and his brothers gained a good measure of prosperity through

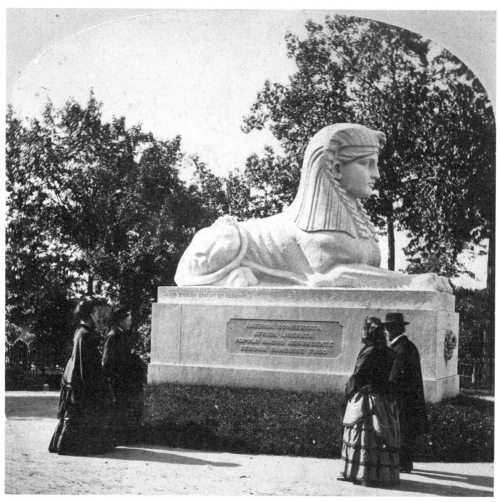

Figure 5.
Martin Milmore, Sphinx, *1871. Mount Auburn Cemetery, Cambridge, Massachusetts. Undated stereograph published by J. A. French. Courtesy of the Historical Society of Cheshire County, Keene, New Hampshire, and Keene Public Library.*

their work, and Martin had begun to acquire regional fame as an industrious sculptor of Civil War soldier monuments and portrait busts.

To create their sphinx, the Milmores followed detailed instructions from Bigelow (1786/87–1879), who had devoted much time in recent years to considering the great civil war that changed the world in which he and his generation had grown to maturity. The doctor had decided to recognize the fallen heroes with a significant monument inscribed with a proclamation of their achievements: "American union preserved; African slavery destroyed." He spoke of a nation "on the dividing ridge of time" that he hoped could now turn its energies from conflict and look forward, like his sphinx, into a limitless future.[3] He understood well that in order for survivors to reconcile the slaughter and proceed with their lives, the deaths of an estimated 620,000 soldiers had to be remembered as meaningful acts of sacrifice for the greater good.[4]

Bigelow was growing old, and he lost his eyesight to cataracts by early 1871, before his hybrid beast was placed on its northward-facing pedestal. Thus historians believe he never saw the final result. He was able, however, to visit it and map out its contours with his fingers in his declining years. Touch had to substitute for vision, but the doctor did at least have the opportunity to feel the shape of the sculpted animal's muscular legs and its mute, stony face at its dedication before his death in 1879.[5]

The completed sculpture inspired prose and poetry and immediately became a public landmark in the cemetery, a park-like strolling ground that visitors entered through an Egyptian revival gate that Bigelow had also arranged decades earlier. It was greeted as a specifically "American sphinx" by a commentator for the *Atlantic Monthly*, who noted that the sculptors had carved a patriotic eagle's head above its brow and a star upon its chest. For other writers, the stone creature evoked multiple associations, including strength, repose, beauty, duration, and mystery, as it guarded memories of the Union Civil War effort.[6] In her ode to the sculpture, poet Charlotte Fiske Bates recalled the Greek tale of Oedipus and the female sphinx who posed a riddle. "How grand she is enthroned among the dead, / The graves like trophies all about her spread," she wrote. "But what the riddle that she now doth ask, / The might of man so fatally to task? / Well may we fancy 'What are Life and Death?' / To be the question that has hushed their breath."[7]

Bostonians, young and old, took carriage rides to Mount Auburn to see the new spectacle, and the sphinx made by the Milmore brothers became part of their common experience. Daniel Chester French, who was six years younger than Martin Milmore but already launching his own sculptural career with a *Minute Man* statue in nearby Concord, noted in his diary in June 1873: "went with Father to Mt. Auburn to see the 'sphinx' by Milmore, just erected."[8] Marian Hooper Adams, whose mother and other relations were buried at Mount Auburn, also mentioned "Mr. Bigelow's sphinx" in an 1873 letter to her father.[9]

Little did Martin Milmore understand how enduringly his family's legacy would be associated with the sphinx. After the Milmore brothers died, French would design a bronze cemetery memorial honoring them, a large high relief that depicted a sculptor carving a sphinx. It immediately attracted national attention.

⬯

French was personally acquainted with Milmore and later described him as having cut a picturesque figure in nineteenth-century Boston, striding the city's streets wearing a broad-brimmed black hat and a cloak that gave him the confident air of an artist or actor (Figure 6). "His appearance was striking, and he knew it," French said in a letter, characterizing the young man as a theatrical "Edwin Booth type."[10]

Milmore's mother, Sarah, had emigrated from County Sligo, Ireland, after the death of her husband (a schoolmaster also named Martin) in 1851. She raised her four sons in Roxbury, a neighborhood where many English, Irish, and German immigrants settled in the nineteenth century.[11] While mythologies often arise about artists' innate talents, evidence

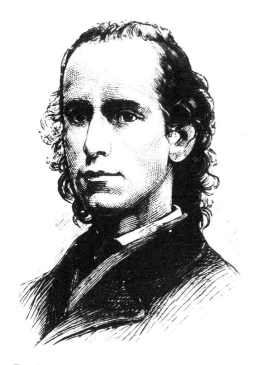

Figure 6.
Portrait of Martin Milmore. Frank Leslie's Illustrated Newspaper,
September 26, 1874, 44.

survives that Martin, the youngest son, was recognized early on as having a special ability. A chalk drawing of "Mountains of the Eastern Hemisphere" that the boy made in elementary school was preserved in his classroom there for decades.[12] At the free Lowell Institute, where Milmore later took art lessons for many years, classmates often gathered around to admire his creations.[13]

Martin's ambitions grew as his older brother, Joseph (1841–1886), shared with him and another brother, James (1843–1872), the carving skills he learned while working as an assistant to a cabinetmaker and then as a marble cutter. At age fourteen or fifteen, Martin persuaded the prominent sculptor Thomas Ball to take him on as an assistant, eagerly agreeing to clean his Boston studio in exchange for a space to work. Ball had just arrived from Florence to create an equestrian sculpture of George Washington for Boston's Public Garden. For Milmore the older man must have represented the Olympian heights of his chosen craft, having met such sculptors of international repute as Hiram Powers and William Wetmore Story in Italy as well as other famous expatriates like the poets Robert and Elizabeth Barrett Browning.[14]

Reports soon began appearing in the Boston papers of the "unusually fine talent" of Ball's teenaged pupil.[15] His "timely" and "gifted" creation of *Devotion,* a statuette of a wounded standard-bearer exhibited at the 1863 Sanitary Fair, and his head of a small child titled *The Motherless* were praised along with his "poetical" *Phosphor* (1862–63), a fairylike woman with a star on her forehead representing hope for a more peaceful future.[16] Just before returning to Italy in late 1864, Ball recommended Milmore for his first large commission, three colossal granite allegorical figures for the facade of Boston's new Horticultural Hall. The project, completed with his brothers' help when Milmore was twenty-two years old, launched his career and allowed him to open his own studio.[17] The next years saw a steady production of marble portrait busts of Boston notables, which were praised as striking likenesses despite the fact that Milmore, like many other sculptors of his day, heroized his subjects by depicting them in classicizing robes. Poet Henry Wadsworth Longfellow, reformer Wendell Phillips, writer Ralph Waldo Emerson, statesman-abolitionist Charles Sumner, and many others sat for him.[18]

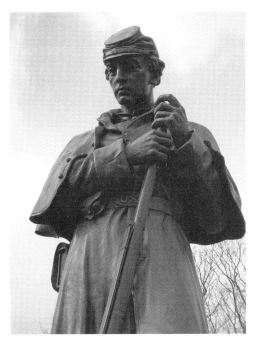

Milmore's first bronze full-length sculpture, depicting a volunteer infantryman in a contemplative moment, his rifle at rest (Figure 7), proved to be another turning point. In the early years after the Civil War, many soldier monuments were placed in cemeteries rather than city squares, for the commemorative emphasis was on mourning the dead. Milmore's statue was commissioned by the Roxbury City Council for Forest Hills Cemetery, located on what is now Boston's emerald necklace of parks, and dedicated on Memorial Day 1868. Before its installation there, the six-and-a-half-foot-tall figure was displayed in front of City Hall for the public to inspect. "It deservedly attracts much attention from the throngs of people who are constantly passing through," the *Boston Evening Transcript* reported. "The young soldier is in a reverie . . . over the graves of his comrades, who have met that fate which he feels may at any moment be the price he too must pay for his devotion to his country."[19] The soldier sculpture was the first of a number of influential military memorials of Milmore's design to be dedicated between 1869 and 1877, and it is often seen as having set a standard for using the figure of a single ordinary soldier or sailor, rather than a general on horseback, as the focus of Civil War remembrance.[20]

The brothers' careers evolved in tandem with a postwar boom in the production of outdoor sculpture, as Americans honored the Civil War dead with myriad monuments in stone and bronze. Their own first cousin Colonel Michael Corcoran (1827–1863) had led New York's Sixty-Ninth Regiment, a command composed of Roman Catholics of Irish birth or descent, at Bull Run, where he was wounded and taken prisoner. Most commemorative sculpture had previously been imported, made by American expatriates working in Italy or fashioned by European-trained immigrant artists.[21] In his early years Milmore thus followed the only training option open to him in Boston by pursuing an apprenticeship, and he also used one of the nation's first successful fine art foundries, the Ames Foundry in Chicopee, Massachusetts, to cast his soldier monument. Bronze figures were rare in cemeteries at this point. As his career evolved, his family assumed a new degree of affluence.

It also suffered hard blows. James Milmore died on Christmas Eve 1872 at age twenty-eight, a heartfelt loss, and he was buried in a lot in Forest Hills Cemetery opposite the soldier's monument. James apparently had suffered Bright's disease, a form of kidney

inflammation that killed many people in that era, including Theodore Roosevelt's first wife and the architect Henry Hobson Richardson.[22] Joseph remained as Martin Milmore's chief collaborator, helping him with stone cutting and making commissioned copies of his work as well as creating his own designs. One visitor described Joseph as a somewhat smaller, less imposing person, but with the same "quiet, unembarrassed and unrelenting manner" as he labored beside Martin in their workshop coated with stone dust.[23]

◯

Martin Milmore's fame was ultimately secured with his multifigure Soldiers and Sailors Monument on the Boston Common, unveiled in 1877.[24] The commission enabled him to fulfill a long-held dream to work in Italy. He went to Rome from late 1872 to 1877 to prepare the sculpted figures for the monument, taking a studio near those of other neoclassical expatriate sculptors such as Chauncey Ives and Franklin Simmons, and very near the Villa Barberini, where William Wetmore Story reigned as a leader of the English-speaking community. French, who was in Italy studying with Thomas Ball, also remembered meeting Milmore in Rome.

During his four and a half years in Italy, Milmore created a whole body of additional portrait work, including a bust of Pope Pius IX. But he continued to make work for Mount Auburn as well, including a marble angel of resurrection, with wings extended, one hand raised and the other holding a trumpet, for the gravesite of Maria Frances Coppenhagen (1874; Plate 5). Maria's grieving mother had asked the artist to make the angel's face "a likeness" of her thirty-one-year-old daughter's face.[25] Ultimately, Milmore's career attracted enough notice to warrant mention in the seminal *History of American Sculpture* by Chicago sculptor-historian Lorado Taft. Taft emphasized the faithful and conscientious nature of the sculptor's work, yet he added that in general, "Mr. Milmore stands for good workmanship rather than for poetic expression."[26]

Except for his few years in Rome, Milmore centered his career and patronage in Boston; he never gravitated to New York City, where he might have gained a more national reputation. Rather, he participated in local arts organizations and kept a studio in the same Studio Building on Tremont Street that, at different times, provided workspace for William Rimmer, Edmonia Lewis, and French, who went on to greater art historical fame.[27]

While French's description of Milmore's artistic aura in dress and manner is often cited, an 1872 passport application and two surviving prints give us some further idea of the impression the artist made. According to the passport application, Milmore was five feet five inches tall, with a dark complexion and "long" face, "Grecian" nose, large mouth, and square chin. A print in *Leslie's Illustrated Newspaper* two years later (see Figure 6) showed his hair combed straight back from a high forehead and falling shoulder length in somewhat unruly curls. His eyebrows were also dark and generous and his nose as long and straight as the passport notary suggested.[28]

Despite his attractive appearance, prosperity, and civic activism, Milmore never married, and after 1877 his artistic production and his health declined. According to the Boston

City Directory, he and his brother Joseph lived with their mother in a house at 113 Hammond Street. But by several accounts he had determined to end his bachelorhood.[29] Two women, Mary E. Hanley and Mary Louise Longfellow, each stated in a later swirl of controversy that he had been engaged to them.

Martin Milmore died on July 21, 1883, at age thirty-eight. The death certificate listed the cause as "cirrhosis," and French later commented that Martin had been known to drink too much alcohol.[30] Newspapers noted that Milmore had been "among Boston's best-known citizens" and mourned his lost youth and promise. According to press accounts, "a large number of friends and relatives" attended the funeral service, a solemn Roman Catholic requiem Mass, at the neo-Gothic Cathedral of the Holy Cross in Boston's South End on the morning of July 24. His mentor Thomas Ball, Boston Mayor Albert Palmer, Civil War General Nathaniel P. Banks, and patron Wendell Phillips were among the pallbearers. The body was carried out of the cathedral—under a large rose window featuring King David with his harp—and transported to Forest Hills Cemetery for burial in the family lot near the soldier monument Milmore had designed there.[31]

A will, dated January 1882, divided most of Martin's estate, appraised at nearly $100,000 (mostly in houses and land in Boston), among his mother and brothers Joseph and Charles. It also arranged funding to erect a monument at the family's Forest Hills gravesite "to the memory mainly of my deceased brother James, but with such inscriptions and in such way and manner as may be to the taste of said Executors most fitting and proper under all the circumstances."[32]

A year after his death the first of a series of startling events involving the Milmore family's estate and legacy occurred. A second will dated June 1882 emerged, mailed anonymously, according to newspaper reports, to a probate judge. It gave a great deal of property to Mary Hanley and two of her daughters and was immediately contested. Mrs. Hanley's son-in-law told a reporter that Milmore had for some time been pursuing her with marriage offers and that she had finally consented and was in Chicago preparing her wedding dress when she received word of his illness. A mutual dislike existed between her and Milmore's family, however, and she was refused entry to his home when she tried to visit him on his deathbed. A detective was hired by the estate's lawyer during the lengthy proceedings, and the first will was held valid. Mrs. Hanley, described in the press as comely in form, moved to New York and in 1909 died at her daughter's home in Florence (her daughter had married a baron).[33]

Sarah Milmore, who must have struggled to raise her hardworking boys, died at age seventy-six in May 1884, less than a year after her son Martin. As for brother Joseph Milmore, he continued his work alone in Boston, gaining a respectability in his own career that had for so long been overshadowed by Martin's talents for Italian-inspired portrait sculpture.[34] In February 1885 Joseph wed Mary Longfellow, who reportedly at one time had also been engaged to his brother, and his lifestyle shifted to a new plane. The couple moved to the Tremont House in Boston and late that summer went abroad. By early December, however,

the *Boston Globe* reported that the sculptor was "in a very precarious condition" in Geneva, Switzerland, where they were wintering. Joseph Milmore passed away there in January at age forty-three due to "a complication of diseases."[35] Mary Longfellow Milmore, thirty-five years old and pregnant with son Oscar, stayed abroad for some time but shipped Joseph's body home in late February for eventual interment in the Milmore lot at Forest Hills Cemetery.[36]

When the news surfaced that he had made a will in Switzerland leaving all but $80 of his estate appraised at $40,000 to his new wife, legal battles over the Milmore estate began anew. The last remaining brother, Charles, who had four children, contested the October 1885 will, contending bitterly that Joseph was not of sound mind when he decided to cut out his only close relatives and was the victim of "undue influence" by his new wife. "It is said that there will be some startling developments made public in relation to Mrs. Milmore's marriage to her husband and her previous history before the question of the will is finally settled," the *New York Times* reported.[37]

Mary Milmore responded in the press via her lawyer that she was a woman of good character who had been "well-regarded" in Cambridge and two nearby towns where she was a teacher for some years, and that her marriage had been presided over by the esteemed Episcopal minister Phillips Brooks of Trinity Church.[38] It was not until January 10, 1888, that the newspapers could report that the will had been "amicably adjusted" in favor of the widow.[39] She moved to Washington, D.C., where she lived in some style with her son, Oscar, on Corcoran Street. Her travels, from Atlantic City to Hawaii, were occasionally reported in the society pages.

Thus it was that after this tangled string of events, Joseph's widow made the final decisions on commissioning a Milmore memorial, with the assistance of James Bailey Richardson, the lawyer designated co-executor of the estate. Joseph's will explicitly requested that the monument Martin had envisioned for the family cemetery lot be erected. It asked that bronze busts or portrait reliefs be placed on the monument "representing my dear mother my two brothers Martin and James Milmore and myself."[40]

Whether the family or lawyer consulted with Martin's mentor, Thomas Ball, is not certain, but it seems likely as Richardson and Mrs. Milmore finally commissioned Ball's most famous student, Daniel Chester French, to memorialize the brothers. Few records about their instructions for the sculpture survive. At some point, though, French or the estate discarded the idea of a portrait monument made up of the kind of Italian-influenced busts the Milmores had sculpted. All three brothers had died young, and French was given the freedom to design a high-style figurative memorial that spoke instead of the universalizing idea of youth's labor, creativity, and promise lost. Ultimately the Milmore brothers, and especially Martin, were to be remembered with a large bronze bas-relief that would be very different from yet rival the Adams Memorial in American cultural history. French summoned up Dr. Bigelow's sphinx and portrayed a young sculptor carving the Egyptian creature as a majestic angel of death approached to touch his hand and lead him to the other side of the veil.

THREE

ANGELS OF GRIEF
ACROSS THE SEA

In the 1890s two grieving expatriate artists—the tousle-haired painter Frank Duveneck and the aging literary lion and sculptor William Wetmore Story—each designed exceptional funerary monuments in Italy to their lost wives. These memorials, conceived with a full awareness of European sculptural traditions, became well known through photographs and copies back home in the United States, where they were viewed as each man's highly individual and emotional response to personal tragedy.

The tomb effigy that Duveneck (1848–1919), a German American artist from Cincinnati, modeled would remain forever in a cemetery in Florence, the city where he and artist Elizabeth Boott Duveneck (1846–1888) lived and worked during a portion of their brief marriage. Like her acquaintance Marian Hooper, Lizzie Boott was born in Boston to a respectable family with an abiding interest in high culture, and she had a close relationship with her protective father. The two women shared a network of friends in elite circles that often overlapped on both sides of the Atlantic. Elizabeth's mother died early, apparently of tubercular pneumonia, when the child was little more than one year old. Her widowed father, unhinged by this loss and the earlier death of an infant son, decided to raise his daughter abroad, ultimately settling in Florence's intellectual expatriate community, where his sister lived. On their six-week sea voyage to the Continent the Bootts shared company with the Story family and would remain lifelong acquaintances.[1] Lizzie grew up in Italy under the paternal guidance of Francis Boott and the watchful care of a beloved nurse, Ann Shenstone, moving to different apartments or pensions in the first years and finally settling in a villa on the hill of Bellosguardo above the city of Florence. There her father, a Harvard graduate and dedicated musical dilettante, refined his talents as an amateur composer and by all accounts devoted himself to her education and happiness, sharing with her his love for opera, theater, and art. That he succeeded—providing tutors in everything from painting and piano to voice, multiple languages, and swimming—is made clear by Henry James's comment that

Elizabeth was among the most exquisitely "produced" young women he had ever met. James called her "the admirable, the infinitely civilized and sympathetic, the markedly produced Lizzie" and described her as a "delightful girl" who had been "educated, cultivated, accomplished, toned above all, as from steeping in a rich, old medium."[2]

Florence was an affordable place to live and study in those years for thousands of Americans. Some families came annually for several months at a time; thus, it seemed that all Boston passed through. Lizzie could count among her extended relations the sculptor Horatio Greenough, who had settled there until shortly before his death in 1852; his younger brother Henry married Lizzie's aunt Fanny (Frances Boott Greenough). Touring Americans visited the studios of artists like the Cincinnati-bred sculptor Hiram Powers, Thomas Ball, and eventually Ball's son-in-law William Couper. The Bootts also spent some winters in Rome, maintaining their family friendship with the poet-sculptor Story, who held court there for the expatriate community. At age five, Lizzie took part in a production of *A Midsummer Night's Dream* in Story's apartments in the Palazzo Barberini; she played one of Titania's fairies, and James Russell Lowell acted the part of Bottom.[3]

Her father's chamber music was also performed there. The art songs he wrote, setting often sentimental poetry by Story, Lowell, Henry Wadsworth Longfellow, and others to music, were favored back home in Boston, where he returned with Lizzie when she reached age nineteen to cement her American connections. During his lifetime, Boott published many albums of his songs (Figure 8), from cradle songs and nostalgic serenades to dirges, hymns, and patriotic tunes, including "Ah, When the Fight Is Won," a tribute to Robert Gould Shaw's Civil War regiment. Although they did not head home to Boston until the end of the Civil War, the Bootts had visited with the Shaw family numerous times on their European travels and followed accounts of the war and of "Bob's" stirring service at the head of the Fifty-Fourth African American unit.[4]

In 1869, when the Bootts spent the month of July at the James family's summer house in Connecticut, Henry James's brother William advised a male friend to make Lizzie's acquaintance quickly, because she was among those "first-class young spinsters" who might not stay single long. "Miss B.," he confided, "although not overpoweringly beautiful, is one of the very best members of her sex I ever met. . . . I never realized before how much a good education . . . added to the charms of a woman." The James family and the Bootts remained close over the years, with Henry especially writing scores of affectionate letters to Lizzie and her father.[5]

Elizabeth determined, however, to become a painter rather than a wife, and her father supported her quest for a serious artistic career. She studied in Boston with artist William Morris Hunt, who offered an influential women's class, and she also attended lectures there by sculptor William Rimmer before working with the French Salon painter Thomas Couture near Paris. She first met Frank Duveneck in the role of a gifted art student seeking his instruction. She and her father had purchased one of Duveneck's paintings in 1875 after visiting an exhibition of his work in Boston, and she was impressed with the bold, expressive

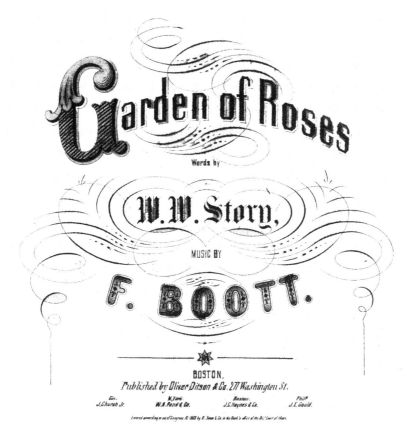

Figure 8.
Francis Boott, "Garden of Roses," with words by W. W. Story and music by F. Boott (Boston: Ditson, 1863). Sheet music cover. Eda Kuhn Loeb Music Library of the Harvard College Library, Cambridge, Massachusetts.

style this rough-mannered and rambunctious-spirited midwesterner had honed during his studies in Munich in the early 1870s. The exuberant confidence of his freely painted, coloristic pictures like *Whistling Boy* (1872), which demonstrate his absorption of the painterly principles of Frans Hals, Diego Velázquez, and Rembrandt, appealed to this sophisticated young woman.[6]

In 1879 Lizzie Boott, by then in her early thirties, joined Duveneck in Bavaria (in the village of Polling, outside Munich) for private studies. He had established a moveable "school," and his loyal students were dubbed the "Duveneck boys." Lizzie persuaded them to decamp to Florence to hold classes there for female students, a situation that offered the artists steady income and patronage. Duveneck and his "boys" began a pattern of spending winters in Tuscany, where he painted Lizzie's father in an imposing aristocratic pose in 1881, and summers in Venice.[7]

An on-again, off-again courtship also began, in which Duveneck wooed Miss Boott and she gently resisted over the years. While he wandered about Italy, she traveled to Spain with other women artists and exhibited her oil and watercolor paintings in Boston, New York,

and Philadelphia in 1883, 1884, and 1885. Reviewers spoke of the vigor, intensity, and "curiously unfeminine" handling of her oil painting as well as the mastery of color and harmony in her pictures of flowers (Figure 9), animal heads, still-life scenes, and portraits, which included depictions of black and gypsy sitters as well as elite mothers and children.[8] Finally, in the fall of 1885, she surrendered to Duveneck's ardent pursuit despite the severe disapproval of her father and others, including Henry James, who worried about her suitor's reliability, gentility, and financial health and acumen. Duveneck, James wrote, was creating work that was "remarkably strong and brilliant" but suffered from "an almost slovenly modesty and want of pretension" and a lack of drive for worldly success. While James admired the couple's "unconventionalism" and found Duveneck to be "an excellent fellow" in some respects, he commented at one point: "Her marrying him would be, given the man, strange (I mean given his roughness, want of education, of a language, etc.)." To another correspondent, he confided in even stronger terms, "He is illiterate, ignorant, and not a gentleman."[9]

Objections aside, the couple married in Paris on March 25, 1886, with the vows exchanged before a magistrate in the Bootts' apartment there. According to one account, Duveneck understood so little French that Lizzie had to prompt him to respond during the ceremony. Her father agreed to join them only after Duveneck signed a prenuptial agreement relinquishing any claim to her estate.[10]

The romance of Lizzie Boott and Frank Duveneck was an oddly appealing meeting of two opposing worlds. Here was Elizabeth, a motherless only child who had spent her life at the center of a sophisticated and comfortable world dedicated to her welfare. Duveneck must have offered something she still found missing—a spontaneous sweetness and unconditional, uncultivated love. "He is a child of Nature but a natural gentleman," she wrote. "He seems to

have led the queerest, most vagrant sort of existence among monks and nuns and convents in America and rough art students here. He is the frankest, truest, kindest hearted of mortals, and the least likely to make his way in the world."[11] By all accounts, Duveneck was an extraordinary and inspiring teacher, whose adoring circle of friends worried about his lack of personal ambition. Though financially impoverished, he was energetically affectionate and illogically generous to those around him. "He seems to be perfectly reckless to give away all his sheckles [sic] to his friends,"[12] Lizzie told friends. While she was fluent in French, Italian, and German, he is said to have spoken an almost comedic mix of English and German in the European years and was so poor that he had to borrow $100 to cover his wedding costs.

Elizabeth's dark hair, which she parted down the center and pulled back into a chignon, set off an open face with large and luminous brown eyes, arched eyebrows, high cheekbones, an aquiline nose, and a strong chin. She was not a delicate flower, but a tall, slender, European-bred beauty. Duveneck, by contrast, came from Covington, Kentucky, a tight-knit working-class German American immigrant community near Cincinnati. His parents ran a neighborhood beer garden and an ale-bottling business. He had at first set his sights, as an impressionable teenager who had demonstrated an unusual artistic facility, on becoming a decorative painter for Roman Catholic churches and seminaries. After arriving in Munich, however, he left the Church and these intentions behind and adopted the life of a Bohemian artist creating picturesque, Halsian paintings of everyday people in dark settings. Handsome in his youth, he was five foot nine and sturdily built, with blond or light brown hair and a thick mustache. Deep-set blue eyes and a distinctive cleft in his chin marked his strong facial features. On his return home from Europe in the 1870s, he swung a cane and affected a Munich cape draped back from his shoulders.[13]

The couple lived at first with Lizzie's father and painted together in Florence for a time before they moved to Paris with their son, who was born in December 1887 and named Francis Boott Duveneck after his grandfather.[14] A portrait of the newlyweds with Francis Boott and nurse Shenstone (Figure 10) on the terrace at Bellosguardo hints at the sometimes tense dynamics of the new arrangement, as Lizzie hovers devotedly near her protective father, enthroned in a rattan armchair. Her husband is left to pose stiffly in the background with the beloved family servant who had helped to raise Lizzie. At the same time, the couple's poses are uncannily parallel, his cane matching her umbrella held perfectly vertically by a gentle gloved hand.

Both Lizzie and Frank planned submissions to the next Salon in Paris. But in the spring of 1888, Lizzie died of pneumonia after a brief illness. They had been married for only two years and she was just forty-one years old when she passed away on March 22, 1888. For her father, history must have seemed to be repeating itself, as he clung to the three-month-old infant she had left for others to raise.

Just before she died Lizzie sat for a portrait in her wedding costume, a brown dress with muff, cape, and bonnet—a picture that Duveneck would submit to the Paris Salon (Plate 6). "Frank has painted a picture of me full length with which Papa is delighted and also all

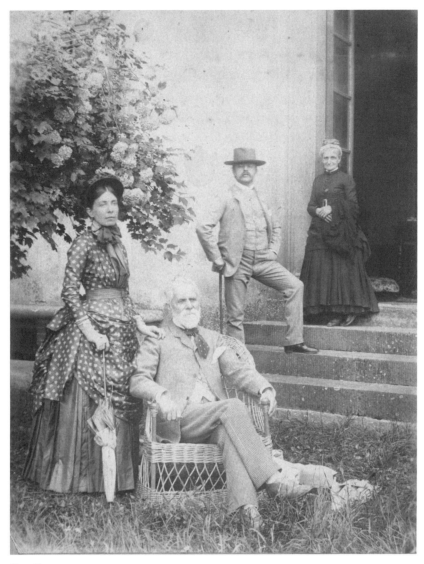

Figure 10.
Elizabeth Boott Duveneck, Francis Boott, Frank Duveneck, and Ann Shenstone, ca. 1886 / unidentified photographer. Frank and Elizabeth Boott Duveneck Papers, Archives of American Art, Smithsonian Institution.

those who have seen it," she wrote on March 13, but complained of exhaustion: "This has taken much of his time and of mine and I am always much occupied with the baby."[15]

Duveneck wrote his brother Charles, "She died yesterday morning at half past seven after four days of great suffering. I can hardly get used to understand this sad blow."[16] Having long ago ceased attending church services, the artist did not appear to seek religious consolation. Rather, he wrote Charles mournfully: "I suppose I must understand it like many others must and in fact all of us must experience [death's blow] sooner or later. . . . I shall try and make the best of it. . . . This morning my wife was taken to a temporary resting place and in the month of May we will take her to Florence her favorite home where she

has lived most of her life, there to rest in that beautiful country of flowers and cypresses she so dearly loved."[17]

Elizabeth Boott Duveneck was buried in the Cimitero Evangelico degli Allori (Evangelical Cemetery of the Laurels), located on the outskirts of Florence near the Bootts' Bellosguardo home. As in Catholic Rome, Protestant foreigners in Florence had to be interred outside the city walls. From 1828 to 1877 the peaceful Cimitero degli Inglesi (English Cemetery) on a hill just outside the city's Porta Pinti gate had been the burial place of many distinguished foreigners, including Hiram Powers, poet Elizabeth Barrett Browning, and Henry Adams's sister Louisa. Nearly ninety Americans were interred there among the fourteen hundred graves, primarily the remains of Anglo-Florentines, Swiss, and sometimes Russian expatriates, or Italian Protestants. During the Risorgimento movement to unify Italy, however, the capital was moved from Florence to Rome in mid-1871; the Florentine city walls were torn down and the "English Cemetery," no longer outside the city boundaries, was closed. The Cimitero Evangelico degli Allori was designated as the new burial site for non-Catholics.[18]

Elizabeth's body was placed in a grave at the Allori cemetery in late April amid rows of tall cypresses. "Great masses of flowers were heaped upon it and her Florentine friends gathered in large numbers to say farewell," James recalled.[19] With Duveneck's apparent assent, Francis Boott took young "Frankie" back to Boston for a correct New England upbringing by a wealthy relation, Arthur Lyman, who had already raised a large brood of his own children. Boott clearly realized that the boy was Lizzie's most enduring memorial and wanted him to be nearby. With his own rearing in an elite Boston family and his decades spent in a highly educated Anglo-American community abroad, Boott apparently did not feel the child could be properly raised by a single artist-father in distant Covington, where Duveneck would return to be near his mother and siblings. Duveneck may have doubted his own parental abilities as well.[20] Although the Cincinnati area had a long and distinguished history as a midwestern center of art, Boott and his circle did not grant it any measure of equality to New England. Henry James wrote snidely to a friend of the "strange fate" that Lizzie had lived just long enough "to tie those two men [Duveneck and her father] with nothing in common, together by that miserable infant and then vanish into space leaving them face to face!" He added, "The child is the complication—without it he and Duveneck could go their ways respectively."[21] Mrs. Lyman noted in her journal that Duveneck had "burst into tears and sobbed aloud" after she told him, "You must come to see [Frankie] often."[22]

Each man would memorialize Lizzie in his own way. Boott's orchestration of a psalm that had often been recited to accompany the burial of the dead was published that year, with the singers repeating "Miserere mei Deus" (Have Mercy on me, O God).[23] Duveneck's portrait of Lizzie was transformed into a memorial when it was exhibited at the Museum of Fine Arts, Boston a month after her death above a laurel wreath, with five of her paintings grouped around it in the main gallery.[24]

After spending an extended time in Boston, Duveneck returned home to the Cincinnati area carrying a deathbed drawing of Lizzie by his friend Louis Ritter (Figure 11).[25] To

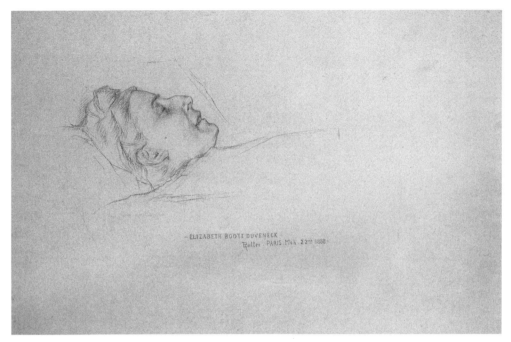

Figure 11.
Louis Ritter. Post-Mortem Portrait of Elizabeth Boott Duveneck. *Cincinnati Art Museum, Gift of Frank Duveneck, 1913.880.*

ease his pain and create a permanent memorial that would be a gift to his father-in-law and son, he collaborated with a younger sculptor named Clement J. Barnhorn (1857–1935) on modeling a recumbent figure of his dead wife, to be cast in bronze. The moving sculpture that resulted would win Duveneck a kind of redemption from her circle of relations and admirers. A number of replicas were eventually displayed in U.S. museums, making the sculpture well known to the American public and keeping the image of Elizabeth Boott Duveneck alive on both sides of the Atlantic.

While the scrappy Duveneck had difficulty winning acceptance among the Boston elite, William Wetmore Story (1819–1895) and his wife, Emelyn Eldredge (1820–1894), had once been held in the highest regard of New England society. During a large share of their five decades of marriage, Story, a sculptor, poet, and raconteur of international renown, and Emelyn had been at the center of a literary and artistic circle of Americans and Europeans who made Italy their mecca. From the Brownings to Nathaniel Hawthorne (who wrote Story into his novel *The Marble Faun*), the expatriate community found itself drawn to the couple's home in the Palazzo Barberini in Rome, where the family settled at midcentury. For their visitors, the Storys often expressed a lighthearted approach to life. The Boston-bred Story (Figure 12)—also an amateur dramatist and musician, Harvard-educated lawyer, and biographer of his famous father, Supreme Court Justice Joseph Story—could be boyishly

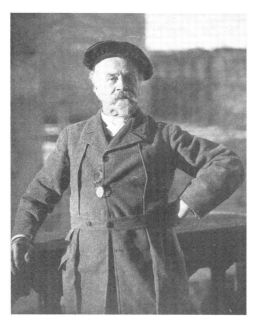

sprightly and "wildly funny." Described by his admirers as an inspired genius and cosmopolitan social charmer with a "beautiful smile," he wrote "little parlor comedies, in which he would act himself, with his children." And he joined in song and conversation, the "gay talker of the company." He had a flair for mimicry, a taste for the hilariously histrionic, and fondness for the theatrical, one observer recalled. He was such a man of the world that he once jested, "I am an Italian, born by mistake in Salem," Massachusetts.[26]

On the occasion of their fiftieth wedding anniversary, "Congratulations poured in from wheresoever the English language was spoken. The presents on this occasion filled several rooms," a journalistic acquaintance recalled of the couple's October 31, 1893, celebration in Rome. "It is to be doubted whether the golden wedding of any Americans on the continent ever attracted more attention than did that of Mr. and Mrs. Story."[27]

Now, however, this rich life was near its end. Story, in his seventies, had become a gray eminence, still beloved only to a dwindling circle of friends for whom he represented the lingering graciousness of an earlier era. His sculptural career was derided by others as a remnant of a moldering past. While he enjoyed the attentions of his three children and his grandchildren, the new generation of American artists had shifted its focus to Paris and adopted a Beaux-Arts aestheticism, favoring bronze sculpture and rejecting his brand of highly narrative white marble neoclassicism. Story, whose first commission had been a sculpture of his father for the chapel of Mount Auburn Cemetery in Cambridge, went on to create a series of brooding mythological, literary, and biblical figures. These imaginative portrayals of powerful or emotionally wrought women—from *Cleopatra* and *Medea* to *Sappho, Judith*, and *Delilah*—earned him a wide reputation in the 1860s and 1870s (Figure 13). Henry James, who at the request of the sculptor's family wrote (with some personal reluctance) a highly complimentary biography of Story, noted that his melodramatic works appealed to the public in those decades because of "the sense of the romantic, the anecdotic, the supposedly historic, the explicitly pathetic. It was still the age in which an image had, before anything else, to tell a story." The sculptor, James added, "told his tale with . . . a strong sense both of character and of drama, so that he created a kind of interest for the statue which had been, without competition, up to that time, reserved for the picture. He gave the marble something of the color of the canvas."[28]

Figure 13.
William Wetmore Story, Medea, *1865; executed 1868. Marble, 82 1/4 × 26 3/4 × 27 1/2 in. Metropolitan Museum of Art, New York, gift of Henry Chauncey. Image © The Metropolitan Museum of Art.*

Even Story's portraits of leading Americans, more popular back home, eliminated any vestiges of the modern trouser and presented them with suggestions of antique garb or without any clothing at all. Marian Adams was one of the touring Americans who visited his studio but who, as a representative of a younger generation, did not appreciate his narrative, classicizing style. In an 1873 letter she commented with disdain, "Oh! How he does spoil nice blocks of white marble." She then compared what she found there with a hometown icon: "Nothing but sibyls on all sides. . . . Call him a genius! I don't see it. I think Dr. Bigelow's Mt. Auburn sphinx is as good *really* as anything in his [Story's] shop." Story, she warned with an acid irony, "will have to ornament tombs in a year or two if he goes on at this rate."[29]

At times Story poured out the melancholy of his life experiences, including the loss of a son, in his poetry. Francis Boott published a song in D flat, "I Am Weary with Rowing," in 1857 after one of Story's compositions: "I am weary with rowing, with rowing, Let me lay down and dream . . . I can struggle no longer, no longer; Here in thy arms let me lie . . . In these arms which are stronger, are stronger Than all of this earth, Let me die, let me die."[30]

By the late 1880s Story's sculptural imagery, based on the imagination, and his artistic and often sentimental literary goals were perceived as outdated. While he had been given the honor of writing the catalogue entry for the American section of the 1876 world's fair, his entry *Salome* for the 1889 fair in Paris was deemed "old fashioned" and spurned by the jury. It ultimately won a space in the American exhibition there only because the weighty female figure had already been shipped to France and Story's son Julian and others appealed for its display, citing the sculptor's fame and advanced age.[31]

Along with this decline in reputation, Story witnessed the advancing illness of his wife, long an indefatigable and active force in his career. "She was my life, my joy," he recalled later. He reportedly fainted when a doctor informed him of his wife's fragile health some years before her death.[32]

Within a few months after the anniversary celebration, Emelyn experienced "progressive paralysis" and then a second stroke.[33] She passed away on January 7, 1894. At a crowded funeral service in St. Paul's American Church on the Via Nazionale, Story "sat in a front seat bent low under the weight of his grief, supported on either side by his son . . . and

his daughter-in-law," the *New York Herald* reported. Emelyn's coffin was covered with flowers, as was the floor around it. Flowers have often been a symbol of life's ephemerality, its brief beauty and inevitable end. The wealth of blooms at the funeral were said to visualize the love and sympathy of Rome's upper-class English-speaking community, which had established the Episcopal church (also known as St. Paul's Within the Walls) in the late 1850s.[34]

Emelyn was described in newspaper tributes as the "wife of the famous American sculptor," and Story said his own "reputation as an artist and man of letters . . . is largely indebted" to her. In an obituary notice placed in the *Boston Transcript*, he wrote that the death of this "remarkable woman . . . closes the book of a past generation." He recalled in his florid, poetic manner the long, flaxen curls of her youth and years of companionship, and declared, "What is left seems to be but a blank of Silence, a dead wall which, when I cry out . . . only echoes back my own voice."[35] In a letter to Julian, he expressed similar feelings: "I know not what I shall do without her—all my thoughts all my memories every place is filled by her and yet she is not here. . . . I can only cry out in my desolation."[36]

Story arranged for his wife's burial in the beautiful Protestant Cemetery in Rome, the resting spot for expatriates from many nations, including the English poets John Keats and Percy Bysshe Shelley. It was Shelley who once wrote that the site, famed for its terraced slopes, cypresses, and vistas, was so sweet a place that it almost "makes one in love with death." The cemetery, near the Testaccio hill and the Cestius Pyramid, was once called *Cimitero Acattolico*, the place—as in Florence—set aside for burial of non-Catholics outside the ancient walls of the city. The Storys were Episcopalians and had interred their first son in the cemetery as early as 1853.[37] Encouraged by his children and friends, Story soon began a monument for Emelyn's gravesite there. It was to be his final completed project.[38]

Story had previously created at least one tomb sculpture, a stiff recumbent figure of founder Ezra Cornell, for Cornell University, where it was placed in the memorial mausoleum of Sage Chapel in the mid-1880s. Now designing the sculpture in his wife's memory seemed to allow him to carry on, converting grief and loneliness through his special skills into a new creative force. He turned from classicizing restraint and the simmering emotion found in his most celebrated works to a figure that symbolized desolation and the unregulated release of feelings, a weeping angel almost human in its frailty, vulnerability, and sorrowful response to God's will (see Plate 4). "I am making a monument to place in the Protestant Cemetery," the widower wrote a relative in the spring of 1894. "And I am always asking myself if she knows it and if she can see it. It represents the angel of Grief, in utter abandonment, throwing herself with drooping wings and hidden face over a funeral altar. It represents what I feel. It represents Prostration. Yet to do it helps me."[39]

Many letters from family members mentioned concern that Story had stopped eating following Emelyn's death. After visiting the aged sculptor in late 1895 at the Palazzo Barberini, Henry James wrote to Francis Boott, "I saw poor W.W. in Rome. . . . he was the ghost, only of his old clownship—very silent and vague and gentle. It was very sad and the Barberini very empty and shabby."[40]

In October 1895 Story died at his daughter's country villa at Vallombrosa, a former Medici hunting lodge outside Florence. Hundreds attended his funeral at St. Paul's Within the Walls, and the event was widely noted in the international press.[41] Story was laid to rest with Emelyn beneath his kneeling angel, leaving three children to carry on his legacy. The barefoot angel rests her head on one lithesome arm, with the other arm extended dejectedly but beautifully before her. The tips of her sagging wings touch the pedestal, and her gown flows downward in long, sad lines. On the front of the white marble monument, the name EMELYN STORY is inscribed within a stone garland. The rest of the inscription reports that she was born in Boston and died in Rome, key moments and places in her life's trajectory. On the east side of the monument were added the words:

> THIS MONUMENT
> THE LAST WORK OF W.W. STORY.
> EXECUTED IN MEMORY OF HIS BELOVED WIFE / ROMA 1895
> HE DIED AT VALLOMBROSA OCTOBER 7TH 1895
> AGED 78 YEARS

PART TWO

THE CONTEXTS
OF MOURNING

FOUR

EMOTIONAL
REGULATION

According to family lore, Henry Adams startled relatives shortly after his wife's death by impulsively tearing a black crepe mourning band from his arm and throwing it under the dinner table. He repeatedly told others that he wanted to press on with his life and not linger in a lethargy of self-seclusion or expressive grieving. Within six months Adams had left Washington on his trip to Japan, enclosing himself in an outer shell of stoicism and public silence about his wife's self-destruction.[1]

During their years together, Henry and Marian Adams had scorned some aspects of mourning decorum, including the strict regulations on dress and conduct that reached their peak in the 1850s as they were approaching adulthood. The couple participated in a shift in attitudes that took place by the 1880s in the wake of the nation's searing Civil War experience. It foreshadowed what French scholar Philippe Ariès has called a "brutal revolution" in the twentieth century in which death became a more private, hushed subject, and survivors were pressured to return to normal life and behavior as soon as possible after their bereavement. This newer philosophy stood in opposition to mid-nineteenth-century social pressures "to make private sorrow public" through frequent, highly visible expressions of sentiment after an initial period of seclusion. By the end of the nineteenth century, lengthy and too visible mourning was viewed by many as an act not of virtue but of self-indulgence—a lack of proper emotional regulation that impinged on the happiness of others.[2]

The Adamses and all of the other historical actors discussed in this book were residents of their time, place, and class. They received letters on black-bordered paper that signaled mourning, and after her father's death Clover wore a respectful black bonnet when a friend accompanied her on occasional carriage rides. Henry no doubt pulled down some of the blinds in his house after her death to signal his seclusion, and family members likely placed mourning ribbons or a wreath on his door. He declined to see visitors immediately and then practiced extreme self-discipline in concealing his emotions from all but a few close relations

and friends. The Irish Milmore family, American newcomers who were never members of the same elite Boston Brahmin society, participated in Catholic rites and somewhat different, probably more demonstrative, traditions among the diversity of expectations and practices brought to the United States by immigrants. The elderly William Wetmore Story, a longtime expatriate in Rome, acted out his grief with considerable melodrama and emotion suited to the older "Victorian" absorption in, and more public exhibition of, sorrow.

In the face of death, adult survivors are often ill prepared for the steps and choices they must take. But when they do act, it is within or against a framework of expectations defined by family rituals and traditions, religious training, period and regional customs, economic options, and even the physical geography of their chosen burial landscape and the availability of memorial materials like granite and bronze and the technologies for using them. Basic assumptions about what could or should be done were changing at the turn of the century, yet the extraordinary individuals discussed in this book had common concerns: they all sought ways to comprehend death's impact and the means to respectfully shape their recollections of their lost ones within established societal boundaries. As they decided how to perform their grief and delineate the narrative contours of their memories, they remained, as Henry Adams noted, members of a "sad fraternity."

At midcentury, bourgeois tradition had required one to two years of mourning for a deceased spouse or parent. Explicit stages of dress and decorum were prescribed in etiquette guides, including deep mourning (strict seclusion from society; the widow to wear dresses made of a lusterless black cloth) and, later, "half-mourning" (when a widow could attend a concert but not balls or dances and wear black with white, gray, or violet to express her imminent availability). Department stores in major cities, such as Lord & Taylor in New York, featured mourning departments, and women's magazines pictured current styles (Figure 14). The width of the black border on stationery was also prescribed depending on the recentness and depth of one's loss, growing narrower as time progressed. These codes were all meant to focus attention on the grief of the survivor in the period of Victorian

Figure 14.
Half-mourning dress; New styles for dressing the hair, 1873. Print,
8 3/4 × 5 1/2 in. From The Peterson Magazine. *Picture Collection,*
New York Public Library, Astor, Lenox and Tilden Foundations.

sentimentalism, the cult of feelings that dominated literature and culture at midcentury. As scholar Karen Halttunen has explained, mourning was deemed an elegant and "necessary social mask" that allowed Americans aspiring to high social status an opportunity to demonstrate their gentility and to stress the bonds of family relationship, while deemphasizing the older focus on the physical body itself, on the morbid biological facts of death.[3] There was always questioning and even criticism, however, of the sincerity of some who wore the black crepe clothing but not the spirit of widowhood—survivors who spent great amounts of money on elaborate funerals with shining black horses and hearses with glass windows, and who purchased expensive mourning wardrobes, including hats, gloves, shoes, black-bordered handkerchiefs, and elaborate jewelry. Women could be critiqued for coming out of mourning too soon or for staying in mourning too long (Figure 15). Deceitful expression of counterfeit or insincere emotions was a serious breach of decorum, burlesqued in cartoons and onstage. Parodies stressing mourners' hypocrisy or mis-motives appeared in the media, and excess was ridiculed.

The Civil War placed the individual death within a larger framework of understanding, inspiring the formation of national cemeteries and contributing to the professionalization of medical and funerary industries. Death and grief services were depersonalized in the decades following the war, with relative strangers paid to complete intimate and highly emotional chores such as preparing the corpse that had once been performed by family members or religious communities. By the 1880s more Americans were dying in hospitals than at home, and the first funeral homes were appearing. Even if most wakes were still

Figure 15.
Charles Dana Gibson, A Widow and Her Friends *(New York: R. H. Russell; London: J. Lane, 1901), Sequence 25. Widener Library, Harvard College Library, Cambridge, Massachusetts.*

held in the family parlor, undertakers often presided over the details. After Marian Adams's death, for instance, her family paid Washington, D.C., undertaker Joseph Gawler $265 for his services.[4] Just the year before her passing, funeral directors meeting in Chicago adopted a national ethics code calling for "delicacy," "secrecy," respect for clients' privacy, and a high-toned morality to elevate their profession.[5]

Alongside these changes, less rigid mourning codes began to be recommended to individuals. "Mourning [dress] is not now usually worn for so great a length of time as formerly; and although some people—at least some women—are very censorious and exacting on this subject, society in general allows more liberty of choice than it once did," etiquette advisor Florence Howe Hall wrote in 1887. To wear mourning dress, she counseled the next year, "is the correct thing," but it "is not now considered obligatory." Some described heavy crepe veils and extended seclusion as unhealthy; others saw the strong public emphasis on sadness, requiring companions to adopt a sober demeanor in the bereaved person's presence, as burdensome and self-centered.[6] Women were clearly the chief bearers of responsibility for mourning. Men, whose duties required them more often to go out into the world, were permitted greater flexibility in their conduct during a shortened bereavement period, and many did not wear special clothing beyond the days of the funeral and interment.

The large number of etiquette guides published at the end of the century were written by diverse authors for a variety of audiences and cannot be taken as a complete and accurate portrayal of American social practices. But they

Figure 16.
Decorum: A Practical Treatise on Etiquette and Dress of the Best American Society *(New York: Union Publishing House, 1880), cover.*

do offer a rich and often neglected outline of standards that governed social interaction in the expanding urban bourgeois culture, as cultural historian John Kasson has explained.[7] In the case of mourning, they provide a direct discussion of matters usually only addressed in private. The writers of these guides advised readers on ways to channel their social ambitions and particularly emphasized restrained behavior. "All manner of ostentation at funerals should be carefully avoided," the 1880 manners book *Decorum* warned (Figure 16), declaring that the "heavy trappings of woe" were no longer in vogue.[8] Scholar Blanche Linden has referred to this as the period of "Denial of Death," which brought to a close the mid-nineteenth-century fascination with heavy veils, cameo brooches, and other accoutrements of sorrow. She noted that by the turn

of the century lovely cut flowers often replaced black crepe drapes, stiff floral set pieces in the shape of crosses and anchors, and black feathers for funerals.[9] Historian David Sloane has described 1855 to 1917 as the era of America's "retreat from sentimentality."[10]

In addition to revisions in mourning dress, greater emotional regulation and a "correct" philosophical stance were advised at the end of the century, reflecting larger societal concerns about the impoliteness of causing others to witness one's grief. Genuine grief can appear ignoble or even ugly, convulsing the features and doing violence to human dignity; thus grief unrestrained and unconcealed could be considered a source of shame. Survivors were obliged to gain mastery over their emotions and facial expressions, what the English naturalist Charles Darwin described as unsightly "grief muscles" in his treatise *The Expression of the Emotion in Man and Animals*. Darwin found that grief often draws the eyebrows together, their inner ends becoming puckered into a fold or lump. The corners of the mouth are drawn down, the upper lip up, and the mouth may open in a groan or cry (Figure 17). He considered emotional facial expressions such as these as vestiges of the primitive, of animalistic functions, like a cat arching its back to warn enemies away since it did not have the ability to use any higher form of language, or of the childish. He concluded that most people can learn, however, to regulate their grief muscles through practice; to do so not only complied with rules of etiquette but improved one's appearance. Darwin noted that expressions of repose or wonder, in opposition to grief, open the face. The brow is smooth and unfurrowed, matching more closely the goals of beauty found in high art.[11]

Figure 17.
Charles Darwin, The Expression of the Emotions in Man and Animals *(London: John Murray, 1872), detail of plate II.*

Survivors in the late nineteenth century were expected to remain in seclusion with the aid of family members and the new death industry workers until they could regain self-control. Once the bereaved could train themselves to manage and cloak the expression of their genuine feelings, however, they were advised to avoid casting a shadow over the collective happiness of others with their personal misery. They were encouraged to express an optimistic attitude about life. It was within the structure of this enforced masking of sincere emotions that Henry Adams, given his family's public profile, found it appropriate to adopt an exaggerated silence after his wife's death, especially since her ending was touched by scandal. Theodore Roosevelt, an acquaintance, also famously avoided mentioning his first wife after her death in 1884, even to his daughter Alice, turning stoicism into a brand of erasure.[12] William Wetmore Story's response to his wife's death could be seen as an unregulated pathos, an emotional outpouring as outdated as his sculptural style.

Self-control was often equated in public discussions with moral character and a suggestion of good breeding. "It is not desirable to enshroud ourselves in gloom after a bereavement, no matter how great it has been," advised the etiquette manual *Decorum*. "It is our duty to ourselves and to the world to regain our cheerfulness as soon as we may, and all that conduces to this we are religiously bound to accept, whether it be music, the bright light of heaven, cheerful clothing or the society of friends."[13]

This was part of a trend toward "positive thinking" and public cheerfulness preached by late nineteenth-century advocates of a can-do breed of American optimism. In her guide entitled *Our Society*, Rose E. Cleveland added: "It is an encouraging sign of progress in the thought of a people, when their burial customs begin to lose much of the sombre and superstitious, and to take on more of the cheerful and philosophic. . . . [D]eath will always be terrible, inscrutable and solemn, and there is surely little need to add to its terrors by gloomy pall and winding sheet, and all the other sombre accessories of the past." Grief, she said, "must not be selfish. . . . It is for the living and those we love that we must live, not for the dead, nor for dead customs, when the spirit of them has departed."[14] These comments and others like them indicated a belief that sincere grieving was unseen grieving.[15]

Those paying condolence visits were, for their part, now urged not to bring up the "painful" and morose subject of death but, as Florence Howe Hall put it, to show one's sympathy "more by manner than in words" and to only give survivors an opportunity to speak about their loss if they wish to, "rather than to mention the subject one's self."[16] The end of lengthy consolation letters was also often advised, with simplified expressions of concern encouraged.

In the light of medical advances such as the development of vaccines and a decline in tuberculosis rates, death would become a more predictable phenomenon by the early twentieth century, inevitable for the elderly but less likely to be waiting each day to strike a near one who had not reached a mature age. In Massachusetts, for example, infant mortality slipped from 131 deaths per 1,000 live births in the early 1850s to 79 in the early 1920s.[17] Once a person survived to age four or five, the chances of living to adulthood increased

dramatically. None of the myriad etiquette guides that appeared in the late nineteenth century, all of which included mourning sections, mentioned situations such as suicide. Despite its growing incidence in urban life, suicide remained a societal taboo. It was also an especially unexpected blow to the survivor, far different than the death of an invalid or aging parent, which might be viewed as a release from travail or pain.

Nor did most of the published guides refer explicitly to different ethnic or religious traditions, whose adherents in the predominantly Protestant United States swelled in the late century thanks to waves of immigrants from Europe. The majority of the more than five million immigrants who arrived in the 1880s were Roman Catholics, Eastern Orthodox, or Jewish, including many Italians and Eastern Europeans. Irish newcomers, who had been a significant portion of earlier waves of immigration from northern and western Europe, also continued to arrive in the decades after the Civil War, eventually threatening the power of the entrenched elite, socially and politically, in places like New York City and Brahmin Boston. The upper class's insistence on restraint in mourning might be considered one effort to distinguish itself from the newcomers, described in Thomas Bailey Aldrich's famous 1895 poem "Unguarded Gates" as "a wild motley throng," as well as separating itself from the nouveau riche.[18]

Martin Milmore's crowded funeral in the Cathedral of the Holy Cross featured an Irish priest and prominent citizens who served as pallbearers. His family's traditions as well as his status as a quasi-public figure in Boston certainly affected mourning and funeral decisions. Irish Catholics in Boston often followed customs from the home country for holding wakes between the time of death and the funeral, a combination of celebration of life mixed with sorrow. The keen, a wailing lament, could be performed by women relatives like Milmore's elderly mother or special professional mourners hired for the occasion to offer songs and chants to help participants move through their grief. A rosary might have been placed with the washed and shrouded corpse, which was likely attended around the clock by kin at the family home, and the rosary was perhaps recited together by a group of relatives led by a priest. At the Latin requiem Mass itself there was music as well as the scent of fragrant incense from censors waved over the body in prayer and veneration and from beeswax candles circling the casket, a sensory spectacle in a church filled with statues and colorful ornament to stir the feelings of mourners who understood themselves to be carrying on age-old rituals.[19]

The funeral service for railroad baron William Vanderbilt II, who died on December 8, 1885, just two days after Clover Adams, provided another striking contrast to the small in-home service that her family chose to have in its intense desire for privacy. Declared by newspapers to be "the richest man in the world," the sixty-five-year-old Vanderbilt was said to have fallen dead of "apoplexy" on the floor of the library of his palatial Fifth Avenue home in New York City, collapsing "without a moment's warning" while conversing with a guest. The details of his death and funeral were related in minute detail in the press. Sixty carriages were reportedly hired to transport the family and friends from the house to St. Bartholomew's Episcopal Church, where his specially made casket was placed on a

low catafalque at the head of the center aisle. Singers led the congregation in an affirming chorus of "Nearer My God to Thee," likely accompanied by organ music. Later, mourners in full regalia took boats to Staten Island and formed a procession to the Moravian Cemetery, where he had a year earlier ordered the construction of a $240,000 mausoleum with interior carvings based on biblical themes from the Creation to the Crucifixion.[20]

Poorer and servant classes lacked the financial resources and free time to mourn in such a conspicuous, or genteel, manner and adopted their own modified rituals. African Americans were segregated in death as in life, with separate funeral homes, burial societies, cemeteries, and customs. "Songs sung at funerals helped mourners release their emotions and they sometimes became overwrought with grief," writes historian Elaine Nichols. "Deep mourning and wailing were expected, and not frowned upon, by the[ir] community."[21]

Mental health experts are still seeking to understand the mourning process, in which rituals and remnants of the older mourning codes continue to serve practical as well as social functions. In the late nineteenth century, the survivor, unmoored by his or her experience, was required to avoid vulgarity while being torn between two realms: holding close and expressing an ongoing attachment to the dead person, and at the same time carrying out a duty to avoid being a burden to the living. At first a spouse whose closest lifemate is gone sometimes feels as if he or she were inhabiting the dead person's body or life, looking out through their eyes and holding each of their possessions precious, guarding memories of their movements and habits. Thus Henry Adams, for instance, made gifts to close friends and relations of cherished pieces of Clover's jewelry, understanding how preciously they would be held in her memory.[22] Frank Duveneck clung to images of his deceased wife, such as the deathbed drawing made by his friend Louis Ritter, with an almost piteous air. The loved one was frozen forever in time, at age twelve or thirty-nine or forty-two, now a part of the past, face and voice and gestures beginning to fade with time. Postmortem or memorial portraits or photographs were often made, especially for children, of the fully dressed corpse, and drawings and death masks of prominent adults.

When survivors left the protection of private domestic spaces and moved into public ones, mourning clothing let others know their status of bereavement without requiring any discussion. For the sensitive it could provide an external cladding shielding inner feelings. In reality, the mourning periods, divided into stages of three months to two years, reflected in an exaggerated and codified fashion some of the realities of grieving. Survivors move to different understandings as they pass through a phased experience of loss, living adrift in a fluid world from the day they first encounter the shock, or the relief, of death to the days on which they confront important anniversaries. The deepest mourning for a close relation takes place within the framework of the first year, psychiatrists note, as the spouse, parent, or child marks each holiday and family benchmark of the calendar. Each familiar occasion forces a survivor to reexperience the absence and, slowly and painfully, to rearrange the shards of joint lives. Finally the bereaved person reemerges, with heartache ideally turning into a kind of wistful nostalgia.

Some believe that death is only a turning point in a continuing relationship, in which a kind of dialogue—surrounding memories of shared experiences, perhaps, and maintenance of shared values—goes on. But the grieving portion of remembering a person is usually conceived as a difficult but terminable process. Sigmund Freud thought so. In his *Mourning and Melancholia* (1917), which examined the experience and expression of grief, he said survivors must be resilient and complete a course of "grief work" to process their loss and reach a form of resolution. They must examine one by one their "memories and expectations" of the deceased, and confront the realization that the person who aroused those thoughts and emotions is dead. This is a "slow and gradual" energy-sapping process of "painful unpleasure" that persists until the internal work of reality testing is completed and the loss is overcome, Freud said.

In this Freudian scenario, mourning has been likened to an internalized slide show in which images associated with the dead person are slowly flashed across a viewing screen. At the end, in the normal course of things, the slides are placed in a box and the box placed in a closet, perhaps to be taken out again only occasionally over the years for review. If there is great trauma attached to certain moments in a relationship, however, the process may be more difficult. Freud described a psychological disorder called "melancholia" in which the survivor's normal path to resolution is blocked, causing greater self-reviling and self-reproach. Modern-day researchers call this "complicated grief" or classify it as "prolonged grief disorder," which can lead to destructive behavior such as suicide or substance abuse. "Its chief symptom is a yearning for the loved one so intense that it strips a person of other desires. Life has no meaning; joy is out of bounds," and the survivor is given to uncontrollable bouts of sadness.[23] Some have suggested that Marian Adams could never psychically resolve the death of her father on whom she was profoundly dependent. William Wetmore Story, unable to get beyond the death of his longtime wife, Emelyn, gave himself permission to join her in death. But Frank Duveneck lived a long life, talking affectionately about his past love for his artist wife, Lizzie, and inspiring generations of students with his painting.

These are some of the ways that individuals mourn. Exploring period attitudes toward mourning behavior and religious consolation helps us to understand that decisions about funerary memorials were not only the results of individual impulses but of an interconnected array of persuasive forces and social pressures. These played a role in late nineteenth-century rituals of bereavement—steps along the way in survivors' quest for a renewed wholeness, a longed-for unity of lives shattered by death.

FIVE

VARIETIES OF RELIGIOUS CONSOLATION

The late nineteenth century is often viewed as an era of increasing secularism and agnosticism amid the influence of Darwinian theory and the growth of a mass consumer culture. Yet most American consolation literature continued to be either explicitly or implicitly religious. It expressed confidence in a loving and kind Christian God and envisioned the dead sleeping peacefully in the grave or happily ensconced in a "better place" closer to the Lord. An acceptance of God's plan for mankind was regularly raised as the only real means to find comfort in a situation that shocked and tested faith. A personal morality of patience, peace, and resignation was stressed, and far less emphasis than in previous centuries was placed on the presence of evil and danger in the world. At the same time, liberal religion and a growing curiosity about non-Christian faiths such as Buddhism, together with the questions science raised about evolution, contributed to a greater diversity and openness in the forms consolation could take. It was possible to view life and death as a riddle—a variable, beautiful, even wondrous mystery beyond the power of earthly humans to resolve. Cemetery memorialization at the turn of the century drew from all of these currents. Arts writer William Walton, for example, observed a "definite movement" in which funerary sculpture sought to give expression to many of the "thronging images, hopes and fears, with which man has in all ages pieced out the scantiness of his knowledge of the unknown."[1]

One of the goals of all religious faiths is to explain death and help people prepare for it. The church provides rituals to assuage grief, traditions that draw even the nonfaithful or fallen-away to religious institutions at the moment of loss. In doing so, it serves a deep human need. Historians have found that people around the world have tried since ancient times to figure out where the conscious person goes at the moment of death—the "vanishing" point—and why people must die.[2] A common trope among various religions has been

to see death as a transition between different manifestations of life, be it a new life in heaven and then resurrection or a series of rebirths in Eastern philosophies. But Albert Raboteau, a professor of religion, noted, "Even with the most confident faith, death destroys the illusion that life goes on to an endless series of tomorrows and raises the classic question: How could God let this happen?"[3]

A socially enforced optimism based on acceptance of the mysterious workings of God was one reason given for revising behavioral codes at the end of the nineteenth century. "According to our belief the loved one has gone to a happier world, free from all pain and care. Why, then, should we surround ourselves with the tokens of a woe that is in some sort a rebellion against the decrees of Divine Providence?" Florence Howe Hall asked in one of her diatribes against extended mourning.[4] Etiquette expert Mary Sherwood also called black clothing "a negatory of our professed belief in the resurrection" and a confession of the human "logic of despair" at a time when rejoicing was really in order.[5] The proper Christian response was to reject despair, which was equated with doubt, denial of faith, and atheism. In Roman Catholicism, in fact, despair had long been associated with one of the seven cardinal sins, denoting a willful lack of joy—a refusal to fully embrace God's world and God's goodness.[6]

The pressure to abandon grieving and celebrate the afterlife was part of a "doctrine of assurance" that emerged after the Second Great Awakening, a Protestant revival movement in the early nineteenth century. This doctrine suggested that adults who had led lives of virtue and children whose innocence had not yet been tarnished should anticipate their own salvation, resurrection, and relocation to a place often imagined in mid-nineteenth-century sentimentalist poems and songs as a heavenly house or mansion. With the promise of salvation, death could be viewed as a sweet deliverance from life.[7] This perspective related to a mentality of "dogged optimism" also found in mass culture's obsession with progress, innovation, and advances in science and technology.[8]

All evidence indicates that the majority of Americans believed that humanity was a creation of God, who continued to guide individuals as father and friend, and who was less the harsh judge he had once been seen to be. For much of the population, literal belief in the Bible persistently undermined the impact of scientific findings such as the concept of evolution, discussed by Charles Darwin in his *On the Origin of Species* (1859). Darwin's findings suggested that God was a bystander to the processes of natural selection, and that man, rather than being a special divine creation, had evolved like the animals to his current state. Positivists went on to predict that science would eventually be able to explain all of the workings of nature and the universe.

In consolation literature and in church funeral services, by contrast, Americans were advised to resign themselves to faith in God's higher power and purpose. Satin-mounted memorial cards, adorned with doves, urns, and flowers (Figure 18), often used verses such as Alfred Lord Tennyson's poem expressing firm belief in a hereafter: "There is no death": "What seems so is transition; / This life of mortal breath / Is but a suburb of the life Elysian, /

Figure 18.
Memorial Card Co. Advertising brochure for memorial cards. *Philadelphia, Pennsylvania, ca. 1891. Courtesy, The Winterthur Library: Joseph Downs Collection of Manuscripts and Printed Ephemera, Winterthur, Delaware.*

Whose portal we call Death." On a similarly comforting brochure for the Mitchell Company, "Asleep in Jesus" could be selected.[9]

Death could provide a moment of doubt, a crack in religious faith, however. For example, on April 12, 1880, Charles A. Belin wrote Mrs. Samuel du Pont in Wilkes-Barre, Pennsylvania, acknowledging that after the loss of his wife he was struggling to seek consolation in God: "My heart is overwhelmed with grief. . . . God has visited me with a great deal of affliction. . . . [T]he cup seems overflowing," he said. She anxiously urged him to understand what happened as part of God's "merciful measure" and not to see it as a fickle or capricious act of a punishing, malevolent greater force.[10]

After the death of the California railroad baron Leland Stanford in 1893, his highly religious widow, Jane Stanford, responded to consolation letters by describing her personal suffering and then imagining her husband reunited in heaven with their son, who had passed away eight years earlier. "I ask myself each day how can it be. I live with this great overwhelming sorrow upon me," she wrote a clergyman. "Alone! All Alone! My aching

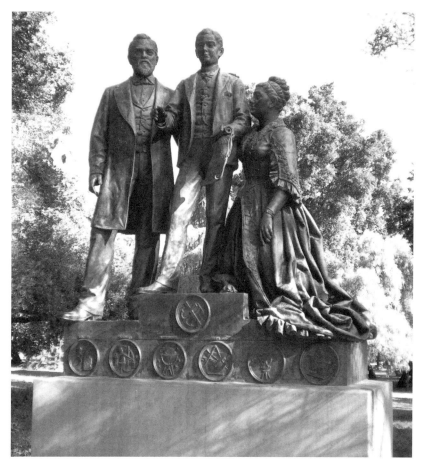

Figure 19.
Larkin Mead, Stanford Family Monument, 1899–1900, Stanford University, Stanford, California. Photo by Cynthia Mills.

bleeding heart cries," she told a friend, "but I look afar and see the joy beyond in the Fairer Land, Father and Son together—father at rest from the toils of the earth." She later commissioned a bronze statue of herself kneeling on a cushion next to the pair, who are standing together above her on stepped pedestals (Figure 19).[11]

Liberal religion stressed good deeds on earth as the best response to the trials of loss. For instance, the Reverend Edward Henry Hall of the First Church (Unitarian) of Cambridge, who officiated at Clover Adams's funeral, had once urged in his sermon titled "Our Dead": "The hurrying ranks of those who work and live cannot pause at the graves of the fallen for idle grief, but catch up their lives into their own, and press forward for the higher and larger tasks which their lives have made possible. . . . What each generation asks of the next is to prove the value of its work already done, by carrying it forward without delay, if need be in wider and loftier ways."[12] When Hall himself died in 1912, a poem read by the minister at his funeral did not mention either evil or doubt or even Jesus's explicit compassion, but softened the blow by figuring Hall as going to bed sooner than his friends and

relations: "Thou hast but taken thy lamp and gone to bed, / I stay a little longer as one stays / To cover up the embers that still burn."[13]

Years later, Henry Adams would talk about his "mansion" in Rock Creek Cemetery, the gravesite where his wife's memorial finally stood—a term that meshed with the period's domestication of death and alluded to Jesus Christ's promise to his followers that "In my Father's house are many mansions" (John 14:2). Adams had regularly attended Unitarian services in Boston, studied the Bible, memorized religious verses, and "went through all the forms" of faith as a youth, recalling that he believed in a "mild deism." But as a young adult he suffered a "disappearance" of belief in conventional religious institutions.[14] His intimate friends thus avoided religious language and bromides in consolation letters. His closest friend, John Hay, wrote, "I cannot force on a man like you the commonplaces of condolence. In the presence of a sorrow like yours, it is little for your friends to say [that] they love you and sympathize with you—but it is all anybody can say. Everything else is mere words." Hay went on to express his confidence that Adams had the fortitude to bear up under his sorrow and recited the need for patience, courage, and other moral values that were part of Protestant culture even if he did not mention religion. He also spoke of the bright candle Clover had been, illuminating the lives of those around her: "Is it any consolation to remember her as she was? That bright intrepid spirit, that keen fine intellect, that lofty scorn of all that was mean, that social charm which made your house such a one as Washington never knew before, and made hundreds of people love her as much as they admired her? No, that makes it all the harder to bear."[15]

○

Americans looked far and wide for sources of consolation, regardless of historical or geographic origin, as part of a syncretic turn-of-the-century search for meaning that embraced Asian traditions, personal spiritual experience, and medieval ideas about the nature of "wonder."[16] After Clover's death, Adams was drawn to Eastern religions as he considered the relative appeals of reason, belief in human progress, and faith or "felt" cognition in a quest for some sort of abstract, universal "truth" or "truths" that would lead to consolation.

Adams's 1886 trip to Japan was not only an attempt to still his restlessness; it also represented a personal exploration of religious expressions in Asia. He talked half-humorously, half-seriously with his traveling companion John La Farge about going on a quest for nirvana, a cessation or release of the passions. A greater pluralism of religious ideas was tolerated among Americans amid investigations of agnosticism at century's end, and Buddhism was much discussed at this time in educated circles. This seemed to be especially true in Boston, where Phillips Brooks, the Episcopal minister of Trinity Church (and Adams's second cousin), wrote only partly in jest in 1883 that a large part of the populace "prefers to consider itself Buddhist rather than Christian."[17] Individuals like Adams with a family background in Unitarianism, which deemphasized rigid creeds and ideas of hell, seemed especially open to Eastern ideas, albeit within the framework and perspective

of their own experiences. Because of its merchant connections, New England had been exposed to Asian cultures for generations. Sir Edwin Arnold's *The Light of Asia*, a life of the Buddha rendered in free verse, was at a height of popularity in America.[18] Travelers' reports, trade items, and expositions helped to create a related vogue for Japanese interior design and gardens as well.

In 1883 and 1884 collector Isabella Stewart Gardner and her husband, John Lowell Gardner Jr., made an ambitious yearlong trip through Japan, China, Cambodia, Java, Burma, and India seeking to visit major Buddhist, Shinto, and Hindu sites. Mrs. Gardner in particular was drawn to the temples not only for their picturesque qualities but in a desire to witness alternative or parallel devotional rituals in faiths "extolling peace, contemplation, the negation of desire," writes historian Alan Chong.[19] A few New Englanders, like Clover's cousin William Sturgis Bigelow, stayed in Asia for years. Their reports helped to whet the tastes of friends like Adams, who no doubt heard stories of religious services held in spectacular architectural and garden settings amid the scent of incense and the sounds of chanting and bells. During his trip to Japan with Henry Adams, La Farge became increasingly interested in Taoism and meditation, and was inspired to make several paintings of the white-robed Kwannon, an intermediary Buddhist figure, meditating on human life (Figure 20).

Adams's interest had been a long-standing one. This look to the East and the idea of nirvana had been alluded to repeatedly, for instance, in his novel *Esther*, published in 1884 under a pseudonym. The novel's theme is one of spiritual hunger at a time when science had fueled new questions about religion, and the term "neurasthenia" was coined for a disease brought on by the anxieties, constraints, and alienation of modern life. In an uncanny foreboding of Clover's death the next year, the main character is left seeking answers about life and death (and the Episcopal minister who wants to marry her) after the demise of her father.[20]

Eastern ideas of the fluidity and continuity of life and death, in a kind of "co-existing flow," were attractive to some Americans seeking answers in their own lives. Buddhism, for instance, sees death as but one stage in an endless cycle of regeneration. This idea softens the harshness of its blow, removing human existence from the iron grip of time and its limits.[21] But the tenets of Eastern faiths got tangled up with the religious traditions and assumptions held by nineteenth-century westerners who were comfortable with seeing death as a portal to heaven and resurrection.

Figure 20.
John La Farge, Kwannon Meditating on Human Life, *1894.*
36 × 34 in. Collection of The Butler Institute of American Art,
Youngstown, Ohio.

They filtered the religious sites they visited through Christian eyes. La Farge, for his part, compared Japanese images of the Buddhist intermediary figures known as bodhisattvas to Renaissance Madonnas or Catholic saints. Isabella Gardner visited Catholic missions during her trip to Asia, considering them another aspect of her exotic adventure.

Writer Henry James's philosopher-psychologist brother William James (Figure 21), an influential theoretician who taught at Harvard University, commented that Buddhism and Christianity are both essentially "religions of deliverance: the man must die to an unreal life before he can be born into the real life." He devoted a portion of his *Varieties of Religious Experience* to the deep-seated American interest in conversion and the expectation that it is part of an adult's life path—redemption in some form and a second birth. Out of these transitions can be born a more deeply conscious being.[22] This notion that life events like death can be transformative portals offered another form of consolation (through the intermediary interest in Asian religion and philosophy) for New England intellectuals like Adams who were otherwise disdainful of evangelical notions of second births.

William James, who knew the Adamses and the Bootts well and certainly knew much about the Storys, was one of the great thinkers of his day who tested a pragmatic approach to philosophy and daily life. In his revolutionary study of American religion, he examined

Figure 21.
Henry James and William James, ca. 1900. Photo from Henry James, ed., The Letters of William James, *vol. 2 (Boston: Atlantic Monthly Press, 1920).*

personal affective experiences instead of looking at church doctrines and institutional infra-structures, as others had done. His book *The Varieties of Religious Experience*, which has been called "the founding text of the modern study of religion," related many first-person accounts that he linked to a human drive for a sense of wholeness and "equilibrium succeeding a period of storm and stress and inconsistency."[23] James also explored human suspicions of the supernatural. Stories of the paranormal, séances, and other emanations of spiritualism reached a high point in the decades after the 1848 case of the Fox sisters, who could elicit answers from an invisible spirit in the form of mysterious rapping sounds in their upstate New York home. Such paranormal accounts were often associated with notions of hoax and fraud. Instead of dismissing the possibility of being able to communicate with people in the afterlife, however, James investigated reports in the most scientific fashion he could, observing mediums, for example, and awaiting a hoped-for transmission from a dead friend. He and a small group of scientists on both sides of the Atlantic studied the possible connections to another realm outside the material world made via "ghosts and raps and messages from spirits" that "can never fully be explained away."[24] Many Americans participated in their own informal experiments in clairvoyance, and in his novel *Esther* Henry Adams at least acknowledged his awareness of spiritualism's pull, when he described a scene aboard a train in which "the tap-tap of the train-men's hammers on the wheels beneath sounded like spirit-rappings. These signs of life behind the veil were like the steady lights of shore to the drowning fisherman off the reef outside." On one occasion, Clover Adams sent a friend a copy of William Dean Howells's novel *Undiscovered Country* (1880), which features séances and a man's mislaid faith in spiritualism.[25]

William James saw individual faith as necessary for a healthy society and thus approved of a human "will to believe," the title of another of his books. He expanded the idea of faith, however, to include such things as notions of the supernatural that were outside the established church. "A man's religious faith . . . means for me essentially his faith in the existence of an unseen order of some kind in which the riddle of the natural order may be found explained," he wrote. Science had yet to offer only "the minutest glimpse of what the universe will really prove to be when adequately understood," he said; thus people should act as if the invisible world they imagine were true.[26]

People have a right to believe in a higher metaphysical power and an individual channel of devotion, James said; it is part of the freedom of human will to do so. In his view, religion could be defined as one's personal experience and self-reflection about it, rather than the church and its rigid hierarchies and structures of belief. A world that exists beyond the senses, continuous with our consciousness, may cause us to have religious feelings, however vague, that satisfy our yearnings more fully than religious institutions, he wrote. Thus, like Adams, he surrounded himself with people who were often interested in notions of creativity, alternative religious systems, and mysticism as well as scientists.

Amid his self-reflections, James periodically fought his own melancholia, and he devoted a lecture in 1895 to the seductive appeal of suicide, talking about the need to grasp

the great "maybe" of life. Suicide could suggest a person's lack of fortitude and faith in God, a rejection of the wondrous happiness religion could offer. Unitarians, among others, probably met the event with doctrinal silence. At the turn of the century, they likely no longer saw it as an absolute barrier to eternal salvation; those ideas were beginning to fade in established religion as the years passed.[27] "In the old days . . . the Church treated suicide victims much as it did murderers and not only condemned them to [heavenly] punishment, but to earthly ignominy in refusing them Christian burial," wrote George Upton in the *Independent* in 1904, "but with the increased weakening of ecclesiastical authority and a growing doubt of eternal punishment and, sometimes, uncertainty as to the definite nature of the hereafter, this restraint has largely disappeared."[28] He reported that suicides were on the increase, especially among women, blaming "our modern complex life [which] gives frequency to self-destruction."

James, writing before Freud's analysis, described melancholy as an incapacity for joyous feeling. Contrasting the positive temperament of someone like Walt Whitman for whom life is full of delight, he spoke of others who cannot help having naturally pessimistic temperaments: "That life is not worth living the whole army of suicides declare." James talked about how deep within each of us is a place of *Binnenleben* (hidden life, hidden self), a "dumb region of the heart in which we dwell alone with our willingness and unwillingnesses, our faiths and fears." He urged in his lecture that we grasp the great "maybe" of life and fight against the dark attractions of self-destruction.[29] In these words and many others, James was among the "modern" educated Americans who, like Adams, valued wonder and the inability to explain the secrets of life, God, and death.

James and Adams, like other leading artists and thinkers of their generation, were familiar with the controversial ideas outlined by Darwin in his *On the Origin of Species* and *The Descent of Man* (1871), that nature was ruled by violent and random forms of natural selection, by chance and not tightly controlled design, and that man was not a special creature of God but different from animals only by matters of degree. They carefully considered the relations between faith and science, experimenting with positivist science that relied on observable phenomena. Yet they were also strongly attracted to Herbert Spencer's promotion, in his talks and in his book *First Principles*, of a brand of agnosticism in which "in its ultimate essence nothing can be known," neither the reality of religion nor the reality of science. Spencer talked about the "Unknowable" and wrote that "the Power which the Universe manifests to us is utterly inscrutable."[30]

Augustus Saint-Gaudens, the sculptor who would create Adams's famed cemetery memorial, mused about an apparent "Great Power that is over us" and concluded that mankind was headed to an uncertain future. "The principal thought in my life is that we are on a planet going no one knows where, probably to something higher (on the Darwinian principle of Evolution)," he once wrote.[31] At Walt Whitman's burial in 1892, the agnostic Robert G. Ingersoll celebrated the poet's openness of faith and wonder, declaring at his graveside, "Again we, in the mystery of Life, are brought face to face with the mystery of Death." Whitman, he

said, "accepted and absorbed all theories, all creeds, all religions, and believed in none. His philosophy was a sky that embraced all clouds and accounted for all clouds."[32]

Henry Adams, a true polymath, later in life also investigated French cathedrals and thirteenth-century Christianity, crossing temporal boundaries as well as geographic ones in his continued quest for understanding and consolation. In *Mont Saint-Michel and Chartres* (1904), he sees the French cathedral as the site of a unity, purpose, and mystical wonder lost to his own epoch—understandings of a past era that he said only a child or very old person can hope to grasp. Thomas Aquinas, who was one focus of Adams's study of medieval culture, had written about the importance of the emotion of wonder in religious life. He associated it with a longing that is resolved not by comprehending the object of wonder, but by appreciating its mystery, by remaining in awe of it and by venerating it as something that cannot be understood. The "wonder experience" was often associated with paradox, a mixture of opposites as in the sphinx made of the head of a bird and body of a lion, or an experience so extraordinary that standard understandings cannot explain. Seventeenth-century French philosopher René Descartes called wonder "the first of all passions," saying, "wonder is a sudden surprise of the soul which makes it tend to consider attentively those objects which seem to it rare and extraordinary."[33]

What appealed to James was a sense that the questing human spirit could be in contact with a realm greater than oneself and the material world, a domain outside and beyond ourselves that we only suspect exists. Modern-day scholar William Kastenbaum has talked of an "emergent quality" that people seek—a sense that the soul could feel liberated, somehow continue to develop, and be part of an evolving relationship between life and death—as a great potential comfort.[34] Perhaps this is why some grieving patrons seeking to memorialize their lost ones in the Gilded Age cemetery chose to do so with a combination of aesthetic beauty and mystery. They sought and generated a form of funerary art in which the great Unknown, the riddle of life and death, was embraced. They wanted monuments that moved visitors in new ways—not with cloying sentiment and confidence about man's place in God's heaven, but with a sense of perfect wonder, a sense that a veil could be lifted for a momentary glimpse here on earth of the meaning of death. There was a dream of a death that was not terrifying and grim for their lost one but that was transformational, performed with a mystic experience, a profound sense of beauty, love, and understanding, and a connection with the larger universe in some form, somewhere, somehow. For the imaginative and sensitive viewer with these sophisticated goals, three-dimensional statues in the sensory landscape of the cemetery provided a focus for highly private meditation, psychic exploration, and reflection about the hereafter.

LANDSCAPES
OF SENSATION

Marian Adams was laid to rest on a grassy slope in Rock Creek Cemetery, the oldest grave-yard in Washington, D.C.[1] According to family members, she was buried in a long willow or wicker basket covered with black cloth, a tradition of the William Sturgis family from which she descended. Most likely cut flowers were placed atop the basket before it was covered with dirt. Without a casket, Clover's body could meld quickly with the earth—"ashes to ashes, dust to dust."[2] Shortly after her interment, Henry Adams ordered a modest "head stone," costing $12, to mark the site temporarily while he considered options for erecting a more elaborate memorial at a later stage in his bereavement.[3]

These simple choices ran counter to the preponderant tradition in which most people were laid to rest in coffins, which were often placed in simpler "outer boxes" before burial to prevent dirt from filling in or marring the burial case.[4] The word "casket" had more re-cently come into use, summoning up the idea of a jewel box. William Vanderbilt II's body was placed in an elaborately constructed casket with silver handles and fittings. After that casket was inserted in its outer box, it was moved to a holding vault to await placement in a stone compartment in his family's new Gothic-style mausoleum on Staten Island. According to newspaper reports, Vanderbilt had just gone to the cemetery with his son to inspect the construction work on the mausoleum a few days before his death.[5] The completed struc-ture features an altar and elaborate carvings. All of these preparations suggested his wealth, public stature, and concern about securing the grave from vandalism as well as his Christian beliefs about resurrection.

In the early 1880s, societies promoting cremation as a burial option had been orga-nized in a number of cities. The societies offered lectures and publications, but this form of interment still met considerable religious opposition; in early 1884 only one crematory was reported to exist in the United States. Advocacy for cremation began to gain strength, how-ever, at the end of the century.[6]

No matter which choice survivors made, the physical body was the center of initial mourning rituals, at the funeral and burial. Ministers might call it the departed person's "house in clay," a shell now abandoned by his or her soul, but the lifeless form remained the unique affective center. Although hidden within its funeral case, it was a real presence around which emotion coiled, along with a dutiful respect and, for some, a certain repugnance and almost superstitious dread. The corpse, it seemed, needed to be both venerated and propitiated at this crucial moment. For most, an empathic encounter with the body could not help but inspire self-reflection on the brevity of all human existence and on its significance.[7]

After the early stages of trauma for survivors and deep mourning, which involved the multiple decisions related to funeral services and interment, the cemetery itself became an important meeting ground with the dead in the weeks and years ahead, a place where the spirits of the deceased seemed for at least a time to cohabit the earth. The cemetery, properly landscaped and ornamented, could offer an aesthetic, sensory envelope of space for this potential crossing of revenants and living. The tombstone or monument placed above the grave provided something concrete and specific for the senses to perceive, a visual and tactile trace that could be physically encountered and even touched—that was not a phantom spirit. As the years passed, these markers, standing in for the harsh reality of the moldering body below, remained as silent witnesses to the interconnection of generations, something real and phenomenologically different from verbal recollections. They invoked the continuing presence of the dead (a subtext usually repressed in daily life) while at the same time confirming that they had departed their earthly community forever.[8]

○

Darkened skies, wind, and a miserable, driving rain marked the day set for Marian Adams's interment, according to a written recollection left by her brother-in-law Charles Francis Adams.[9] But sister Ellen Gurney dwelled instead on the constant natural beauty of the surrounding landscape in a letter to a friend, reassuring her that Marian's grave was located "in a most peaceful church yard . . . with room for us all if we wish it . . . a place which they often went to together and where the spring comes early."[10] Henry and Clover had indeed visited this graveyard, where some of his distant relations rested, a number of times. In December 1878, for example, Clover wrote her father about a *Hamlet*-like experience they had in the "beautiful" old cemetery: "a curious chat with a handsome gay old grave digger" they met who regaled them with his life story.[11] They had also toured Civil War cemeteries such as Arlington Cemetery across the Potomac River, seeing them as sites of communication with nature and the universal, history, and respectful familial reverence. "We rode to Arlington Friday P.M. and it was lovely with its fifteen thousand quiet sleepers," Clover wrote her father in 1882.[12] They were only too familiar as well with the first garden cemetery in America, Mount Auburn Cemetery near Boston, which influenced the development of all future graveyards.

Henry Adams's role in making an imprint on the U.S. cemetery landscape seemed almost foreordained by these experiences and a string of earlier events. He had been delivered into this world by Jacob Bigelow, who was the doctor to Boston's most elite residents but is now best remembered as a founder of Mount Auburn Cemetery. "I was roused at three o'clock this morning by my wife who soon gave indications of the necessity of Dr. Bigelow's presence," Charles Francis Adams wrote, describing his son Henry's birth in his diary entry for February 16, 1838. "I accordingly went for him in the midst of a snow storm and in the extraordinary silence of the streets."[13]

Bigelow and other leading citizens in Boston had opened Mount Auburn Cemetery in Cambridge seven years earlier, in 1831, in response to growing concerns about health hazards from graveyards located in city centers. They adopted new European ideas about using the cemetery as a romantic landscape of memory and moral and historical instruction, a place where the body could decay in the embrace of God-given natural beauty and visitors could be instructed about their ancestors.[14] Clover's grandfather William Sturgis (1782–1863), a sea captain and wealthy merchant, had been among a dozen influential Bostonians who joined Bigelow in launching plans for its creation, and Sturgis also was among the first Bostonians to acquire a family lot there.[15] The Bigelows and Sturgises intermarried, and Clover's close relations included a Bigelow cousin. Henry Adams became familiar with Mount Auburn from excursions in his boyhood and significant visits in his adulthood. His father described after-dinner strolls in the cemetery in his diary during the years of Henry's childhood. Later, the Sturgis family lot was the place where Henry joined Clover in witnessing Dr. Hooper's burial beside her mother's grave. It was the hillside resting place as well for many of Clover's other relatives.

Modeled after the famous Père Lachaise Cemetery in Paris and also influenced by English garden theories and U.S. horticultural interests, Mount Auburn represented a new kind of graveyard for America. Removed from the city center, it featured serpentine walks, ponds, and scenic views amid evergreens and ornamental trees (Figure 22). In this natural park families could buy large plots to bury their dead together and could control the way these plots were decorated, landscaped, and bounded with railings, with an expectation of permanence. Mount Auburn quickly became the prototype for scores of rural garden cemeteries opened across America in the 1830s and 1840s, including Laurel Hill in Philadelphia, Green Mount in Baltimore, and Green-Wood in Brooklyn. By midcentury these nonsectarian cemeteries existed in most cities, replacing or superseding crowded urban graveyards.[16] Rock Creek Cemetery in Washington, which had been established much earlier, about 1719, slowly adopted many of the aesthetic principles of the picturesque new garden cemeteries and eventually became a nonsectarian site, chartered by Congress as a public cemetery in 1871.

Leaving behind the slate slabs with winged skulls of earlier times, most of the monuments of the 1830s and 1840s were three-dimensional marble structures, frequently obelisks or sarcophagi, broken columns and flaming or draped urns placed atop pedestals. These symbols drew on classicizing, Egyptian, and sometimes Gothic sources suggesting

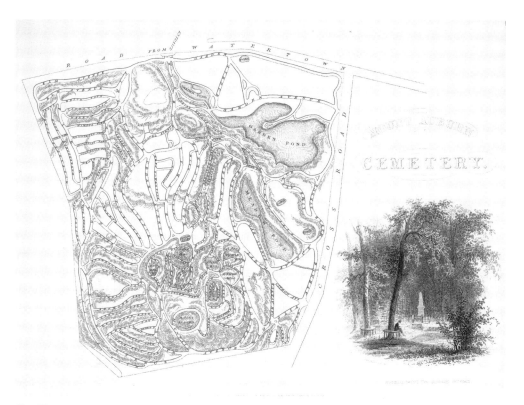

Figure 22.
James Smillie, Mount Auburn Cemetery—Monument to Judge Story [and map of the cemetery, Boston, Mass.], ca. 1848. Engraving. Frontispiece, Mount Auburn Cemetery Illustrated. *Prints and Photographs Division, Library of Congress, Reproduction number LC-USZ62-91748.*

the continuity of civilizations and the permanence of memory after life itself is interrupted. They were visual euphemisms for death, adopted at the same time that the graveyard was renamed the "cemetery"—from the Greek word for sleeping place—and that death itself was relabeled "passing on." Monuments at Mount Auburn and elsewhere also often glorified the centrality of family relations. Epitaphs describe women and children in terms of a patriarchal system of family relations—"Beloved Mother," "Beloved Father"—and suggest the chain of generations that survives when one life is snuffed out. Life dates were almost always included as a matter of family record. In addition to portrait statues and stone angels, neoclassical women mourners and sentimental allegorical figures of Faith, Hope, Charity, and Memory, with wreath, book, or flowers, were the most frequently seen figurative works.[17] Period prints showed parents leading children to cemetery monuments and discussing the lessons contained in them and in the natural setting of the rural cemetery.

William Wetmore Story's father, Associate Supreme Court Justice Joseph Story, delivered the consecration address at the opening of Mount Auburn Cemetery. Story, who had recently lost a ten-year-old daughter to scarlet fever, spoke movingly of the consoling impact of the natural space, saying, "All around us there breathes a solemn calm, as if we were in the bosom of a wilderness, broken only by a breeze as it murmurs through the tops of the

forest. . . . Ascend but a few steps and what a change of scenery to surprise and delight us." Visitors, he concluded, return to the world feeling "purer, and better, and wiser, from this communion with the dead."[18]

In the hushed silence, with only the sounds of trees rustling and birds singing and the touch of a breeze on one's face, a stroller could contemplate higher thoughts, large and moral thoughts. The visitor walking through the funerary arena could also experience the natural space as a series of images and sensations, much as a person processes a filmic array of impressions crossing a bridge. These change with proximity and distance, the seasons and time of day, dampness, chill, and warmth. Philosophers such as Edward Casey have talked about how each visit to a site of experience, such as a cemetery, is a unique event. The living, moving body is the vehicle and agent of this specific "emplaced experience" as it passes through the landscape.[19] The pilgrim to a cemetery might sense that this is a special place where the survivor's spirit seems closer to an authentic consciousness of life and God and yet-unknown universal forces. It could lift the visitor to a fleeting glimpse of a state of being beyond what we can see with our eyes or touch with our hands.

Jacob Bigelow understood these ideas and sought to add further elements of mystery and difference. A minister's son who aspired to be a true enlightenment intellectual, he could cite Herodotus and Pliny as well as William Cullen Bryant's "Thanatopsis," and, when not practicing medicine, he wrote about art and landscape design, botany and technology. He used architectural symbolism to impose his taste and philosophical ideas on Mount Auburn's forested landscape. For instance, the Egyptian revival gate he designed, first built in wood in 1832, signaled to visitors that they were entering a realm of the dead akin to the ancient pyramids—an eternal domain beyond the normal powers of reason. The gate became the emblem of Mount Auburn.[20] The large stone sphinx memorial that Bigelow later commissioned from Martin Milmore and his brothers continued this theme. While early Civil War monuments were often erected in cemeteries in the American North and South, Bigelow sought something different than a soldier monument. He was well aware that the figure of a sphinx summoned up multiple associations. Egyptian and Greek in its most ancient origins, it had also functioned as picturesque garden sculpture in places like Versailles and Blenheim Palace in England.[21] Along with the Egyptian gate, it raised the notion that wonder and ancient mystery—along with recorded life dates, religious certainties, and family relations—had a distinctive place in the American cemetery. It promoted the suspicion that past, present, and future come together most clearly in the cemetery, a sanctuary where nature and unusual monuments with enduring associations intensified sensory perceptions.

〇

By the time of Clover Adams's suicide, William Vanderbilt's collapse on the floor of his Fifth Avenue home, and the deaths of the Milmore brothers, Mount Auburn and the other garden cemeteries it had influenced had been transformed by the eclectic wishes of their lot owners. They had lost much of their natural wilderness qualities. Competition among lot

Figure 23.
Profusion of monuments in Mount Auburn Cemetery of many sizes and styles. Photo by Frank J. Conahan.

owners jeopardized the founders' original goals for picturesque beauty. Families often built fences, or "grave guards," around their lots or landscaped them to their own liking. Different heights and styles of monuments were erected over the years, often several within one family lot, creating a disharmonious mishmash (Figure 23). At the same time, cemeteries acted as early parks and became popular enough that rules had to be posted to restrain picnicking and rowdy or irregular behavior that disrupted the desired calm. "Visitors are requested to keep on the walks, and not to pluck flowers or shrubs, or to injure the trees," noted the early rules of Laurel Hill Cemetery, which also forebade dogs and saddle horses.[22]

Although the founders had counseled modesty, regulations had to be issued to maintain a naturalistic setting. Many cemeteries set height limits, as columns and obelisks grew taller and taller, with more stone apparently signaling more wealth and virtue for some survivors or patrons. In the postwar years certainly, the oldest styles of tombstones had become the subject of ridicule and doggerel in newspapers and even on the theatrical stage. Stories about famous people's grave monuments were common in newspapers, which regularly carried "tombstone" oddities, silly epitaphs, and short stories about grave markers for favored pets and legal disputes. Commercial monument dealers often were blamed for encouraging this profusion of monuments, as they promoted sentimental symbols, fussy details, higher and higher obelisks, and clashing styles in their relentless drive for profit.

As scholar Karen Halttunen has noted, the "full emergence of the cult of mourning that distinguished nineteenth-century views of death had occurred in the rural cemetery

movement of the 1830s." Now the new national military cemeteries, such as Arlington near Washington, D.C., that were created during and after the Civil War reinforced the same retreat from romantic sentimentality that was seen in mourning mores, funeral rites, and literature. In their orderly grandeur, the military graveyards also added to an impetus for a new order and simplification of the cemetery landscape.[23]

Marian Adams, having lost her cousin Robert Gould Shaw and other acquaintances in the war, was an astute observer of these new forms of postwar memorialization. The sheer numbers and simplicity of the rows of uniform military grave markers placed on the grassy slopes of Arlington Cemetery moved her deeply. She memorialized a visit she and her husband made to Arlington in mid-November 1883 by taking a photograph (Figure 24). A warped print of this picture preserved in the Massachusetts Historical Society appears slightly unfocused, but it is clear that Adams found beauty in the enforced sameness of the soldiers' monuments spread across the field and the leaves still clinging to the trees before winter set in. For her, the grave markers were not emotionally sterile allegories; in their lack of ornament they were proximate to the innocence and purity of youth and nature. On this print, she wrote in the margin, "Ich gehe durch dem Todeschlaf / Zu Gott ein als soldat und Crau." That phrase is a quotation from Goethe's *Faust* in which a soldier speaks to his sister about honor and then dies, telling her, "Now through the slumber of the grave I go to God, a soldier brave."[24]

Sculptor Augustus Saint-Gaudens, who would design the Adams Memorial, took a special interest in the funerary landscape in his later years and especially singled out for praise

Figure 24.
"*Arlington National Cemetery.*" *Photograph by Marian Hooper Adams, November 5, 1883. From the Marian Hooper Adams Photographs. Photograph number 50.94. Courtesy of the Massachusetts Historical Society.*

the "extraordinary dignity, impressiveness and nobility" of the cemetery at the U.S. Soldiers' Home opposite Rock Creek Cemetery, with its neat rows of vertical markers. Its aesthetic was attained not by an eclectic array of large monuments, he noted, but "by the very simplicity and uniformity of the whole." He urged that open areas of Arlington be similarly undisturbed by "the invasion of monuments which utterly annihilate the sense of beauty and repose."[25]

After the Civil War, cemetery superintendents across the country began taking steps to attain long, sweeping vistas with fewer and more tasteful large monuments and lower profiles for all but one central family monument on each lot. A new, landscape-lawn aesthetic for cemeteries had emerged most influentially at Spring Grove Cemetery in Cincinnati, where it was pioneered by landscape designer Adolph Strauch in the late 1850s and early 1860s. Now, in the ideal plan, monuments were to be subordinated to "broad and unbroken" landscape vistas (Figure 25). A natural appearance was emphasized and too tall, vertical monuments were discouraged in an attempt to create a unified aesthetic in which all could share.[26] These ideas were rapidly adopted elsewhere. In Woodlawn Cemetery in New York, for instance, founded on a rural cemetery model, lots were proposed on the new landscape-lawn model by the late 1860s, within a few years of its opening. Strauch's words opposing the tasteless "multiplication of monuments" were cited in annual reports to Woodlawn lot owners by managers who had traveled to Cincinnati to study his efforts: "People have lots, they have

Figure 25.
Landscape-Lawn vista. View of Spring Grove Cemetery, Cincinnati, ca. 1890. Cincinnati Museum Center.

money, they must do something, and they unfortunately have not that taste which leads them to find their gratification in a consistent whole, rather than in the ornamentation of a particular spot," wrote Strauch. "They . . . produce effects that people of cultivation regret. . . . Those who have monuments to erect, should wait until they can avail themselves of the advice of persons of taste, and thereby make a real addition to the attractions of a place, in whose beauty so many have an interest."[27]

Cemetery managers insisted on greater central control over placement and choice of monuments, enforcing a more harmonious vision for the resting place of the dead via new regulations and launching an era of reform (Figure 26). The tangled, winding, woodsy paths of garden cemeteries were abandoned for more rounded, flowing lines and fields of grass, height limitations for monuments were adopted, and fences and hedges surrounding lots were stripped away in many cemeteries.[28] Family control over individual plots was restricted. Lot owners were encouraged to install only one tasteful and "artistic" family monument per lot (and preferably not a tall obelisk). If families felt it necessary to mark the position of each body as well, they were encouraged to do so with small granite "footstones" resting flush with the ground or projecting just a few inches above it. These were stable and easily maintained, unlike tall, thin slabs of stone, which broke or tipped over more easily. Strauch encouragingly

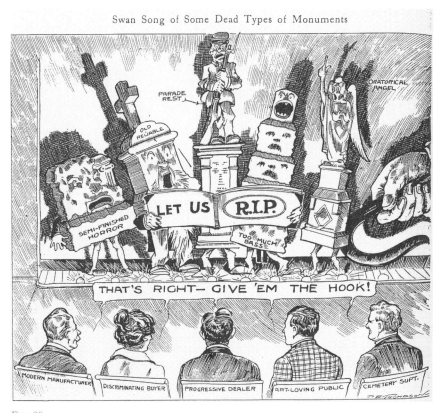

Figure 26.
"Swan Song of Some Dead Types of Monuments," Monumental News *27, no. 2 (February 1915).*

pointed out the example of the "late Duke of Saxe-Gotha" who had directed that his only monument be a tree planted on his grave.[29]

Severe limitations on monument inscriptions were also favored, in contrast to the sometimes lengthy, highly personalized quotations marking earlier American graves. "Epitaphs should be plain and simple," Strauch said.[30] Turn-of-the-century cemetery managers preferred that family monuments bear only the family name and that individual markers carry only name or initials, birth and death dates. The restricted inscriptions on turn-of-the-century cemetery monuments stood in stark contrast to the earlier emphasis on kinship and patriarchal family structure on cemetery memorials. Leaving behind terms like Mother, Sister, Daughter, or Father, the new forms reflected a shift in gender spheres and family relations amid industrialization, advances in transportation, and greater social mobility.[31]

All in all, fewer, lower, simpler, more uniform markers were encouraged, fitting within a more open expanse of land. Old styles lingered, as they do today. But many cemeteries began setting aside large areas in which only markers resting flat to the ground were allowed. The Association of American Cemetery Superintendents, an influential trade association founded in 1887, pushed hard to let gently varied meadowlands be the new iconography of memorialization.[32] Bellett Lawson, president of the association, summed up members' attitudes in a speech in 1902 in which he declared: "I am fully aware that the time has not arrived when a total abandonment of monuments can be advocated, desirable as it may be, but I do think that more stringent and compulsory measures might be adopted to educate the public to subordinate personal desire and individual taste to dictation and advice of cemetery managers."[33] As tasteful accents to the whole, some cemeteries encouraged naturalistic monuments, such as tree trunks carved out of limestone or living trees or the occasional large boulder bearing a tablet inscribed with the family name. Art critic Mariana Van Rensselaer commented that a boulder, with much of its surface left moss-grown or ivy-covered, "is a simple, serious, dignified and artistic monument, worthy of the noblest dead."[34]

Ideas developed in the aesthetic movement and fine-arts realms ultimately worked their way into the domain of the cemetery, and a scattering of high-style monuments was welcomed, the effect of which would, in theory at least, benefit all. They appeared at a time when public monuments also blossomed on city squares, and refined pedagogical murals were installed in public buildings amid the turn-of-the-century City Beautiful movement. In the landscape-lawn aesthetic, cemetery officials accepted the occasional heroic-sized figurative monument—especially when it was located on a larger-than-usual plot of land and made by a fine artist for a great man—as a tasteful landmark that could grace the whole harmonious environment. Great memorial art could now be equated with great ideal art.

By the beginning of the twentieth century, cemetery sculpture could also be a place for a community of mourners and admirers to contemplate life's meaning without offering explicit consolation or promises of rebirth. It no longer was required to stress overt, didactic

praise about the dead one being the exemplar of the good man, or to focus, Victorian style, on personal details. Evocative rather than descriptive techniques were adopted to suggest a reality beyond earthly relationships.[35]

The changes in cemetery design originally were hailed as democratizing (Mount Auburn had been formed as a private association of families and individuals), yet a chasm continued to exist in death between educated, wealthy, Euro-American Protestants and members of other faiths, races, and ethnic and income groups.[36] Cemeteries frequently featured socially stratified zones, like the best streets on which the wealthy lived, in the late nineteenth century. Some complained that the new landscape aesthetic provided another spur for the rich to flaunt their wealth. J. H. Griffith, who wrote in *Monumental News* in 1902, for example, argued that the landscape-lawn plan "encourages wealthy lot owners to erect costly memorials because of the better opportunity of their showing off to advantage amid unobtrusive and artistic surroundings."[37] But other points of view prevailed.

"For the present, it is fortunate for all that wealth insures many large lots in cemeteries, thus securing a proportion of comparatively open space," Fanny Copley Seavey told a convention of cemetery officials in St. Louis in 1896.[38] She envisioned a "cemetery of the future" in which all classes of Americans could share equally in the open lawns. In that ideal cemetery, however, she said, such works of sculptural art as Daniel Chester French's Milmore Memorial "and kindred dreams of beauty will readily be given a suitable setting because they will never be too numerous and are in harmony with the atmosphere of these landscape homes of the dead."[39]

Mariana Van Rensselaer, whose writing was admired by a prestigious circle of sculptors, painters, and architects, including Saint-Gaudens (who sculpted a bas-relief portrait of Van Rensselaer), also urged fewer, better monuments in cemeteries in her *Art Out-of-Doors*, declaring: "Owners should be encouraged to make their monuments, not merely as artistic, but also as simple and unobtrusive, as possible. Only a great man, one to whose grave strangers are likely to come as pilgrims, is entitled to a conspicuous tomb. Even he does not require it."[40] She called for more active involvement of fine artists in cemetery commemoration, which had been largely the province of monument dealers and associated stone quarries:

> If, in . . . telling other people that we loved our dead, we could consent to speak less loudly and more carefully, how beautiful, how touching and impressive a cemetery might be! The price now paid for a big monument, bad in design and worse in ornamentation, might persuade even a great artist to design a cross or head-stone which, in its simple way, would be an object of the utmost value. Such an object would really honor the memory of our dead, instead of simply shouting out their names with a crude and vulgar voice; and the association of many such would make our cemeteries really beautiful spots.[41]

Cemetery officials agreed, demanding that where there was statuary in the graveyard, it should "keep pace with the progress which is shown in the other branches of the sculptor's craft."[42] Good design was sought to contribute to a unified, therapeutic environment that

would aid the contemplation and recuperation of mourners. Design was regarded as another agent of human improvement, another marker of progress in the domain of the cemetery.[43] But it was still clear that the upper class could buy a greater degree of individual identity in the graveyard, as elsewhere, than denizens of the lower classes. A social chasm continued in death as in life.

PART THREE

THE ARTIST
AND THE CEMETERY

SEVEN

THERAPEUTIC
BEAUTY

When Henry Adams returned to Washington in October 1886 following his trip to Japan, he found his season of death extended. Upon arrival he learned of the passing of his brother-in-law Ephraim Gurney, another "savage blow."[1] A month later, Adams's father succumbed at age seventy-nine, ending several years of mental decline, and Henry took on the added responsibility of caring for his frail mother for the final three summers of her life. "During the last eighteen months I have not had the good luck to attend my own funeral, but with that exception have buried pretty nearly everything I lived for," he wrote a friend.[2] These losses and his duties in providing a suitable cemetery monument for his father in Quincy, Massachusetts, turned his thoughts increasingly to the need to memorialize his wife as he marked the first anniversary of her death. At age forty-nine, Adams was aware that her Washington, D.C., gravesite would also become his tomb one day, an indicator of status and public memory for his prestigious family as well as a vehicle for personal catharsis.[3] Having become a widower early, he had the opportunity to face these difficult issues in his prime, and he would take a strong personal role in conceiving the essential idea behind the Rock Creek Cemetery monument.

With the encouragement of his friend John La Farge and the support of Clover's relatives, Adams commissioned thirty-eight-year-old Augustus Saint-Gaudens (Figure 27), who was fast becoming one of the most important American sculptors of his time, to make the bronze grave figure.[4] The Irish-born, French-trained Saint-Gaudens already had re-interpreted two genres of sculpture, the war memorial and bas-relief portrait, in America. He had catapulted to public fame with his bold Farragut Memorial, unveiled in 1881 in New York City. His *Standing Lincoln* for Chicago was about to be dedicated, and he had garnered a major commission in 1882 for another Civil War monument in Boston honoring Clover's cousin Robert Gould Shaw and the black regiment Shaw led. These public monuments featured naturalistic bronze figures within an innovative architectural environment, at

Figure 27.
Kenyon Cox, Augustus Saint-Gaudens, 1887, replica 1908. Oil on canvas, 33 1/2 × 47 1/8 in. Metropolitan Museum of Art, New York, Gift of friends of the artist, through August Jaccaci. Image © the Metropolitan Museum of Art.

times combined with allegorical attendants of almost supernatural force. On a more intimate level, Saint-Gaudens's delicate bas-relief portraits of members of his artistic circle and the literary, social, and economic elite, sometimes made as gifts, were highly prized, showing his subjects to be self-confident, at peace with themselves, and secure in their lives. "They are . . . refined and artistic. They are what one wants to be," Adams said of the small portraits, mostly made in bronze.[5] Each of Saint-Gaudens's subjects appears locked in an expressionless reverie (and usually in profile), disconnected from us, yet honorable and innocent. The young sculptor gained a reputation as sensitive to the wishes of his patrons, whose likenesses he gently improved, while refusing to betray his own standards of perfectionism inspired by Italian Renaissance bas-reliefs. At times he offered choices to his clients, involving them in the creative process while subtly directing their taste.

In the realm of cemetery sculpture, artists' skills, motivations, and relationships with patrons varied greatly. Artisans, trained in an apprentice system and often working directly with stone quarries, had been responsible for many tombstones in the earlier decades of the nineteenth century. But funerary commissions late in the century offered a new generation of Beaux-Arts-trained sculptors an opportunity to make "ideal" or imaginative work, leaving behind the steady stream of portrait orders that were the staple of their oeuvres, even for artists like Saint-Gaudens. The relationship that evolved in the creation of a grave memorial could be a personal, even emotional one: Adams's expectations for his sculpture led to high hopes followed by periods of deep bitterness and, in the end, profound personal gratitude. Daniel Chester French's relationship with the Milmore family and the judge-executor of the Milmore brothers' wills was less close, a professional service negotiated with the aid of a lawyer. Frank Duveneck and William Wetmore Story faced the challenge of executing their own memorials for their lost wives.

Over the decades, Saint-Gaudens's sculptures were often described as "noble" and "beautiful"—yet embodying a "penetrating vision."[6] Saint-Gaudens himself seemed to elicit a protective sense of loyalty and reverence among acquaintances, patrons, and assistants, who saw him as an individual touched by a unique talent and guided by intuition: a meticulous perfectionist who was a warm, humorous, and generous man, yet also a vulnerable, reticent personality, who was at times nervous, introverted, and quick to outbursts, suffering periods of depression. Women wanted to care for him (and he maintained a mistress, Davida Clark, and illegitimate child, Louis); male friends found him a hearty companion who loved musical evenings and ribald humor. As his success grew, he sometimes made patrons uneasy,

however, because he juggled a number of projects at once and insisted on not rushing the final result, creating notoriously lengthy waits for his attention.

Saint-Gaudens had learned to work hard during his early years in a humble immigrant family in lower Manhattan. As a child, he delivered shoes for his father, whose handmade French styles attracted New York's well-to-do; perhaps these kinds of tasks began to shape "Gus's" deferential, boyish charm. He left school at age thirteen to apprentice with a cameo maker, and then another, and supported himself by the tedious labor involved in making cameos for brooches, bracelets, and necklaces for many years, even after his parents sent him abroad in 1867. Aided by his fluency in French (originally of a curious Gascon variety, which he learned from his Pyreneen-born father) and the night-school art classes he had taken in New York, he became one of the earliest American students to win admission to the École des Beaux-Arts in Paris. He witnessed firsthand the displays of contemporary European art at the 1867 Paris Exposition, including work by such "neo-Florentine" French artists as Paul Dubois, who won his admiration. But at the outbreak of the Franco-Prussian War in 1870 he went to Rome until 1875, and it was there that he launched his career as a sculptor and met his future wife and first significant patrons. Back in New York, he furthered friendships with other creative individuals like architect Stanford White and editor Richard Watson Gilder, engaging in a genteel bohemianism of studio visits and concerts. In 1877 he married Augusta Homer, an art student from Roxbury, Massachusetts, and took his bride to Paris for three years, where he labored on the Farragut Memorial that led to his first great success.

Henry Adams's brother Charles later described his surprise on meeting the by-then venerated Saint-Gaudens to discover how rumpled and ordinary he looked ("I should have taken him for the foreman of a mechanical concern"), and how his talk was "decidedly American and unaffected," lacking any pretense.[7] Saint-Gaudens was of medium height but attractive, with thick, reddish brown hair, piercing blue eyes beneath bushy brows, and a sensuous mouth. Biographer Charles Lewis Hind called his a "strong, beautiful face."[8] The sculptor caricatured his own long, straight "Greek" nose, square forehead, wavy hair, and generous ears in self-portrait sketches he included in letters to friends, and he usually drew a halo over his head as well, since his name was "Saint." Saint-Gaudens joked too about the "Assyrian" beard he affected in the mid-1880s, squared at the front. Fellow artist Kenyon Cox chose to paint the sculptor in profile to accentuate these features and gave him a genteel demeanor. Photographs often highlight his large hands, and some portray him in his work clothes, soiled by plaster dust, the marks of the sculptor's studio, but most photos as the years passed show him in tweedy suits, the peer of his upper-crust clients, comfortable in the world of artists, writers, and cultural achievers in which he circulated. His strong features gave his face an increasingly craggy appearance as he aged. All of these qualities helped him to become ultimately, in one commentator's words, a "confidante of the powerful, and arbiter of taste for a generation of American sculptors who were his pupils."[9] Endlessly encountering financial concerns, Saint-Gaudens seemed to lack business acumen, however, floating in some "higher" realm, and he often seemed to depend on colleagues like White or his wife,

Augusta, to look out for his diplomatic or financial needs. While thoroughly cosmopolitan in the increasingly global late nineteenth century, by all accounts he was no intellectual; he did not read a great deal until later in life, and he was often uncomfortable articulating his self-reflections.

Adams's relationship with Saint-Gaudens suggested one model for the Gilded Age patron of funerary art. Unlike the process for many public sculpture commissions, competitions were not held nor were public notices posted about desired projects for private cemetery memorials. The sculptor worked directly with the family of the deceased or a designated intermediary. For Adams it was a highly personal and private matter. His diary indicates that he spent time with Saint-Gaudens in June 1886 just before his trip to Japan, a little more than six months after Clover's death. He ultimately came to see Saint-Gaudens as a special emotional vehicle, a medium or instrument to make concrete and visible his longings for resolution—not just a technician or craftsman contracted to execute a monument, but someone with an innate sensibility or gift. Adams felt that he as patron should provide the core concept for a memorial, and the sculptor, with his special abilities for felt expression, should actualize it in durable physical form.[10] Adams, whose life had been reconfigured by loss, gained consolation from playing a personal role in the creative project, his participation at times becoming a form of therapy. For his part, Saint-Gaudens needed to gain deep intuitive understanding of the patron's feelings and goals in order to convey them. The creative process thus involved multiple face-to-face meetings, with appropriate performances of respect and sympathy by the artist, and numerous written exchanges, although Adams controlled tightly his own availability for these encounters and eventually withdrew.[11] The sculptor was required to perform what sociologist Arlie Hochschild has termed "emotional labor," a kind of labor increasingly common in modern life in which outsiders were paid to take on duties such as undertaking, nursing, or hospitality services once conducted by family members or personal acquaintances. In this work demeanor is an essential part of the product, involving what Hochschild calls "deep acting"; the worker expends his emotional self to promote reciprocal feelings, a desired state in the client.[12] Thus Saint-Gaudens might have told Adams (like other male friends, he addressed him as "Adams") with deep sympathy about his feelings after his own mother's death in 1875. "There is always the 'triste' undertone in my soul that comes from my sweet Irish mother" (Mary McGuiness Saint-Gaudens), the sculptor's son later recalled Saint-Gaudens as saying. In a sympathy letter written to Richard Watson Gilder in 1885 after the death of Gilder's mother, Saint-Gaudens wrote, "I have gone through the same grief you are having; and . . . at times it seemed as if I could not bear it. . . . [T]he trial has been like a great fire that has passed, and it seems, after all these years, as the one holy spot in my life, my sweet mother. I am with you in your grief, believe me." Saint-Gaudens's son, Homer, recalls him sobbing in his studio on the night his father died.[13]

Emotional workers may eventually begin to interiorize the beliefs they act out so as not to feel that they are acting in an inauthentic way; their labor in producing affective experience can be draining. Saint-Gaudens commented on his wavering empathy for clients

in his partially completed autobiography, saying that he had an ability to see things from multiple perspectives. "This seeing a subject so that I can take either side with equal sympathy and equal conviction I sometimes think a weakness. Then again I'm thinking it a strength."[14] "I'm convinced that, if I would overcome the sense of consciousness, I should be a wonderful actor."[15]

Adams hoped for an empathic worker who could carry out with mind and hands something higher than he could imagine, yet be guided by his desires, creating an object whose success he ultimately had the special intelligence and heart to recognize. Saint-Gaudens appeared to be deferential, listening attentively in discussions, but his Beaux-Arts training, his obsession with the process of creation, also gave him his own stubborn agenda. He insisted on a long period of gestation and development that allowed him to put his personal stamp on his sculpture. "I make seventeen models for each statue I create," he once said. "It's the brain work not the finger work that takes the time."[16] This slow progress led Adams to worry that his project would never be completed, and that it would not ultimately be the Asian-influenced "Budha" that he envisioned, embodying ideas of ambivalence and multiplicity. It was clear that Saint-Gaudens, this mix of immigrant street urchin and cosmopolitan artist, ultimately inscribed some of his own aesthetic concerns in the resulting memorial. His deference was in part authentic, and in part a performance of the artist's required role in a commission resulting from personal loss and heartbreak.[17]

○

The 1880s was a period of "statumania" in which American sculptors who had trained abroad (or immigrant sculptors settling in this country) found their skills in considerable demand. While the Civil War provided a major theme of public monuments, the cemetery also became a site of renewed aesthetic consideration. Saint-Gaudens had never shied away from the genre of funerary sculpture, collaborating with La Farge on some of his earliest gravestone and church decorations, which he completed in France. "When I first met Saint-Gaudens . . . he was carving tombstones in Paris," Sir Caspar Purdon Clarke, director of the Metropolitan Museum of Art, commented years later, suggesting the lowly nature of cemetery ornamentation in an American sculptor's repertoire in that earlier era.[18]

But Saint-Gaudens and La Farge were familiar with the greater importance accorded funerary art in Europe, especially in France, where sculpture for such cemeteries as Père Lachaise and Montmartre in Paris was regularly exhibited at the fine-arts salon. During his later career, Saint-Gaudens actively sought reform of American cemetery aesthetics. A studio photo (Figure 28) from the 1870s shows his early work in three genres: a bust of Farragut for his large-scale public memorial, a bas-relief portrait of a woman, and a cross he designed for the family tomb of Edward King, the largest landowner in Newport, Rhode Island. In this picture capturing his achievements, Saint-Gaudens did not flinch from showing the graveyard cross as the equal of his other work. Over the course of his career he would make nearly a dozen sculptures or reliefs for cemeteries.

Figure 28.
Augustus Saint-Gaudens, Bust of Admiral Farragut, bas-relief of Leonie
Marguerite Le Noble, and King tomb cross in the artist's Rome studio,
1877–78. Plaster. Papers of Augustus Saint-Gaudens. Courtesy of
Dartmouth College Library.

La Farge had steered other patrons such as Cornelius Vanderbilt II to Saint-Gaudens for portraits of family members and decorative work, prime commissions in this era of Gilded Age fortunes and palatial houses built by the new industrialist millionaires. And it was likely La Farge who persuaded Adams to retain the sculptor for his project, a conspicuous high-style monument that would cost far more than any standard cemetery artisan's work. La Farge, via his acquaintance with both men, performed the role of facilitator and intermediary over time. Adams's comments indicate that he was deeply influenced by his old friend's ideas. These included La Farge's investigations into an art of mystical ambiguity that can promote a gentle reverie of mind and spirit, and his related interest in an experiential form of art that required the discrimination and vision of the spectator to complete its meaning.

La Farge had a number of friends (such as geologist Clarence King) in common with Adams, moving in an overlapping international, cosmopolitan social circle. The painter and Saint-Gaudens also had many things in common: both were bilingual and had been raised in Catholic immigrant households in lower Manhattan, for example. La Farge's parents were much more prosperous and cultivated than Saint-Gaudens's shoemaker father, however, and he had completed a college education. It is possible that Adams might have seen the faint aura of French Catholicism that the two artists shared as an onramp to a special relationship with mysticism missing from his own New England Congregational/Unitarian upbringing. La Farge, who was much older than his protégé, had overseen the execution of major decorative projects, and he had retained Saint-Gaudens on several of these in the 1870s, including Trinity Church in Boston, St. Thomas Church in New York, and the King tomb in Rhode Island.[19] Balding and bespectacled with a wispy mustache over his small pursed mouth, La Farge loved to puff on cigars and maintained an almost oriental demeanor in the paintings and photographs that survive, including an early self-portrait of the lean, six-foot-tall artist wearing a wide-brimmed black hat and carrying a walking stick on a path leading into an unknown distance (Figure 29), a metaphor for his life. He had followed a partially self-guided course of artistic training and experimentation in Boston and abroad, consistently drawn to the problem of how one communicates a sense of musing or

Figure 29.
John La Farge, Portrait of the Painter, *1859. Oil on wood panel, 16 1/16 × 11 1/2 in. Metropolitan Museum of Art, Samuel D. Lee Fund. Image © the Metropolitan Museum of Art.*

abstracted daydream, inspired by an artifact—the sense that an object held, and could share, an essential secret. Curator Henry Duffy has noted that La Farge introduced Saint-Gaudens to a new concept of art based on his personal reworking of medieval and Asian design mixed with the Arts and Crafts style of William Morris and the Pre-Raphaelites. Saint-Gaudens wrote in his memoirs, "There is no doubt that my intimacy with La Farge had been a spur to higher endeavor, equal to, if not greater than any other I have received from outside sources."[20]

All of these men, Adams and La Farge as well as Stanford White, who worked with Saint-Gaudens, understood the consequences of installing an object of moving beauty in the cemetery, and they shared a desire to avoid the mawkishly sentimental, merely pretty, or overly melo-dramatic. The artists understood Adams's desire to use the monument and the evocative questions it would pose to counter any sense of shame or guilt that arose from Clover's suicide and the ensuing scandal. Beauty could serve a palliative function, perhaps easing pain, but it could also be equated to something that was good and true, with a moral life and outlook. It could cloak or assist in denying ugly truths. Ideally, it could be a means to transform, address, or mask the unspeakable, the trauma subject beyond the scope of normal language. The goal was to turn a tragedy into poetry, to counterbalance the horrific and convert a sense of grief to one of awe or wonder, something positive that awaited in a realm beyond grief. It would distract from the reality of Clover's corpse lying beneath the ground a few steps away, its brutal degradation and stench thankfully covered by the earth.

By providing this bridge between pain and beauty, a memorial sculpture, it was hoped, could suggest some sort of elevating truth and give insightful visitors a sense that through it they had glimpsed a secret connection to the larger cosmic realm outside daily life—perhaps, for some viewers, to God—aiding them on a path to greater self-reflection. As French philosopher Victor Cousin said in his book *The True, the Beautiful, and the Good*, beauty "is a noble ally of the moral and religious sentiments; it awakens, preserves, and develops them. . . . So art, which is founded on this sentiment . . . is naturally associated with all that ennobles the soul."[21] A material impression that reaches us through our eye, or through a combination of the senses, was thought to trigger profound thought and introspection. Artists like

Saint-Gaudens surely considered ways in which beauty, created through combinations of symmetry, curving contours, and color, could manipulate emotions and also temporarily displace certain feelings that survivors did not wish to acknowledge—be they a grief too deep to speak of, anger, relief that the burden of a sick soul had ended, or guilt at their own triumphant survival. In a way the monument offered Adams, who had refused all words about his wife's death, a means to break the silence, to speak his piece and rewrite history, claiming a grace and nobility for his wife's life through the visual while attempting to repress other subtexts, the unwanted emotions that kept resurfacing.

Adams was no doubt aware of the great tragedy that Saint-Gaudens had experienced in 1884, when fire destroyed a choir of three angelic marble figures, each nine feet tall, being prepared to stand atop the mausoleum of Edwin D. Morgan in Hartford, Connecticut. Morgan (1811–1883) had been among Saint-Gaudens's early patrons, having commissioned a marble version of his *Hiawatha* and also advocated for the young sculptor's selection to design the Farragut Memorial; thus, Saint-Gaudens considered this sculptural group to be another critical commission. Morgan, governor of New York State during the Civil War and briefly a U.S. senator, was also a Protestant religious philanthropist, who had given at least $750,000 to Union Theological Seminary, a Presbyterian institution, in New York for religious training. His fortune was estimated at nearly $10 million. He and his wife, Eliza Waterman (a first cousin), had suffered greatly in other ways, however. Only one of their five children lived to adulthood, and that son, Edwin II, died in 1881 before his parents. Having grown up and begun his political career in Connecticut, Morgan decided in 1868 to buy one of the finest lots high up in the new Cedar Hill Cemetery in Hartford. Cedar Hill was one of the new cemeteries, consecrated only that year, built in the wake of the rural cemetery movement but representing new advances in landscape design. Designer Jacob Weidemann, who later wrote a book about his ideas, put more emphasis, for instance, on creating unbroken vistas, with fewer hedges and boundaries, in a curving landscape. Unusual was a sixty-five-acre area of landscape and ponds but no graves, known as an ornamental foreground, which visitors must cross before coming to the first gravesites. A chapel at the entrance was being constructed at the same time as the angels. Many of Hartford's wealthiest citizens would be buried there beneath big, expensive monuments.

Saint-Gaudens was not a churchgoing man in his adult life and held no professed religious beliefs, but he willingly made religious figures when asked to do so. He reportedly made (at top speed) an angel a day for the large bas-relief he completed at St. Thomas's Episcopal Church in New York.[22] As early as 1875, Governor Morgan was in discussions with Saint-Gaudens and White for a twenty-five-foot-high cross and a ring of eight nine-foot angels to surmount his planned mausoleum at Cedar Hill. The project as originally envisioned would have been a sensation, more than thirty-five feet high in all. There was almost nothing like it in America unless you consider a monument like Abraham Lincoln's

Figure 30.
Augustus Saint-Gaudens, sketch for central angel for the Morgan Tomb,
ca. 1879. Photo by George Collins Cox from the Photographic History
Collection, National Museum of American History, Smithsonian Institution.

huge, wholly secular tomb, completed in 1874 in a Springfield, Illinois, cemetery, with bronze sculpture by Larkin Mead. Saint-Gaudens and White quickly settled on the reduced plan for three angels to stand atop the mausoleum under a colossal cross, since Morgan declined to spend more than $20,000 (the same cost, ultimately, as the Adams Memorial), and the commission for the Morgan angels was finally awarded in early 1878. In the final design the central angel, distinctive for its swaying posture and costume, with a low-slung floral belt and floral hair decoration, held a musical scroll (Figure 30). Two flanking angels played stringed instruments, singing of their joy about the Resurrection, according to surviving correspondence. White counseled Saint-Gaudens to make his figures severe rather than pretty or sentimental, and the result was dignified and androgynous. According to a description by White, the angels were all chanting "Gloria in Excelsis Deo," a hymn of praise. They were to stand before a tree of life that sprang from the cross, its leaves creating a natural aureole over their heads (eliminating any need for halos, which Saint-Gaudens feared were too much associated with Catholicism). Saint-Gaudens, juggling other commissions, made Morgan wait for years until he finally selected and shipped two huge blocks of Carrara marble to the Hartford cemetery, where local stonecutters carved the angels and cross on site, using his plaster models as their guide. The stonecutters labored winter and summer for nearly two years, and Morgan died before seeing the project completed. Then in August 1884, "calamity" struck, when fire broke out in a temporary shed the marble carvers had built around the sculptures to protect them from the elements. The marbles were blackened and Saint-Gaudens declared the "utter ruin" of his angels after rushing to the graveyard in his horse-drawn carriage. Privately, he blamed a discontented former laborer. To his horror, the widowed Mrs. Morgan refused to restart the carving, and the sculptural project was abandoned.[23]

Over the years Saint-Gaudens put his Morgan tomb angels to good use, however, in other realms. He used similar figures, without wings, for the red marble caryatids holding up a mosaic fireplace mantel in the Cornelius Vanderbilt house in New York (1881–83), flanked by leaded-glass windows designed by La Farge. A winged marble figure for the tomb of Anna Maria Smith in Newport, Rhode Island, also emerged from the Morgan

Figure 31.
Augustus Saint-Gaudens, ca. 1898, in his Paris studio with a variant of his Amor Caritas, *prepared for the John Hudson Hall Memorial in Sleepy Hollow Cemetery, Tarrytown, New York. U.S. Department of the Interior, National Park Service, Saint-Gaudens National Historic Site, Cornish, New Hampshire.*

tomb project, later modified in bronze with a more wraithlike body, a belt and crown of passionflowers, and a raised tablet bearing the words "Amor Caritas," his only work to be purchased by the French government. Other variations or reductions were completed over the years (Figure 31).[24]

Before accepting the Adams Memorial commission, Saint-Gaudens also worked on a bronze bas-relief for the Stewart Memorial in Brooklyn for the father of arts patron Isabella Stewart Gardner, another angelic theme. In 1887 he began conceiving of a bronze memorial featuring two praying women for the family cemetery lot of statesman Hamilton Fish in St. Philip's Churchyard at Garrison, New York (Plate 7). Fish, a former secretary of state, U.S. senator, and governor of New York, had just lost his wife, Julia. He wanted a monument remembering her and their daughter Elizabeth d'Hauteville who had died in 1864. Thus in the final memorial, one woman is depicted as older, one younger—general likenesses of the mother and daughter based on photographs and miniatures supplied to the artist.[25] Saint-Gaudens worked on this project on and off during much the same years as the Adams commission, taking so long to complete it that an aging Fish sent him pitiful pleas. Late in the process he surprised the patron by proposing that he set aside the kneeling figures he had designed and substitute standing sculptures. "In my researches . . . I have found that the gesture of prayer or adoration with the early Christians is a standing one, and very impressive with the costume I have," he wrote; "so impressive that I am led to believe that I can go beyond what I have already accomplished."[26] Fish consented but kept pressing Saint-Gaudens to send the plaster figures to the foundry, fearing that otherwise he, like Morgan, would not live to see his monument completed. Writing in late August 1891 of his painful disappointment that they had yet to be cast, Fish, then eighty-three and ailing, expressed fear that with the winter season approaching the ground would be too hard to install the memorial and that "would throw me over to another season (if I am to be

allowed to see another season)." The figures were finally realized in bronze in late October of that year.[27]

○

Henry Adams had carefully considered his goals for the gravesite in Rock Creek Cemetery. Because of the circumstances of Marian Adams's life and death, some traditional options for memorializing a woman seemed unsuitable. The maternal instinct celebrated in many monuments for females was not appropriate, for Clover had been childless. Both she and Henry were religious skeptics, so the optimism of Protestant religious faith—crosses, angels, and Bible verses, which Edwin Morgan had insisted on and Hamilton Fish included—fell flat. Guided by La Farge, Adams would instead seek a newer conception of consolation that synthesized Western and Eastern tastes, the rational and nonrational, and ultimately male and female. He was attracted to the ideas of philosophical acceptance and centered wholeness contained in Buddhism, and to related imagery such as the seated Kwannon bodhisattva that had fascinated La Farge during their trip to Japan. He and La Farge thought these could be melded with the highest heritage of Western art, its classicizing themes of nobility and serenity.[28]

In the Washington, D.C., city directory, the section listing cemeteries began with the lines, "Side by side the high and low / And rich and poor shall equal lie."[29] It is evident that Adams also wished an assertion of high taste that would separate his monument from the democracy and often-discussed poor taste of the cemetery and its multitude of stock monuments.

EIGHT

MAKING THE
ADAMS MEMORIAL

Commissions for funerary art were often so private, or sometimes so indifferent, that little correspondence about the creative process survives. The Adams Memorial, however, is one of the best-documented cemetery sculptures of its era. Letters written by Henry Adams, John La Farge, Augustus Saint-Gaudens, and Stanford White survive, and descriptions of the surrounding events were published, sounding the same basic themes though with some variance. It seems clear that the creative process began with a primitive stick-figure drawing, followed by small clay sketches, then the larger clay conception, worked out behind a screen in the sculptor's New York studio; finally, a plaster version was prepared for casting in bronze. Saint-Gaudens's method involved many rounds of trial efforts, destruction, and reworking, until he felt the whole had come together satisfactorily. It was a fluid process of experimenting and perfecting at a time when the sculptor was also managing a number of other major projects and duties such as teaching at the Art Students League. While Saint-Gaudens was conceiving the figure for Adams's memorial, difficult negotiations continued between the patron and White about the architectural setting that shaped the visitors' approach and overall experience.

The undated stick-figure drawing in Saint-Gaudens's papers (Figure 32) appears to record one of the earliest conversations conveying Adams's wishes. It shows a single seated figure, drawn with a few quick lines, below the words "Adam," "Buhda," and "Mental Repose" in Saint-Gaudens's hand. Added to these is the scribbled phrase, "Calm reflection in contrast with Violence or force of nature," hauntingly similar to Adams's description of his feelings after the death of his sister Louisa. The single word "reflect" is repeated at the left.[1] At the bottom of the same page the sculptor also drew two standing figures in a rectangle with the notation, "medallion with two people looking at something with back of one figure showing only."[2] But this latter idea of two selves separated by the veil of death appears to have been quickly discarded. It seems that a portrait statue was never considered.

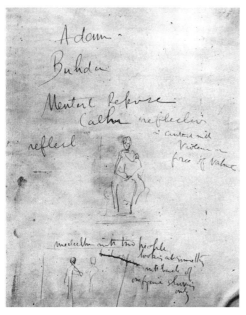

Figure 32.
Augustus Saint-Gaudens, initial drawing of concept for the Adams Memorial, ca. 1886–87. Augustus Saint-Gaudens Papers. Courtesy of Dartmouth College Library.

Clay maquettes were produced after Adams sent Saint-Gaudens photographs of Buddhist sculpture and figures by Michelangelo, suggesting his interest in a fusion of Eastern and Western aesthetics. Saint-Gaudens thanked Adams for the photos in a letter of September 11, 1887, saying they proved to be "pretty good food" for conceiving preliminary three-dimensional sketches. "I will be in New York after October 1st," the sculptor added. "If you catch me in, I will show you the result of Michelangelo, Budha and St Gaudens."[3] A few months later Stanford White, whose aid Saint-Gaudens had enlisted in the project, described seeing "very small and rough" preliminary sketches.[4] These may have included the three clay reliefs (Figure 33) illustrated in *The Reminiscences of Augustus Saint-Gaudens*, a compilation of the sculptor's recollections, edited and amplified by his son, Homer, in 1913. Homer, who in his writings provided one of the major surviving accounts of how the monument was conceived, said that Adams "did not cast his desires in any definite

Figure 33.
"Three sketches of the Adams Monument, showing the original idea of Socrates." Plate from Homer Saint-Gaudens, ed., The Reminiscences of Augustus Saint-Gaudens *(New York: Century Co., 1913), showing clay sketches made ca. 1888.*

BEYOND GRIEF

mold." Instead, Adams suggested that Saint-Gaudens talk with La Farge, who understood his sympathy with Asian religious attitudes, and proposed that he "have about him such objects as photographs of Michelangelo's frescoes in the Sistine Chapel. As the result of this advice . . . my father first sought to embody a philosophic calm, a peaceful acceptance of death and whatever lay in the future."[5] Homer said his father initially modeled a relief of Socrates for the Adams tomb. The Greek philosopher ended his life by drinking hemlock, and this sketch (at right, Figure 33) shows a bearded male figure in antique dress seated on a bench and holding a footed cup.

> Immediately Stanford White, La Farge, and indeed all my father's friends, took exception to the idea as painful for the reason of suicide, since Mrs. Adams too had died by her own hand. So he gave up the scheme and turned his attention to a number of large photographs and drawings of Buddhas. . . . From the conception of "Nirvana" so produced, his thought broadened out, becoming more inclusive and universal until he attempted the present figure, which he occasionally explained as both sexless and passionate, a figure for which sometimes a male model, Mr. John Flanagan, posed and sometimes a female one.[6]

The other two clay sketches reproduced in *Reminiscences* as well as several others that survive in the form of archival photos also portray single draped figures. One (at the center of Figure 33) appears to be female, with a piece of long, flowing drapery cloaking her head and reaching to her feet. Her arms are crossed and a flower—possibly a poppy, symbolizing sleep and death—appears to one side. She may be seated on a rock. The third sketch, the most similar in gesture to the final Adams Memorial, is of a heavily draped, seated figure with its proper left hand held beneath the figure's chin. It has the simplest backing, a rectangular stele with a cornice marked off with two horizontal lines. The models suggest that a basic conception for experimentation was settled on quite early.

Saint-Gaudens and White frequently used antique and Renaissance sculpture as references for their work, and these initial sketches are compatible with ancient grave stele at the Metropolitan Museum of Art in New York.[7] They also were compatible with figures from the Sistine Chapel at the Vatican, such as *Jesse* or the Sibyls. John Flanagan, who worked as a studio assistant to Saint-Gaudens at that time, recalled "that Mr. Adams brought to the studio several [Adolphe] Braun photographs of lunettes from this [Sistine Chapel] ceiling and I am quite certain that St Gaudens found the general arrangement of the drapery of the Nirvana in these figures."[8]

The other major account of the origins of the Adams Memorial is a 1910 newspaper article based on an interview with La Farge. According to this article, Adams asked Saint-Gaudens if he could make a figure to symbolize "the acceptance, intellectually, of the inevitable."

> Saint-Gaudens immediately became interested, and made a gesture indicating the pose which Mr. Adams' words had suggested to his mind. "No," said Mr. Adams, "the way you're doing that is a 'Penseroso.'" Thereupon the sculptor made several other

gestures until one of them struck Mr. Adams as corresponding with his idea. . . . Saint-Gaudens grabbed the Italian boy who was mixing clay, put him into the pose and draped a blanket over him. . . . "Now that's done," said Mr. Adams, "the pose is settled. Go to La Farge about any original ideas of Kwannon. I don't want to see the statue till it's finished."[9]

According to this account, La Farge carried out his role by simply reading stories of the Kwannon, a Buddhist intermediary figure, to Saint-Gaudens.[10]

The sketches and surviving correspondence suggest that a relief sculpture was initially under consideration and that both of these published accounts compressed and simplified events that took place over a longer period of time amid negotiations in which photographs and plans were sent back and forth. In fact, the model may have been Flanagan, then twenty-two years old, for he recalled later that Saint-Gaudens "tried various arrangements of drapery on me—the material was Russian crape—and photographed them."[11]

In suggesting sources such as Michelangelo and Buddhist sculptures, Adams was asking that the reference for the tomb be high art rather than stock Western cemetery styles. In saying that he did not want a "Penseroso" pose, Adams must have meant that he did not want a conventional, easily readable iconography. Americans of the mid-nineteenth century often associated that title with Milton's poem "Il Penseroso," describing the goddess of melancholy, which was the subject of numerous artworks.[12]

Saint-Gaudens enjoyed the opportunity to create a wholly imaginative sculpture, unlike his monuments to Civil War heroes, which usually combined physical likenesses and allegorical figures.[13] On April 29, 1888, Adams wrote in his diary, "Last Sunday I was in New York. . . . I saw La Farge and St Gaudens, and made another step in advance towards my Buddha grave. Nothing now remains but to begin work, and St Gaudens hopes to play with it as a pleasure while he labors over the coats and trowsers of statesmen and warriors."[14]

Adams signed a contract with White by August 1888 for designing and supervising the stone work, but negotiations for a separate contract with Saint-Gaudens dragged on for several months, delayed by genteel sensitivities as each man tried to emphasize the creative and personal nature of the project. Both acted as though money dealings and deadlines were an unfortunate but necessary part of the process, yet a sculptor needed to be a businessman, covering the cost of materials and a team of assistants, and Adams worried about the injury to his personal wealth.[15] The monument eventually cost him $20,000, to be paid in stages on completion of each step of the sculpture making, such as the full-size clay model, bronze casting, and the architectural setting. Saint-Gaudens's contract said the sculptor "agrees to execute for Mr. Adams and place in position in Mr. Adam's lot in Rock Creek Cemetery in Washington D.C. a figure in bronze of heroic size . . . said figure to be similar in general disposition to a small rough sketch made by Mr. St Gaudens and approved by Mr. Adams." He asked Adams to fill in the name of the cemetery and date of completion, "say the Autumn of /89 if that suits you. I expect to have it done before then."[16] But the project was not to be finished until 1891.

As the third "haunting anniversary" of his wife's December death passed, a restless Adams went to New York on December 9, 1888, to visit Saint-Gaudens, "who has begun the Buddha [triggering a payment]. We discussed the scale, and I came away telling him that I did not think it wise for me to see it again, in which he acquiesced."[17] Whether or not Adams was disingenuous, he later was credited, by this withdrawal, with giving Saint-Gaudens the artistic freedom to create a masterwork. He stated, however, that he did so out of fearfulness rather than trust; at this point when there was no turning back, he worried that Saint-Gaudens, steeped in Beaux-Arts and classical training, was not up to the task of comprehending Asian philosophy as he wished. The sculptor, who had asked Adams if he could recommend "any book not long that you think might assist me in grasping the situation any," met with La Farge at Adams's suggestion and reported that "in an hour I got all I wished from him as you predicted."[18] Saint-Gaudens then entered a long period of reconsideration and deferral.[19]

Amid the mutual deference between patron and sculptor, the question of the setting and backing to be designed by White was a subject of lengthy consideration and finally heated contention. An unsuccessful early proposal may be represented in three sketches for the monument that show a dark figure set against a rounded, rough-hewn rock, as if within a grotto (Figure 34). Facing the figure is a long, straight seat for visitors, with upward-stretching wings accenting the two ends. Low stone "copings" outline the perimeter of the rectangular space within the monument proper. The architectural setting seems to have taken its approximate final shape by August 1888, with a polished rectangular stele rather than a rockface boulder behind the figure and a more classicizing seat fashioned in sections

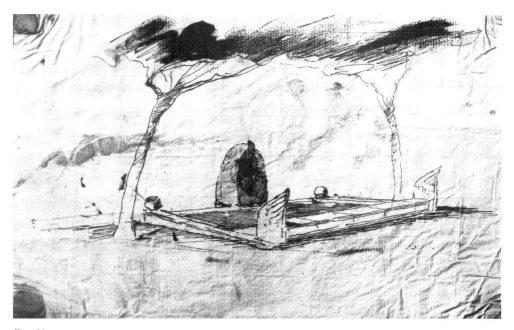

Figure 34.
Stanford White, early concept for the setting of the Adams Memorial. Ink drawing. Augustus Saint-Gaudens Papers. Courtesy of Dartmouth College

to harmonize with the six-sided shape chosen for the monument's interior layout.[20] Like the earlier proposal, this design would manipulate the viewer. The visitor must enter the interior space, separated from the cemetery grounds like the space of an open-air temple or sacred area, before turning to see the sculpture. In each case, entry is from the rear or side of the sculpture, via steps that face the seat. The seat and environment were part of the initial plan for a harmonious melding of architecture and sculpture, somewhat similar to the complex spatial plans Saint-Gaudens and White had designed for their public sculptures, such as *The Puritan* and the *Standing Lincoln*. Just as the visitor passes through the gates of the cemetery to enter a space beyond the daily material world, so must the visitor ascend two steps to enter a separate space for contemplation at the Adams Memorial, still further removed. As scholar Kirk Savage has explained, Saint-Gaudens and White were pioneers in a broader shift in the conception of the public monument, from an object of reverence to a space of subjective experience, here within a natural multisensorial context.[21] One could circulate around the sculpture from left to right, but the monument's setting and landscaping ultimately guided and restricted the visitor's steps.[22] In the final setting, owl's wings demarcate the ends of the seat.[23] Landscaping added after the memorial's completion also shielded the sculpture from the viewers' sight until they had entered the memorial, which over the years became a kind of natural chapel as the plantings grew.

Adams and White had agreed to place the sculpture in a green marble setting, but the stone company found that it could not extract large enough blocks for the project, and a rosy granite had to be chosen instead.[24] This unexpected development was part of a slow evolution over the years to a simpler and less decorative monument than originally considered. The green marble, perhaps related to Adams's love of Renaissance sculpture with its colorful inlaid *pietra dura* setting, would have featured much veining and a considerable variation in color—quite different from the uniform consistency of color in the pink granite. Granite is also harder and more expensive to polish, not allowing the detail that can be carved in marble. But it has likely worn far better than the green marble would have and proved, as White said, the surer stone.[25] All of the materials, however, were much more colorful and conspicuous than the white stone markers that predominated in the cemetery. Bronze figures were still unusual in cemeteries, some of which prohibited metal sculpture.

During the summer of 1889, Adams's mother passed away, and his anxiety about the memorial grew. White and Saint-Gaudens, meantime, both took time out to travel to Europe. Saint-Gaudens joined the architect in Paris for about two weeks to see the 1889 world's fair, which critics hailed as bringing together the work of "the best modern French sculptors."[26] While Saint-Gaudens already had developed his basic conception for the Adams figure before his trip abroad, prototypes offered in Paris may have helped shape its completion, in part by reaffirming the high importance of funerary sculpture in Europe. Among the French sculptures on exhibit was Antonin Mercié's *Le Souvenir* (Figure 35), also designed for the grave of a deceased wife. The high-relief marble figure is a seated woman, with her knees turned to her right and head tilted to her left. She is young, very pretty,

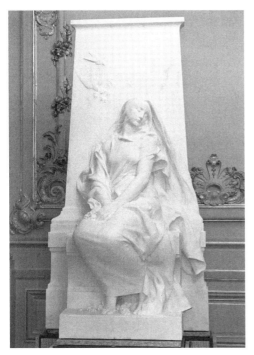

Figure 35.
Antonin Mercié, Le Souvenir, 1885–89. Replica of the tomb of Madame Charles Ferry Parnay (Maine-et-Loire). Musée d'Orsay, Paris, France. © R.M.N-Grand Palais / Art Resource, N.Y.

clearly female, with the drapery over her head more delicate and active than in the final Adams monument.[27] It is far from the weighty, more abstract supernatural being Saint-Gaudens would create, and the naming of the figure (*Memory*) helps to plant her identity firmly as an allegory and separate her from her more indeterminate and distant cousin. Also at the exposition were the moody, archaizing paintings of French artist Puvis de Chavannes, which critics saw as truly spiritual. Puvis was a precursor to a more radical vein of symbolism that was developing in tandem with Saint-Gaudens's work on the Adams monument, preferring the evocative to the descriptive, the realm of intuition, dream, and the antirational. In addition, Saint-Gaudens may have revisited Père Lachaise, Montmartre, or Montparnasse cemeteries, the grand repositories of French memorial art, during his trip.[28]

On his return to the United States, White reported to Adams October 26, "I found St. Gaudens working like a beaver on your figure. I was very much impressed by it. I think if he finishes it as well as he has started it, it will be the most poetical thing he has done."[29] Saint-Gaudens worked in his New York studio on the full-size figure with a model still posing before him. It has been suggested that at this stage he first modeled a seated nude in clay, and then dipped coarse burlap in a thin clay slurry and draped this over the figure.[30] In his *Reminiscences*, Saint-Gaudens describes how the tonalist painter Thomas Dewing sat "quietly smoking beside the posing model and chatting with me" one day as he worked "on the platform there at Mr. Henry Adams' Rock Creek Cemetery figure."[31] The Shaw monument (on which he labored for thirteen years) stood in the center of the studio, extending from wall to wall. Dewing, through his paintings of isolated female figures, was one of the leaders of an aesthetic of hazy quietism in American art, which eschewed detailed description. He also became something of an aficionado of Japanese prints in later years, when he aided collector Charles Lang Freer, who bought Asian and American art that shared this quality. Thus Dewing and Saint-Gaudens would have shared an understanding of the seated figure as a vehicle to mental serenity.

"I've demolished the figure several times and now its all going at once," Saint-Gaudens wrote Adams on February 21, 1890. Two months later he asked Adams to come see the figure, offering with tact to have him "look at it during my absence" before discussing it.[32]

When Adams declined the invitation, Saint-Gaudens offered to "bronze" the plaster and set it up in the cemetery "so that you can judge of its effect in metal." He continued, "In any event I should like to have you see the face of the figure in the clay. If it were not for that part of the work I would not trouble you but the face is an instrument on which different strains can be played and I may have struck a key in a direction quite different from your feeling in the matter. With a word from you I could strike another tone with as much interest and fervor as I have had with the present one."[33]

Adams wrote later, perhaps with some disingenuousness, that he declined to look at the model because he had "many misgivings" that it would not meet his own ideal and was afraid that he "might not be able to conceal my disappointment. So I devolved the duty on La Farge" of looking at it and talking it over with Saint-Gaudens. "I knew well that I should only injure St Gaudens' work . . . by suggesting changes, for the artist is usually right in regarding changes, not his own, as blemishes," he said, thus crediting himself with an unusually liberal attitude toward artistic freedom to complete a graveyard sculpture.[34] With no visit from Adams expected, Saint-Gaudens finally wrote on May 16, 1890: "I have gone as far as I can in the figure and shall now have it cast."[35]

As Saint-Gaudens was winding up his work on the figure, a dispute over the design of the granite stele that would stand behind it opened a bitter personal schism between Adams and White. The architect would bear the brunt of Adams's impatience with delay after delay in the production of the monument.[36] Adams wished the upright stone behind the figure to be relatively plain. But his austere taste went strongly against the kind of classicizing ornamentation used customarily by White and Saint-Gaudens on their public monuments. White frequently replicated details of antique sculpture and decoration on his Beaux-Arts public buildings and opulent Gilded Age homes for the wealthy. His houses were full of eclectic bits of European and Greek ornament, which he called "tools of trade."[37] White designed picture frames with borders of beribboned laurel leaves, intricately patterned magazine covers and jewelry, and he was a sought-after decorator, who brought together a catholic taste in rich textures, varied colors, and juxtaposition of elements. He espoused the theory that all things intrinsically good can be brought into harmony, and his slogan was that architecture was one of the fine arts.[38]

Adams preferred to exclude the ornament and traditional inscription that White proposed. "You will have to settle this," White wrote Saint-Gaudens on February 4, 1890, declaring that if the slab of stone were left plain, there would be "a lack of design . . . which is somewhat stupid, and of course the monument as a whole will be very much injured by a lack of holding together in style." At the same time, White added, "I think your figure and Adams' wishes should be first considered, so let me know what you wish done."[39]

Architectural drawings now retained in the McKim, Mead & White collection at the New-York Historical Society (Figure 36) show that certain design elements had been anticipated. On the "front" of the headstone, a circle is shown behind the figure's head and upper body, much like the nimbus found in Japanese representations of the Kwannon and

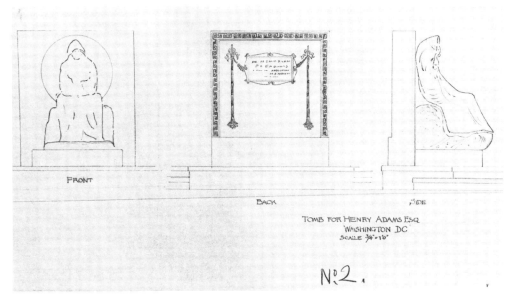

Figure 36.
Plan for the Adams Memorial, with circle for zodiac in front and upside-down torches and inscription at the back, 1890. McKim, Mead and White Architectural Records, Collection of the New-York Historical Society.

La Farge's paintings of the Buddhist deity. White clearly expected through May 1890 that it would be a part of the final design, for he wrote Saint-Gaudens then asking for its measurements. While awaiting an answer, he wrote the contractor, "Mr. St. Gaudens, the sculptor, had some ideas of having the signs of the zodiac running around here and I have written him at once."[40] In the drawings, the "back" of the headstone also contained a tablet with the inscription: "IN MEMORIAM," then "PKE ADAMS," with Roman numerals for life dates. White wrote the contractor in January 1890 that the letters would be incised. On both sides of the tablet, the drawings showed upside-down torches, a conventional sign for life extinguished.[41] A Greek meander bordered the stone slab.

"You asked that in whatever was placed back of the figure the architecture should have nothing to say and above all that it should not be classic," Saint-Gaudens wrote Adams. "White and I have mulled over this a great deal with the enclosed results. . . . I do not think the small classical cornice and base can affect the figure and to my thinking the monument will be better as a whole."[42] Adams seems to have accepted the "classical cornice and base," as they appear on the final monument. Much of the rest of White's planned decoration was eliminated, however, after a battle of miscommunication and strong wills, and the back is now decorated with two interlocking wreaths symbolizing lives intertwined.

Adams grew increasingly testy as he prepared to depart in August 1890 for a trip to the South Seas with La Farge. He had hoped to see the monument in place before he began the year-and-a-half-long journey. Before leaving, he arranged to leave checks for White to distribute to Norcross Brothers and Saint-Gaudens on completion of the project. He apparently used that occasion to berate the architect about the delays and dispute over ornamentation.

White was often described as a man who invested a great deal of effort in building and retaining friendships.[43] His relation with Saint-Gaudens was a close and precious one, and his handwritten June 24 letter records his angry response to Adams:

> I shall say nothing to St Gaudens about your note—as I am sure it would completely upset him—and perhaps injure the work in its completion—at the same time, it is quite a weight of woe for me to carry alone. . . . I cannot tell you how badly your letter has made me feel—and I do not know but that the next artist you deal with without the same gentleness of spirit, may perhaps be more fortunate and be left in a much more comfortable frame of mind than myself. Goodbye.[44]

White felt Adams had exceeded the boundaries of friendship and violated his code for personal and commercial relations. White wrote just one further letter to Adams that year—on July 7, 1890—acknowledging receipt of the checks for himself and Norcross Brothers and agreeing to pay Saint-Gaudens $3,000 when the bronze was completed and $3,500 when the bronze was erected and the monument completed. He concluded icily, "I beg you to believe that you will hear nothing further about it save its completion."[45]

On July 27 White sent the contractor "a new revision of the Adams headstone" that could be carved out of the already roughed-out granite block, eliminating the upside-down torches envisaged for the back and the circle on the front of the headstone.[46] The changes to the back may be seen in the plan: two circles for the wreaths have been drawn on top of the earlier inscription and scribbled lines crisscross the torches (Figure 37). An entwining vine and flowers remain. The cornice is smaller and lower than once expected.[47] With these changes, the monument took on its final nature. On Adams's instructions, it contained no words whatsoever—a radical move for this time. At what point this now-famous decision was made and whether it always was intended by Adams is not known. But it was only in the final months that White instructed the contractor to remove the tablet designed to bear the inscription.

Whether by Adams's expressed wish or Saint-Gaudens's sensitive discernment of his desires, the finished monument also bears no visible foundry mark or any signature of the artist—it is wordless out of respect for Adams's privacy. Adams did

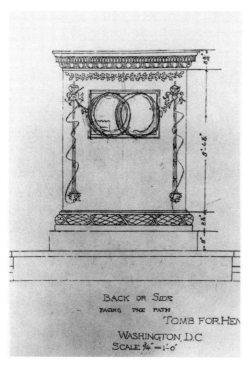

Figure 37.
Revised plan for the back of the Adams Memorial, with torches and inscription scribbled out and interlocking wreaths added, 1890. McKim, Mead and White Architectural Records, Collection of the New-York Historical Society.

not believe in mixing the verbal and the visual.[48] He courted anonymity in writing his novels and some journalistic pieces and had jealously guarded his privacy. At times, he wished to see if his work would be received as meritorious without the Adams name.

The casting by Henry-Bonnard Bronze Co. apparently was completed by December 10, 1890, when White sent Saint-Gaudens his check for $3,000, "fourth payment on account of figure for tomb at Washington."[49] A Kwannon-type rock for the figure to sit upon was shaped from Quincy granite, an interesting iconographic selection since Quincy, after all, was the "ancestral village" of the Adamses, and Quincy granite is a stone famed for its strength and permanence. The tombs of Henry Adams's ancestors in Quincy's Hancock Cemetery also were encased in local granite.[50]

On August 15, 1890, Adams departed for San Francisco with La Farge to begin his South Seas journey, still anxious that he might be leaving his monument in the hands of an artist and architect who did not understand his personal goals. "St. Gaudens is not in the least oriental, and is not even familiar with oriental conceptions. Stanford White is still less so," he wrote later, spelling out the concerns he had suffered.[51] As he visited Hawaii, Samoa, and Tahiti, his letters home frequently inquired about the progress of his monument. His harsh words to White in 1890 were repeated in letters to his friends, including Elizabeth Cameron, to whom he wrote repeatedly and with an increasing intimacy and emotional dependency. Adams clearly had long-held and deep feelings for Cameron, a former friend of Clover's and a niece of General William Tecumseh Sherman, who was locked in a loveless marriage to a U.S. senator. Scholars have speculated as to whether his attraction to her contributed to Clover's suicide and whether the pair ever consummated their relationship.[52] With considerable irony, Adams wrote Cameron from Tahiti on February 6: "Formerly, in Hawaii, whenever a new house or temple was built, a human victim had to be killed to be put under its first post. If I could, I should club St Gaudens and Stanford White, and put them under their own structure. Nothing has distressed me like their outrageous disregard of my feelings in this matter. Never spare an architect or artist hereafter. Make their lives intolerable, and have no pity, for they will have none on you."[53]

And on February 10, 1891, he wrote Theodore Dwight that he had still received no word from Saint-Gaudens: "Apparently both St Gaudens and White are afraid to write to me . . . White knows already my feelings on the subject, and I think St Gaudens must suspect them, if no more. . . . At times I begin to doubt whether St Gaudens will ever let the work be finished. I half suspect that my refusal to take the responsibility of formally approving it, in the clay, frightened him. . . . From the first I told St Gaudens that he should be absolutely free from interference. The result is that after nearly five years I am not certain that his work will ever be delivered."[54]

◯

Adams's doubts were not borne out, however, as the monument finally was installed in Rock Creek Cemetery in March. Norcross called for the bronze figure on February 28,

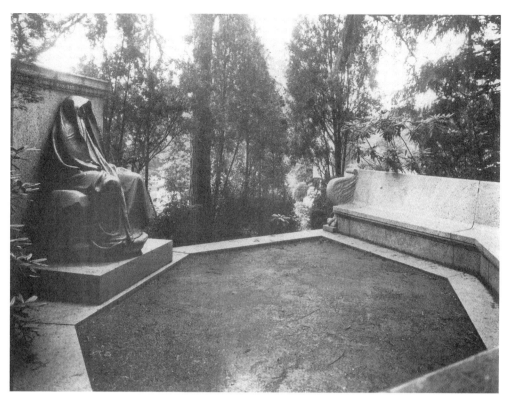

Figure 38.
The Adams Memorial in its final setting. Undated photograph. Prints and Photograph Division, Library of Congress.

1891, saying he wanted it "before I take down [the] Derrick as I presume it is heavy."[55] On March 13, Saint-Gaudens sent Adams his receipt for $3,500, "final payment on account of bronze figure placed in Rock Creek Cemetery."[56] And on March 14 Cameron could at long last write: "My dear Mr. Adams: The work at Rock Creek is now quite finished, and I think that you will be satisfied and pleased with it. . . . it is inexpressibly noble and beautiful" (Figures 38, 39).[57] John Hay also wrote in late March that he had visited the cemetery with his son Adelbert, joining Cameron and another friend there. His report seemed to summarize all that the patron had hoped for: "The work is indescribably noble and imposing. It is, to my mind, St. Gaudens's masterpiece. It is full of poetry and suggestion. Infinite wisdom; a past without beginning and a future without end; a repose, after limitless experience; a peace, to which nothing matters—all embodied in this austere and beautiful face and form."[58]

Adams said he wept when he read Hay's words. He quoted them to Saint-Gaudens in a letter from Fiji, declaring, "Certainly I could not have expressed my own wishes so exactly, and if your work approaches Hay's description, you cannot fear criticism from me."[59] Hay's description of a being in a state of serenity—an impersonal, universalized statement— would become the canonical interpretation for Adams's inner circle, and Adams repeated it to Saint-Gaudens after he received the first photographs of the monument in place.

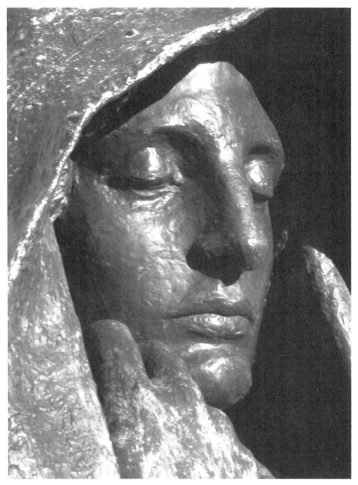

Figure 39.
Augustus Saint-Gaudens, the Adams Memorial (detail). Photo by Cynthia Mills.

Clara Hay also took Clarence King, whose own health was failing, to the cemetery. "He thinks as I do that it is the most important work yet done on our side [of the Atlantic]; the best of St. Gaudens or anybody else," her husband wrote Adams in June 1891, striking a note of nationalistic pride.[60] By the reactions they conveyed to Adams, the members of this alliance of genteel cosmopolitans reaffirmed their loyalties as they rose above the popular culture of the cemetery. They were aware that most American cemetery monuments were "stock productions," the result of commercial transactions in which there was no parity or personal relations between purchaser, maker, and seller, and the degree of personalization of the average marker was minimal. By contrast, they felt that this monument was the product of an intellectual and artistic collaboration worthy of an American Medici. Cemeteries also were places where rivalries in displays of wealth were played out. These friends, with Adams, felt taste and "art" ultimately would outrank massive stone mausoleums of the nouveau riche and ever-taller obelisks.

Adams would agree when he finally saw the monument upon his return from the South Seas. Rather than explaining his goals for the monument, he laid down a challenge about its real meaning and its distinctive assertion of group identity in his later autobiography, writing in the third person: "His first step, on returning to Washington, took him out to the cemetery known as Rock Creek, to see the bronze figure which St. Gaudens had made for him in his absence. Naturally every detail interested him; every line; every touch of the artist; every change of light and shade; every point of relation; every possible doubt of St. Gaudens's correctness of taste or feeling." Adams said he interpreted the statue's "meaning" to be "the oldest idea known to human thought," an idea he never spelled out. Instead, he said,

> He knew that if he asked an Asiatic its meaning, not a man, woman, or child from Cairo to Kamtchatka would have needed more than a glance to reply. From the Egyptian Sphinx to the Kamakura Diabuts; from Prometheus to Christ; from Michel Angelo to Shelley, art had wrought on this eternal figure almost as though it had nothing to say. The interest of the figure was not in its meaning, but in the response of the observer. . . . Like all great artists, St. Gaudens held up the mirror and no more.[61]

As Adams predicted, the reception of the monument became a shifting terrain for a battle over identity and legacy.

NINE

DEATH AND
THE SCULPTOR

The Milmore Memorial emerged from a different process of creation and from a more distant, businesslike relationship between the sculptor Daniel Chester French and his patrons. Unlike Henry Adams, who insisted on a veil of privacy and a strategy of indirection, the Milmore heirs wanted the monument to cement the public fame of the departed sculptor brothers. Joseph Milmore's widow and son insisted that the Milmore name be prominently incised on the memorial and on later replicas. The resulting monument can also be viewed as offering a gently hopeful narrative in comparison with the more questioning attitude presented by the Adams Memorial. Its universalizing drama of youth cut off in its prime by death touched viewers from many backgrounds who saw in it a variety of themes related to Christian love, the value of creative labor, memories of war, and the ultimate mystery of death.

Little correspondence survives about the monument commission, but it seems certain that James Bailey Richardson, the prominent Boston lawyer who was co-executor of the Milmore estate, discussed it with French soon after Joseph's will was settled, finally concluding an agreement in late 1889 for an "artistic" bronze monument of "heroic" scale.[1] The sculptor was given considerable liberty—as much or perhaps even more than Saint-Gaudens—in conceiving and composing the memorial design.[2] He quickly abandoned the idea, suggested in the Milmore wills, of including busts of each of the brothers as well as a portrait of their mother, in favor of a large, bronze, high-style tableau featuring a majestic angel reaching out to stay the hand of a young sculptor.

"I am working on the design for the Milmore memorial, which will test my abilities to do an ideal thing," French wrote his brother William, director of the Art Institute of Chicago, in February 1889, welcoming the opportunity to make a major sculpture drawn from his imagination.[3] French had been seeking an opportunity to design an angelic grouping, especially following the recent loss of his own sister and father. In her biography *Journey into*

Fame, his daughter Margaret Cresson says the Milmore project "interested him greatly. It looked as though at last he would be asked to do his 'Angel of Death,' an idea that he had been turning over in his mind for a long time."[4] French knew well that this sculpture, so different from the historical and portrait monuments he had been creating in his early career, would be viewed as part and parcel of his own legacy as well as the Milmores' renown. It was also his first high relief, a form in which he would prove his mastery again and again over time. He likely publicized the project to promote his career; in July 1889, for example, the *Magazine of Art* would report the news that "A monument to Martin Millmore [*sic*], the sculptor, is to be erected in the Forrest [*sic*] Hill Cemetery. . . . It will be the work of Daniel Chester French."[5]

French was just completing his formative years as a sculptor and ambitious to take his place in the art world. Born in 1850 in New Hampshire, he had moved with his three siblings and widowed father, a lawyer-farmer who later became assistant secretary of the U.S. Treasury, to Cambridge, Massachusetts, and then to Concord a little to the north, where his family became acquainted with some of the surviving members of the transcendentalist literary community.[6] He attended the Massachusetts Institute of Technology for a year but struggled in subjects like chemistry and algebra and never completed his studies there. With the help of tools loaned by artist May Alcott (a younger sister of writer Louisa May Alcott), he began modeling small portraits and animal figurines at home. After a month of training in the studio of sculptor John Quincy Adams Ward in New York in 1870 and lessons during two winters in Boston from artists William Rimmer and William Morris Hunt, the young man won a local commission to make a statue of a vigilant Minuteman (1875) for the centennial of the Battle of Concord in the American Revolution. He labored two years on the monument, first envisioned in granite and then finally cast in bronze. Owing to his inexperience, French asked only to be paid his expenses for this single-soldier statue, which launched his career, but he was awarded an additional $1,000 after philosopher Ralph Waldo Emerson, among other influential citizens, praised the result. "If I ask an artist to make me a silver bowl and he gives me one of gold I cannot refuse to pay him for it if I accept it," Emerson wrote.[7] Shortly before the dedication of the *Minuteman*, French headed to Italy for a year and a half, accepting an invitation to live in Florence with the family of his friend Preston Powers, the son of sculptor Hiram Powers, and to work in the nearby studio of Thomas Ball, who became a lifelong mentor for him as he would also be for Martin Milmore. After his return to the United States in 1876, French made portrait busts, including one of Emerson, and designed a statue of benefactor John Harvard for Harvard University. His father's position as a high official in the Treasury Department in Washington in those years also helped him to secure contracts for several projects decorating government buildings.

Seeing that other artists of his generation were training in Paris rather than Italy, the young sculptor also considered going to France to study. He finally went in October 1886 after his father's death late the previous year. He accompanied his stepmother, Pamela Prentiss French, who was struggling with her bereavement, on the trip to Europe. She was described

as making "a pathetic picture in her deep black dress . . . her grief . . . too living to witness calmly," and friends suggested that travel overseas would help her to recover.[8]

In Paris, French worked on a marble statue of Michigan senator Lewis Cass for the U.S. Capitol, took drawing classes, signed up for Antonin Mercié's evening sculpture class, and studied firsthand the sculpture in museums and the work of French contemporaries such as Paul Dubois and Emmanuel Frémiet.[9] His experience in France was different from that of Saint-Gaudens, however. He admitted a real shyness about his ability to speak the language, relying in part on Anglophone acquaintances.[10] In addition, he was older when he arrived and came from a more refined social and professional background than many French sculptors. He said later that he wished he had gone to Paris earlier. While previous generations of American sculptors had looked to Italy as their training ground, the art of neoclassicists such as William Wetmore Story was by this time spurned as outdated. Story, for his part, denounced France's artistic influence as a contagion afflicting U.S. art—a system in which mastery of technique was given priority over ideas, resulting in "a debauched imagination" and a corruption of sentiment.[11] But Story's was the voice of the past. Saint-Gaudens was seen as the leading edge of the post–Civil War generation that chose to study in Paris, modeling more naturalistic figures, which they produced in bronze instead of marble and in contemporary or historical dress instead of togas, putting greater emphasis on use of the life model to understand anatomy, on learning technique through systematic training, and on melding sculpture with other media in Beaux-Arts architectural settings. Daniel Chester French straddled all of these traditions in his training. Writer-sculptor Lorado Taft said French may actually have gained an advantage by his late arrival in the City of Light and by his abbreviated stay there: his approach already partly shaped, his oeuvre retained a particularly "American" character, in that Chicago critic's view, and French was not seduced by an overly facile European artfulness. Regardless of questions of style, skill, or artistic affiliation, the years in Boston, Florence, and Paris helped the sculptor forge a network of useful connections.

French was a handsome young man, with large eyes, a strong chin, and a bushy mustache, but his head of thick dark hair was already beginning to thin above the forehead. Tall and slim, he loved the outdoors; photos show him walking, canoeing, and on horseback. At the time of the Milmore commission, he had just recently married his cousin Mary French, after wavering over the possible controversy the match with a close relation might inspire. The couple moved to cosmopolitan New York in part to assure acceptance. While there, French worked on his portrait statue of Thomas Gallaudet for the Columbia Institution for the Deaf (now Gallaudet University) in Washington, D.C., which demonstrated his new skill in multifigure composition. Gallaudet, a pioneering educator of the deaf, is shown teaching his first student to form the letter *A* in sign language. By this time, Saint-Gaudens was often consulted about public commissions, and French chided him half-jokingly in mid-1887 about venturing into "my huckle-berry patch" for having lent possible support to a different (deaf) sculptor for the Gallaudet project. Saint-Gaudens chalked this up to a misunderstanding,[12]

and later aided French by advising him to lengthen the figure's legs. This suggestion wound up delaying French's wedding, but the young man expressed gratitude, saying, "[W]hen you can pin Saint-Gaudens down and get a real criticism from him, it is better than anybody's, and so what can I do except give the Doctor an inch or two more of leg."[13] Saint-Gaudens would become an important booster of French's career, helping him, for instance, to gain a key role in the decoration of the 1893 world's fair in Chicago. French, in return, would later push the Metropolitan Museum of Art in New York to acquire works by Saint-Gaudens for its influential American sculpture collection.[14]

By the fall of 1889 French had completed a small maquette (Figure 40) for his Milmore Memorial.[15] French had an unusual ability to conceive his work in three dimensions at an initial stage. Ball had advised him that "the closer we adhere to our small models if they have been studied carefully, the more grand and broad our large work will be."[16] In this respect French put less emphasis on the fluidity of process preferred by Saint-Gaudens, who could begin a sculpture with a primitive stick figure and allow it to emerge over time through myriad instances of trial and error. French's early sketch for the Milmore Memorial established the basic elements of the final composition: a majestic winged angel at left facing a sculptor, both figures modeled in high relief. The monument's focal point is the angel's beautiful gesture, reaching across to touch the sculptor's chisel and arrest the surprised youth's attention. She stands ready to guide him on an untimely journey to another realm. In the maquette, even more than in the final version, the angel's movement recalled—and at the same time inverted the meaning of—the famous scene in Michelangelo's Sistine Chapel

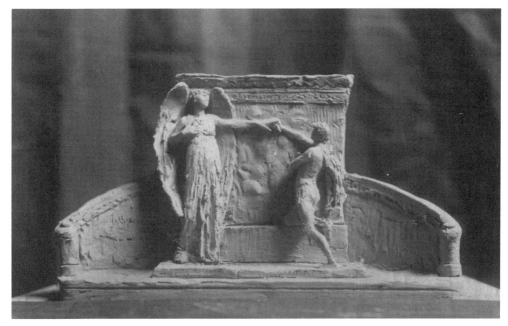

Figure 40.
Daniel Chester French, clay maquette for the Milmore Memorial, 1889. Courtesy of the Chesterwood Archives, Chapin Library, Williams College, gift of the National Trust for Historic Preservation and Chesterwood, a National Trust Historic Site in Stockbridge, Massachusetts.

ceiling in which God stretches out his hand to give life to Adam. Given that sculpture in this period had limited means (for instance, lack of color range and a restricted ability to include background and atmosphere), gesture was a vital tool, and French recognized in laying out his dramatic narrative that touch could be the most moving gesture of all. From the beginning, the choice of a high-relief format contributed to a pictorial quality for the sculpture—requiring a frontal view and not allowing the greater multiplicity of perspectives found in works in the round like the Adams Memorial. French was aware that a relief format was well suited to his narrative theme, implying a passage of events over time: the angel's arrival, the youth's recognition, and their imminent departure together.

A photograph of this maquette was no doubt the basis for the December 1889 memo of agreement that French signed with Richardson for a monument to be called *The Angel of Death Stay the Hand of the Sculptor*. "It shall consist in part of two bronze figures of heroic size, and such other bronze background placed in stone, as shall be required to give it the best artistic effect," the contract said, promising that the final sculpture would be "substantially like the design heretofore submitted in photograph." French agreed to finish the project within two years in exchange for payments totaling $9,400.[17]

What sparked French's interest in angels? French was not a churchgoing man, although his wife, like her mother, aunt, and older sister, had attended the all-girls Convent of the Visitation high school associated with Georgetown University in Washington, D.C., and must have had a thorough religious education there.[18] A letter he received from Sarita Brady, a family relation, after the 1881 assassination of President James Garfield suggests the kind of language he was surrounded with when discussions of death took place. Brady, also raised a Roman Catholic, noted that the president "had passed into the Great Mystery of Death."[19] French would later talk about the Milmore Memorial as expressing hopefulness about a sweet hereafter, regardless of one's beliefs.[20] Yet when Thomas Ball's wife, Ellen Louisa Wild, died in early 1891, French wrote of his sheer inability to express his painful feelings, telling his former teacher, "I grieve with you and [your daughter] Lizzie. O my dear, dear friend and master, I find I cannot write to you now. The poor offering of my sorrow and pity and sympathy is too inadequate to bring you at this time even though I know you will value it."[21]

French's interest in angels was inspired in part by his passion for nature. As he prepared his working model for the Milmore monument, he requested specimens of bird wings from his boyhood friend William "Will" Brewster, who had become curator of ornithology at Harvard University's Museum of Comparative Zoology. He and Brewster had tramped Cambridge fields together on birding excursions and pored over Audubon and Nuttall ornithology handbooks during their childhood. "The Judge" (as French's father was often called) also loved birds and knew something about taxidermy, so he had shown them how to stuff birds. French kept a bird book in his youth. He and Brewster stayed in touch over the passing decades via letters and occasional visits. After the death of French's younger sister Sallie, for example, Brewster sent word in 1883 of his deep sympathy: "[S]uch blows must

come to all of us, sooner or later, and we must bear them with what strength we may. Only believe that I am feeling very strongly for you and that I would do anything that I could to help or comfort you."[22]

On October 5, 1890, French wrote Brewster "on a matter where our pursuits join hands. I have this winter to model an angel and it occurred to me the other day that you might help me in the study of wings." Wondering if his friend could get him "a lot of them" on an upcoming trip to Umbagog Lake, which straddles the New Hampshire–Maine border, he said, "I should like a half dozen pairs or so of different kinds and sizes, not with a view of copying any one particular specimen, but for the purpose of studying up on the subject. They would serve my purpose best, dried just as they naturally close."[23] Mere "copying" was not his goal; French once commented that his objective instead was to look to nature but improve on it.

French was also a longtime friend of artist and naturalist Abbott Handerson Thayer, best known today for his large oil paintings of his children with angelic wings based on real, feathered reconstructions. Although one of these paintings is entitled *Angel* (Figure 41), Thayer most often referred to his images of idealized women and cherubic children simply as "winged figures" and said the feathers were added primarily to lift his models out of the commonplace. He recognized that the wings provided an "exalted atmosphere" and majesty outside of or beyond Christian iconography,[24] and his paintings remain popular with museum audiences today. When French was in Paris he would have seen the many ways in which European sculptors used wings to add a sense of motion, of the supernatural, or to indicate that a figure is an allegory, representing an abstract idea. These would have included the celebrated winged figures, for example, of Dance, Lyrical Drama, Instrumental Music, and Harmony in front of the Paris Opéra, entirely unrelated to solemn Christian themes.

In the Milmore Memorial, the angel linked the sculptural grouping securely to another significant tradition, winged figures made for American cemeteries in the nineteenth century. These angels, who are depicted guiding souls, guarding graves, recording in books, and pointing up toward heaven, appear in large numbers and in a wide array of poses. Their wings enable them to travel between earth and the world beyond, scholar Elisabeth Roark notes, and are "a sign of super-human spirituality, power, and swiftness."[25] Many of these sculptures were insipid marble or

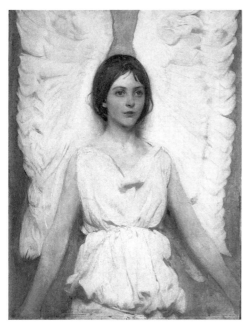

Figure 41.
Abbott Handerson Thayer, Angel, *1887. Oil, 36 1/4 × 28 1/8 in. Smithsonian American Art Museum, gift of John Gellatly, 1929.6.112.*

granite angels manufactured by local quarries or funerary monument companies. But the
Milmore Memorial angel could also be interpreted as a specific allusion to Martin Milmore's
own Coppenhagen angel, a female figure holding a bronze trumpet in one hand and raising
her other hand, created for Mount Auburn Cemetery in 1872 (see Plate 5).[26] The trumpet
will sound on Resurrection Day. French's angel, however, is far more decorative and majes-
tic, an updated angel. It represents a great stylistic stride as well from their mentor Thomas
Ball's stone Jonas Chickering Memorial in the same cemetery, which shows a boyish *Angel of
Death Lifting a Veil from the Eyes of Faith* (1872).[27]

A later photograph of French at work in his New York studio on the full-size clay
model for the Milmore monument, eight feet wide and nearly eight feet high (Figure 42),

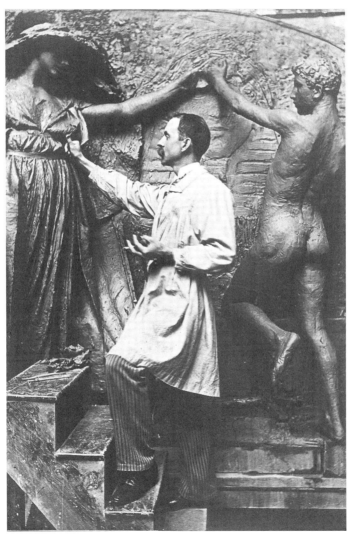

Figure 42.
*Daniel Chester French at work on the Milmore Memorial in his New York studio. Courtesy of the Chester-
wood Archives, Chapin Library, Williams College, gift of the National Trust for Historic Preservation and
Chesterwood, a National Trust Historic Site in Stockbridge, Massachusetts.*

gives us a fascinating picture of its evolution. The monument occupied most of one end of his studio. The partly defined head of a sphinx in low relief can now be seen, the unfinished carving on which the sculptor has been intently working. The picture shows that French first modeled the youth in the nude, presumably from sessions with a life model, and added the figure's work apron and tightly fitting leggings only later on. The youth's body is taking form as vital and healthy, and he now stands taller on his straight right leg than in the maquette, more nearly the same height as the majestic angel. The sculptor's arm is drawn back, mallet in hand, ready to strike his poised chisel; he is immersed in his work, concentrating his mind as well as his physical being on the task. While his head remains in profile, his body is turned more fully away from the viewer in contrast to the angel's frontal form. The two figures' arms no longer form a straight line but join in a graceful balletic gesture, as if they are participating in an elegant, stylized dance of life and death. A cloak sweeps across the formerly uncovered head of the angel, casting its face in shadow; its face is also more fully in profile with eyes open but looking into the distance rather than directly at the youth. The drapery, which

Figure 43.
A model poses in Daniel Chester French's studio. Undated photograph.
Courtesy of the Chesterwood Archives, Chapin Library, Williams College,
gift of the National Trust for Historic Preservation and Chesterwood, a
National Trust Historic Site in Stockbridge, Massachusetts.

hung straight down in the maquette, is now a complex play of sweeping curved forms, spread out in a decorative, almost abstract, play of lines and shapes. French might have used a live model (Figure 43) as well as a lay figure, a jointed model that can be posed in any attitude (as seen at left of the memorial in Figure 44), to capture the play of the drapery.

Figure 44 also shows one important feature of the sculpture's design that was cut off in the best-known, more tightly focused picture of French at work: the angel originally held a horn or trumpet, a common attribute of the angel of the resurrection in cemetery sculpture such as Milmore's Coppenhagen angel. This horn was later tellingly replaced by poppies, which shift the references from Christian iconography to time-honored equations of sleep (poppies are the source of the narcotic opium) and death. For period audiences the poppies might have summoned up themes popular among the British Pre-Raphaelite painters, including especially Dante Gabriel Rossetti's *Beata Beatrix*

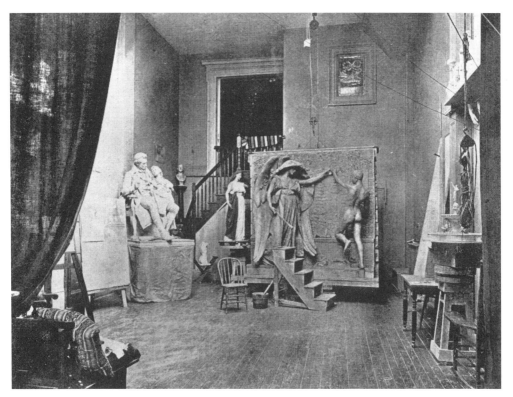

(1872), in which a dove brings a poppy of sleep to the artist's languid, dying wife. John Everett Millais's dead *Ophelia* also carries one blood-red poppy. French had visited the studios of such British artists as Sir Frederick Leighton, Edward Burne-Jones, and Lawrence Alma-Tadema in London on his 1886 European trip and was familiar with these themes.[28]

French's angel represents a gentle guide rather than a grim or violent personification of Death. It was compared and contrasted with such well-known images as George Frederic Watts's *Love and Death* (Figure 45), which was mentioned by a number of critics, and the somber Angel of Death in Elihu Vedder's illustrations for Khalil Gibran's *Rubáiyát of Omar Khayyám*. Both of these offered humanized depictions of death that were gentler than the skeletons and cadavers found in art of past centuries.[29] In Watts's well-known painting, which exists in multiple versions, a small boy representing winged Love tries in vain to stop the approach of a looming white-draped Death. Love's fragile wings are crushed as he struggles to hold off the inevitable. Death tramples the roses in its path as it advances, yet leaves a living dove untouched at lower right. Vedder included a moody "Angel of the Darker Drink" in the illustrations he composed for the *Rubáiyát*, which achieved unparalleled success, its first edition selling out in Boston in 1884. His turbaned male angel garbed in white offers a cup of death to a beautiful young woman who cannot resist its force. The angel, with outstretched

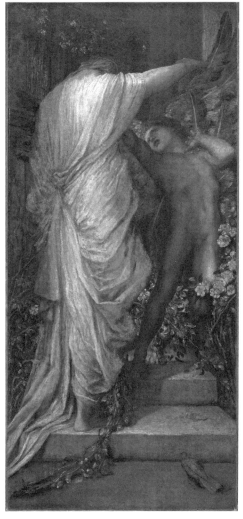

Figure 45.
George Frederic Watts, Love and Death, *1877–87. Oil on canvas,*
97 × 46 in. Tate Britain, London. Courtesy of Tate Images.

wings, turns his head to avoid the swooning figure's eyes, but he may soon fold her in his arms as she collapses. Vedder's image fuses Christian references to resurrection and wine with the Persian poet's verses.[30] William Wetmore Story's highly personal Angel of Grief performed her prostration with an all-too-human sense of despair and loss and is of a quite different register from these and from French's comforting escort. Yet all share a common function.

French exhibited his Milmore Memorial in fine-arts settings under the title *The Angel of Death and the Sculptor* but referred to it most often in correspondence simply as "Death and the Sculptor." Robert Kastenbaum, a scholar of the ways in which societies deal with death, has noted that personifications can help individuals and societies to cope with death by "objectifying an abstract concept that is difficult to grasp with the mind alone . . . expressing feelings that are difficult to put into words . . . [and] serving as a coin of communication among people who otherwise would hesitate to share their feelings." They provide symbols, he added, "that can be repeatedly reshaped to stimulate emotional healing and cognitive integration."[31]

In a letter to sculptor-critic F. Wellington Ruckstuhl, French expressed similar ideas about visual consolation, offering an open-ended explanation for his memorial:

> My message, if I had any to give, was to protest against the usual representation of Death as the horrible, gruesome preserve that it has been represented to be ever since the Christian era. It has always seemed to me that this was in direct opposition to the teachings of Christ which represent the next world as a vast improvement over this one. "That men may be content to live, the Gods have hidden from them that it is sweet to die" was the utterance of a Greek philosopher.[32]

French used the form of an angel to accomplish his goal. During the late nineteenth century angels moved from biblical and religious contexts into the mass culture of the industrial world, as writer Paul Gardella has explained. They proliferated in parks as well as

cemeteries and public war memorials, prints, and fictional accounts. Angels appeared, for example, in the writings of Henry Wadsworth Longfellow, Herman Melville, the spiritualist best-seller Elizabeth Stuart Phelps, Mark Twain, and Walt Whitman, and in the lithographs of Currier and Ives, such as *The Angels of the Battlefield*, which shows a winged figure coming to guard the spirit of a dying soldier.[33] They were mentioned in consolation literature, epitaphs, and in the Protestant hymns developed in the nineteenth century.[34] *The Gates Ajar* (1868), Phelps's immensely popular serialized fictional dialogue about the afterlife, identified "any servant of God" as an angel in this critical time. Consolation literature like George Wood's *The Gates Wide Open, or Scenes in Another World* (1870) and *Letters from Heaven* (1887) talked in terms of personal guardian angels assigned to each of those who passed away, guiding them to a pleasant new home in heaven, similar to the one on earth. A bronze *Angel of the Waters* by sculptor Emma Stebbins was commissioned for a fountain in New York's Central Park in the 1870s and became much beloved. French would go on to be the greatest American master of angelic sculpture, making at least ten major sculptures. As Gardella notes, artists like French used angels in the late nineteenth century to invoke "spiritual power without dogma, contributing to a new realm of nondenominational religion."[35]

While the Milmore Memorial could be interpreted as less focused on an interior questioning and self-reflection than the Adams Memorial, it did suggest universal themes with much wider resonance than the specific story of the three Milmore sculptor-brothers. Americans, familiar with such publications as John Bunyan's *The Pilgrim's Progress* and with Thomas Cole's allegorical paintings, often saw life as a kind of journey. The Milmore angel can be seen as arriving to lead the young sculptor on the final leg of that journey, sooner than expected. Similarly, a guardian angel watched over the life of one man, from childhood to old age, in Cole's celebrated four-painting series *The Voyage of Life* (1840). Angels surrounded the Virgin Mary or the risen Jesus in myriad ascension scenes from the Renaissance and baroque periods, and they also take George Washington aloft in a well-known American print and in the apotheosis scene in the dome of the U.S. Capitol. Viewers with different understandings of religious faith thus might bring to the Milmore sculpture their own expectations and interpretations.[36]

Eventually, French worked out the costume of the sculptor, which had been suggested in his early maquette. The young man wears an apron, tight leggings, a sleeveless shirt, and soft slippers. The final figure is not a gentleman sculptor but a youthful laborer more akin to an idealized artisan or quarry worker. Yet his deep concentration and aura of internal serenity suggest that he possesses a native genius and authentic, natural nobility. In this way, he seems a close descendant of a variety of figures of "primitive" people with a Rousseauean spirit deemed to be superior to the academically trained, overcultivated, and well-to-do. One close example is Jules Joseph Lefebvre's *Young Painter Painting a Greek Mask* (1865), which shows a Greek youth, also facing away from the viewer with one leg lifted on a bench, as he focuses with almost childlike intensity on painting a theatrical mask (Figure 46). That lithe figure shares a lack of awareness of his observer. Lefebvre, a teacher at the Académie Julian,

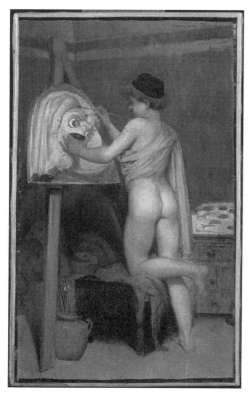

Figure 46.
Jules-Joseph Lefebvre, Young Painter Painting a Greek Mask, *1865. Oil on canvas, 13 × 7.9 in. Photo: René-Gabriel Ojèda. Musée des Beaux-Arts, Valenciennes, France. © RMN-Grand Palais / Art Resource, NY.*

where many Americans trained, stressed to his students a need for precision in life drawing and painted many beautiful nude figures. He had just won the grand prize at the 1889 Universal Exposition in Paris and was highly celebrated at the time French was creating his Milmore Memorial.[37] Images such as these suggested the "natural" talent and creative vigor of youth in the production of art.

Accounts of Martin Milmore's career had often talked more about the "immense amount of labor" involved in projects like his colossal Sphinx for Mount Auburn Cemetery or the grand Boston Common soldiers' monument than of his aesthetic achievements. "No artist works harder or longer every day than Milmore," said one newspaper report about the expatriate community in Italy.[38] The sculptor in the Milmore Memorial is thus shown as an older-style artisan, carving hard stone, presumably marble or limestone, instead of fashioning a clay model with his fingers for future casting in bronze in the Beaux-Arts style. Those who worked hard in life and took pride in their achievements might see themselves in the figure of the sculptor. While the Adams Memorial might be viewed as more about the head than the body or heart, this sculpture could speak of the real exigencies and pleasures of creative labor. Death becomes a rest from a life filled with work. A number of turn-of-the-century cemetery memorials sounded this theme, as for example Karl Bitter's later Henry Villard monument (1904) in New York's Sleepy Hollow Cemetery, dedicated to a railroad financier whose capital employed many workers, and Charles Niehaus's Drake Memorial in Woodlawn Cemetery, Titusville, Pennsylvania. They all question the meaning of life's labors, creativity, and the surcease of work.

The horizontal ledge upon which the youth rests his knee, together with the vertical edges of the relief and the curving top line, frame the low-relief sphinx that appears within the larger tableau. While surviving photos show that the head of the sphinx faced forward in an earlier design, it is seen in profile in the final iteration (see Plate 2), behind and between the angel and the youth. Their faces are also in profile, and the creature becomes the third major element in the sculptural grouping, uniting the whole. French said later that the choice of a sphinx such as Milmore had made for Jacob Bigelow was a "coincidence."

He insisted that he added the sphinx solely to introduce an element of mystery, "in this case the mystery of life and death."[39] But his comment seems disingenuous. The Bigelow sphinx was by far the most famous emanation of this Egyptian form in the American landscape of death. And French's own diary entry documents his early personal awareness of the sphinx in Mount Auburn Cemetery, a major Civil War monument that lingered in viewers' minds.

French referred at least twice in letters to the fact that Milmore had made the sphinx as a "war memorial" or "soldiers monument." While his Milmore monument clearly contains specific references to the Milmore brothers' lives, therefore, it also must be remembered that it was created at a time of renewed recollections of the Civil War and should be interpreted in that context as well. In 1888, the year French took on the commission, the nation marked the twenty-fifth anniversary of the war with large-scale veterans' reunions and many other events and publications. A popular series of war reminiscences in *Century* magazine from 1884 to 1887, for example, had become the basis for a four-volume collection, *Battles and Leaders of the Civil War*. Magazines specifically devoted to the war, such as *Confederate Veteran* (1893–1932), reached their peak circulation at the turn of the century. Battlefield parks were being developed, and large numbers of regimental monuments were erected by veterans groups and by groups formed by the sons and daughters of veterans to mark the passing of the war generation.[40]

Against this backdrop, the sculpted youth whose life is shown ending prematurely after giving his all to his labors might be a stand-in for the many young men who died during the war as well as for the bodies of the Milmore brothers buried at the Roxbury gravesite.

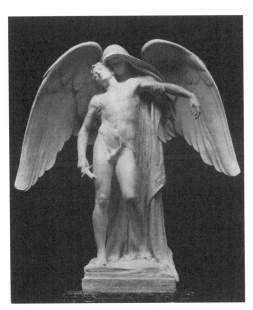

Its essential theme is life cut off, for which an extensive iconography existed, seen in endless repetitions in American cemeteries of broken columns, rose petals dropped to the ground, drooping flowers, and sleeping lambs. French would return to this theme much later in his moving war memorial, *Death and Youth*, a marble group depicting an angel supporting a dying soldier in the chapel at St. Paul's School, Concord, New Hampshire. Dedicated in 1929, it paid tribute to students who had died in World War I. French explained the Concord sculpture (Figure 47) in terms like those used for his Milmore Memorial, saying that he had intended it to counter ideas about the terrors of death, and adding, "It is this that I should like to have my group convey;—that the angel who is

taking the youth in her protecting arms is ushering him into a higher and better life."[41] During the Civil War, when soldiers died far from home and without the presence of ministers, families were sometimes reassured by letters from witnesses confirming that their sons or husbands or fathers had faced death peacefully, with self-control and with a confident patriotic purpose.[42] A sculpture such as French's Milmore group could be another form of consolation for those who had lost young ones in the war after a life of duty and sacrifice. The death it portrays is quiet and beautiful, not violent, retaining a sense of wonder and mystery.

In choosing the sphinx, French selected a symbol that was both specific and universal, and one that resonated with the times. A newspaper sketch shows that the artist completed the hybrid creature last, after adding clothing to his youth.[43] French's sphinx for the Milmore Memorial wears a royal head cloth, and the sculptor is shown at work defining its crown. In his published description of the memorial, Lorado Taft also suggested that the sphinx was introduced as a fortuitous afterthought, noting that the figure of the young sculptor was not meant to be a portrait of Milmore but a concept, and arguing that the same was true of the sphinx, which can be a multivalent symbol.[44] A sphinx, of course, summoned up thoughts of ancient Egyptian pyramids, with their emphasis on guarding the bodies and souls of the dead. Egyptian culture and its eternal mysteries were of current interest after the obelisk known as Cleopatra's Needle arrived in New York in 1881, covered with indecipherable hieroglyphics; Egyptian themes would be sounded on the midway as well at the 1893 world's fair, suggesting their expanding popularity. In the 1880s and 1890s, the word *sphinx* was widely used in the media and even in the advertising world for any object (or person) that conceals secrets. For example, one political cartoon showed U.S. Senator George Hoar as "'uncommitted,' solid as a sphinx"; another described prominent public figure James Blaine as "the political sphinx of the republican party. The riddle is: what does he mean to do—to run, to decline to run, to withdraw." "Sphinx's Eyes" was an optical illusion used in advertisements. Octave Feuillet's play *Sphinx* was presented in New York and then Boston after a run in Paris. A Sphinx senior society was founded in 1886 at Dartmouth, where both French's father and executor Richardson were alumni. Elite tourists like Henry and Marian Adams as well as orientalist artists had enjoyed cruises down the Nile to see the original, and painters such as Vedder and later John Singer Sargent included the sphinx in their productions. The Adams Memorial was often later referred to as a "sphinx" because of its indecipherability.[45]

The sphinx could become a metaphor for the way a work of art conceals the "intimate thought" it embodies and the ways it can help unlock life's riddles, notes author Scott C. Alan, who calls the sphinx the "mother of all symbols."[46] It has long been a popular assumption that at the last moment of life, the mortally ill departing this earth have a "privileged insight into the meaning of life and mystery of death."[47] Is it that Milmore, carving the sphinx as he seeks to puzzle out life's ultimate riddle, actually sees the heavy three-dimensional angel that appears before him in the sculpture? Or does his angelic visitor appear only in his mind's eye as at the last breath, standing before the sphinx, the famous oracle, he gets a glimpse of the true understanding of the cycles of life and death, faith and hope? A perfect rush of

insight about the wholeness and interconnectedness of the universe, heaven and earth, may flood his mind and spirit—a tantalizing glimpse of a higher consciousness for which Gilded Age visitors yearned.

◯

In October 1891 French returned to Paris, this time to have his Milmore tableau cast in bronze and to begin a three-foot model of his colossal figure of the Republic for the upcoming Chicago world's fair.[48] He took a studio not far from the Arc de Triomphe and next to the atelier of French sculptor Emmanuel Frémiet, and made final modifications there.[49] On January 5, 1892, French wrote his brother jubilantly that more than one hundred people had come to see the final plaster of the Milmore monument during a "big reception" at his studio. "Some French sculptors, Frémiet among them, came before the reception-day, and really, William, it looks as if I had done tolerably well this time. [American sculptor Paul Wayland] Bartlett says Frémiet almost never praises anything, and he said some really civil things about my relief."[50]

French contracted with the E. Gruet Jeune Foundry in Paris to make the bronze cast, which was not completed, however, until after his return to the United States to prepare for the world's fair. Thus he was not in France to personally approve the cast or to see his work exhibited, first at the original Salon on the Champs-Élysées and then at the smaller new Salon on the Champ-de-Mars, which was seen as more welcoming to foreign artists; there he was awarded a third-class medal, and he reported that "the Paris papers are speaking respectfully of the Milmore."[51] Thomas Ball kindly wrote that he too had seen and admired "your beautiful monument to Martin Milmore" in Paris.[52]

This was a time of terrific excitement for French, a famously soft-spoken man with a patient demeanor, as he worked with a production team for the Chicago fair. French wrote his brother on February 3, 1893, that successful exhibitions of the plaster Milmore relief had also been arranged at the Society of American Artists and Architectural League shows in New York. "The exhibition of the Milmore here was a ten stroke. The Society Am. Artists had it first then the Architectural League . . . gave it the place of honor. The newspapers have puffed it and the *Century* [magazine] is to picture it in March or April and I am likely to be impoverished giving away photographs."[53]

French also showed the plaster at the 1893 world's fair, where it attracted considerable attention, while the original was finally quietly installed in August of that same year in the Forest Hills Cemetery to serve its original function as a private memorial.[54] The bronze for the cemetery, inscribed with the artist's name "D C French" and the year 1891, was placed in a stone setting designed by C. Howard Walker, the adequacy of which became a long-standing source of contention between the estate and the sculptor. It is clear that French, busy with his grand productions for the world's fair, did not work closely with Walker, as Saint-Gaudens had with White, and that the setting was more of an afterthought than an integral part of the design. French admitted later there was little money left to devote to it

after the casting and shipping of the bronze. The gravesite became a less visible emanation of the memorial design, which was better known in public fine-art displays. Fragments of correspondence that survive suggest the setting became a significant issue of tension between French and the estate immediately after the installation, when French apparently even considered withdrawing the original bronze. A resolution was finally reached, however, and there was no more mention about discontent with the setting until about 1914, when a new exchange with the family occurred about the need to repair and maintain it.[55]

Following delicate negotiations with James Bailey Richardson, co-executor of the estate, plaster replicas were approved for placement in major American museums in Boston, Chicago, St. Louis, and Philadelphia, and discussions were held about sending one to a European institution. A marble version was later created for the Metropolitan Museum of Art in New York.[56] The sculpture, quickly entering the realm of fine art, helped to cement French's emerging career. It would be interpreted over time as being both about the Milmores' lives and about ideas extending beyond the Milmore brothers' achievements.

TEN

DUVENECK'S LADY

In the Adams Memorial, a sturdy bronze body cloaked in heavy drapery puts into physical form an abstract idea, the unanswerable question posed by human mortality. In the Milmore Memorial, a vigorous-looking youth and a powerful angel also present artistic euphemisms for life cut short. Both of these monuments feature symbolic figures that emerged from the sculptors' imagination, intended to console and to turn visitors' attention away from the cemetery's primary role as the physical lodging place for decaying bodies. Frank Duveneck, locked in his own domain of regret after his wife Lizzie's death, also wanted to make a monument that would aid the process of catharsis. But he chose a different approach in the memorial to his lost love, created with the aid of a young sculptor named Clement Barnhorn. He designed a recumbent figure of his wife, frankly dead but still beautiful, a portrait sculpture configured in the time-honored gisant tradition in which the full-length corpses of kings and queens and bishops are presented for public memory and reverence, most often in church settings. Duveneck "envisioned her as a knight's lady in death," one account noted, "and so he posed her, resting with her hands folded on her breast amid flowing drapery."[1] It is a serene passing that the artist portrays, even an elegant one, tantamount to a peaceful sleep, reverently observed. Yet his cemetery memorial does not deny that Elizabeth's actual body, wraithlike and deprived of the vital force of life, lies beneath the ground at her gravesite in Florence. She is dead, tragically dead, like Clover Adams and Martin Milmore, before her time.

Unlike the other memorial figures, Lizzie's is a clear and careful portrait, created with the aid of a deathbed drawing (see Figure 11). It shows us what Elizabeth Boott Duveneck's face looked like, albeit in an idealized fashion. In addition, an inscription on the side of the pink granite base gives us her name and the cities and dates of her birth and death.[2] The sculpture has a specificity not present in the Adams Memorial and a particularity even greater than the Milmore Memorial, creating a space for any visitor to learn about this unique person whose likeness is presented or to remember her. It was never tagged with an allegorical name such as "Grief" (as the Adams monument was commonly called) or "the Angel of Death." Yet it also serves an elastic pedagogical purpose, reminding us of

the universal brevity of life and inevitability of death. Something beautiful, like a flower or a flame or a work of art, notes writer Elaine Scarry, "fills the mind yet invites the search for something beyond itself . . . with which it needs to be brought into relation." A beautiful object requires "sustained regard" and "requires perceptual acuity, high dives of seeing, hearing, touching."[3]

The monument for Lizzie's gravesite in Florence began to take shape after Frank Duveneck's return to Cincinnati in 1889. While he had traveled widely in Europe at the height of his career and would continue to do so intermittently for the rest of his life, he shifted directions after Lizzie's death. His best work as a painter was behind him, and he focused more of his time and energy on teaching in the Midwest while spending many summers in Gloucester, Massachusetts, to be near his son. He had two brothers, Charles and John, still living in the Cincinnati area, as well as his elderly mother and an unmarried sister, Mollie, who would share with him the modest house in Covington, Kentucky, where he was born and raised. Duveneck enlisted the aid of Barnhorn, a local sculptor he had first met a dozen years earlier, in preparing his memorial. More than ten years younger than Duveneck, Barnhorn would become his most loyal friend in future decades, when both men would teach at the Cincinnati Art Academy. Barnhorn apparently offered Duveneck space in his studio in the six-story Pike Building on downtown Cincinnati's busy Fourth Street, where a number of artists worked, and provided the tools he needed to begin designing the monument for Lizzie.[4] While Duveneck did not formally return to the church until just before his death in 1919, he was comfortable in the company of Barnhorn, a devout Catholic who attended Mass daily and who shared Duveneck's German American heritage.[5] Described as more mild-mannered and methodical in his methods than the dashing Duveneck, Barnhorn presumably contributed guidance and the technical expertise the painter needed to create such a complex figure in clay in his first major sculptural project. Having worked in a wide range of sculptural materials, from wood and stone carving to pottery, Barnhorn had begun to master low relief and architectural form, and Duveneck always credited him as his collaborator. Barnhorn went abroad to study for five years immediately after working on the project with Duveneck and, upon his return from Paris, made biblical subjects a central theme of his long sculptural career as well as portraits and playful fountain figures of children.

A clay model for the monument to Lizzie was fashioned first, and then in 1891 the plaster (Figure 48) was completed, from which the bronze was cast by Galli Brothers in Florence. A newspaper article published in July 1891 sheds light on Duveneck's thoughts about the sculptural media he employed, and the ways in which he earnestly kept his wife's memory alive.

In the article in the *Cincinnati Times Star* titled "An Artist's Grief: How It Finds Expression in Cold Bronze," a reporter described meeting Duveneck at the studio where the artist was preparing his final model for the foundry. Duveneck began by providing practical rather than emotional explanations for his decision to have the full-length reclining figure cast in bronze, despite the tradition for gisants made of stone. "Of course, I would prefer

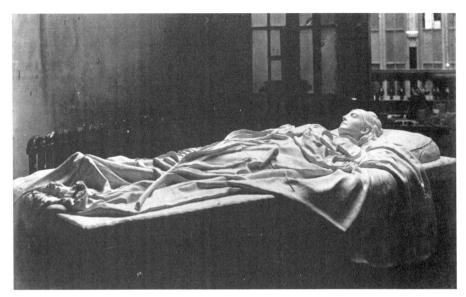

Figure 48.
Frank Duveneck and Clement Barnhorn, plaster model for the Elizabeth Boott Duveneck Memorial, 1891. Cincinnati Art Museum.

marble but I wanted something lasting as well as appropriate," he told the correspondent. "Then marble is too apt to be marred, either by people or the weather. This memorial will not be more than three or four feet high, and could be easily got at. . . . [R]elic hunters are not over particular, and it would not be long perhaps before there would be a finger gone or the nose broken off, or other portions marked and hacked. So take it all round I found that bronze . . . would be the best of all [media] I could select. Come in and see it."[6]

The reporter, for his part, was moved by the "face of exquisite sweetness" in the model, saying, "The likeness was of the dear being it was sought to immortalize. Two delicate hands were folded over the breast, and a robe sweeps gracefully away. . . . Over all is a long palm branch that completely takes away all that hardness and starkness of the reclining figure in effigy. There is relief, repose, rest. The work is the idea, and possibly the ideal of a master artist to the most beloved of his life." The interviewer indicated that Duveneck spoke openly in his earnest and unpretentious manner of his wife, their past happiness, and his hopes for the memorial. Unlike Henry Adams, he often talked about his late wife, friends said, with great affection and without shame or remorse.

Duveneck, with Barnhorn's help, achieved a simple yet elegant monument that combines affection, reverence, and imagination. For him, the personal effort of creation must have been critical in resolving any lingering guilt over having failed to prevent Elizabeth's death. He was aware of her father's concerns about his capabilities as a suitable husband and protector—to the point that Francis Boott had arranged for the care of the couple's child, Frank. In the end, Duveneck's innocent, heartfelt warmth and caring nature come through—qualities that his wife had so well understood.

Duveneck, in his first significant sculpture, created a composition with strong massing, clean contours, and without fussy detail that could detract from the overall sense of a unified composition, leaving the focus on the clear, uncluttered silhouette of Lizzie's profile and on her folded hands. In doing so, despite his closeness to the subject, he made a monument that did not suffer from being overly sentimental but that expressed instead a subtle play of the material and immaterial, the real and the decorative. He clearly hoped that it would serve not only to aid his own recovery from this personal tragedy but that it could also be a pilgrimage site for his son and for Lizzie's father, who was waiting in judgment. With this memorial, Duveneck offered his late wife and those who loved her all that he had to give: his talent to create a modern artwork that drew on a variety of traditions. Despite his own unpretentious, plainspoken manner, he captured her innate intelligence and the aura of cosmopolitan elegance that surrounded her life. He achieved a restraint that was more Lizzie's and her father's than a part of his own personality, hinting at his desire to please.

Throughout history, sleep has been described as "counterfeit death," and representations of death have frequently been softened by depicting the person enveloped in slumber.[7] In the tradition of recumbent memorials of young women, Elizabeth is shown asleep in death, with the hint of a smile on her lips and without any gesture of anguish. Kings and queens and civic, military, and religious leaders have also been memorialized as calmly sleeping, and thus Duveneck's creation summons up a panoply of historical allusions to effigies of great men and women found in European Gothic and Renaissance churches that promised future resurrection for the faithful (Figure 49).[8] For Duveneck, a former altar boy who began his career as a church decorator, this must have been comfortable territory, harking back to his early training. The monument is laid out on a cleanly cut block of modern pink granite, in the shape of a sarcophagus or, perhaps, an altar. Duveneck had made and gilded altars in a workshop as part of his youthful training.

Elizabeth's brow is open and honest, without any signs of anxiety. Her eyes are gently closed, and her head, supported by a plush bronze cushion, lies in comfortable alignment with the rest of her body. While her face is the most clearly defined part of the sculpture, her hair becomes an abstract play of shapes, accurately reflecting the way she parted her dark locks in the center and braided her hair tightly in the back. Some European gisants, such as François Rude's famous 1847 sculpture of the antiroyalist Godefroy Cavaignac in Paris's Montmartre Cemetery, show bodies stiffened and backs arched in death, arms thrown aside. But her hands are crossed over her heart, right hand over left, as if presented in a coffin for a genteel last viewing. Her deathbed gown flows downward from the high collar snugly encircling her neck. Pleats radiating from this collar direct attention to the head. The long, wide, loose sleeves of the gown cover even her wrists. The cloth extends beyond her tiny, upward-pointing feet and over the end of the bed. Her form has become so slight that the volumes of her breasts, belly, and hips are barely sensed beneath the flowing drapery. Her enrobed body appears to rest on another cloth, which is spread over the edge of the bronze bed, like a cavalier's cape, and folded up at one side. The large palm frond laid diagonally atop the entire

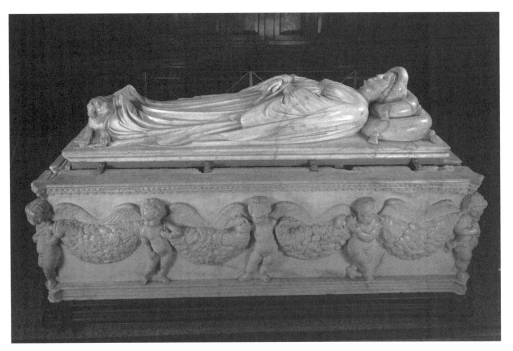

Figure 49.
Jacopo della Quercia, Funerary monument of Ilaria del Carretto (post-cleaning), 1405–1407/8. Duomo (S. Martino), Lucca, Italy. Marble, figure 80 × 27 in. Scala / Art Resource, NY.

length of Lizzie's form provides the major decorative element other than the folds of the gown and cloth. The curve of its stem and irregular shapes of its leaves overlay the flowing drapery to unite the whole and link the monument finally to a decorative aestheticism more closely associated with British nineteenth-century art than with earlier gisant traditions.

The memorial constitutes a horizontal relief sculpture, life-size in scale (about 86 inches long) and is thus best viewed from one side and above, where the whole figure and the palm can be seen. The palm branch is the major allegorical element. Historically, it suggests both ideas of martyrdom and victory in Christian symbolism, victory of the spirit over the flesh in death. Here it becomes a laurel for a life of creativity, fidelity, self-sacrifice, and virtue.

Works of art can be sites where fundamental issues are illuminated and reconsidered by groups of viewers, large or small. In the community around Elizabeth Boott Duveneck, the desire for a funerary monument was not so much an urgent need for a portrait likeness as a desire for another indicator of her intelligence, good character, lack of self-indulgence, and place within refined society, concerns similar to those of Henry Adams's circle of friends. The monument helped to create a memory space about her role as a member of the Florentine community of Brahmins and, for others, as a bright flower who strived for excellence and a sensitive, sympathetic nature in her art and life. It thus fit into a tradition of expatriate Brahmins supporting each other's legacies, often by writing memoirs, as Henry Adams did, that mentioned each other's achievements and shared values. Lizzie's father penned a family

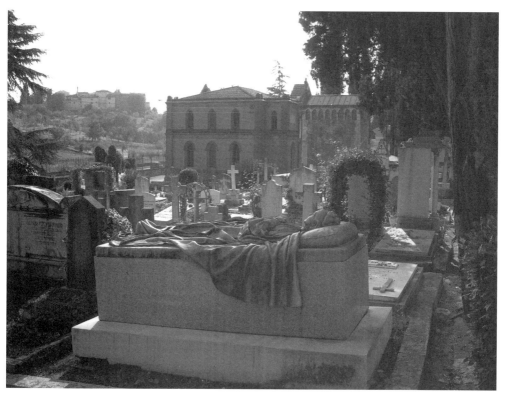

Figure 50.
Frank Duveneck and Clement Barnhorn, Elizabeth Boott Duveneck Memorial, Allori Cemetery, Florence. Photo by Cynthia Mills.

account, *Recollections of Francis Boott for His Grandson F.B.D.*, in 1912. These elites also perpetuated their cultural legacies by donating artworks to the new museums arising in America as well as with a variety of expensive artistic funerary monuments that helped to establish a collective identity. The Anglo-American community in Florence would have been familiar, for example, with the elaborate tomb erected for poet Elizabeth Barrett Browning, one symbol of the expatriate community in which Lizzie lived.[9] Thus several groups could find their own readings in the monument.

Henry James hailed the Duveneck monument (Figure 50) in 1893, writing to Francis Boott that the work is "noble and beautiful, and simply serene and unique." He continued, "One is touched to tears by this particular example which comes home to one so—of the jolly truth that it is *art* that triumphs over fate."[10] He had in mind the Latin phrase *Ars longa, vita brevis* (Art is long, life is short).

The location of the gravesite in Florence made pilgrimages difficult, however, and Duveneck and his father-in-law did not object to the circulation of the image at home via replicas and photographs, which functioned differently than the monument in the cemetery. Sculpture can be a multiple form, reproduced in various media and sizes, and placed in diverse settings and locales that serve different functions over time; these can be made even

more visible by the circulation of prints and photographs. Eventually museums in a number of major American cities acquired plaster, marble, and bronze replicas of the Duveneck monument. Francis Boott began this wave of interest and replication in 1893 when he commissioned a white marble version, which was carved in Italy and finished there by Duveneck's own hand.[11] Boott loaned it in 1895 to the Museum of Fine Arts, Boston, where he and his circle of acquaintances could visit it.[12] That year the plaster was also exhibited at the Paris Salon, where it won an honorable mention for Duveneck and Barnhorn.

While cemetery memorials often begin with a sense of urgency, as in Adams's case, the survivors find themselves in a different place in the process of mourning by the time, years later, that a sculpture is completed; many complicated steps are involved, including financing, design, casting, and installation. As the years passed, Francis Boott's attitude toward his son-in-law softened further and warmed. Boott received many positive comments from acquaintances who saw the marble sculpture in Boston (his friend Henry Lee, for example, wrote of its impression of Lizzie's sweetness, "the grace and feeling of that statue," praising its beauty and repose).[13] Whether visiting the marble in the museum or the original in the cemetery, friends described it as noble and serene, and valued the strong likeness they found in the face.[14] The old man reportedly took his grandson "Frankie" every Sunday to the museum, where he told him stories of his mother.[15] His private memories were perpetuated across generational lines in a public, fine-art setting.

Speaking of the "delight" the monument brought to audiences, Boott gave permission for another plaster to be created for the Art Institute of Chicago in 1898, when a version was also exhibited at the National Sculpture Society show in New York. Sculptor-critic Lorado Taft commented that the Duveneck tomb "seemed to convert its surroundings into a memorial chapel" at the Sculpture Society show, creating a tone of reverence.[16] Other plaster versions of the Duveneck Memorial were eventually acquired or exhibited at the Metropolitan Museum of Art in New York (which later had it cast in bronze and gilded; see Plate 3), the University of Nebraska at Lincoln, the Pennsylvania Academy of the Fine Arts, the San Francisco Art Association, and Yale University.[17] It was not unusual for American museums at this point to exhibit casts of famous works of art; only later did the idea that museums should exclusively display original works of art, created by the hand of the artist, take hold, at which point some of these plaster casts were destroyed along with other cast collections.

Although the gisant form of memorial sculpture experienced a revival in some European settings in the nineteenth century, it was not adopted with any frequency in American cemeteries. It did come into fashion, however, in a few churches in the United States. An early example is a figure of lawyer Edward Shippen Burd, with hands folded in prayer, on a wall tomb commissioned by his widow after his death in 1848, for St. Stephen's Church in Philadelphia. A marble gisant of Southern cavalier-general Robert E. Lee, made decades later and enshrined in a special chapel at Washington & Lee University in Lexington, Virginia, is still an important Southern pilgrimage site. William Wetmore Story created a rather stiff, fully clothed recumbent portrait figure of Ezra Cornell for the nondenominational Gothic-revival

crypt created in 1883 beneath Cornell University's memorial chapel, where memorials to men important to the university's history were paired with figures of their wives or daughters; these include Jennie McGraw Fiske, who reclines holding a decorative branch akin to Lizzie's.[18] Tomb figures of important Episcopal clergymen were represented in gisant form after 1898 in Trinity Church, the Church of St. Mary the Virgin, and the Cathedral of St. John the Divine in New York, as well as the Cathedral of St. Luke in Portland, Maine, all closely based on European medieval and Renaissance traditions.[19]

Churches, like cemeteries, were never deemed to be sites of particularly high achievement in American sculpture. In fact, critic Sadakichi Hartmann complained that the "mechanical" repetition of "stereotyped mediocrities" stamped church sculpture as products of a "trade" rather than of the highest minds of creative art.[20] The fine-art displays, however, of the Duveneck Memorial in addition to the growing critical knowledge of the Adams and Milmore memorials ultimately helped to shift negative art-world attitudes toward funerary sculpture. The best sepulchral sculpture could now be elevated to a status akin to high art, suitable for exhibition in museums and fine-art galleries. It was no longer simply an anonymous artisan's work.

After seeing the marble sculpture in the Boston Museum, Daniel Chester French wrote Duveneck in 1895 of his "deep and sincere admiration and respect" for the beautiful monument. "I came upon it just after the death of my mother, thus, perhaps, I was more than usually in a mood to appreciate the sweet and serious sentiment of it and I have seldom been so moved and impressed by a work of art," he said. "[I]t is as excellent in execution as in feeling. . . . I think your greatest happiness must come from your having succeeded in raising so noble a memorial to your wife." French also wrote Duveneck's son years later that he had fond remembrances of Lizzie, given that she had "attended Dr. Rimmer's lectures in Boston about the same time that I did—about 1870."[21]

Duveneck completed only a few other works of sculpture in his remaining career and, despite French's kind remarks, complained in an 1896 letter to Francis Boott that all such work in Boston was done by French or Saint-Gaudens or the pupils they recommended, so that he had no hope of further prospects for commissions there. But he also related to Boott how personally moved he had been by an "unexpected ovation" he received at a meeting of the Society of Western Artists, when "someone got up and proposed to drink to the health of the American Phidias," comparing Duveneck to the legendary Greek sculptor.[22]

Duveneck considered making a second funerary monument, honoring his mother, Katherine Siemers Decker, an immigrant from Oldenburg, Germany, after her death in 1905. But he decided instead to paint a three-part mural for the new French Gothic–inspired Roman Catholic cathedral in Covington, Kentucky, St. Mary's Cathedral Basilica of the Assumption, as a memorial to her (Figure 51). The mural, completed in late 1909, features Mary Magdalene kneeling beneath the crucified Jesus in the central panel, with God the Father and the Holy Ghost above. Side panels, each twenty-four feet high, represent the Old and New Testaments: a Jewish priest praying in a temple, and a Catholic priest lifting up the sacrament

Figure 51.
Frank Duveneck, Panel from mural for St. Mary's Cathedral Basilica of the Assumption, Covington, Kentucky, 1909. Inscribed "in Memory of his Mother, Katherine Siemers Duveneck, dedicated by the artist Frank Duveneck." Creative Commons photo by Nheyob.

of the Mass. The coloristic panels, featuring figures clearly defined in a decorative range of saturated blues, gold, and reds, are unified by a choir of white-robed angels across the top. One local commentator called it "the greatest church decoration in America."[23] It is inscribed, "in Memory of his Mother, Katherine Siemers Duveneck, dedicated by the artist Frank Duveneck." Barnhorn, for his part, created all of the sculptural decorations for the central facade of this important new cathedral.

Duveneck died of cancer at age seventy-one. His funeral was held at the cathedral on a wintry morning in January 1919, when his body lay in a casket covered with a blanket of oak leaves; newspaper reports noted that a facsimile of his artistic signature had been created in red flowers in the center. Barnhorn was among the grieving former colleagues and students who acted as pallbearers. Only Duveneck's son, a Harvard-educated engineer then serving as a radio officer in the U.S. military in France, was absent.[24]

By retreating to Cincinnati after his wife's death, Duveneck had removed himself from the East Coast center of the American art world, yet he was now cited as one of the most important American artists of his time. The many encomiums published after his death mentioned the national honors finally bestowed on Duveneck in his late years: these included a gold medal of honor in 1915 at the Panama-Pacific International Exposition in San Francisco, where a cast of the Elizabeth Boott Duveneck Memorial was displayed at the center of a gallery devoted entirely to his works (Figure 52). Obituaries often recalled his "magnetic" personality, and he was described by critic Royal Cortissoz as "a personality born to excite sympathy and devotion."[25]

After Duveneck's death, family and friends expressed a wish to complete the sculptural memorial he had once planned for his mother, but this time as a memorial to the artist himself. Barnhorn was given the task of executing it. It consists of a massive block of Red Warsaw stone, with bronze angels, wings spread wide, at each of the four corners (Figure 53). They represent Faith, Hope, Charity, and Resurrection. One angel holds a Chi Ro sign (the first two letters of Christ's name), another a tablet reading "surrexit non est hic" (from

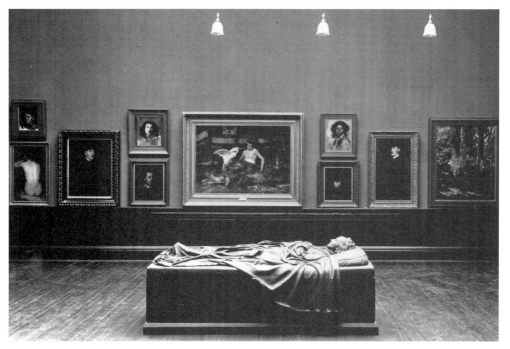

the biblical phrase "he is not here"; he is risen). A third angel (the only one who appears to be female) holds a heart in one hand and gently touches the stone memorial with her other, while the fourth angelic figure holds one hand to his forehead, gathering the material of his cloak before his body with the other hand. The monument is located in Mother of God Cemetery in Latonia, Kentucky, where Duveneck's devoted students and friends gathered annually, and where admirers still gather, to express their abiding affection for his generosity of spirit and contributions to Cincinnati art.[26] A Crucifixion group composed by Barnhorn earlier, in 1915, stands nearby on a high base, overlooking the tomb and the cemetery.[27]

Duveneck had retained much of his own artwork and actively reacquired some that he no longer owned. He left all of this, in addition to the plaster of Lizzie's tomb, to the Cincinnati Art Museum, where he had served as a consultant, extending his realm of influence by actively helping to direct its acquisitions.[28] A palm frond like the one gracing Lizzie's tomb was used on the frontispiece of the catalogue for the museum's retrospective exhibition, held in 1919, after Duveneck's death.[29] Photographs show that the plaster of the Elizabeth Boott Duveneck tomb was again placed in a central position, in a room surrounded by his paintings. In his late career, and with his death, his productions for the cemetery thus were interpreted as requiems to the artist himself and to his expression of personal emotion. This would be true in the cases of Augustus Saint-Gaudens and Daniel

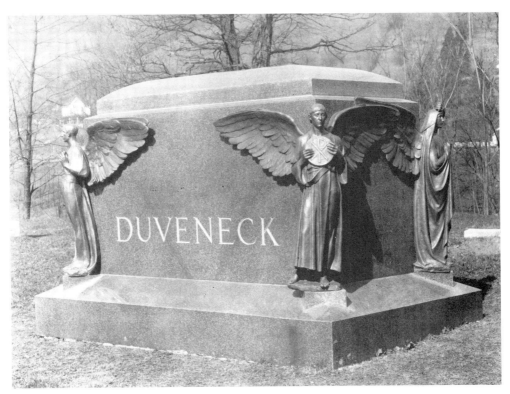

Figure 53.
Clement Barnhorn, Tomb of Frank Duveneck, ca. 1923. Mother of God Cemetery, Latonia, Kentucky. Photo by Sean McCormally.

Chester French as well as for Duveneck, and especially for William Wetmore Story. The meanings of the memorials shifted with the decades, and they became monuments as much or more to the artists who had made them as to the deceased whose graves they marked. It was a strange thing that funerary sculptures, intended by their patrons to seal a vivid wound, ultimately became monuments instead to their creators, the sculptors. There were many reasons for this, but, as it turns out, French would play an important part in shaping this new attitude.

ELEVEN

THE CEMETERY
IN THE MUSEUM

Over the years, Daniel Chester French (Figure 54) had learned to organize large civic proj-
ects in collaboration with other artists and architects, taking bids, managing budgets, and
persuading patrons and committees to lend their support. Despite his occasional private
complaints, he gained a reputation for being a mild-mannered professional who worked
harmoniously with others, as well as attaining renown for his skill and excellent judgment
in design and execution. He generously participated in a number of artistic organizations,
especially after performing his central role in the 1893 world's fair, which added greatly to
his network of associates. Later his Lincoln Memorial figure in Washington, D.C., confirmed
his status, making him the major public sculptor of his era after the death of Saint-Gaudens.

French ultimately used his nexus of connections to become an ambassador for con-
temporary American sculpture and, in a parallel development, for funerary sculpture in
the United States, through his decades of work with the Metropolitan Museum of Art in
New York. While the museum had an initial collection of neoclassical sculpture, prominently
including William Wetmore Story's dramatic *Medea* and *Cleopatra*, and increased its acqui-
sitions in number and stylistic variety in the late nineteenth century with the aid of such
artist-consultants as John Quincy Adams Ward, French greatly influenced its holdings after
his election as a trustee and chairman of the museum's Committee on Sculpture in 1903. Ac-
cording to sculpture curator Thayer Tolles, French was almost single-handedly responsible
for the acquisition by the museum of its substantial core collection of American bronzes in
the early twentieth century. Under French and with the aid of an important bequest from
Jacob S. Rogers, a member of the museum who died in 1901, the Metropolitan established
the single most influential collection of contemporary American sculpture, with key exam-
ples from all major sculptors.[1]

The museum began acquiring plasters of essential pieces, with the idea that it would
later commission bronze casts or marble carvings of some of these works. French considered

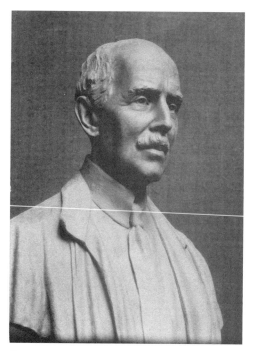

Figure 54.
Margaret French Cresson, bronze bust of Daniel Chester French, 1933.
Courtesy of The Chesterwood Archives, Chapin Library, Williams
College, gift of the National Trust for Historic Preservation and Chester-
wood, a National Trust Historic Site in Stockbridge, Massachusetts.

key cemetery sculptures to be suitable for inclusion in the contemporary collection as well as in exhibitions. In 1908 he also played a central role in organizing an ambitious retrospective exhibition of 154 works by Augustus Saint-Gaudens after the celebrated sculptor's passing, and the Metropolitan arranged with Henry Adams for a cast of the Adams Memorial to be created and loaned to the museum for inclusion in that show. Due to Adams's great desire for privacy, this was the first major public exhibition of the Adams monument outside the cemetery, a situation very different from the extensive earlier showings of the Duveneck and Milmore memorials.[2] The sculpture became, in effect, a memorial to Saint-Gaudens in the art world.

Saint-Gaudens had died August 3, 1907, at age fifty-nine at his country home in Cornish, New Hampshire, after a long, painful battle with cancer. Tragically, his close friend and associate Stanford White had been murdered in Madison Square Garden just the year before. Harry Thaw, the millionaire husband of White's mistress, shot the architect in a jealous rage, and the sensational trial that followed, ending in a deadlocked jury, only deepened Saint-Gaudens's depression during his struggle with illness.[3] In his final years, he investigated the image of Jesus Christ in several of his projects, including a memorial to the Episcopal minister Phillips Brooks at Trinity Church in Boston, developing a new personal introspection about Christianity. His last funerary sculpture design, which was completed by assistants in 1911, was a seated Christ flanked by two bas-relief angels, created for the family gravesite of the wealthy banker George Fisher Baker in Valhalla, New York.[4] A death mask made by plaster caster Gaetan Ardisson at the time of Saint-Gaudens's passing documents the decline and great suffering of this once robust and beloved artist (Figure 55).[5]

After the sculptor's remains had been taken to Mount Auburn Cemetery for cremation and then carried back to Cornish by his son Homer, a private funeral service was held in the small studio at Cornish. Unitarian minister Oliver B. Emerson, the artist's brother-in-law, read a prayer by Robert Louis Stevenson that appears on a monument Saint-Gaudens designed: "Give us grace and strength to forbear and to persevere. Give us courage and gaiety and a quiet mind." Artist Kenyon Cox told the hushed assembly of family and friends that while Saint-Gaudens had professed no specific religious creed, "he believed in the universal God

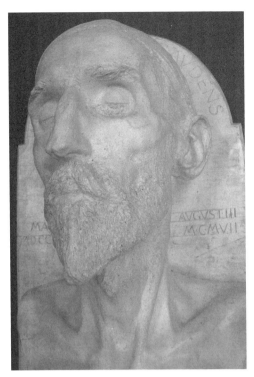

Figure 55.
Gaetano Ardisson, Death Mask of Augustus Saint-Gaudens, *1907. U.S. Department of the Interior, National Park Service, Saint-Gaudens National Historic Site, Cornish, New Hampshire.*

Figure 56.
Saint-Gaudens family tomb, 1914. Marble. Saint-Gaudens National Historic Site, Cornish, New Hampshire. Photo by Cynthia Mills.

and was a God-inspired man." The service in the studio, accompanied by organ music, was decorated with "many beautiful floral emblems," the *Boston Herald* reported.[6] At his wife Augusta's wish, the classical temple and altar and the two Ionic columns that had figured as a stage set for a pageant (known as the Masque of the Golden Bowl) held at Cornish in 1905 in Saint-Gaudens's honor were eventually re-created in white Vermont marble as the family sepulcher (Figure 56).[7] The temple is located in a secluded area on the grounds of the Cornish estate, which Saint-Gaudens had named Aspet after his father's native village in France. It is decorated with classicizing emblems such as eagles, garlands, and ram's heads, and the words "In Memoriam Augustus Saint-Gaudens" and "Beati Mortui Qui in Domino Moriuntur Anodo Iam dicit Spiritus ut requiescant a laboribus suis opera enim illorum sequuntur illos" (Blessed are the dead who die in the grace of the Lord. Yes, says the spirit, that they may rest from their labors and their good works follow them; Revelation 14:13).[8]

With Saint-Gaudens's death, the early sensitivity about the display or reproduction of the Adams Memorial ended. The sculpture was pictured and described repeatedly in the spate of public praise for the late sculptor's work, integrity, courage, and patriotism. The image of the Adams monument, now disassociated from Marian Adams's death and Henry Adams's decades of mourning, was even placed on the cover of the program handed out at a large memorial gathering honoring Saint-Gaudens, at New York City's Mendelssohn Hall on February 29, 1908. Mayor

George B. McClellan gave the keynote speech at the memorial meeting, which was held just before the gala March 3 opening of the retrospective exhibition of the sculptor's works at the Metropolitan Museum of Art. Hailing Saint-Gaudens's abilities, the mayor commented that the "inscrutable and wonderful" statue in Rock Creek Cemetery, standing apart in its mystery from his other work, was masterful enough to have won him celebrity on its own without his many other achievements.[9]

For his part, Henry Adams began deferring to Augusta Saint-Gaudens, who made it her mission to spread the fame of her deceased husband's works and to personally control their display and reproduction. When Metropolitan Museum of Art official Edward Robinson formally requested Adams's permission to have the plaster cast made of the cemetery monument for the 1908 Saint-Gaudens retrospective, Adams quickly agreed out of a desire to honor his late sculptor-friend.[10]

The New York retrospective exhibition of Saint-Gaudens's work was hailed as the largest display ever of one American sculptor's works staged to date. An aging Adams's only condition for including the plaster cast was that it bear no allegorical title like "Grief," which the media had insisted on attaching to it. To strengthen his view that such a title would dilute the monument's power in suggesting the mystery of death, he now stated that it would dishonor Saint-Gaudens's intentions. He wrote to Robinson in January 1908: "Do you think it necessary to tag poor St Gaudens' work when he did not? My notion of it is that he meant it to ask the question,—like the Sphinx,—and that he wanted to leave the riddle to be answered by each individual. . . . [A]t all events, for the salvation of your soul, do not inflict on it the usual names of newspapers." The plaster finally was shown with the title *Adams Monument, Rock Creek Cemetery, Washington, D.C.* A note in the exhibition catalogue added, "The figure has been variously interpreted, although Saint-Gaudens gave no name to it."[11]

The retrospective drew tens of thousands of visitors, who had the opportunity to see the Adams figure displayed along a side wall flanked by greenery. There was some criticism, however, that the sculpture was decontextualized in the museum show, in which the pieces were arranged more or less chronologically. The experience of a personal pilgrimage to the cemetery was lost, as was the Stanford White stonework. Writer Royal Cortissoz commented that the work appeared at a "distinct disadvantage" without its natural setting, saying, "It would have been wiser to have shown this masterpiece in an immense photograph." Augusta Saint-Gaudens also was unhappy with the Metropolitan exhibition, especially since the Adams monument was displayed on a raised platform when she felt it was meant to be viewed at eye level as at the cemetery. She had architect Glenn Brown take charge of installing the retrospective when it traveled to the Corcoran Gallery of Art in Washington, D.C., in late 1908 (Figure 57) and then the Carnegie Institute in Pittsburgh, Art Institute of Chicago, and John Herron Art Institute in Indianapolis in 1909.[12]

President Theodore Roosevelt and ambassadors from a number of nations spoke at the black-tie opening of the Washington exhibition in December 1908, attended by some two thousand of the capital city's elite. At the Corcoran, the plaster cast was shown between two

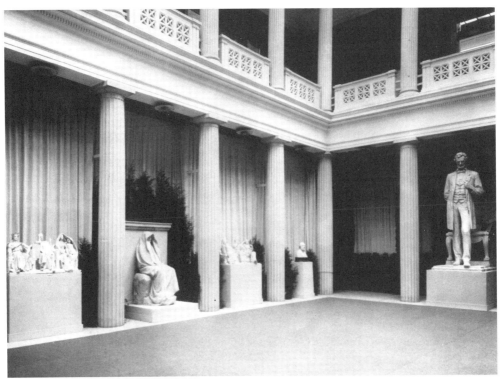

Figure 57.
Cast of the Adams Memorial on display at the Corcoran Gallery, Washington, D.C., during retrospective exhibition of the work of Augustus Saint-Gaudens, 1908. Augustus Saint-Gaudens Papers. Courtesy of Dartmouth College Library.

Doric columns, with cypress plantings creating a separate environment for it, and a green grass mat on the floor.[13]

The plaster cast shown in these retrospectives eventually was donated, along with a number of others, to the Saint-Gaudens Memorial, a kind of museum established by Augusta Saint-Gaudens at the family estate at Cornish, now administered by the National Park Service. It remained there until it was destroyed in a 1944 fire.[14] Though the Metropolitan Museum under French took steps to acquire other works by Saint-Gaudens, now holding an important collection second only to the one at Cornish, it was never able to acquire a cast of the Adams tomb for its permanent collection.

○

In 1918 funerary works by Saint-Gaudens, French, and Duveneck were displayed at a major exhibition of American sculpture at the Metropolitan Museum, spurring a new wave of interest in these achievements. French had arranged for the museum to acquire a plaster of the Elizabeth Boott Duveneck tomb, cast from one at the Cincinnati museum.[15] Plasters of the Adams Memorial, Saint-Gaudens's *Amor Caritas*, and French's own *Angel of Death and the Sculptor* were also shown at the 1918 exhibition, which led to critical comparisons of the

three artists' most famous funerary work.[16] The *New York Times*, for example, called French's Milmore opus "magnificent" and noted the presence of Saint-Gaudens's Adams Memorial. It devoted the most attention to the Duveneck tomb, however, saying, "A beautiful figure, which occupies the centre of one of the galleries, is Frank Duveneck's 'Recumbent Figure of Mrs. Elizabeth Booth [*sic*] Duveneck,' for a sarcophagus, with a sweet young face, which has the appearance of sleep. Upon the full draperies rests a large palm."[17] In the museum, the monuments were separated from the grim reality of bodies resting below in the cemetery, and comparisons proved inevitable.

Arts writer Adeline Adams compared and contrasted the Adams and Milmore memorials in her more extended discussion for the Metropolitan Museum's own *Bulletin*, writing:

> In the two great memorials, one by Saint-Gaudens, one by French, the spectator notes two different, yet two equally lofty ways of meeting and interpreting the great mystery. The Rock Creek figure, almost Oriental and fatalistic, supremely truthful in theme as in handling, holds out to the passer no promises which may never be performed, and neither affirms nor denies for him whatever faith may be in him. She remains aloof, unfathomed, a subject for endless conjecture, while the Milmore angel, scarcely less majestic, draws nearer to our common humanity because she offers an infinitely consoling answer to our human questionings.[18]

The Duveneck tomb's clear continuity of tradition with Renaissance forms and portraiture contributed to its being admired by critics and sculptors alike in museum settings. By 1925 writer Francis Hamilton commented in *International Studio* that recumbent mortuary sculpture in general had been wrongly neglected by writers and the American public. Describing the Duveneck Memorial, he asserted, "It may be considered heretical to say so but I call this effigy infinitely more touching than the more famous Adams memorial figure by Saint-Gaudens in the Rock Creek Cemetery in Washington. In that work Saint-Gaudens appeared to say, 'Behold I tell you a mystery,' and his mystery appears to have any solution the beholder chooses. But in the case of the Mrs. Duveneck figure devotion was its spring and devotion remains its dominant effect. In that lies one of its perfections."[19] As we shall see, the work by Saint-Gaudens and French, however, went on to gain much greater popular awareness and recognition through photographs and pilgrimages, as did ultimately the grieving angel of William Wetmore Story, which apparently was never shown in a museum setting but gained its own following via photographs and copies found in American cemeteries.

While Saint-Gaudens had died at fifty-nine, French worked on nearly until his death at age eighty-one, and continued to be instrumental over the decades in the Metropolitan Museum's acquisitions, including additional works by Saint-Gaudens.[20] Once a genteel rival, French helped cement his colleague's career as well as that of Duveneck.[21] Meantime, a marble version of French's own Milmore Memorial, dated 1929, was commissioned by the museum trustees and was carved by the Piccirilli Brothers. French had become a major maker of funerary monuments himself and the most famous sculptor of angels in America. His *Mourning Victory* from the Melvin Memorial in Sleepy Hollow Cemetery, Concord, Massachusetts (1908;

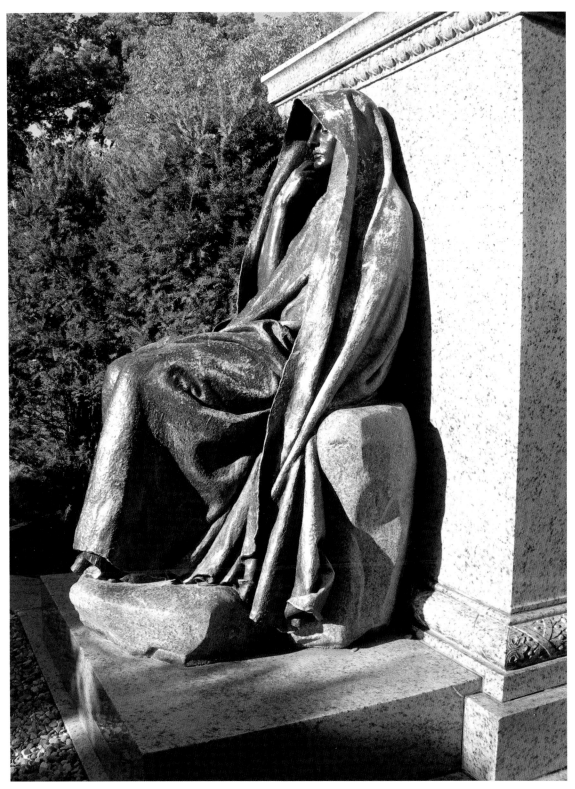

Plate 1.
Augustus Saint-Gaudens, The Adams Memorial, 1891. Rock Creek Cemetery, Washington, D.C. Photo by Cynthia Mills.

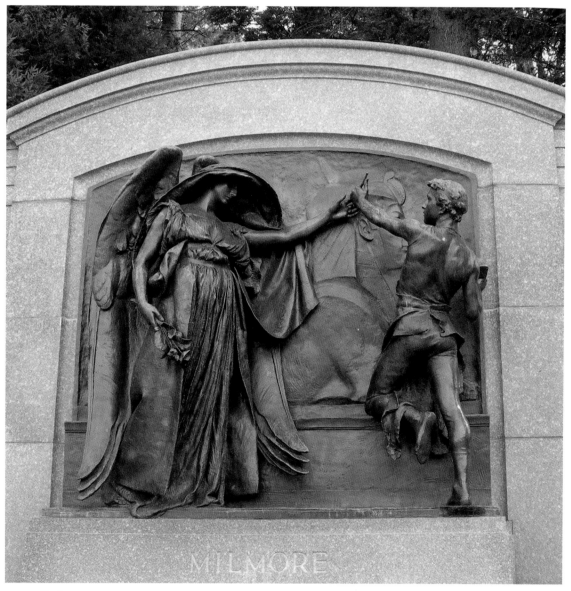

Plate 2.
*Daniel Chester French, The Milmore Memorial (*The Angel of Death Staying the Hand of the Sculptor*), 1892. Forest Hills Cemetery, Boston.*
Photo by Cynthia Mills.

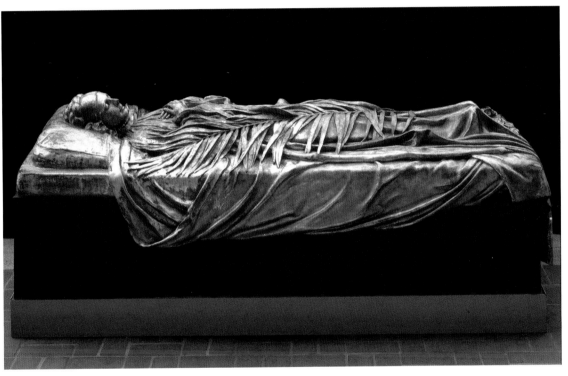

Plate 3.
Frank Duveneck, Tomb Effigy of Elizabeth Boott Duveneck. Bronze and gold leaf, cast in 1927 for the Metropolitan Museum after the artist's 1891 design for the Cimitero Evangelico degli Allori, Florence, Italy. Image copyright © The Metropolitan Museum of Art. Image source: Art Resource, NY.

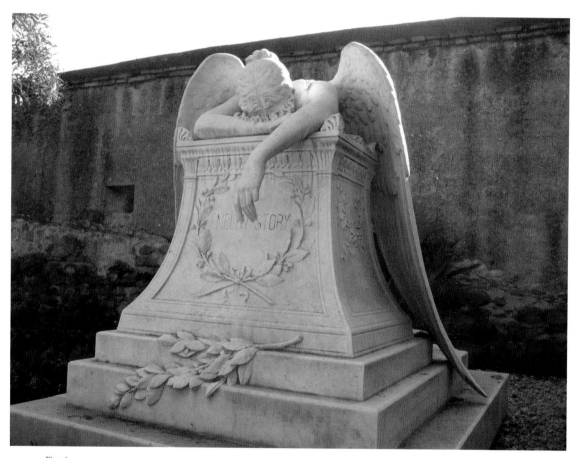

Plate 4.
William Wetmore Story, Angel of Grief Weeping Bitterly over the Dismantled Altar of His Life, *1894. Protestant Cemetery, Rome. Photo by Sean McCormally.*

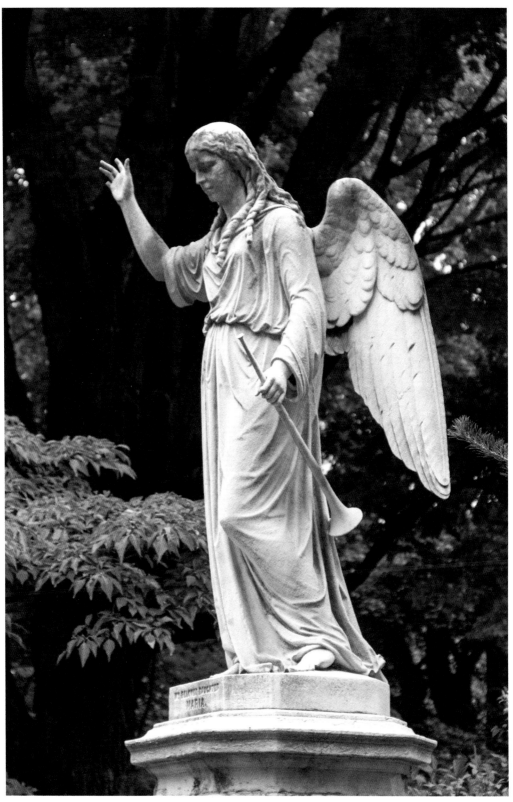

Plate 5.
Martin Milmore, Coppenhagen Monument, 1874. Mount Auburn Cemetery, Cambridge, Massachusetts. Photo by Frank J. Conahan.

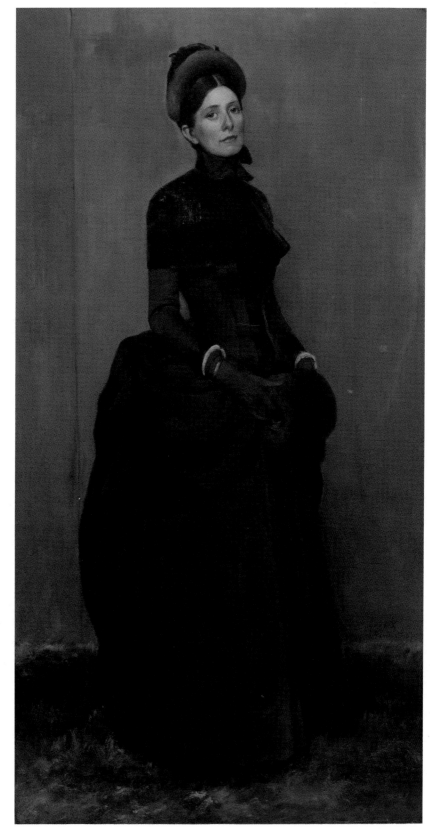

Plate 6.
Frank Duveneck, Elizabeth Boott Duveneck. *Cincinnati Art Museum, Gift of the Artist, 1915.78.*

Plate 7.
Augustus Saint-Gaudens, Hamilton Fish Memorial, 1892. St. Philip's Churchyard, Garrison, New York. Photo by Anthony Badalamenti.

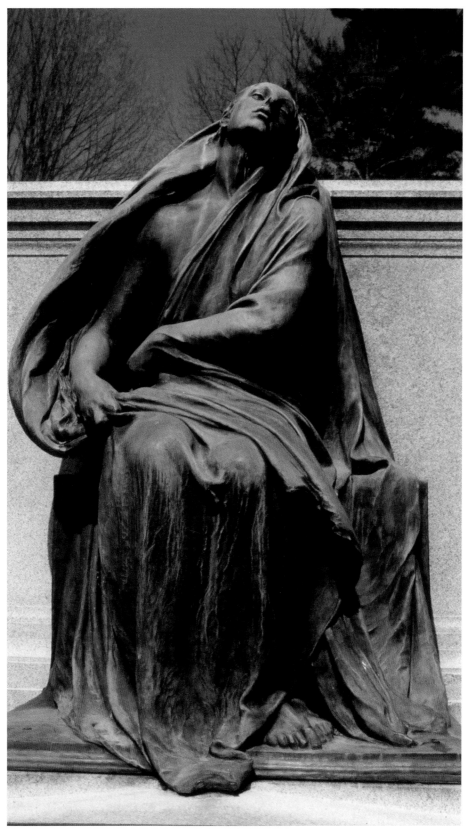

Plate 8.
Karl Bitter, Hubbard Memorial, 1902. Green Mount Cemetery, Montpelier, Vermont. Photo by Sean McCormally.

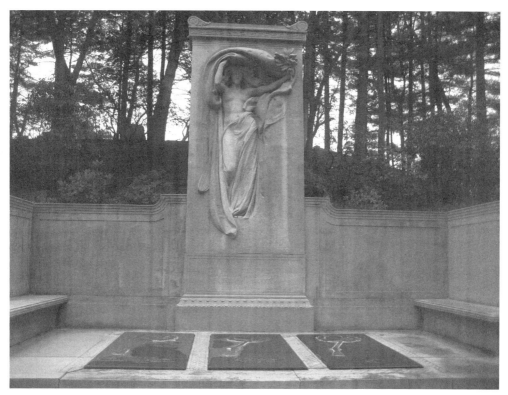

Figure 58), a majestic sunken relief honoring three brothers who died in the Civil War, is also represented in the collection by a 1915 marble carving. Today versions of the Milmore Angel of Death, the Melvin Memorial, and the Duveneck Memorial share space in the Metropolitan Museum of Art sculpture court along with Saint-Gaudens's *Amor Caritas*, which evolved from the Morgan tomb project, making the museum one of the major fine-art centers for American funerary sculpture. These sculptures and others like the Marshall Field Memorial in Chicago and George White Memorial in Boston completed by French helped to inspire an evolving interest in museum-quality symbolic figures created by fine artists in cemeteries.

A letter that French sent his friend Abbott Handerson Thayer in 1916 offers some insight into his feelings about the comparative qualities of his sculptures and those of Saint-Gaudens, which had attracted the greater praise to date. French acknowledged that critics often found his own work to be "placid." But he added, "As to your comparison of Saint Gaudens and me, our work is so very different that it does not seem to me that any comparison is possible. I fear that posterity will not put me very near him, but I am sure posterity will find eternal pleasure in his work and I hope some discerning people will find something agreeable in some of mine." French continued, "[I]t strikes me as a new idea [by Thayer] that he was too realistic or adhered too closely to nature. It is too long a subject to discuss

by letter and I think I do see what you mean, but it is odd that I have thought that, if there was a defect in him, it was that he was somewhat too intent upon making a thing artistic and, in his conceptions at least, thought too much of the great things that had preceded him."[22]

French died in October 1931, and funeral services were held in the studio at his country estate, Chesterwood, in Stockbridge, Massachusetts, set against the hills and fields he had loved. Episcopal ministers read the 23rd and 121st Psalms, beginning "The Lord is my Shepherd" and "I will lift up mine eyes unto the hills," and the soprano Rosalie Miller sang "Rest in Peace" by Franz Schubert and "Twilight and Dawn" by Oley Speaks. One studio wall was banked with hemlocks, and a white plaster model for French's winged figure *The Genius of Creation* stood with arms stretched over his coffin, draped with gray velvet and a wreath decorated with sculptor's tools. French's ashes were buried at Sleepy Hollow Cemetery in Concord, Massachusetts, not far from his Melvin Memorial and the graves of Emerson, Thoreau, and the Alcotts, who had influenced his youth.[23] His grave is marked by a simple stone slab with a garland of leaves and the words "A Heritage of Beauty," a memorial similar to one he had designed for his brother's tomb in Chicago after William's death in 1914.[24] Visitors leave pennies with the Lincoln Memorial on them in the garland.

With the passing of French, Saint-Gaudens, and Duveneck, the memorial art they had realized became a requiem to the artists as well as to the persons whose legacy they had been commissioned to secure. Yet it is to these heights of artistic memorialization that other patrons aspired, also wanting to join this league of the American Medicis who commissioned exceptional cemetery decorations.

Each man had contributed to the growth of interest in this form in fine-art circles. In the early years of the twentieth century the appeal of such celebrated, custom-made memorials attracted a new clientele. Artists were happy to expand their work into this realm, long honored in Europe. It was an opportunity to make ideal sculpture at a time when most public monuments still demanded a variant of naturalistic portraiture or decorative aestheticism. Designs for mortuary art began to appear more frequently in fine-art exhibitions, such as those of the National Sculpture Society, as well as museum settings. For example, a plaster of French's Marshall Field Memorial was prominently exhibited at the Architectural League show in New York. Karl Bitter exhibited his funerary sculpture widely, showing his Hubbard and Villard memorials a few feet from each other at the National Sculpture Society's *Flower & Sculpture Exhibition* at New York's Madison Square Garden in November 1902. By April 1908 a Sculpture Society exhibition in Baltimore included models, variants, or photographs of work destined for cemeteries by Louis Amateis, Edward Berge, Bitter, Ephraim Keyser, Evelyn B. Longman, and Hans Schuler, among others.[25] The campaign for improvement of cemetery sculpture continued in the years leading up to and immediately following World War I, when Adeline Adams reminded members of the American Arts Federation of the importance of memorial art throughout history, declaring, "We have said that taste and the tomb are often at odds, but let us remember that some of the most precious things of beauty shrined in our Museums were made for tombs and nothing else."[26]

PART FOUR

GRIEF AND
COMMERCE

TWELVE

PUBLIC SORROW

In 1901 an anarchist named Leon Czolgoz walked up to President William McKinley at a reception in the Temple of Music at the Buffalo world's fair, his hand wrapped in a cloth to conceal the pistol he carried. He fired two shots point-blank, striking the president's chest and abdomen. While at first it appeared that McKinley might survive the wounds, his condition worsened after emergency surgery, and he died a week later, at 2:15 a.m. on September 14. As a shocked nation awoke to the news, a Danish immigrant named Eduard L. A. Pausch (1856–1931) was summoned to take a plaster impression of McKinley's lifeless face, creating a historical record of his features. Pausch was a modeler of cemetery memorials and portrait monuments who had worked for a decade with a New England granite company. He had studied with several minor sculptors, including Karl Gerhardt (1853–1940), a Paris-trained artist who had made the death mask of General Ulysses S. Grant.[1] In Buffalo, Pausch thus offered his expert services to McKinley's retinue and was paid $1,200 to make the plaster mask, which he spent a month perfecting in his studio, placing it in a safety deposit vault each evening for security's sake.[2] Based on his personal measurements of the president's head, he created not just a cast of his face but an entire head, which weighed twenty-five pounds (Figure 59). It was sent to the Smithsonian Institution, which already held plaster impressions of Abraham Lincoln's face. Due to the omnipresence of photography in the new age of Kodakers and the increasing ease of recording a person's appearance, interest in the death-mask format would wane in the twentieth century. But Pausch took great pride in his achievement, which he hoped would dramatically advance his career.[3] When possible, sculptors used masks and measurements of famous men as the basis for scientifically accurate likenesses in portrait statues. Augustus Saint-Gaudens had considered an 1860 life mask of Lincoln, made by Leonard Wells Volk, to be so important that he joined a group of thirty-three elite citizens who purchased it as a gift to the U.S. government, selling bronze casts of the original to fund the donation. Saint-Gaudens used the cast as well as photographs as a basis for his highly regarded monument to Lincoln in Chicago, and he used another of James Garfield in making his Garfield Memorial in Philadelphia.[4]

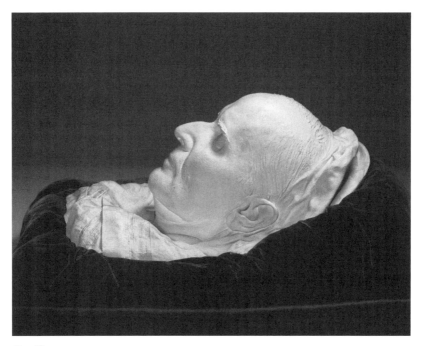

Figure 59.
Eduard Pausch, Death mask of President William McKinley, 1901. Division of Political History, National Museum of American History, Smithsonian Institution.

Pausch went on to make a bronze monument of McKinley in Reading, Pennsylvania, and a bust of McKinley for the Philadelphia post office, which he could claim to be authentic in appearance. With his combination of technical skills and studio training, he described himself as a "figure and ornamental sculptor" and worked across the blurry line that distinguished a skilled artisan from high-art sculptors such as Saint-Gaudens or Daniel Chester French, who were sought after for the most expensive and visible public commissions. While Pausch aspired to gain monumental commissions, he never matched the more famous sculptors' skills nor displayed his work at fine-arts exhibitions such as the National Academy of Design or National Sculpture Society in New York. Rather, he remained an active participant in the commerce of the granite, monument, and deathways industries, where notions of originality and genius were often less important than issues of function, customer satisfaction, and cost. In a letter sent a few years later to Metropolitan Museum of Art curator Edwin Elwell, who was collecting information about contemporary American sculptors, Pausch noted that he had had a "plain" career, built on "hard study and work." An early commission for a cemetery monument "brought me in that channel or class of work," he explained.[5] Pausch's ideas about cemetery memorials as both business and art, demonstrations of artistic talent and objects suitable for multiple reproduction, differed, if sometimes only in degree, from those of Saint-Gaudens, French, and William Wetmore Story. Over time, his mask became one source for a number of honorific public sculptures of President McKinley. His angels

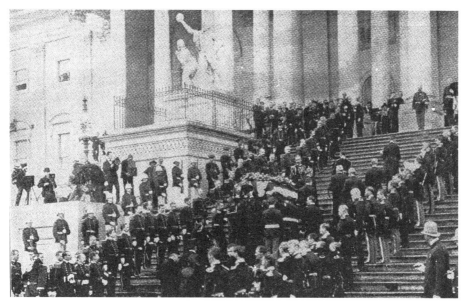

Figure 60.
President McKinley's casket is borne up the steps of the U.S. Capitol as cameramen at left film the scene. Photo from Murat Halstead, The Illustrious Life of William McKinley, Our Martyred President, *1901, p. 400.*

and crosses for cemeteries also multiplied. Sculpture in multiples constituted an important part of the American system of memorialization.

The old modes of memory work, like Pausch's death mask, intersected with more modern methods at the time of McKinley's assassination, as mass-media publications rushed photographic images surrounding the president's death to print, and Thomas Edison's company recorded the grand rituals around his funeral and subsequent interment with a new technology: motion picture film. Due to advances in printing and transportation systems, the grieving public all across the country was able to view photographic images of memorial events with a greater immediacy and volume than ever before. Artists' illustrations, not photographs, had been most widely circulated after the deaths of Lincoln and Garfield. Now, photos of McKinley's body being borne up the steps of the Capitol (Figure 60) and lying in state in the White House, of memorial services decorated with elaborate floral bouquets, and of the holding vault where the president's corpse was placed were among the many visual aspects of his passing that could quickly be featured in daily newspapers and national photogravure magazines. This was made possible by the halftone process of mechanical reproduction, which since the late 1880s had enabled photographs to be included alongside text on printed pages, and also by the national distribution systems that had flowered. The steady expansion of the steam-powered railroad and shipping lines worked a transportation revolution that permitted periodicals as well as other products to be shipped across vast geographic distances in ever-shortening times.

With the rise of the motion picture, the multiple funeral processions were also captured by the Edison Company's cameras—first in Buffalo, where the president died at the

Pan-American Exposition; then in Washington, D.C.; and in his hometown of Canton, Ohio, where pallbearers removed his flag-draped casket from a railroad car. Finally, the cameras followed his hearse on its journey to the cemetery. Edison's cameramen made eleven short films in all of the events surrounding McKinley's death rites, from a variety of camera angles. At the opening of the twentieth century, these were sold in packages to theaters, which showed them together with other shorts and motion pictures.[6]

McKinley was treated with considerable respect in death, as an American martyr. One artist's illustration from the era shows him entering the "Hall of Martyrs" already occupied by Presidents Lincoln and Garfield, guided by allegorical figures depicting the nation's North and South. Henry Adams's friend John Hay, who had formerly served as Lincoln's secretary, delivered a eulogy before the U.S. Congress. A grand mausoleum was built to house McKinley's remains, an edifice that is still the pride of Canton, Ohio.

His passing certainly represented a unique tragedy of national dimensions. Yet the coincidence of advancing technology, a growing mass media, a more rapid and broad chain of distribution, and an attentive national audience exposed to a new wave of imagery—all observed in the public response to the president's demise—would have an impact on wider expressions of mourning at the turn of the century. American memorialization was becoming less local and private than before. It was becoming big business. All of these developments— aspects of the increasing connectedness of things—added another element, an element of risk, to the selection of funerary memorials. Issues of morality and propriety of behavior, of good taste, and even of the soundness of financial decisions made at this time of private grief and loss became more visible—and more subject to potential critique or appropriation in an era of easy communication.

While elite patrons, museums, and expert critics came to embrace figurative bronze funerary monuments as important works of high art, appropriate for the museum as well as the cemetery, the greater world around them was changing. Decisions about memorialization were more readily susceptible to expressions of public judgment separate from specialist opinion. Readers accustomed to the strategies of mass-media publishing and advertising, and audiences familiar with the spectacle of motion pictures and vaudeville were trained in new modes of viewing and consumption involving curiosity and skepticism. The rapidly growing American press had adopted aggressive strategies for building circulation, featuring gossip and "personals," celebrity interviews, and many human interest stories.[7] In the more questioning, less polite discourse of the vernacular culture, humor and the grotesque were devices used to puncture the rich and the pompous. The rising commercial culture also worked a change on attitudes about what constituted value in modern times and how to avoid the shame of an overly sentimental, emotional, or grandiose response to death. The new monuments were not always viewed with the reverence intended. Instead, rude or romanticized counternarratives could arise, resisting and even inverting the patrons' and artists' goals of erecting an enduring legacy of restrained nobility in bronze and stone.

In a graveyard—which was a quasi-public place—how could a family ensure that its monument would attract dignified respect and not be subject to derision? Mistakes of cost expended and taste misjudged could subject the patron and the deceased to ridicule. This was particularly true for the wealthy, whose missteps—especially attempts at grandeur—were special fodder for a pitiless press, which loved to lampoon the pomposity of the rich in this era of rapid economic growth and frenzied speculation.

At the turn of the century, monument making was a multimillion-dollar industry. Purchasers, presented with an expanding array of choices (Figure 61), needed to determine which decisions would be rewarded by an enduring tribute and which might lead down the path of public shame. Shame involved a denial of honor and dignity at just the moment when these goals seem most poignant and important after a personal loss. Shame is not much discussed in the twenty-first century (in fact, some have talked about the death of shame), but it was a crucial concern for patrons at the turn of the twentieth century. A strong desire to avoid errors of taste influenced the course of vernacular and fine-art memorialization in cemeteries. Salesmen and artists alike exploited these concerns in their transactions with prospective patrons, who wanted to do the right thing for their loved ones.

Just after the year 1900, selection of a simple grave marker was no longer a decision necessarily made in a face-to-face encounter with a nearby stone dealer who might carve the monument locally. Rather, suppliers ranged from import companies to large domestic

Figure 61.
A. W. Ayers. Trade card for monuments and mantels, *Elmira, New York, ca. 1883. Courtesy, The Winterthur Library: Joseph Downs Collection of Manuscripts and Printed Ephemera, Winterthur, Delaware.*

monument firms, which were associated with quarries in places like Westerly, Rhode Island, and Barre, Vermont, to the mass-produced inventory advertised in Sears Roebuck & Co. mail-order catalogues, or a more selective, customized array of crosses, ledger monuments, and mausoleums offered by Tiffany Studios. All of these spoke in terms of high-quality memorial "art," but many of them offered stock designs such as angel number 123 and lettering no. M44 to choose from with examples pictured in catalogues or displayed in showrooms.

Well-to-do or high-status individuals like William Vanderbilt II often chose grand sarcophagi or the security of the mausoleum, especially after thieves stole department store mogul A. T. Stewart's corpse from a Manhattan churchyard in November 1878. "The Grave-Yard Robbery" case was front-page news for thirteen straight days after its discovery, and the search for the "Ghouls" or "Resurrectionists" who took Stewart's body became a matter of wide public lore.[8] These elite patrons favored classicizing, medieval, or Egyptian styles for their mausoleums, sometimes selecting the same architects and contractors who had created their homes in life. Or they selected customized stone monuments or figurative sculptures in stone or bronze that afforded them a greater individual identity than the less privileged. Their monuments were on bigger lots, often more prominently placed, adding to a sense of class stratification in the cemetery. But with any of these, wealthy patrons sometimes unintentionally became the butt of public humor. In their book *The Gilded Age*, Mark Twain and Charles Dudley Warner had punctured the greed and pomposity of this period of vast new wealth; they lampooned the years after the Civil War as an era when a thin layer of gold veiled a society characterized by materialism, inequality, waves of immigration, and the drudgery of industrial labor. In the cemetery, excess of cost, excess in the amount of stone piled up (sometimes to gigantesque heights), or excess of sentimentality in the epitaph or figure could cross the fine line from sparking tribute to inspiring jokes. Monument firms concerned with profit margins encouraged patrons to use the greatest possible amount of stone, as if more stone signaled greater virtue on the part of the deceased. This seems to have been true in the case of *Hope, Faith and Charity*, a colossal monument constructed by prosperous businessman William Hoyt in Chicago's Graceland Cemetery after the death of his daughter and her three children in a theater fire in 1903.[9] Or consider the towering Corinthian column in the same cemetery erected to George Pullman, inventor of the Pullman sleeping car, whose body was placed in an elaborate concrete bunker beneath to ensure that it was never vandalized or stolen. Pullman's family had feared retaliation after a bitter 1894 strike over workers' wages and rents. But the excessive security around his monument became the topic of ironic commentary in guidebooks and newspaper accounts from the early days.[10] High security also was required around the graves of such moguls as Jay Gould, who was entombed in an Ionic temple on a large swathe of land in New York's Woodlawn Cemetery as a crowd of idlers looked on, making "irreverent chatter."[11] Newspapers reported that Gould was carried from his home, also surrounded by onlookers, to the cemetery in an "extremely plain hearse" accompanied by eight carriages, and his mausoleum bears no name on the outside, to avoid attracting the wrong sort of attention. Similarly, the magnificent mausoleum in the

form of a classical temple built by the Stanford family in California after the death of their son drew ridicule as well as respect, with the *Los Angeles Times* commenting at one point that it was a monument not only to "a very commonplace youth" and the grief of his parents, but also to "the vanity which prompted them to believe that they could render a name immortal that represented but a few years of a life interesting to them alone."[12] The Adams Memorial itself was sometimes dubbed a monument to "despair" or more commonly "Grief," in the media, breaching Henry Adams's desires for reverent contemplation and privacy.

Newspapers always questioned the equity of memorial expenditures, noting, for example, the oddity of the situation when Cleveland millionaire H. A. Lozier left $2,500 in his will for his own tombstone while directing that a $200 monument be erected over his mother's grave.[13] At the same time art critics like Mariana Van Rensselaer counseled restraint, warning against cemeteries full of "big monuments, bad in design, that simply shout out their names with a crude and vulgar voice."[14] Saint-Gaudens himself wrote later in an urban planning report about modern cemeteries: "[T]here is certainly nothing that suffers more from vulgarity, ignorance and pretentiousness on the one side, and grasping unscrupulousness on the other. . . . [T]he eye and the feelings are constantly shocked by the monstrosities which dominate in all modern cemeteries."[15]

By the turn of the century, after decades of debate about science, religion, and human evolution had tempered the literalism of at least some Americans' beliefs in heaven and hell, humor about death and the hereafter was permitted in certain circumstances. For example, Hereafter was the name of an entertainment pavilion on the Pike at the St. Louis world's fair in 1904, loosely based on Dante's *Inferno* (Figure 62).[16] Visitors who paid twenty-five cents could cross the River of Death and travel to Hades and the underground throne room of Satan himself, experiencing a variety of mechanical effects, before heading to the Gates of Paradise and another exhibit about Creation.

Public figures like Mark Twain frequently jested about funerals and neglected tombstones. Tom Sawyer and Huck Finn attend their own funeral, listening to eulogies before revealing themselves, and they and other characters visit cemeteries and make sundry graveyard jokes.[17] The nagging wife's tombstone and other gravestone references were a stock feature of vaudeville at the turn of the century.[18] Mentions in period newspapers of the word "tombstone" are often connected with jokes or puns, such as humorous epithets placed on such stones or imagined by writers. One example repeated in the *New York Times* was about a man named Mud: "Here lies Matthew Mud / Death did him no hurt / When alive he was Mud and now dead, he is dirt."[19] Actual lengthy inscriptions on grave monuments were viewed as outdated, since other means such as newspaper obituaries had in essence replaced the need to outline the character of the deceased in stone; longer or more sentimental epithets were thus often mocked with doggerel.[20]

Scholar Michael Leja in his book *Looking Askance* has shown how the public in the years around 1900 was prepared for trickery in its viewing habits. Americans had become attuned to the showmanship of P. T. Barnum, bearded ladies exhibited as curiosities, and a climate of

Figure 62.
On the Pike: Hereafter, *Official Photographic Company*, 1904. Photo of world's fair midway attraction. *Missouri History Museum, St. Louis.*

confidence men and hucksterism. In addition to exposure to spirit photos, deceptive advertising images, and newspaper sensationalism, they had witnessed scientific revelations of the previously invisible, such as X-ray technology. How could they then judge the visual culture that surrounded them at the turn of the century? "To function successfully, even to survive, every inhabitant of the modern city, every target of competitive marketing, every participant in the new mass culture, every beneficiary of modern science and technology, every believer in spiritual realms had to process visual experiences with some measure of suspicion, caution, and guile," Leja wrote.[21] Amid this fluid new environment, monument dealers, undertakers, sculptors, and cemetery patrons also concerned themselves with questions of duplicity, shame, and its avoidance in memorialization. In fact, an aggressive salesmanship of fear arose in these uncertain times. Monument company salesmen played on tombstone patrons' anxieties about expending the correct amount of money to erect appropriate grave markers and choosing the correct design and materials. Questions about propriety, personal values, and gullibility were in the forefront. In a discussion with writer-editor Norman Hapgood in 1906 revisiting the "horrible desecration" of American cemeteries, Saint-Gaudens complained, "You know it is awful, the monumental granite men lay around like sharks," ready to persuade the emotionally vulnerable.[22]

Both Sears and Tiffany addressed these concerns as they developed national advertising and distribution campaigns. Sears appealed to the most primal fear, the fear of being cheated at a time of special susceptibility. By 1900 Sears had established a Department of Memorial Art, and by 1902 it offered a special mail-order catalogue for tombstones and monuments. The catalogue noted that the purchase of a gravestone was a "perhaps once in a life time" decision, for which few people are well prepared.[23] "[I]t is a peculiar line of goods, a line of goods on which the intending buyer is not so likely to question the matter of price" and "is inclined to be liberal" about cost when visiting a local dealer who charges an inflated rate, it said. Sears promised to deliver top value and good materials, hand cut by "expert artisans," at half the usual cost. It said it could deliver high-quality products more cheaply because of its large factory and the quantity it was able to sell, citing the cost-efficiency of its bulk sales, departmentalized lines of manufacturing combined with mail-order distribution, and the modesty of the company's profit. Customers could have tombstones shipped by rail anywhere in the country within four to six weeks for a five-dollar deposit, and if a monument did not prove satisfactory, they could ship it back at no cost. This enabled the company to market its work to far-flung customers previously limited to local markets, at a time when a third of the U.S. population lived west of the Mississippi. Examples pictured in the catalogue include the $18.40 Father Mother stone, with space for other appropriate lettering at 2 1/2 cents per letter in a certain style. Or the $21.28 Beautiful Monument with a Cross (Figure 63), or The Most Magnificent Monument, which "can be owned by you at $90 and upwards, according to size." Clients could write their own inscriptions or choose among the most popular, such as "God's finger touched him, and he slept" (75 cents) or "Gone but not forgotten" (47 cents), to cite some of the shortest ones, each classified by catalogue number.[24]

Sears applied modern consumer sales methods to win the trust of the public, strategies that worked with other kinds of goods such as sewing machines, garden tools, or watches. Its plainspoken ads emphasized that no trickery was used (such as applying acid to carve a stone) and promised that the company would control the quality of stone from the Acme Blue

Figure 63.
Advertisement for a Sears grave monument. Sears Roebuck & Co., Tomb-stones and Monuments (Chicago: Sears Roebuck & Co., 1902).

Marble Quarries of Vermont. A sample piece of veined marble could be ordered in advance for a few pennies. To assuage the concerns of prospective clients who feared being duped by slick urban entrepreneurs, the Sears catalogue included reassuring testimonials from satisfied customers about the enduring handsomeness of monuments and the reliability of their delivery. Among these printed testimonials, G. W. Stuller, for example, mentioned that his stone, on arrival, was just "as represented in [the] catalogue." Sadie B. Hubbard commented that it is "one of the best I ever saw for the money. The quality being, I consider, tip top."[25] The Sears sales pitch took advantage of another worry: lawsuits that were sometimes described in newspapers. Heirs sometimes brought legal actions complaining that too much was being spent on a monument, that such an expenditure went beyond reason and was a form of immorality. In a Long Island, New York, court in 1897, a family member challenged the outlay of more than $1,000 for the erection of a grave marker for David C. Smith. Niece Julia Betts argued "that the monument was a piece of extravagance" and said she would "try to show that one costing not more than one-third of the amount would have been good enough."[26] For Americans like Betts, the purchase of an acceptable monument at a fair price was a matter of funerary virtue and of fairness to survivors whose inheritances could be affected. Sears catalogues did not urge people to seek originality in style but, rather, stressed functionality, durability, and avoidance of fraud and derision.

Other choices for those willing to spend a bit more money on memorials included finished Italian imports, often purchased through a middleman such as a regional dealer, that promised a degree of aesthetic security. Townsend, Townsend & Co. guaranteed in its 1901 ads that each of its statues imported from Italy would be "Works of Art" (Figure 64). American granite quarries developed strong presences in the marketplace at the end of the nineteenth century, and after 1900 U.S. quarries, foundries, and monument manufacturers increasingly hawked their grave sculptures nationally as being in the highest artistic taste, offering a blanket of aesthetic security. Charles Bianchi & Sons of Barre, Vermont, for example, pictured

Figure 64.
Townsend, Townsend & Co. advertisement, "Italian Statuary," 1892.
Monumental News.

one of its stone angels in an advertisement with the headline, "Artistic Monuments and Mausoleums Built for the Connoisseur."[27]

Firms like the Smith Granite Company in Westerly, Rhode Island, offered catalogues with stock designs, some prepared by second-tier sculptors such as Eduard Pausch, who had taken the death mask of President McKinley.[28] Pausch had worked with the Smith company for ten years after training in his youth with Carl Conrads, an older sculptor who had a long association with another monument firm, New England Granite Works. Many monument companies and quarries developed their own designers, usually men (but occasionally women) who had learned their trade by working with others rather than in any formal academic system. They were sometimes skilled immigrants who had experience as carvers or modelers before their arrival in the United States, but usually they had not had the luxury of studying in a system like the École des Beaux-Arts.[29] Their work as "tombstone sculptors" or "monument men" might be exhibited at trade expositions or showrooms rather than fine-arts shows or museums. Monument dealers such as Charles F. Schroeder of Philadelphia moved to more elaborate display methods of their own in later years, when Schroeder installed a large window with elaborate night lighting to attract passersby to its sculpted angels.[30] The monument companies fiercely protected their own designs from rival firms.

In contrast to Sears's high-pitched advertising about reliability and price, the Tiffany firm, best known as a high-end purveyor of jewelry and interior design products, stressed art and a refined elegance in its mortuary line (Figures 65, 66), telling its customers that the period after the loss of a loved one is no time to scrimp on spending. Its ads stated that value lay in a tasteful design, not in the number of dollars paid out or stingily saved. Tiffany's 1898 catalogue, entitled *Out-of-Door Memorials: Mausoleums, Tombs, Headstones, and All Forms of Mortuary Monuments*, and other publications explained why the firm had opened a special department related to cemetery memorials. Most memorials to date, often sold in multiples like Sears's stock, had been "common-place to the last degree" and even "repellent . . . commercial, crude, uninteresting and completely devoid of all artistic merit," it declared in its literature. Thus, "people of taste and discernment, from time to time, have come to us, and insisted upon our making designs and supervising their realization," seeking the twin qualities of beauty of design and durability associated with the Tiffany name.[31]

Harmony of design and color were related in Tiffany's sales promotions to qualities of morality and virtue. To raise fears of a shameful result, its catalogue showed illustrations of poor-quality monuments, ill-kempt and surrounded by weeds, and featuring a cluttered array of letters. "[I]f . . . the design is of no value the memorial will only excite a spirit of derision and criticism, thereby defeating the object of its existence," it warned. "If on the other hand the design is a work of art the memorial will be a constant source of delight to all, and a sure means of keeping alive the memory of the departed."[32]

The 1898 catalogue described an artistic monument as one in which each part of the form is in proper proportion, with the accompanying ornamentation, with the environment,

Figure 65.
"A Tiffany Monolith." Celtic cross designed by Tiffany studios and dated 1901 for the gravesite of Captain Thomas Mayhew Woodruff, Arlington National Cemetery, Virginia. Illustrated in Tiffany Studios, Memorials in Glass and Stone, *1913.*

Figure 66.
Out-of-Door Memorials: Mausoleums, Tombs, Headstones, and All Forms of Mortuary Monuments *(New York: Tiffany Glass & Decorating Company, 1898).*

and with a correct choice of color. "Competition of cost should never enter into the matter," it concluded. "Let the sum to be expended be frankly given," it counseled, so that the best design can result.[33]

Despite these statements, today's viewers might be surprised by the limited range of design elements Tiffany offered as an appropriate antidote to poor funerary design. Louis Comfort Tiffany had long loved the intricate design of Irish carving, and the Tiffany Studios Ecclesiastical Department, under which mortuary materials were placed, featured a variety of small or large Celtic crosses as options for memorials, as well as ledger stones, table monuments, sarcophagi, and monoliths featuring bas-reliefs, decorated with leafy lilies symbolizing resurrection and passionflowers, all at a range of costs. The cross, once avoided by Protestants as a sign of "popery," was widely adopted in funerary decoration at the turn of the century.[34] Tiffany mausoleums also combined mosaics and Tiffany windows. These products demonstrated a careful study of ornamental patterns from a variety of traditions, including Attic grave markers from the classical world, patterns from such sources as Owen Jones's *The Grammar of Ornament* (1868), and the Celtic revival, which was spurred by the Arts

and Crafts movement and the ideas of John Ruskin and William Morris promoting hand-made products to counter the increasingly industrial nature of society.

There were few figurative designs, although some of the rare Tiffany company monoliths are of exceptional quality, ranging from the unusual Egyptian low-relief figure featured on the Edmund Augustus Cummings Monument (before 1900) in Oak Park, Illinois, to the later Coburn Haskell Monolith (1927) in Cleveland and the Spencer Monument (copyrighted 1927–28), a very low-relief angel emerging from an enormous block of white stone at Oak Hill Cemetery in Washington, D.C., and the freestanding Benjamin Rose Monument (1904) in Cleveland.[35] In the teens, Tiffany bought his own quarry at Cohasset, Massachusetts, so that his memorials could be made of "Tiffany stone."

Sometimes Tiffany's worked with major architects, as in the beautiful McKim, Mead & White Twombly Memorial in a classicizing style at Woodlawn Cemetery, where New York's upper crust were buried and dozens of Tiffany headstones or structures stand. But styles ran the gamut so that we can also find the Webb mausoleum there purchased from Tiffany, which looks like a Victorian gingerbread cake, or the rough-hewn David Belasco mausoleum (1913) in Brooklyn. In 1914 Tiffany published a catalogue focusing solely on mausoleums, many featuring his famous stained-glass windows, often with the River of Life design, a landscape in which a gleaming blue stream wanders through the countryside, often a spring or autumn scene with jewel-like colors, speaking of the cycles of fading life and new life.[36]

These options eschewed some of the more maudlin appeals to emotion that had dominated nineteenth-century tomb sculpture. And while Sears charged by the letter for its sometimes lengthy gravestone epitaphs, Tiffany suggested that its patrons abandon old-style inscriptions and simply include the family name. The Tiffany catalogue quoted the old saying, "Praises on tombs are trifles vainly spent: a good man's name is his best monument." Fulsome eulogies are "transparently absurd," one of its catalogues said and, even appealing to patriotism, noted, "The word 'Washington' on a tomb at Mount Vernon is better than long periods of Latin panegyric."[37]

Although most Tiffany monuments were erected in the Northeast, the studio's memorials can be found in thirty-two states across the country, and Tiffany claimed to be personally responsible for improving America's cemeteries.[38] He said all of his monuments, even if not created by an "artist," were "original" works created "under the supervision of an artist." Renderings were prepared for client review, and a polite diplomacy marked the transactions.[39] It could take a year or more for a project to be completed. Tiffany's literature argued for the value of the "original" versus the multiple, for artistic taste and hand-workmanship versus the mechanical, for a willingness to spend enough money to get true quality versus a short-term bargain. Tiffany copyrighted his designs and publicly warned others not to breach this legal claim. Despite the seeming modesty of some of the gravestones, the Tiffany name, as with the firm's other products, was used most of all to guarantee the buyer of one thing, an absence of risk. Surely you were safe from criticism if you owned a "Tiffany" gravestone.

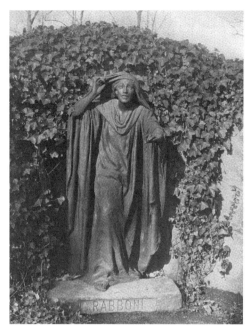

It was in this context that elite Americans continued to make their own decisions about memorialization and value in the years after Henry Adams and the Milmore family commissioned their memorials and Frank Duveneck and William Wetmore Story realized theirs. Many wealthy individuals still chose enormous amounts of granite. But a few who wished to establish a distinctive memorial legacy chose original high-style monuments, figurative compositions made of bronze by well-known sculptors whose work appeared in museums and fine-arts expositions, to distinguish themselves from the masses. Works like the Hubbard Memorial by Karl Bitter in Green Mount Cemetery in Montpelier, Vermont (Plate 8); the Marshall Fields Memorial by Daniel Chester French in Chicago's Graceland Cemetery; the "Rabboni" sculpture (Figure 67) for the Ffoulke family in Rock Creek Cemetery, Washington, D.C., by Gutzon Borglum; and the Pulitzer monument in New York's Woodlawn Cemetery and Kauffmann Memorial in Rock Creek Cemetery by William Ordway Partridge are among those that stand out in this new wave of funerary sculpture.[40] Memorials from this period by fine-art sculptors Adolf Weinman, James Earle Fraser, Philip Martiny, and Lorado Taft also decorate cemeteries, as well as contributions from Paul Bartlett, Bela Pratt, Robert Aitken, Augustus Lukeman, Andrew O'Connor, and Hans Schuler, among many others.

The patrons for the new bronze monuments of the era recognized the value of the truly original work of art in the cemetery, concluding that art was not merchandise, and that the ability to rise above the desires and tastes produced in mass culture signaled an authentic identity and a legacy of great value.[41] They could distinguish themselves and their loved ones from the masses in death as well as life. As discussed in the previous chapter, sculptors' efforts were validated by exhibition of cemetery memorials at high-art venues and inclusion of models in collections of museums like the Metropolitan. In their ardent desire to separate themselves from the commercial context, these fine-art sculptors and patrons took great offense when monument companies hired artisans to make illicit copies of memorials. They felt that unapproved reproduction and reinterpretation diluted and vulgarized their original contributions, which had been intended to mark the deceased as extraordinary people. The singularity of a monument was supposed to suggest the exceptional quality of an individual's morality, public service, and taste. But this was another area of risk, the risk of visual piracy.

THIRTEEN

CEMETERY PIRATES

Amid all of these developments, *The Angel of Death and the Sculptor* and the Adams Memorial stood out as two of the best-known sculptures in America, familiar to readers of popular periodicals and a national audience of schoolchildren as well as museumgoers and participants in elite artistic circles in the early twentieth century. By 1913 they were listed as the fourth and fifth greatest outdoor monuments in the United States in a survey taken by the Committee for Art in Public Schools of the American Federation for the Arts.[1]

Photographs of *The Angel of Death and the Sculptor* "are to be seen in every picture store," wrote Lorado Taft in *Brush and Pencil* magazine; "they hang in thousands of homes. I have seen them in offices and upon the desks of business men."[2] A writer for the *Monumental News* trade journal agreed that the Milmore Memorial "had probably made a wider appeal to popular conception than any work of sculpture ever executed in this country. It has been photographically reproduced in countless ways and numbers, and makes its appeal to every class and every shade of opinion."[3]

Photos often found their way into privileged positions in households across America. Writer Samuel L. Clemens (Mark Twain), for example, kept a "print" of the Adams Memorial on his mantel, according to his biographer. But the Adams monument was also included, by 1912, under the title "Grief" as a "library print" purchasable for 75 cents in the Detroit Publishing Co.'s *Thistle Publications* series of art reproductions.[4] Curtis & Cameron's annual catalogue of "Copley prints" of important artworks located in America also listed both the Adams and Milmore memorials for sale, for $2 or $3 each depending on the size.[5] Prints by Timothy Cole of the Milmore Memorial were distributed as well.

At the same time, monument dealers and cemetery officials expressed a close familiarity with these memorials. In September 1905, for example, when members of the Association of American Cemetery Superintendents held their annual convention in Washington, D.C., they made pilgrimages to the White House grounds in the morning and to the Adams monument in the afternoon. A report in *Monumental News* pictured the monument and said it was "a mecca for the party" of professionals as well as a "famous point of interest for sightseers."[6]

Popularity meant a loss of control, however, for patron and artist, a possible rupture between the intended message of these memorials and the public reception by "outsiders" who did not approach them with the intended attitude of reverence, insisting instead on establishing their own subversive narratives. Meant to be custodians of a particular truth, the monuments were reinterpreted over time, especially when they were replicated and appeared in new contexts. Clearly, the photographs were often sold and labeled without the artists' or patrons' permission. This lack of deference proved to be especially difficult for Adams. While his close circle of friends hailed his monument as noble and serene, one of the earliest newspaper accounts had declared that his cemetery figure "represents despair" and reported that the rector of Rock Creek Church found its Asian-inspired aura of mystery and contemplation to be shockingly "unchristian" in its lack of certainty about the afterlife.[7] Other accounts over the years spoke of suicide and scandal.

Indeed, the monument Adams had erected was extremely conspicuous, unusual in the cemetery of that era in its combination of a bronze figure placed in an elaborate setting of colored stone. It attracted an attention that breached his simultaneously stated desire for privacy. In response, Adams surrounded the monument with a circle of yews and other plantings, which grew into a natural temple enclosing it and screening it from the rest of the cemetery. As the years passed, he diligently spurned requests that he explain the intended meaning of the strange figure, arguing that words would only detract from its amorphous power. Once he did confide to *Century* magazine editor Richard Watson Gilder, "My own name for it is 'The Peace of God.'" But Adams urged Gilder and others not to publicly fix the sculpture with any allegorical name or other title "that the public could turn into a limitation of its nature." He referred to the name "Grief" as a low-brow media title akin to advertising slogans for soap or other banal products designed for "popular consumption."[8] "Grief" suggested a vulgar passion uncontrolled, not the more elevated qualities of wonder and mystery associated with aesthetic beauty.

Ironically, the lack of name or explanation and the challenge involved in finding the monument, hidden behind thick plantings, only fanned the public's interest, first via word of mouth and then in guidebooks and newspaper and magazine articles. The sculpture in the cemetery became a pilgrimage site for visitors to Washington, and Adams often found his solitary meditations at the gravesite interrupted by strangers, including old soldiers from the nearby home for veterans. Sitting anonymously on the bench before his memorial, he overheard their speculations about Clover's death and the amount of money spent on his memorial (Adams noted that the figure of $62,000 was frequently mentioned, while the memorial's actual cost "did not exceed $25,000"), and in his elitist manner he judged them to be vulgar and ignorant.[9] Adams would have agreed with etiquette adviser Jane Aser, who had written that an overfamiliarity by strangers, a deficiency of respect, and an inability to recognize higher intent were all signs of coarseness, poor breeding, and lack of good taste.[10] The right to privacy has traditionally been one property of power. Adams's friends still did not speak to him of Clover's suicide, honoring his desire for silence on that front. Titillating

accounts continued in the media, however, including one newspaper story headlined "Sculpture, Romance, Gossip," which told a complex tale of Clover's suicide having been inspired by "the mistaken belief that her husband no longer loved her" after he showed "marked friendliness for an especially clever woman of their set."[11]

This unwanted public intrusion only increased after the death of Saint-Gaudens in 1907 and the subsequent museum retrospectives. And then something even worse happened: Adams found that he could not even guard the unique appearance of his monument from design thieves. Adams learned that the cemetery was truly a place filled with danger, where private ownership rights to a sculptural composition were denied and efforts to leave a respectable memorial were turned into commerce.

Within a few months of Saint-Gaudens's death, Adams reported finding evidence that someone had made a partial casting from the Rock Creek Cemetery bronze. "Even now, the head of the figure bears evident traces of some surreptitious casting, which the workman did not even take the pains to wash off," he wrote the Metropolitan Museum's Edward Robinson on November 6, 1907. Adams derided art pirates who sought "to make money at second hand out of St. Gaudens by stealing his work, either by cast or photograph, in order to sell it."[12]

A year later Augusta Saint-Gaudens confirmed his fears. "I have just heard," she wrote, "that a General Felix Agnus of the Baltimore American [newspaper] has put up in the Pikesville Cemetery near Baltimore a poor life size reproduction of your monument at Rock Creek." Mrs. Saint-Gaudens, who devoted her remaining years to promoting her husband's legacy, asked, "Is there anything we can either of us do? Augustus did not copyright it—It was a matter of sentiment with him I am sure as I believe he thought it must be with you and so I suppose legally we are powerless . . . but above all things my occupation is to do honor to him and his work."[13]

By this time, she viewed the Adams figure as a memorial to her husband, created by his own hand. Although his ashes were buried at Cornish, she unfailingly visited the Adams monument when she was in Washington. She also was aware of national concern about protecting intellectual property. Leading artists and writers, including Samuel Clemens and William Dean Howells, had appeared at congressional hearings on this issue. The resulting Copyright Act of 1909 would be the first major overhaul of copyright law in America since its inception in 1790. Mrs. Saint-Gaudens believed that Adams, as the owner of the uncopyrighted monument, held primary authority to restrict reproduction; she used this incident to persuade Adams to cede that legal authority to her.

She apparently traveled to Druid Ridge Cemetery in Pikesville, Maryland, just north of Baltimore to see the copy (Figure 68), a likeness of Saint-Gaudens's bronze figure, seated on a rock and backed by a similarly shaped granite stele, but with the family name AGNUS incised in the base. The stele was proportionately higher than in the Adams Memorial, the cornice heavier, and the stone of the setting a nondescript gray rather than the polished pink granite of the original. The Baltimore monument also lacked the bench for visitors and private landscaped environment of the Washington sculpture.

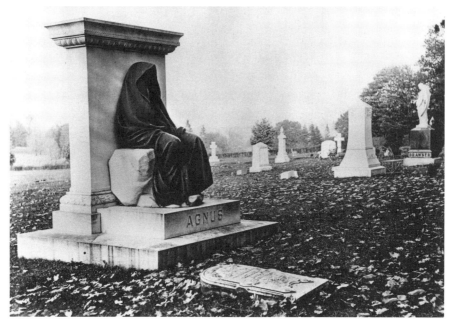

Figure 68.
Eduard L. A. Pausch after Augustus Saint-Gaudens, Agnus Monument in Druid Ridge Cemetery, 1907. Bronze figure in granite setting, 69 × 42 × 38 in. Early photograph from Druid Ridge Cemetery Archive, Pikesville, Maryland.

Augusta Saint-Gaudens promptly asked her lawyer, Charles O. Brewster, to look into the matter. Declaring that Agnus "must be a good deal of a barbarian to copy a work of art in such a way," he arranged to meet the newspaper publisher, who claimed to be the innocent victim of unscrupulous monument dealers. Agnus said he had been approached in 1906 by a representative of John Salter & Son, a Groton, Connecticut, monument dealer, who showed him a variety of photographs, including one of the Adams Memorial. The dealer "assured the general that the Salter firm had bought the right to sell one copy of the Adams Memorial to each of the principal cities of the country," Brewster reported. Agnus ordered the sculpture, and it was erected the next year for $3,900.[14]

The lawyer found Felix Agnus (1839–1925) to be a shrewd negotiator with a considerable personal knowledge about sculpture. Born near Lyons, France, Agnus (Figure 69) had worked briefly at the Barbedienne foundry in Paris and later at Tiffany & Co. in New York as a sculptor and chaser. By the time he arrived in the United States about 1860 he also had traveled around the world on a French trading vessel and served as a volunteer in a French Zouave regiment in Italy. When the American Civil War began, he enlisted in Duryee's Zouaves (5th New York Volunteer Infantry); later he helped raise another Zouave unit, rising through the ranks to brevet brigadier-general. Agnus met Annie Fulton, the daughter of *Baltimore American* newspaper proprietor Charles Carroll Fulton, when she helped to nurse him back to health after he suffered a war injury in 1862. The couple married, and Agnus went to work for his father-in-law, becoming publisher of the *American* when Fulton died in 1883 and launching an evening paper, the *Star*, in 1908. He and his wife had a five-hundred-acre

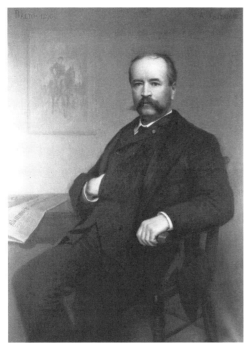

Figure 69.
J. André Castaigne, Felix Agnus, *1890. Oil on canvas, 52 1/4 × 38 in. Museum Department. Courtesy of the Maryland Historical Society, 1943.40.9.*

country estate called Nacirema (American spelled backward), where they raised horses, cattle, and sheep. In this life of prosperity, Agnus brought the body of his mother, Ann Bernera Agnus (1804–1880), from France for interment in 1905 at the family gravesite he had just purchased in the new Druid Ridge Cemetery. He commissioned the copy of the Adams monument for this new cemetery lot.[15]

Augusta Saint-Gaudens's attorney now asked him to give up the fraudulent sculpture and to permit legal action to be brought in his name against the dealer who had wrongly sold it. Brewster at first held out hope to an unhappy Agnus that the Saint-Gaudens estate would provide him with an authorized replacement cast if he cooperated. The lawyer enlisted John La Farge to be a go-between with Henry Adams on this matter and began soliciting estimates.[16] When talks with Agnus reached an impasse over the issue of payment and Brewster detected reluctance on Adams's part about allowing an authorized cast, however, he withdrew the offer of a replica and tried another tack, applying public pressure on Agnus through the newspapers. Brewster and Augusta Saint-Gaudens persuaded arts critic Royal Cortissoz to draft an account of what had happened.

The story appeared in the *New York Tribune* on February 5, 1909, under the front-page headline "The Adams Monument: A Case of Its Unauthorized Reproduction." It added further details that Brewster had obtained. The Agnus bronze had been cast by Bureau Brothers of Philadelphia from a model made by Eduard Pausch, still best known as the maker of McKinley's death mask. Brewster sent a detective to Buffalo, who found Pausch ready to furnish other copies to prospective buyers. Pausch said "he had made drawings, sketches and measurements of the monument at Washington," according to the *Tribune* account. Cemeteries were full of monumental imitations of sculpture from around the world, and Pausch saw no harm in preparing multiple versions of such a landmark image for commercial gain.

Saint-Gaudens's work was revered in the arts world, and a furor erupted. On February 6, 1909, the *Tribune* reported a number of sculptors' reactions to this scandalous act of design piracy. "General indignation was expressed at the erection of the copy without authority from Mr. Adams," the article stated. "It looks like plain stealing to me . . . the transaction was dishonest and unprofessional," Daniel Chester French was quoted as saying.

His colleague Karl Bitter commented, "It seems to me . . . that the common law regarding theft would cover the case perfectly. Certainly it ought to make the destruction of the copy possible, if there was no authority for the reproduction. That copy should not be allowed to stay. That is outrageous."[17]

Brewster took further steps at this time to guard the Adams Memorial against piracy. After persuading Adams to transfer copyright authority to Mrs. Saint-Gaudens, he registered the design with the U.S. Copyright Office in Washington, D.C., in her name. In a letter to Adams, the lawyer also proposed placing the inscription "Copyrighted 1909 by Augusta St. Gaudens Executrix" on the statue "in such a way as to be hardly noticeable." Adams firmly objected and Brewster swiftly backed off, writing, "It is a source of regret that I ever suggested putting any mark upon it." Brewster did receive permission from Adams, however, to have the copyright inscription included on the plaster cast being displayed at the Saint-Gaudens retrospective exhibitions. The 1909 copyright law emphasized the need for a copyright notice to be affixed on copies of works that are displayed publicly or sold.[18]

As for Felix Agnus, he filed suit against the monument dealer in April 1910, charging that he was the victim of fraud. On June 30 a court in New London, Connecticut, returned a $4,532 judgment against the dealer. Agnus stubbornly refused, however, to give up his monument, and he and his wife were buried in front of it in Druid Ridge Cemetery in the 1920s. A bronze medallion showing Agnus in profile on the back of the stele is inscribed: "GENERAL FELIX AGNUS / SCULPTOR AUTHOR ORATOR / BRAVE SOLDIER GALLANT OFFICER / TRUE FRIEND / NEARLY 40 YEARS PUBLISHER / OF THE BALTIMORE AMERICAN."[19]

The presence of words did not fix the Agnus monument, however, as a symbol for his family's status or achievements. Within a decade of Agnus's death, urban legends that the statue in Druid Ridge Cemetery was haunted began to give the monument eerie renown, and it became known as "The Black Aggie." These legends bore no relation to the lives of Agnus or Henry and Marian Adams but were local tales of witchcraft, curses, and superstitions. They were significant and persistent enough to be included in the final report of the Study Commission on Maryland Folklife in 1970. Teenage pranks and disturbances requiring police intervention prompted newspaper reports that perpetuated the stories. Legends developed that "Aggie's" eyes would turn red and glow at midnight and that "she" let out a blood-curdling scream against the background sound of clanking chains at that hour. Tales were told of people who had dared to sit in the statue's lap after dark and who were later found dead. It thus became a teenage challenge to clamber into the sculpted figure's lap late at night.[20]

So many macabre hijinks and fraternity initiation rites occurred at the site that cemetery officials finally urged Felix Agnus's descendants to remove the graffiti-covered monument (Figure 70). Believing the sculpture to be an actual cast of the Adams monument, the family donated it in 1967 to the Smithsonian Institution's National Collection of Fine Arts in Washington. After the monument had been shipped from Baltimore, however, Smithsonian researchers concluded that it was an unauthorized freehand copy, unsuitable for public

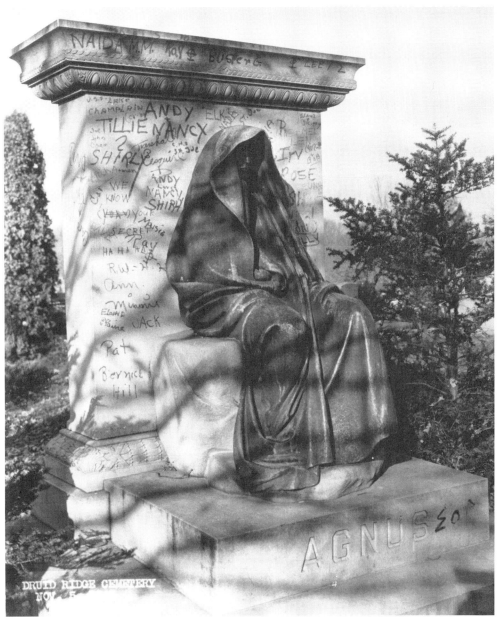

Figure 70.
The Agnus Monument in Druid Ridge Cemetery, defaced by graffiti. Undated photograph from Druid Ridge Cemetery Archive, Pikesville, Maryland.

display. Bearing the nicks and scrapes of years of vandalism, it sat beneath a staircase at the museum until it was transferred in the late 1980s to the General Services Administration, which ironically chose to display it in a courtyard of the National Courts Building across La-fayette Square from the former site of the Henry Adams and John Hay homes.[21]

Other imitations exist as well, including a three-quarter-size variation carved in gray granite in Cedar Lawn Cemetery, Paterson, New Jersey (Figure 71). In this case, the figure

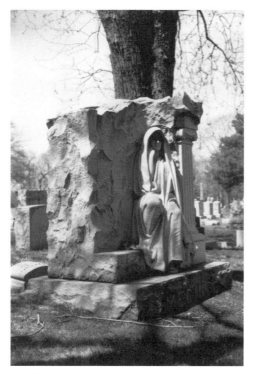

Figure 71.
Meding Monument, Cedar Lawn Cemetery, Paterson, New Jersey, ca.
1906–18. Granite, 53 1/2 in. high. Photo by Sean McCormally.

has been inset into a rock-face granite block with a fluted Ionic pilaster next to it. The figure sits at an angle, facing the earliest graves of family members. The family name is carved in large raised letters on the base, with an ornamental honeycomb pattern of holes drilled around each stick-like letter. Again, no bench or hedge is included to create a special environment for the monument.

While the pose, gesture, and drapery broadly imitate the Rock Creek figure, this stone monument is clearly not based on a surreptitious cast. The unpolished figure measures 53 1/2 inches in height, compared with the larger-than-life, 70-inch height of the Adams bronze, and details, such as the presence of an incipient ear and a sandaled foot, vary. As in the original, no sculptor's or carver's name is included. Nonetheless, this ungainly clone melds reminiscences of the Saint-Gaudens figure with features routinely found on stock cemetery memorials. Rock-face stones combined with areas of smoothly finished surface were popular in late nineteenth-century burial markers, suggesting a closeness to nature and a sense of transition. The short column or pilaster spoke to turn-of-the-century viewers both of the nobility of an individual's life and of the limited time allowed each person. Hodgepodges of these elements were the stock-in-trade of the average monument dealer.

In this case, the monument honors a prominent silk manufacturer, Charles Eugene Meding (1848–1918) and his family. It appears to date between 1906 and 1918, but no link with Pausch or the Salter firm has been documented. Regardless of the date, the treatment and setting of the figure in this monument demonstrate that its meaning to patron and audience had changed. It was now a memorial to a specific, clearly identified family, and—as in the Agnus Memorial—the linkage with the nationally important Adams clan is gone.[22]

By 1913 Henry Adams apparently gave up hope of controlling the situation. When a British friend asked permission in 1913 to erect a replica on the grounds of his country house in East Sussex, saying he had long been haunted and comforted by its "strange presence," Adams did not object. Adams, seventy-five and recovering from a stroke suffered the previous year, gave Moreton Frewen (1853–1924) his tacit consent. Over the years the patron's attitude had softened, and just before his own death, after decades of silence, he began to speak privately of his recollections of his wife at the request of a young companion.[23]

Acknowledging the inevitability of his monument's absorption into the popular culture, he confided, "I have shuddered for years at the prospect, but now I hope at least not [to live] to see it." He told Frewen, "Anyone may take what he likes that is mine, and I am only too glad if it is a friend."[24] Frewen applied to Augusta Saint-Gaudens to purchase a cast, as Adams advised him to do, but World War I intervened and his children preferred other traditions; thus, he never did erect his copy of the Adams Memorial at his estate as he had hoped.

Ultimately, Augusta Saint-Gaudens never did approve a cast of the whole figure for any purpose. She did, however, have bronze casts made of the head of the figure before her death in 1926. She presented one in 1912 to sculptor Herbert Adams, a friend of Saint-Gaudens who helped to establish the Saint-Gaudens Memorial at Cornish. In her late years, she sold the other head to the Brooklyn Museum in 1923 as part of a group of seven Saint-Gaudens works.[25]

<center>◯</center>

Like the Adams Memorial, the Milmore Memorial was sometimes used or reinterpreted by its audiences in ways never intended by its patrons or sculptor. Photos and descriptions circulated widely, and its image was appropriated as well by monument-making companies, who used it in advertisements to elevate their trade's identity. French himself wound up embroiled in a nasty dispute with the patrons over its setting, upkeep, and ownership later in his career. But in the long run the monument was protected from replication in the cemetery by the complexity of its multifigure composition and the particularity of its narrative.

At the 1893 Chicago world's fair, where a plaster was shown, *The Angel of Death and the Sculptor* was sometimes viewed as the three-dimensional parallel to a celebrated painting entitled *Breaking Home Ties* (Figure 72), which fairgoers lined up to see. Scholar Sarah Burns has noted that the oil by Thomas Hovenden appealed to "self-made connoisseurs" much more than to the professional critics. Regular citizens saw in it a familiar, truly "American" story.[26] Like the Milmore Memorial, it was featured in reproductions available in myriad picture dealers' windows. The figures of a mother and her adolescent son stand at the center of the painting, which is set in a New England farmhouse. She places her hands on his shoulders in tender farewell as he prepares to depart for the city to seek his fortune, facing a time of trial and homesickness. He does not look directly at her but into the distance, to his unknown future. The painting pulled at the heartstrings of viewers, who expressed compassion for the innocent youth. They could foresee his rocky transformation to adulthood in the next stage of life. His mother was also a central figure in the picture, standing large and calm and stable before this period of great change.

In their descriptions of the Milmore monument, a number of writers detected a similar underlying theme that resonated with the sculpture's equivalently large audiences. They reinterpreted the angel depicted in the sculpture as another mother and the story it told as a companion tale of a caring parent and young son facing his ultimate destiny. While angels were historically male or androgynous, nearly all of the commentators described this angel as

Figure 72.
Thomas Hovendon, Breaking Home Ties, *1890. Oil on canvas, 52 1/8 × 72 1/4 in. Philadelphia Museum of Art: Gift of Ellen Harrison McMichael in memory of C. Emory McMichael, 1942.*

a female, of mature years. They deemphasized direct biblical associations, instead placing the story within a domestic family circle and a community of hopeful caring, repeatedly using words like "mother" and "home." These remarks, suggesting a more generalized, secular, and sentimental narrative, allied the sculptural group with such paintings as *Breaking Home Ties* and removed it from the particular biography of the Milmore family and the grim lessons of the cemetery.

Helen B. Emerson, writing in *New England Magazine*, recalled making almost daily pilgrimages to the Fine Arts Building at the fair during the exposition to see the "robust young sculptor, chisel in hand, and the motherly figure of the Angel of Death," which in its universal message of love "was the most admired and popular piece of modern sculpture at the World's Fair."[27] The angel "calls the youth home as the wistful mother seeks her child," reported *Munsey's Magazine* in an 1898 essay about French and his work that featured a full-page engraving of the Milmore Memorial. "The sculptor has not portrayed her as a hideous and dreadful monster. Rather, she comes as a beautiful woman in full maturity to perform her allotted and inevitable duty with a sense of tender sadness."[28]

"This memorial has won more admirers than perhaps any other of the sculptor's works, and the reason is not far to seek. The allegory conveys a human story with such precision and tender sincerity that all can read it and few can fail to be affected," wrote

Charles Caffin more than a decade later in his book *American Masters of Sculpture*. "Death has been symbolized by a woman of noble and inviting mien, whose arms might fold themselves around the young sculptor's form as with a mother's caress."[29]

A poem by Lawrence Wachs repeated the theme in describing youth and angel: "Ah, there he stands, young manhood carrying out / His fate, the sphinx, the mystery of life. . . . They are as one, that mother and that son; and there is neither fear nor sorrow there."[30] On another occasion, an essay by Preston Remington in the *Metropolitan Museum of Art Bulletin* called the angel "the Great Mother from whom all energies are given out."[31]

Lorado Taft specifically compared and contrasted the sculpture with Hovenden's paintings and with James McNeill Whistler's more modernist aesthetic productions, declaring: "Hovenden's 'Home Ties' was dear to the multitude; [James] Whistler's shadowy but soulless forms delight the painters; Mr. French's life and talent have vouchsafed a yet finer thing—a message of universal appeal in the form of a masterpiece of artistic rendering."[32] By the time French died in 1931, writer Adeline Adams could declare the memorial to be "doubtless the best-known household work in American sculpture today."[33] To its public audience, it seemed an appropriate image to be placed in domestic interiors, far removed from the cemetery and, by chance perhaps rather than intention, reviving a sense of the familial closeness once shared by the Milmore sons and their beloved Irish mother.

As the years passed, the figure of the sculptor in the memorial also became an icon of the monument-making trade. Commercial monument firms adopted the now-famous image of the Milmore Memorial, without attribution, in advertisements for their products. The figure of a sculptor dressed in simple apron and leggings and hard at work seemed appropriate for their purposes. In one ad by Baldwin & More, with offices in Vermont, Ohio, and Scotland, the sculptor carves out the word "MONUMENTS" above the heading "Get Our Quotations" (Figure 73). An allegorical figure meant to sum up the unfathomable loss of a human life, whose worth could not be measured in dollars, was appropriated by this transformation for goals of commercial profit. In another ad that appeared in *Monumental News* magazine, the sculptor carves out the name "Kavanagh Brothers Company / Westerly Granite / Monuments / Quincy Adams Mass." near the text, "Kavanagh Quality Monuments" (Figure 74).[34] Many companies also incorporated the image of a sphinx in their notices. Without mentioning the name Milmore (or Daniel Chester French), the image was in fact reinterpreted here in a context quite familiar to the Milmore brothers, the realm of the stone carver, hard at work in the business as well as the artistry of the monument industry. There were limits, however, to the design's commercial use. French commented drily on one occasion that he had just turned down a request by an undertaker to use the image of the Milmore Memorial on his hearse.[35]

In a critique of the monument industry's brazen hunt for profit, William Walton commented in *American Architect* magazine that "the frankness with which what should be Art is replaced by Commerce is frequently surprising." He cited the "flagrant case of a stolen copy of Saint-Gaudens' seated figure" in Baltimore and "a very recent instance [in which]

Figure 73.
Baldwin & More monument company advertisement, Monumental News 21, no. 9 (September 1909): 728.

"KAVANAGH QUALITY"
MONUMENTS
IN
WESTERLY GRANITE
WILL PLEASE THE
MOST PARTICULAR.

KAVANAGH BROTHERS COMPANY
QUINCY ADAMS, MASSACHUSETTS

A FEW FINISHED MONUMENTS
READY FOR IMMEDIATE DELIVERY

Figure 74.
Advertisement by the Kavanagh Brothers monument company, Monumental News 23, no. 12 (December 1911): 922.

Mr. French's youthful sculptor in his Milmore Memorial reappears in the illustration of an advertisement of a granite company, chiseling the name of the company on a rock." These incidents, he declared, take an especially "serious turn in the ignorant, or unauthorized copying of work of high merit."[36] The monument dealers' (and possibly the new patrons') lack of expected deference and sober, silent respect crossed a line that prompted outrage.

As the decades passed, however, it no longer seemed a breach of privacy to some to use even the Adams monument for faintly commercial uses. By the 1930s Rock Creek Cemetery used photographs of the Adams Memorial in its promotional literature to suggest that the cemetery was an attractive "outdoor museum of art" full of famous works from the past.[37] In the 1950s, Adams Memorial "cards" and historical souvenir folders were offered to visitors. In 1940 the Washington Gas Light Company issued promotional calendars featuring the Adams Memorial and "some interesting facts about this famous statue," with a recipe for "Steamed Mince Meat Pudding" and an advertisement for the Modern Gas Range on the back.[38]

During his lifetime, Daniel Chester French discovered that he too was losing control of the appearance and installation of his *Angel of Death and the Sculptor* in the cemetery where the original rests. His relations with the Milmore family had suffered a difficult turn in 1914. Unlike the considerable thought given by Stanford White to the Adams Memorial setting, French as a young man had not devoted great attention to the original masonry setting for his Forest Hills Cemetery production, which he arranged with architect C. Howard Walker in 1893. It apparently had long been a source of tension with the estate, and French had at one point ordered some repairs. Then in 1914 French exchanged letters and visits with the widow Mary Milmore and her son Oscar about the deteriorating state of the monument. Families were usually responsible for the maintenance of cemetery memorials and lots, and often this led to problems of neglect decades later. The Milmore Memorial was in such bad condition that Theodore Dwight, Henry Adams's former assistant, sent French a letter in 1914 pointing out the need for action after having visited the cemetery. French tried in vain to persuade the family to hand over the memorial to the cemetery trustees so that they could care for it and move it to a more visible location worthy of its public fame. He proposed a new setting by architect Henry Bacon, the plans of which survive, and the cemetery offered a new site. The family resisted loss of control and of the rights to the image that any transfer of ownership might bring, however, and at first also resisted any expenditure for repairs. Son Oscar Milmore apparently responded at one point by blaming the sculptor for the shoddy setting and French took considerable umbrage. "When you say that the masonry work was not what the contract specified, you are coming pretty near to accusing me of dishonesty," he wrote Oscar in a letter drafted on August 4, 1914, adding that other than repair work he had arranged at his own expense, "I think that the monument has received no attention whatever in the twenty one or two years since its erection." French offered to pay half of the $6,000 cost, but the family declined, and Oscar finally arranged independently for modifications to the setting.[39] The family must have understood that the image of the Milmore Memorial already had greater weight in the museum than in the cemetery and wanted to hold on to its

private legacy. At the same time, these events made clear to French the importance of having a marble version created for the Metropolitan Museum to preserve his artistic legacy. The marble, requested by the museum commission, was created in 1926. Finally, in 1943, some six years after Mrs. Milmore's death, the original memorial in Forest Hills Cemetery was moved to a prominent lot near the entrance to the cemetery, where it now stands, provided with a new architectural setting.[40] While the monument companies and their advertisements have long been forgotten, the memorial itself continues to attract visitors who find it just beyond the cemetery gate. Some are aware of the sculpture's long and prestigious history, while others puzzle over it, but each visitor approaches with his or her own twenty-first-century ideas about what it means.

FOURTEEN

AFTERLIVES

While artistic circles were complaining about cemetery commerce and piracy, William Wetmore Story's *Angel of Grief* lived on in the American popular imagination owing largely to a multitude of unauthorized copies. No casts of Story's white marble angel were displayed in U.S. museums or fine-arts exhibitions. His neoclassical style had lost its luster in the American art world, and he died soon after he completed the sculpture. But his monument in Rome—his highly personal expression of deeply held emotion—did not long remain a one-of-a-kind object. Located high on a hill at the edge of the Protestant Cemetery, where the graves of the romantic poets Shelley and Keats are also found, it became a well-known pilgrimage site for English-speaking tourists and artists who visited the Eternal City. And for monument dealers, too. The image soon crossed the sea and became one of the most replicated memorials designed by a fine artist in the American cemetery, with nearly twenty unapproved copies surviving today.[1]

A cemetery exists outside time, with all of its generations of "sleepers" resting together, and memorial styles often overlap there. Easily recognizable versions of Story's design, ranging dramatically in quality and cost, can be discovered in cemeteries across the United States, from New York to New Orleans to Palo Alto, California. Some of these copies were commissioned by highly respected and well-to-do citizens in the American West, who considered their acquisition to be an act of universal human empathy rather than piracy. These included the extraordinary Jane Stanford (Figure 75), who with her husband, the railroad baron Leland Stanford Sr., founded Stanford University as a monument to their only child. Mrs. Stanford had determined to devote the rest of her life to God, whom she called "the great Comforter," and to the memorialization of her family after her beloved son, Leland Jr., was stricken by typhoid fever at the age of fifteen during a trip to Florence, Italy, in 1884. She intensified her devotion after her husband's death in 1893 and her brother's passing in 1899, ultimately making the university's campus one of the most significant mortuary sites on the American West Coast. Eventually a copy of Story's *Angel of Grief* was installed there as well.

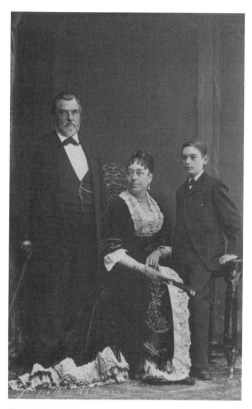

"I have turned for comfort [over the years] to the giver of both good and evil . . . and now again I turn to Him with entreaties to save to me my darling boy," Mrs. Stanford wrote a friend from Italy as she anguished at the bedside of her adolescent son. An attending physician had expressed cautious hope that young Leland Stanford Jr. might gradually recover from his illness.[2] But on March 13, 1884, the worst occurred, and the bereaved parents sent the same friend this telegram from Italy: "Our darling boy was taken from us this morning after an illness of three weeks with typhoid fever pray for us."[3]

The Stanfords, flush with the new money produced by the expansion of the railroads in the second half of the nineteenth century, had used their wealth to decorate multiple grand homes in California, and they had treated their son like a prince. He was especially loved as he had been a long-sought but late arrival in their marriage, coming into the world when Jane was forty. The couple dedicated themselves to his education and wrote letters laden with praise about his extraordinary intellectual capacities and curiosity. Leland Stanford Sr., who was president of the Central Pacific Railroad Company, governor of California, and then a U.S. senator, said he had a vision on the night of their boy's untimely passing in Florence: the youth came to him in his dreams and asked him not to despair but to "live for humanity." Stanford and his wife thus decided, as a memorial, to found their tuition-free university in California to educate young people. In addition, they built a museum in honor of their son, who had loved collecting and archaeology. Stanford also ordered the erection of a magnificent mausoleum on the university grounds, a white granite and marble temple surrounded by Ionic columns (Figure 76). Stone sphinxes flank the entry, and within are marble sarcophagi for just three bodies, those of the parents and son, whose names are listed just above the bronze doors.

According to a newspaper interview with the architect, the mausoleum was designed in 1888 to eclipse in excellence those monuments by Jay Gould at New York's Woodlawn Cemetery and the Vanderbilt family on Staten Island, also famed for their immense wealth.[4] No limit was set on the cost of the materials used—massive blocks of gray Vermont granite for the exterior and white Italian marble in the interior—and, despite its simple purity

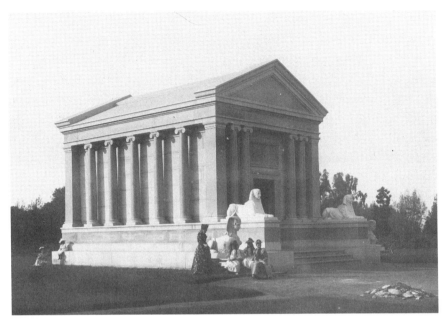

Figure 76.
The Stanford Mausoleum designed by architect Robert Caterson. Male sphinxes created by sculptor William Couper replace the original female sphinxes at the front of the structure. Stanford Historical Photograph Collection, Stanford University.

of design, the structure was at one point estimated at more than $100,000.[5] The same architect, Robert Caterson, was involved in work on New York's Grand Central Station and would later prepare the mausoleum in New York for fellow railroad entrepreneur Collis Huntington.[6]

The *Los Angeles Times*, describing plans for their mausoleum before its completion in the summer of 1889, noted that the Stanfords would be leaving no heirs and thus put great store in their architectural and institutional legacy. "The mausoleum . . . will be a fitting abode for the remains of one of the most successful men of the day," the newspaper declared, "a railroad magnate, a millionaire and a philanthropist, who is building a university . . . a man who lives magnificently, with wealth and friends, and everything that makes life worth living, yet who has had the great sorrow of losing his son, his only child, and when he and his wife are called to another world and their remains occupy their stately tomb, the family history will end."[7]

Unhappy with the sphinxes originally provided by Caterson—a pair of bare-breasted female hybrid creatures that especially displeased Jane—the Stanfords commissioned the expatriate sculptor William Couper, who worked in Florence, to design another set of sphinxes in Carrara marble to flank the entryway of their mausoleum. Couper was an exceptionally well-connected maker of angels and memorials of all sorts. He had married the daughter of Thomas Ball, the former mentor of both Martin Milmore and Daniel Chester French, and worked closely with Ball in Florence. An expert on Italian stone, he had also some years earlier helped Frank Duveneck acquire the Italian marble necessary for the replica of his

Elizabeth Boott Duveneck Memorial in Boston. By chance it was Couper who had been summoned to take a death mask of young Leland Stanford in Florence, and he recalled in a letter to Jane how he had arrived to complete this terrible task "in the most trying moments of your affliction."[8] His relationship with the Stanfords thus came full circle when, more than six years later, the heavily muscled male sphinxes he designed for them were shipped from Italy to New York and then on to California in 1891. Couper asked Mrs. Stanford to send him photos so that he could see, halfway around the world, what the stone creatures looked like in their place in the American West.[9] Caterson's sphinxes were not cast off but, rather, moved to the back of the mausoleum.

In the meantime and ever after, Jane Stanford did not restrain her own, often immoderate, expressions of grief, talking about her son at each opportunity and marking the events of his life and death on every anniversary. In this older Victorian manner of making her sorrow conspicuous, her conduct was far removed from Henry Adams's public denial and silence, or even Frank Duveneck's warm, nostalgic remembrances of his lost wife, and closer to William Wetmore Story's expressive grieving. Mrs. Stanford can be seen in photos wearing a portrait of her son, whom she referred to as "our loved one,"[10] on a brooch, her rather plain, dour face staring outward. She wrote long, poignant letters to distant acquaintances as well as intimate friends. She indicated no shame at the high visibility of her emotions and extreme sentimentality over every aspect of young Leland's memory, seeing him as literally still alive in heaven above. On May 15, 1889, for example, she wrote of commemorating "the birth day of my precious son who was twenty one years old—flowers, God's jewels to his children, were strewn along his pathway there, and here I laid a lovely pillow of flowers on his bed in the place where his head had lain so many times, and we placed flowers all around before his pictures . . . and silently I praised God for his great goodness to me in giving me this priceless gift of a son."[11]

The university, which prepared students (female as well as male) for a "useful career," was the couple's true memorial to their son, an option they were able to choose because of their wealth.[12] Their lifestyle had been opulent. Mrs. Stanford had lived in a forty-four-room mansion in Sacramento with her husband, and she later engaged painter Astley Cooper to record on canvas, as a souvenir, the collection of jewels her husband had given her over the years.[13] But the couple also shared strong philanthropic values. After the death of Leland Stanford Sr. at age sixty-nine, Mrs. Stanford showed the strength of will to carry their university through difficult times following the panic of 1893 and in the face of a perilous court suit. She ultimately left her necklaces, earrings, brooches, and bracelets to the university as the Jewel Fund to support its libraries.

She also created a spectacular nonsectarian Memorial Church on the university campus, dedicated, in enormous capital letters across the front, "To the Glory of God and in Loving Memory of My Husband Leland Stanford" (Figure 77). She stated that she did not want Stanford to be a Godless university. She hoped instead to see students experience "soul development" as well as other forms of education there. In a September 5, 1899, letter to

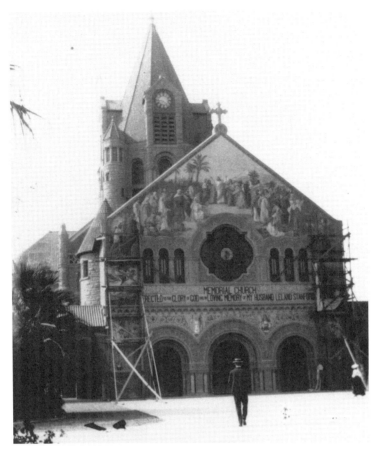

Figure 77.
Memorial Church, Stanford University (before the 1906 earthquake). Stanford Historical Photograph Collection,
Stanford University.

university president David Starr Jordan, she spoke of a man named Ingersoll who had died
without acknowledging God or life beyond, and she asked: "What monument has he left
behind? What consolation has his family?"[14]

A deeply religious woman, Jane Stanford attended various Protestant churches but
followed her own eclectic ideas about faith, and she was also attracted to the ritual and
decorative richness of Italian Catholicism. Like her husband, she never committed to any
particular denomination, and the Memorial Church offered no single specific creed.[15] Her
true religion was to view God as a comforter whom she could address personally in her
grief. This view is summed up in one of the many inspirational statements by Jane Stanford
that are carved into Memorial Church's interior sandstone walls: "Religion is intended as a
comfort, a solace, a necessity to the soul's welfare; and whichever form of religion furnishes
the greatest comfort, the greatest solace it is the form which should be adopted be its name
what it will. The best form of religion is, trust in God and a firm belief in the immortality of
the soul, life everlasting."

She contrasted "earth-life" with the "angel-life" and appeared to believe that her husband and son literally were together in heaven and that she would join them there one day, even commissioning a bronze statue by sculptor Larkin Mead in 1899 of her kneeling on a cushion before the two men she loved, who stand above her (see Figure 19).[16] When she revised her will in 1901, she ended it with a declaration of her gratitude to "an allwise, loving Heavenly Father," declaring that through her bereavement "I have leaned hard on this Great Comforter and found peace and rest. I have no doubt about a future life beyond this: a fair land where no more tears will be shed and no more partings had."[17] On another occasion she wrote, noting that her husband's birthday was approaching on a Saturday: "[H]e will be seventy one years old that day I feel sure he and dear Leland will talk about 'dear Mamma' that day—just as we used to talk about our dear boy on these days."[18]

The Stanford Memorial Church was loosely modeled on H. H. Richardson's Trinity Church in Boston. It featured exterior and interior mosaics by A. Salviati and Co. of Venice, a firm that had been involved in the restoration of St. Mark's in Venice, and a multitude of stained-glass windows by leading designers: J & R Lamb Studios of New York, Tiffany, and Gorham. Visitors who looked upward could view an "all-seeing eye" of God, with a teardrop in it, in the interior dome, surrounded by cherubs and a shooting star. The large rose window featured the face of a small child in the center.[19] The decorative scheme featured numerous angels throughout, including four across the entry facade and a bronze angel lectern. For Jane Stanford the "real" was heaven, and art could provide concrete reminders of what was to come. The figure of the angel became for her a key symbol of the next world.

In 1901 she sent friends copies of a popular book of poems by Ernest Shurtleff titled *The Shadow of the Angel*, which she said had helped her through her trials.[20] "By every troubled soul some angel stands, And stretches forth her gentle, pitying hands," it states, addressing all those in pain, including "the mother bowed, with lips too sad for prayer."[21] The Stanfords had commissioned from French artist Émile Munier a painting of their son Leland coming to earth as an angel to comfort his grieving mother (Figure 78). Over his career, Munier painted many charming pictures of children, one of which—a little girl with a kitten and a dog—was adapted as a publicity poster for Pears Soap. The painting he made for the Stanfords shows a sweetly calm Leland with angel's wings and with rays of light emanating from his head. He places one hand on the shoulder of his mother, who buries her face in her hands, eyes closed as if he were coming to her in a dream.[22] In a stained-glass window designed for the church by Antonio Paoletti, the boy is shown being carried by angels up to the sky. The angels described in the Shurtleff book and the angels displayed in her church and in Munier's painting all illustrated how a grieving Mrs. Stanford had been saved by the idea of love for God being above all, and by the belief that her boy and her husband were called not to death but home to an endless life in heaven.

For Jane Stanford, the most important aspect of visual art, like religion, was its capacity for giving comfort. Its effectiveness was more crucial than its originality. Her church was thus filled not only with angels but also with copies, in a variety of materials ranging from mosaics

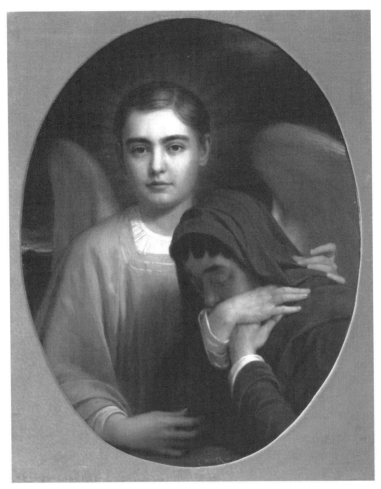

Figure 78.
Émile Munier, Leland Stanford Jr. as an Angel Comforting His Grieving Mother, *1884. Oil on canvas.*
Iris & B. Gerald Cantor Center for Visual Arts at Stanford University; Stanford Family Collections. JLS.14897.

to stained glass and marble, of European artworks that she believed created an inspirational environment. The Stanford museum and her homes included some copies of artworks as well. The Stanfords commissioned or purchased original works by a number of important contemporary French and American artists, such as portraits by Léon Bonnat and Ernest Meissonier and paintings by artists of western scenes such as Albert Bierstadt. But they also participated in the late nineteenth-century "valorization of imitation and illusion" that included the acquisition of sculptural casts by museums. As scholar Miles Orvell has noted, "the nineteenth-century culture of imitation was fascinated by reproduction of all sorts—replicas of furniture, architecture, art works, replicas of the real thing in any shape or form imaginable."[23] At the turn of the century the shift was beginning from a culture of imitation to a cult of authenticity, in which the "original" would be privileged as far superior. Jane apparently felt that the copies she acquired created the best atmosphere for both devotion and the study of art, and she did

not make acquisition of original old master paintings a major focus of her collecting activity. Rather, she had Raphael's *Sistine Madonna* copied twice, once for the museum and once for the Roman Catholic cathedral in Sacramento. She also owned a copy of Raphael's *Madonna of the Chair* in one of her homes.[24] The stained-glass windows in the church were mostly inspired by well-known European artworks, including, for example, Pre-Raphaelite painter William Holman Hunt's *Christ in the Temple*. A mosaic of the Lord's Supper in the church was described as an exact reproduction of the fresco by Cosimo Rosselli in the Vatican's Sistine Chapel, and Mrs. Stanford obtained permission from the pope to commission it. Under the mosaic in the apse stood marble figures of the twelve apostles, again "exact copies" of figures from the Basilica of St. John Lateran in Rome, executed by Bernieri & Company, a firm based in Carrara, Italy, which provided other replicas in the church.[25]

Shortly before ground was broken for the church, Mrs. Stanford was forced to write that she was facing another wrenching personal loss, having "almost lived night and day" by the sickbed of her brother Henry Clay Lathrop. She feared she would soon face "disaster" in "parting with a brother who has been devoted and loving through all my life."[26] Lathrop had been ill for eight years and had lived part of that time with his sister. He died in early April 1899, apparently of cirrhosis of the liver, and Jane had to consider how to memorialize him as well.[27]

According to an account in the *San Francisco Examiner*, she looked at many designs for a memorial sculpture and finally chose William Wetmore Story's beautiful *Angel of Grief* from a photograph.[28] Its sentimentality and pathos and apparent emphasis on the plight of the lonely survivor appealed to her. In her book *The Gates Ajar* (1868), Elizabeth Stuart had identified "any servant of God" as an angel; for Jane this may have meant also the human survivor who had to struggle with absence after being abandoned on earth. She wrote of being left "Alone! Alone!" describing herself once as "the lonely bleeding bruised one here."[29] What's more, Story's angel is distinctively a female angel, more so than Daniel Chester French's majestic angel of death; it is delicate and vulnerable in appearance. It is all too human, not supernatural, in its momentary surrender to grief. Jane Stanford decided to install a copy of Story's grieving angel near the Stanford Mausoleum in her brother's memory. Her commission went to Antonio Bernieri, who fabricated the sculpture in Italy, reportedly carving it from a single block of Carrara marble. Bernieri also set the angel in an elaborate marble canopy that must have added significantly to its cost (Figure 79). It was erected by early March 1901, as work on the church was also under way. A bronze urn containing Henry Lathrop's ashes was set into a hollow in the granite base, and then the statue was rolled into place over it. The marble had reached the Palo Alto train depot after a three-month journey across the sea, from Genoa to New Orleans and from there by rail to California. The tips of the angel's wings were damaged in transit, and they had to be slightly shortened and reshaped on arrival.[30]

Did Mrs. Stanford or Antonio Bernieri ever consider whether they were committing an unethical act, an act of piracy, by copying Story's angel? Jane certainly knew of the Story family, having commissioned two neoclassical marble reliefs from the sculptor's son Waldo (1855–1915). Yet nothing in her records or the correspondence of Waldo Story suggests that

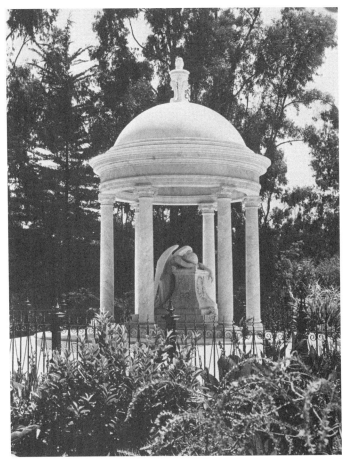

Figure 79.
Antonio Bernieri, Angel of Grief *(Henry Clay Lathrop Tomb), Stanford University, 1899–1901.*
Stanford Historical Photograph Collection, Stanford University.

she ever asked the artist's estate for permission. (The account in the *San Francisco Examiner* mistakenly stated that the statue was a copy of a work Story made for the Rothschild family in Paris, not for his own wife's grave.) Yet the Stanford replica provoked milder bursts of outrage than Eduard Pausch's copying of the Adams Memorial. A few months after its erection, the trade journal *Monumental News* did decry the commissioning of an unauthorized copy by "one of the wealthiest women of the country." But it noted that there were mitigating circumstances: "The original was probably not copyrighted and it has been duplicated more than once in American cities."[31] Since the monument originated on foreign soil and its double was fashioned there for a site on the western edge of the American continent, its great distance from East Coast art and legal centers may have had much to do with the lack of furor, eliminating a sense of high risk. Story did not have a widow who aggressively looked after his intellectual property. Bernieri had used high-quality stone and created the memorial for a rich philanthropist.

Mrs. Stanford was looking for beauty and utility but was less concerned with the singularity of her monument—with its being a work of one artist's imagination and creative genius. She could have asked a sculptor such as Couper, or Daniel Chester French, both of whom made many angels of their own design, for assistance, but that would have entailed a higher cost. For her purposes, too much newness, novelty of composition, might even be suspect. She was not a great connoisseur of sculpture (although she had collected a few other works created by neoclassical American artists), but she was a connoisseur of expressive feeling.[32] Her pieces were intended to be didactic, to inspire, and to persuade in an often eclectic and usually moralizing combination. Thus she did not care if the artist himself had made the work, or if a workshop like Bernieri's, which specialized in replicating other people's designs, executed it. In fact, in mid-nineteenth-century neoclassical sculpture the greatest originality had come in the initial conception, and the execution was usually done by workmen, perhaps with some finishing touches by the artist himself. There is no evidence that Mrs. Stanford ever gave Story any credit for the design, though she was apparently aware of his role as the original creator.

Shortly after Jane Stanford's death[33] in 1905 and her funeral in her Memorial Church, the great San Francisco earthquake wreaked great destruction on the Stanford campus, severely damaging the church. The family mausoleum stood, but the *Angel of Grief* sculpture was damaged and its canopy destroyed (Figure 80). In 1908 Bernieri replaced the original sculpture with a second angel of the same design, but without a canopy.[34]

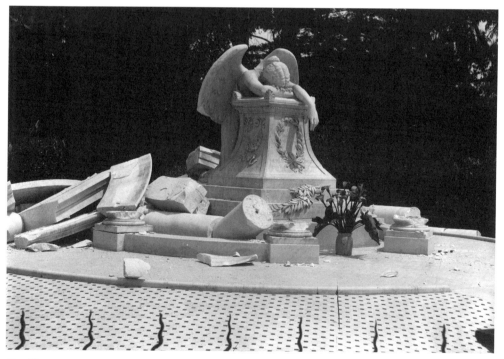

Figure 80.
Angel of Grief *(Henry Clay Lathrop Tomb) after 1906 earthquake. Stanford Historical Photograph Collection, Stanford University.*

Mrs. Stanford's experience, and the later earthquake incident, may have helped to spawn future generations of reproductions of the Story angel in the United States. Several nearly contemporary examples are known in the state of Texas, for example, where a German immigrant sculptor named Frank Teich made at least two versions of the Story angel. Teich, who had come to the United States in his early twenties, opened a monument works in Texas about 1901 and completed many Confederate memorials in southern states as well as a number of cemetery sculptures. His reproductions of Story's angels, erected about 1903 and 1904, became local icons. He continued to advertise the design in a 1926 catalogue of Teich's Studio of Memorial Art, which features a picture of the sculptor at work on one of these angels, a laborer with a pneumatic tool assisting him as he poses (Figure 81).[35]

Peter Youree, a Confederate veteran who became a prominent Shreveport, Louisiana, businessman and banker, and his wife, Mary Scott, had commissioned Teich to make a copy of the *Angel of Grief* for their family burial site in Scottsville, Texas, after the interment of

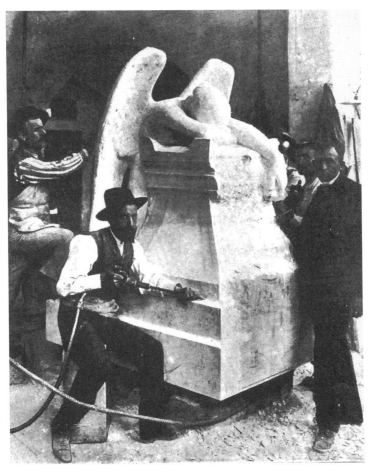

Figure 81.
Frank Teich carving his version of the Story Memorial in Texas. Photo from Frank Teich, Book of Miscellaneous Memorials We Executed and Erected, *a promotional and sales catalogue of Teich's Studio of Memorial Art, Llano, 1926.*

their only son, William Scott Youree, age thirty-one, there.[36] Teich's catalogue reported that recommendations from the patron, based on his satisfaction with the angel, later proved to be a boon to the monument company, contributing at least $40,000 worth of orders of all kinds. Teich also had made an angel memorial in Houston's Glenwood Cemetery, presumably after the death in 1903 of Angie Hill, the European-educated daughter of Judge E. P. Hill (1838–1920). A newspaper obituary said Ms. Hill, who was about thirty-seven years old, had been "engaged in literary pursuits in the North."[37]

The makers of other reproductions of the angel in the United States, including one example inside an expensive mausoleum in New Orleans's Metairie Cemetery, are unknown, but most likely the sculptures were created by regional monumental works, such as Kavanagh Brothers. One of these, the monument to Maria Hooper in Hingham Cemetery, Massachusetts, not far from Boston, was pictured in an influential book on memorial art without any reference to its origin overseas.[38] In some reproductions the angel holds a wreath or a scroll; all are carved in stone. In each, the names of the specific individuals and their life and death dates, and perhaps cities of birth and passing, are listed.[39] Further copies are still being made in the twenty-first century, and recently the monument has been featured on blogs, websites, YouTube videos, and cover art for musical groups.[40] The story of its creation by William Wetmore Story seems well known and is sometimes mentioned, yet the sculpture's continuing appeal appears to lie not in its history but in its simple visual expression of a heartfelt sentiment.

Story had written a treatise, *The Proportions of the Human Figure* (1866), and admirers across the decades, consciously or not, have recognized the essential harmony of his angelic figure and its altar-base. The sculpture embodies his interest in combining the circle, square, and triangle. "The circle is the world," he wrote in his book; "the triangle is the Trinity or divine nature enclosed within the world, or Christ, the ideal man, the God in nature; and the square is his manifestation and establishment according to law in the world."[41]

At the same time, however, the sculpture refuses to cloak the artist's despair, or the angel's, over the way death, even for the most faithful, separates loved ones from the living before resurrection. Unlike Henry Adams, Story never minded the word "grief," and his figure is universally known as *The Angel of Grief*. It also was criticized by at least one writer, Lilian Whiting, as being nearly atheistic in its lack of any "vision of divine consolation," since the angel does not celebrate resurrection and the dead person's arrival in heaven but rather dwells on loss. She notes in one of her Italian travel guides that the angel's head is "bowed in the utter despair and desolation of hopeless sorrow," a grief "that has no support of faith."[42] She preferred Franklin Simmons's later *Angel of Resurrection*, a more optimistic-seeming monument to his wife who died in 1905, also erected in the Protestant Cemetery.

But Story had explained in a poem his view, like Mrs. Stanford's, that grief and belief could go hand in hand: "I sing the hymn of the conquered, who fell in the battle of life—, The hymn of the wounded, the beaten, who died overwhelmed in the strive; / . . . With the wreck of their life all around them, unpitied, unheeded alone, / With death sweeping down

o'er their failure and all but their faith overthrown." It was later republished in the *Boston Daily Globe*.[43]

The presence of so many reproductions over time suggests that others shared Story's views or reinterpreted them. For them this frankly emotional expression of temporary prostration was more moving than intellectual allegories of psychic serenity. For some, it spoke a greater truth, acknowledging rather than hiding the real, immediate human response to loss, expressing overtly one's grief in defiance of society's stoicism and taboos.

Story's extraordinary monument thus lived on in America through piracy and the popular imagination. Other artists like Daniel Chester French and Frank Duveneck had arranged casts of their works in high-art settings in order to protect and preserve their designs. Oddly, things did not work out as they had hoped, for the museums where they had sent approved copies to guard their fine-arts legacy began obliterating them in the twentieth century.

After French's death in 1931, his only child, Margaret Cresson, an accomplished sculptor herself, wrote a biography of her father and actively preserved his estate, playing a role in this respect similar to that of Augusta Saint-Gaudens at Cornish. Under her care, Chesterwood became a historic site and museum honoring the sculptor's legacy, and she acquired examples of his most important works to display there. In her research, she discovered that all but one of the plaster casts of her father's *Angel of Death and the Sculptor*, made for major museums, had been destroyed over the years. With the permission of the Milmores, French had arranged for the creation of four or five such casts in addition to the marble at the Metropolitan Museum of Art. Cresson visited the Frick Art Reference Library in New York to research the issue "and wrote to seven or eight museums which had owned plaster casts by my father," she told a colleague in a May 4, 1956, letter. To her "horror," she discovered that most of the large plaster casts had been destroyed: "Museums nowadays only want bronzes and marbles and so they take it upon themselves to get rid of anything in plaster." Cresson took steps to acquire "at any cost" a cast of the Milmore relief that was being sold by the Corcoran Gallery in Washington, D.C., and it remains on display at the Chesterwood estate.[44]

Similarly, a number of the plasters of the Duveneck Memorial were destroyed, though versions at the Museum of Fine Arts, Boston, the Metropolitan Museum of Art in New York, and the Cincinnati Art Museum were carefully preserved and revered, remaining on view, perhaps in part because of their associations with one artist's personal life story and their suitability, as gisants, to a museum environment, where they fit in an art-historical continuity with the story of royalty and Renaissance sculpture.[45] The Metropolitan cast its version in bronze in 1927, years after Duveneck's death, and covered it with gold leaf, likely under French's guidance, giving it a sense of even greater preciousness (see Plate 3).

The casts had been created in the 1890s at the height of interest in building American cast collections in the newly developed museums in major cities. Casts, especially those of ancient Greek and European Renaissance art, were deemed to be an important way to circulate knowledge about high culture in the nineteenth century and to develop U.S. culture

in competition with the Old World. Augustus Saint-Gaudens and Stanford White were members of a special Metropolitan Museum cast committee that raised $80,000 in the early 1890s to support development of its historically arranged cast collection there.[46] But as the twentieth century unfolded, ideas of originality took precedence and aestheticism was given greater importance than education in museum settings. Casts were no longer valued in the same way. Museums began to deemphasize casts, replacing them with expensive original artworks with the help of elite millionaire collectors on their boards or in their donor circles, such as J. P. Morgan.[47] What were museums to do with casts no longer on display? The plaster degraded with time, and museums did not wish to expend the considerable sums that would be needed to repair them; they also needed the storage space these huge sculptures took up for other purposes. Museums sometimes offered them to other institutions or ultimately simply broke them up and removed them. Some Milmore and Duveneck casts were destroyed in this process, casualties of this trend, even though they had been acquired with the participation of the artists themselves.

Sculpture by its nature is a medium of multiples. Yet in the swirl of time, changes in material, venue, attitudes about originality and genius, and viewers' expectations transformed all of these monuments, leading to the destruction of some copies of celebrated memorials but keeping alive through reproductions the legacy of William Wetmore Story's deep personal emotion in American cemetery settings.

E P I L O G U E

Before his death in 1917, acquaintances sometimes asked Henry Adams's advice for creating their own family cemetery memorials. He unfailingly recommended that the patron develop a central concept to pass on to his or her chosen artist. He had proposed to Saint-Gaudens the idea of combining the "calm reflection" of Buddhist teachings from Asia with the "peace of God" more familiar to Western cultures. Many years later Adams advised fellow Washingtonian Florence Boardman Keep: "The conventions" may be the artist's, but "the feelings must be yours." He continued: "A monument is a symbol, and the symbol should be your's. If there is a single one in the whole innumerable catalogue of symbols, since the creation, that you *feel*, you should give that to the artist to put in form."[1] He seems to have given similar advice to John Hay's widow, Clara, who chose the idea of an armed "Peace" for her husband's memorial in Lake View Cemetery in Cleveland, Ohio. The stone archangel honoring Hay, a colossal winged figure with helmet and sword, was ultimately completed by sculptor James Earle Fraser. These patrons were among numerous members of social and economic elites who sought monuments that might match or rival the power of the great memorials of the late nineteenth century. The resulting sculptures became a collective elegy to the hopes and fears of the Gilded Age generations and to their achievements.

For his part, Saint-Gaudens in his last years had begun work on a final funerary memorial for a different kind of patron, banker George Fisher Baker, who "had come to him asking for a seated figure that should carry something of the same feeling as that brought by the one at Rock Creek."[2] The sculptor had also been engaged in creating a monument to pastor Phillips Brooks for installation at Boston's Trinity Church, which included a depiction of Christ, and so he proposed to Baker a seated figure of Jesus flanked by angels (Figure 82). Despite Saint-Gaudens's own earlier aversions to the Catholicism in which he was reared, his son Homer wrote: "Now, as he gave the subject more and more individual thought, Christ no longer stood to him as the head of a cult that announced bewildering self-contradictions and endless punishment of sin, but became the man of men, a teacher of peace and happiness. . . . Saint-Gaudens began to express a genuine faith in his conception of the physical image of Christ as a man, tender yet firm, suffering yet strong."[3] For the Baker commission, Homer said, his father felt "impelled to express still further his new sense of the beauty of Christ."[4] The final heroic-sized bronze, which was completed by an assistant after Saint-Gaudens's death, appears to have been set in place by September 1911 (Figure 83).[5] It is seated on a rock

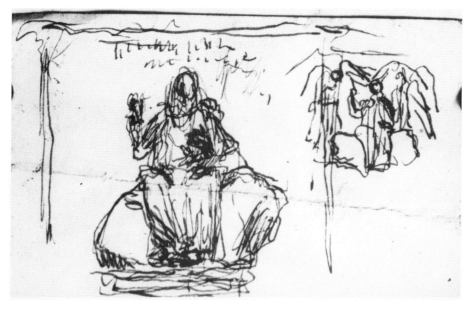

Figure 82.
Augustus Saint-Gaudens, drawings for the George Fisher Baker Memorial, 1906–7. Augustus Saint-Gaudens Papers. Courtesy of Dartmouth College Library.

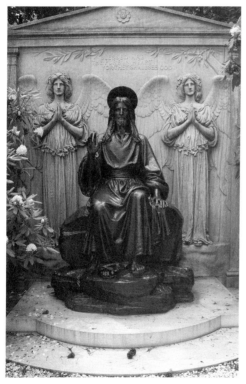

Figure 83.
George Fisher Baker Memorial, completed after the death of Saint-Gaudens and installed in Kensico Cemetery, Valhalla, New York, 1911. Photo by Lee Sandstead.

like the Adams figure, with the inscription above the figure and two bas-relief angels: "BLESSED ARE / THE PURE IN HEART / FOR THEY SHALL SEE GOD." It combines suggestions of a vision of God and of Christ as teacher and exemplar bound to earth via the rock he sits on, as the bodhisattva Kwannon was linked to nature in his/her desire to aid man.

While Adams was one of the last of the great amateur historians and scion of a leading Boston Brahmin family, Baker came from another background, anchored in commerce. He had secured the respect of Gilded Age tycoons for his financial management skills, accruing a fortune said to have been worth $200 million at its height and serving on the boards of scores of corporations. With this wealth, he decorated his houses in New York City and Tuxedo, New York, with expensive, carefully

selected art objects, including paintings and tapestries, deemed commensurate with his financial success.[6] At the same time, a privately printed biography of Baker, commissioned by his family, stressed his qualities of fairness, frugality, good judgment, caring family relations, modesty, and self-restraint. After his wife's death, Baker, sharing the growing uncertainties of his age about individual immortality, institutionalized memories of his public virtue by increasing his philanthropic giving, especially for educational projects. His philanthropic decisions may have been influenced by the example of other "self-made" men of his ilk, like Andrew Carnegie, J. P. Morgan, and J. J. Hill.[7] These captains of industry, pushing out the older aristocracy like the Adams family to become the new role models for leadership, found art collections and "artistic taste" a crucial way to affirm their status and the virtues of their systems for producing wealth. But they also had new avenues for their philanthropic dollars, making contributions to museums, symphony orchestras, universities, and libraries as leisure activities changed and "culture" became more hierarchically organized at the end of the nineteenth century. The high-style cemetery monument was another insignia of rank and an argument for the retention of economic leaders as moral and civic leaders, but philanthropic goals competed with it and began to overshadow it in importance for many.[8]

Others, including the businessman John Erastus Hubbard in Montpelier, Vermont, tried to use monuments and philanthropy to repair reputations. After having been vilified during his life for wresting his aunt's fortune from the city in a legal battle, he left the bulk of his wealth to Montpelier for a park, library, and other public services along with a handsome amount for a cemetery memorial to himself. The administrators of his estate commissioned sculptor Karl Bitter to design a memorial filled with suggestions of redemption (Plate 8). Completed in 1902, it stands out among all others in the rugged, spectacularly beautiful landscape of Montpelier's Green Mount Cemetery. The five-foot seated bronze figure, with lips parted and eyes closed, is covered with drapery that swirls in a serpentine configuration like a winding sheet. On the curving walls of the granite exedra radiating out to both sides are lines from William Cullen Bryant's *Thanatopsis*, saying that he did not go from the world "like the quarry slave at night scourged to his dungeon" but had lived in virtue and died "sustained and soothed by an unfaltering trust."[9] Bitter went on to produce some of the most beautiful cemetery memorials of the era, including his monument to Henry Villard in Sleepy Hollow Cemetery in Tarrytown, New York, which he described as a more "modern" sculpture influenced by the symbolic work of George Gray Barnard and Charles Grafly and sculpture at the 1901 Buffalo world's fair. Another important sculptor of funerary subjects was William Ordway Partridge, who made the beautiful Kauffmann and Pulitzer monuments in Washington and New York. Most sculptors of Saint-Gaudens's generation ultimately completed some funerary work as part of their oeuvre. Together their work formed a stylistic grouping of bronze high-style Beaux-Arts memorials around the turn of the century sought by patrons seeking to express their membership in an elite, creative community replete with civic and individual virtue. They changed the face of the urban American cemetery, primarily in the Northeast, where they had the greatest influence.

Sculptures such as the Adams Memorial and *The Angel of Death and the Sculptor*, and others like the Hubbard Memorial and the Marshall Field Memorial completed by Daniel Chester French to honor the department store mogul in Chicago's Graceland Cemetery, helped to inspire this continuing, evolving interest in museum-quality symbolic figures created by fine artists in cemeteries. French went on to be the great maker of angels and memorials, heightening the significance of funerary sculpture both in his art-making and his museum activities. But these styles waned after World War I.

In 1917 the Gorham Galleries in New York advertised its ability to put prospective patrons "in touch with sculptors of sympathetic insight and artistic perceptions, who have the ability to interpret" memorial subjects "in harmony with the highest ideals of the profession." Its paid promotion in *Arts and Decoration* magazine noted, "In recent years, people of discernment have devoted thoughtful attention to symbolic figures and monuments as memorials, engaging sculptors of recognized ability, in place of the mediocre talent formerly employed."[10] This ad featured a photograph of *Solace* (1911), an elongated two-figure group by Isidore Konti (Figure 84). But the taste for figurative memorial sculpture, its function and styles were rapidly changing in the twentieth century, and the Gorham Galleries ad was in reality a plea not to abandon an already fading tradition. The heyday of the Beaux-Arts monument was over.

Figure 84.
Gorham Galleries advertisement for modern monuments in Arts and Decoration *7 (March 1917): 277.*

The excesses of the Gilded Age and corporate culture had created concern about too much concentration of America's wealth and helped to spur the passage in 1913 of the sixteenth amendment giving Congress power to levy an individual income tax. During World War I and afterward, a heavy income tax was applied to the nation's richest people, reducing the amounts of wealth held in private hands. At the same time, more than 100,000 American troops were among the 10 million people who died in the war. Social changes accompanying the military draft in 1917–18 and a continued distancing from death transformed the desires and expectations Americans brought to the cemetery. The war added an increased emphasis to the heroism of self-restraint in the face of a community of death. In a 1916 article

entitled "The New Mien of Grief," for instance, the *Literary Digest* quoted the inspirational writings of the Reverend Archibald Alexander, a British writer popular in the United States, about the "new etiquette of sorrow with the washen face." Alexander celebrated the legions of uncomplaining parents, wives, and children who "have made a new virtue of cheerfulness" and brave smiles in the face of bereavement, seeing it as their duty to efface as far as possible the signs of woe. "What fills one with reverent admiration is that so many of those whose hearts we know have been so cruelly wounded have set up a new and noble precedent in the matter of courage and self-control. . . . They wear their hurt gently like a flower in the breast. . . . Out from the secret chambers they come, with washen face and brave lips to do their duty and refrain themselves. How beautiful it is!"[11] The realities of war contributed to a rising tide of secularism as questions arose about how a beneficent God could have allowed such tragic events. The stock market crash at the end of the 1920s and the Great Depression further damaged the monument market, and the Tiffany studios soon shut their doors.

As cities continued to invest in urban parks where residents could stroll and picnic, and then in neighborhood parks, the cemeteries lost their early function as important places to interact with nature. Other options for outdoor recreation now existed for city dwellers. A shift also occurred in the landscape philosophy of many cemeteries, with the arrival of the "memorial park" aesthetic in such places as Forest Lawn Cemetery near Los Angeles, begun in the 1910s and highly influential by the 1930s. The large family monument was unwelcome in these parks, which emphasized standardized, ground-level grave markers that were commercially manufactured.

At Forest Lawn, planner Hubert Eaton eliminated the central family monument in favor of individual bronze markers flush to the ground in cemetery sections with ecumenical themes appealing to the middle class and allowing room for diversity of faith and ethnic origins. Copies of high-art monuments from the past, such as a reproduction of Michelangelo's *David*, were featured, to be shared by all. A new emphasis was also put on the placement of ashes of the cremated, and cemeteries erected columbaria. The retreat from sentimentality begun in the last century was extended in the new "cemetery without gloom." As urban areas developed, they also pressed closer to the cemeteries' once-rural locations and limited the scenic views beyond. The cemetery became a less and less meaningful place to visit.[12]

Amid all of these changes, the integrity, "moral beauty," and "moral earnestness" that writer Adeline Adams described in the Beaux-Arts sculpture of artists like Saint-Gaudens—what she saw as their stand against the superficiality and emptiness of American culture—became outdated.[13] The era of monumania ended, and the world's fairs of 1893, 1901, 1904, and 1915 turned out to have been the high point and then turning point for training public sculptors. By the 1920s Beaux-Arts ideals and French-influenced styles were challenged or met with indifference, and the idea of the sculptor's role as a teacher of both good design and moral values, allied goals, changed amid a breakdown in belief systems.[14] A new generation of sculptors was also interested in working in less naturalistic styles and in experimenting with a greater variety of materials than the standard academic bronze or marble. Garden sculptures, sun dials,

and decorative commissions, such as reliefs and gates on mausoleums, often provided work for them in the cemetery. This reflected general trends in American sculpture, which included smaller objects for the interior, more suitable for the museum and private collector than the grand-scale public monuments for City Beautiful exteriors and outdoor spaces.[15]

Modernist experimentation, based on European developments like cubism, futurism, and dada, was slow to appear in the essentially conservative cemetery, where the need for durability and limited range of themes restricted choices. Yet a simplified symbolic mode, usually still based on figurative personifications, was often adopted with roots in art deco or a more geometrical classical revival, such as the Greek sources tapped at times by Paul Manship. A more streamlined form emerged, and materials such as cast concrete/cement and different metals were used. There was also a return to carved stone amid the general new interest in materials and process.[16]

Beaux-Arts memorials in cemeteries, which had once stood for the newest aesthetic styles, eventually became visual symbols for older modes of mourning, and the public had difficulty at times differentiating them from baby lambs and Victorian sentiment and the iconography of monument companies. Their emphasis on moral commentary and their fusion of real and ideal could be seen as parody or even hokeyness by new generations in the context of the mixed and overlapping styles found in the cemetery. Over time, the original landscaping was sometimes stripped away to conform with the new more open cemetery aesthetic.

Academic sculptors from the Beaux-Arts tradition mourned the passing of a taste for their style of figurative cemetery art. An aging generation of sculptors was left with unused models. In a 1934 interview with *American Cemetery* magazine, for example, Augustus Lukeman, a protégé of Daniel Chester French, appealed to cemeteries to encourage the reintroduction of sculptural memorials. He cited the Adams Memorial as the symbol of a type of memorial art that he and others wished to continue making. "The average person is decidedly not enticed by the idea of visiting a burial place, as such" these days, he commented. But then he asked his interviewer, "You have been to Rock Creek Cemetery in Washington?" Americans were still making pilgrimages there to see the Adams Memorial, which had made that cemetery "a national landmark," Lukeman commented pointedly. He showed his interviewer a design he had made for a monument featuring a cloaked, seated figure with one hand to its face. Lukeman said he and other artists had such models ready, left begging for places. He suggested that the "group monument" idea central to the newer memorial parks could be a cost-effective way to continue injecting sculpture into the cemetery. Philanthropists had stopped making cemeteries the objects of their generosity, preferring other cultural and educational institutions, he noted with distress. He proposed that memorial parks call on the wealthy to make such investments again in gardens of community remembrance.[17]

Monumental News, losing faith in cemetery sculpture as a steady source of income, however, slashed its sections about high-art sculpture in the cemetery after World War I, filling its issues instead with discussions of how to make and sell the new styles of grave markers. Cemetery art reportedly was specifically excluded from some 1930s fine-arts exhibitions in New

York as incompatible with notions of the "modern."[18] By the end of the Great Depression a generational shift had also occurred. After World War II, art and architecture styles changed dramatically, and art deco forms were replaced by the International Style, using the shape of the building itself as the primary means of decoration.

As the years passed after the war, the memory of the Adams monument, *The Angel of Death and the Sculptor*, and the Story angel was preserved, however, in poems, art history textbooks, encyclopedias, and even advertisements. Individuals continued, and continue, to make pilgrimages to these sites, while the Duveneck Memorial is primarily noticed by museumgoers in Boston, Cincinnati, and New York. The Adams Memorial remains the most celebrated of the nineteenth-century memorials.

One famous visitor and chronicler of the memorial was author John Galsworthy, who first saw "St. Gaudens statue of grief" on April 29, 1912, when he proclaimed it in his journal "the most beautiful piece of sculpture since the Renaissance." He returned in 1919 and 1920.[19] He incorporated his admiration for it in the opening pages of "Passers by," a portion of *Two Forsyte Interludes*, where the narrator noted that it was something beyond the power of commerce, writing: "Apart from the general attraction of a cemetery, this statue awakened the connoisseur within him. Though not a thing you could acquire, it was undoubtedly a work of art, and produced a very marked effect. . . . That great greenish bronze figure of a seated woman with in the hooding folds of her ample cloak seemed to carry him down to the bottom of his own soul."

One of the Adams Memorial's most celebrated visitors, Eleanor Roosevelt, took a sad look back on her life when she invited a journalist to accompany her to Rock Creek Cemetery in the 1930s. Mrs. Roosevelt had repeatedly retreated to the Adams Memorial in 1918 to meditate in the months after learning of the extramarital liaison between her husband and her social secretary, Lucy Page Mercer. She seemed then to see the monument as the representation of another wronged woman who had suffered bitter unhappiness but had come through her pale of grief with a strange serenity. On the eve of her husband's inauguration in March 1933, Eleanor Roosevelt returned to the gravesite with newspaper reporter Lorena Hitchcock, telling Hitchcock that she wanted to show her "something that used to mean a very great deal to me." The reporter later described how the two women entered the monument in silence.

> Finally Mrs. Roosevelt spoke, in a hushed tone, as though she were in church. "It's by Saint Gaudens," she said. "He called it 'Grief,' but it's better known as the Adams Memorial. Henry Adams had it erected here, in memory of his wife. . . . In the old days, when we lived here, I was much younger and not so very wise. Sometimes I'd be very unhappy and sorry for myself. When I was feeling that way, if I could manage it, I'd come out here, alone, and sit and look at that woman. And I'd always come away somehow feeling better. And stronger. I've been here many, many times."[20]

Sculptor Penelope Jencks tapped these insights into Eleanor Roosevelt's feelings in the 1990s when she created a statue of the former first lady to be placed at the southern

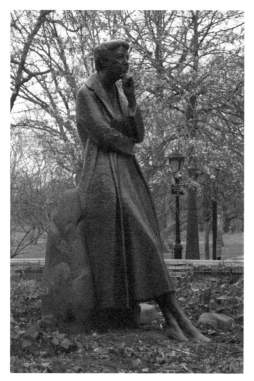

tip of Riverside Park in Manhattan. The model she created shows Mrs. Roosevelt leaning against a large rock with one arm across her waist and the fingers of her other hand touching her chin in a gesture reminiscent of the Adams Memorial (Figure 85).

Writer Alexander Woollcott urged an end to the reticence about Clover Adams's life and suicide, saying she had "merely exercised her inalienable privilege of taking her own life." Yet because of this, he said, she was effaced from her husband's writings and her death was not even confronted later by biographer James Truslow Adams. "The most beautiful thing ever fashioned by the hand of man on this continent marks the nameless grave of a woman who is not mentioned in her husband's autobiography," Woollcott declared in his book *When Rome Burns*:

Figure 85.
Penelope Jencks, Monument to Eleanor Roosevelt, 1996. Riverside Park, Manhattan. Photo by James Lancel McElhinney.

It is the ineffably tranquil bronze—the hypnotically tranquil bronze—which you will find in an evergreen thicket of cypress, holly and pine on a slope in Rock Creek Cemetery, Washington. I have often encountered a popular disposition to call it "Grief," but if there be one thing indisputably certain about the utter composure of that passionless figure, it is that it is beyond grief, as it is beyond pain and all the hurt the world can do. In the more than forty years of its standing there, it has become a recognized node in the increasing vibration of American life. Scurrying little pilgrims . . . go to it, stay a while, and come away again. The oblivious figure challenges each and every one. Motionless, it reaches out and draws a holy circle around its bit of fragrant earth, saying with such an imperious force as no mere prelate ever commanded, "Here, here is sanctuary."[21]

By the 1950s even an aging Bernard Berenson, the famous connoisseur who had been among Henry Adams's acquaintances, could look back a little mournfully on the turn-of-the-century craze for Saint-Gaudens's work and the celebrity of his friend's memorial. In a 1955 letter, Berenson recalled Saint-Gaudens's "wonderful" portrait reliefs, equestrian statues, and memorial art, concluding: "His Sherman delighted, & his famous allegorical figure over the tomb of Mrs. Henry Adams, impressed me. All this so long ago! I wonder what I should think now."[22]

BEYOND GRIEF

ACKNOWLEDGMENTS

This book could not have been completed without the assistance and encouragement of many generous colleagues and friends over nearly two decades.

It evolved from my dissertation at the University of Maryland, where committee members included Franklin Kelly, Sally Promey, and June Hargrove, whose courses in nineteenth-century art had helped to inspire my interest in sculptural memorials of that era. I finished writing the dissertation in 1996 with the help of a predoctoral fellowship at the National Museum of American Art (now the Smithsonian American Art Museum), where I worked with curator George Gurney. I also gained immensely from conversations during this period with Julie Aronson, Eunyoung Cho, Ellen Grayson, Janet Headley, Anne Verplanck, Neil Harris, Richard Murray, and Sidra Stich, all of whom I met through the Smithsonian's fellowship program, as well as classmates Debora Rindge and Susan Libby at the University of Maryland.

The book manuscript developed slowly over the following years, as other demands on my time often took precedence. Postdoctoral research fellowships at Winterthur and at the Sterling and Francine Clark Art Institute, whose research center was headed by Michael Holly, as well as a fellowship received from the American Council for Learned Societies (ACLS) provided crucial support.

Among professional colleagues, whom I now count as friends, I especially thank Sarah Burns for her astute comments on a draft of the manuscript, and Wanda Corn and William Truettner for their earnest support. Art historians Erika Doss and Michele Bogart, curators Thayer Tolles at the Metropolitan Museum of Art, Henry Duffy at the Saint-Gaudens National Historic Site, and Donna Hassler at Chesterwood (and assistants Anne Cathcart and Erika Cohn) all took time to talk with me and aid my efforts over the years. Karen Lemmey also was an important reader of the text after she became curator of sculpture at the Smithsonian American Art Museum. Charles Vandersee, a co-editor of the Henry Adams letters, was a valued early mentor. Katherine Manthorne and spouse James Lancel McElhinney kindly provided the final photo for the book.

My special thanks to archivist Wayne Hammond at the Chapin Library of Rare Books, Williams College, which holds the Chesterwood Archives. Mona Chapin assisted my research at the Cincinnati Art Museum library, and Julie Aronson, now a longtime curator there, answered many of my questions about the Duvenecks. Staff members were helpful at the

Dartmouth College Library, Library of Congress Manuscript Reading Room, and Massachusetts Historical Society, where I had the great pleasure of participating in a 2001 conference, "Henry Adams and the Need to Know."

Also at the Smithsonian, I benefited from research assistance from Christine Hennessey, Robin Dettre, and Amelia Goerlitz at the Smithsonian American Art Museum Research and Scholars Center, and from librarians Pat Lynagh, Cecilia Chin, Anne Evenhaugen, and Douglas Litts. I often learned much from fellows in residence at the Smithsonian, and I especially thank Kimberly Hyde, Kathleen Lawrence, and Kate Lemay for their help on different occasions.

Cemeteries today have become more welcoming places for historians. Julia Bolton Holloway at the English Cemetery in Florence gave me a memorable tour and shared information about its history. Other cemetery specialists who offered assistance and a wealth of hard-won personal knowledge include David Downes at Rock Creek Cemetery, Washington, D.C.; Susan Olsen at Woodlawn Cemetery in New York's Bronx; Elise Ciregna at Forest Hills Cemetery in Boston; and Janet Heywood at Mount Auburn Cemetery, Cambridge, Massachusetts.

Among many others who offered generous aid over the years, I thank Charles Francis Adams IV, Natalie Dykstra, Marianne McCormally and Stephen F. Obarski, Caterina Pierre, and Brian Pohanka.

This book could not have been written without the work of those who have gone before. Influential work on specific artists has included studies of Augustus Saint-Gaudens by John Dryfhout, Henry Duffy, Kathryn Greenthal, Ruth Marcus, and Joyce Schiller. Michael Richman did the important early study on sculpture by Daniel Chester French, and much work remains to be done on this sculptor's lengthy career, largely untapped by scholars. Antoinette le Normand-Romain wrote about Paris cemeteries, and kindly took the time to talk with me about my project.

I also depended on the small but growing body of published information about specific cemeteries or cemeteries in specific cities. Among the most important for me were Blanche Linden's *Silent City on the Hill* about Mount Auburn Cemetery and *Spring Grove: Celebrating 150 Years*, both significant urban landscape studies. Gary Laderman's *The Sacred Remains* and David Sloane's *The Last Great Necessity: Cemeteries in American History* have added much to earlier discussions by writers. Thanks, too, to Elisabeth Roark for her long study of angelic figures in American cemeteries.

The manuscript gained editorially from a close review by the extraordinary Fronia W. Simpson. I thank Ginger Strader at the Smithsonian Institution Scholarly Press for believing in my book and making it a reality, and Deborah Stultz for shepherding it with great care through the production process.

On the personal side, I am also grateful to Joann Moser and Nicholas Berkoff for lending me their West Virginia home for a month at a much-needed time for reflection. All members of the McCormally clan, including my daughter Brenda, provided support at a

difficult time. My sister, Judy, brainstormed with me over the years, providing critical insights, as she drew her own challenging project to its conclusion, and, most important, kept me supplied with cookies and Finnish bread. Brother-in-law Frank "Skip" Conahan took photos at Mount Auburn and chauffeured us on a memorable trip to Maine. And through it all my husband, Sean McCormally, was chief companion, chauffeur, cameraman, and reader, whose faith in this book and gentle insistence helped me to bring it, finally, across the finish line.

NOTES

INTRODUCTION

1. See "Death's Sudden Summons," *Washington Post*, December 7, 1885, 1; "Mrs. Adams's Sudden Death," *New York Sun*, December 9, 1885, 7; and "The Sudden Death of Mrs. Adams," *New-York Daily Tribune*, December 11, 1885, 5. Ellen Gurney to Edwin L. Godkin, December 30, 1885, Godkin Papers, Houghton Library, Harvard University. Death certificate for Marian Adams, District of Columbia Health Department.

2. "Hell" is from Henry Adams (hereafter HA) to John Hay, December 8, [1885]; "calm," HA to Henry Cabot Lodge, December 14, 1885; "crushing," from HA to E. L. Godkin, December 16, 1885; "wretched bundle," HA to John Hay, December 17, 1885; and "endurance," HA to Oliver Wendell Holmes, December 29, 1885, all in J. C. Levenson et al., *The Letters of Henry Adams*, 6 vols. (Cambridge, Mass.: Belknap Press of Harvard University Press, 1982–88) (hereafter cited as *HA Letters*). Because the letters are arranged in these volumes in chronological order, only the date will be given.

3. HA to Henry Holt, March 8, 1886, in ibid.

4. Michel Foucault, *History of Sexuality* (New York: Vintage Books, 1980), 1:27. Vivien Green Fryd, "The 'Ghosting' of Incest and Female Liaisons in Harriet Hosmer's *Beatrice Cenci*," *Art Bulletin* 88, no. 2 (June 2006): 292–93, builds on this theme.

I. ADAMS'S QUEST FOR CONSOLATION

1. The literature on Adams is voluminous, including multivolume biographies by Ernest Samuels and Edward Chalfant as well as Patricia O'Toole's *The Five of Hearts: An Intimate Portrait of Henry Adams and His Friends, 1880–1918* (New York: Clarkson Potter, 1990). Adams family papers can be found at the Massachusetts Historical Society, and Henry Adams Papers from the collections of the Massachusetts Historical Society, the Houghton Library at Harvard University, and the John Hay Library at Brown University are accessible as a microfilm edition. Adams's third-person autobiography, *The Education of Henry Adams*, was posthumously awarded a Pulitzer Prize in 1919.

2. Robert Gould Shaw to his sister Effie, February 25, 1863 in *Blue-Eyed Child of Fortune: The Civil War Letters of Colonel Robert Gould Shaw*, ed. Russell Duncan (Athens: University of Georgia Press, 1992), 299. Clover's brother, Ned, also wrote many letters to her from his post on the Sea Islands off the coast of South Carolina, where he helped direct the care of former Southern slaves, known as contraband; see Natalie Dykstra, *Clover Adams: A Gilded and Heartbreaking Life* (Boston: Houghton Mifflin Harcourt, 2012), 33–36.

3. Marian Hooper to cousin Mary Louisa Shaw, Boston, May 28, 1865, in *The Letters of Mrs. Henry Adams, 1865–1883*, ed. Ward Thoron (Boston: Little, Brown and Co., 1936), 3–10, 468–71.

4. On their respective heights, see O'Toole, *The Five of Hearts*, 13. For the "clever woman" quote, see HA to brother Brooks Adams, March 3, 1872, in *HA Letters*.

5. HA to Charles Milne Gaskell, August 21, 1878, in *HA Letters*.

6. Kathryn Allamong Jacob, *Capital Elites: High Society in Washington D.C. after the Civil War* (Washington, D.C.: Smithsonian Institution Press, 1995), 2, 207.

7. Henry Adams encouraged her hobby but opposed publication of her pictures. After Clover's death, the *New York World*, December 10, 1885, described her as "a very skillful amateur photographer" who "was a member of the Amateur Photographers' Club here. She has made a number of very artistic negatives of distinguished people

among her friends and acquaintances." Her interest preceded the introduction of the popular handheld Kodak camera in 1888. Three albums containing 113 of her pictures, a notebook in which she listed dates and technical details about her photographs from May 1883 to January 1884, and an album of commercial photographs purchased during her European travels, captioned in her hand, are held by the Massachusetts Historical Society.

8. HA to Anna Barker Ward, December 27, 1885, in *HA Letters*.

9. HA to Henry Lee Higginson, March 27, 1885, in ibid.

10. For "tired traveler," see Marian Adams to John Hay, April 24, 1885; for "long and hard spell," see HA to Charles Milnes Gaskell, May 10, 1885, both in *HA Letters*. After Marian's death, an old friend, Eleanor Whiteside, wrote, "How often we have spoken of Clover as having all she wanted, all this world would give, except perhaps children. And now at forty years old, down comes a black curtain, & all is over." Eleanor Whiteside [1885], George C. Shattuck Papers, Massachusetts Historical Society.

11. See, for example, Dykstra, *Clover Adams*; and Eugenia Kaledin, *The Education of Mrs. Henry Adams* (Philadelphia: Temple University Press, 1981).

12. HA to Charles Milne Gaskell, November 8, 1885, and HA to Robert Cunliffe, November 29, 1885, in *HA Letters*. Tradition required a year of mourning for a parent, but these time periods were being relaxed by the mid-1880s. See Mary Elizabeth Sherwood, *Manners and Social Usages* (New York: Harper & Brothers, 1887), 192, and Richard A. Wells, *Manners, Culture and Dress of the Best American Society* (Springfield, Mass.: King, Richardson & Son, 1890), 318–19.

13. Rebecca Dodge Rae to Louisa Hooper Thoron, April 8, [1930s?], as cited in Edward Chalfant, *Better in Darkness: A Biography of Henry Adams; His Second Life, 1862–1891* (Hamden, Conn.: Archon Books, 1994), 499.

14. "Memorabilia," May 3, 1891, Charles Francis Adams II Papers, Massachusetts Historical Society.

15. "The Sudden Death of Mrs. Adams," *New-York Daily Tribune*, December 11, 1885, 5.

16. HA to Rebecca Dodge, December 6, 1885; HA to John Hay, December 8–9, 1885, in *HA Letters*. Hay had lost his father-in-law, Amasa Stone, to suicide in May 1883.

17. "Was It a Case of Suicide?" *Critic*, December 12, 1885; the *New-York Daily Tribune* and the *New York World* carried similar comments on December 11 and December 13, 1885, respectively. The newspapers suggested that Marian Adams was the author of the novel *Democracy*, which "savagely criticized" Washington society.

18. Henry James to Elizabeth Boott, January 7, 1886, London, in *Henry James Letters*, vol. 3, *1883–1895*, ed. Leon Edel (Cambridge, Mass.: Belknap Press of Harvard University Press, 1980), 107.

19. Ellen Gurney to Elizabeth Cabot, December 31, 1885 (envelope dated January 1, 1886), Swann Papers Family Collection, Stockbridge, Massachusetts, as quoted in Chalfant, *Better in Darkness*, 503–4, 840–43; Chalfant notes that Mrs. Gurney sent similar extracts from Clover's letter to editor E. L. Godkin on December 30, 1885.

20. Adams also telegraphed his brothers with the shocking news. Charles, never a favorite in-law of Clover's, recalled in his private journal in May 1891 that he was not surprised to learn of her sudden end. Charles said he had warned Henry before the marriage about her family's inherited "latent tendency to suicidal mania." One aunt, Susan Sturgis Bigelow, had poisoned herself when Clover was a child, and he remembered saying, "They're all crazy as coots." Charles wrote that Henry spoke freely with him in the days following Clover's death, indicating he had twice before pulled her through "morbid periods" and had believed he could save her again. "Memorabilia," Charles Francis Adams II Papers. Charles's recollections contain some errors, however, and Chalfant questioned his motivations for penning such a harsh account of Marian Adams's emotional frailty; *Better in Darkness*, 628–29. On asylums, see Carla Yanni, *The Architecture of Madness: Insane Asylums in the United States* (Minneapolis: University of Minnesota, 2007).

21. Kaledin, *The Education of Mrs. Henry Adams*, 33.

22. See Dykstra, *Clover Adams*, 200.

23. Ellen Gurney to Elizabeth Cabot, December 31, 1885.

24. Elisabeth Kübler-Ross, *On Death and Dying* (New York: Collier Books, 1993). Recently scholars have disputed the stages of mourning established by Kübler-Ross and revised notions about the intensity and duration of grief; see Ruth David Konigsberg, *The Truth about Grief: The Myth of Its Five Stages and the New Science of Loss* (New York: Simon & Schuster, 2011).

25. See Isabel Anderson, ed., *Letters and Journals of General Nicholas Longworth Anderson* (New York: F. H. Revell, 1942), December 9, 1885, 252.

26. Adams, *The Education of Henry Adams* (1918; New York: Time, 1964), 1:58–59.

27. Ibid. "Sister Lou" (Catherine Louise Kuhn, d. 1870, the wife of Charles Kuhn) was buried in a tomb in the Protestant Cemetery, the Cimitero degli Inglesi (the English Cemetery) in Florence. According to Sister

Julia Bolton Holloway, custodian and president of the Aureo Anello Associazione (Golden Ring Association) that oversees the cemetery, records verify the burial, but no marker remains.

28. HA to Elizabeth Cameron, December 10, 1885, and to John Hay, December 8, 1885 in *HA Letters*.

29. While much has been made of Henry Adams's pleas for silence and privacy, his immediate response was socially acceptable. "No one should call upon a bereaved family while the dead remains in the house, and they are excusable if they refuse to see friends and relatives. . . . No one of the immediate family of the deceased should leave the house between the time of the death and the funeral." Wells, *Manners, Culture and Dress of the Best American Society*, 314, 318.

30. According to an accounting filed with the Probate Court at Boston by Edward Hooper, executor of Marian Adams's estate, Reverend Hall was paid $250 on December 15 for his "services at funeral and trav exp." Schedule B, Executor's account filed January 31, 1890, in case No. 74682, Suffolk County Probate Court.

31. As quoted by Austin S. Garver in *Edward H. Hall: An Address Given in the Church of the Second Parish, Worcester, 14 April 1912* (Worcester, Mass., 1913), 6.

32. See, for example, "The Dying of Death," *American Monthly Review of Reviews* 20 (September 1899): 364–65.

33. Clover's relatives, especially her mother, had been part of a group of intellectual Massachusetts Transcendentalists. Although Robert Hooper kept a pew at King's Chapel Unitarian church in Boston, he rarely occupied it and was said to have expressed his religious feelings more "in his personal character" than in churchgoing. Clover herself did not embrace any institutionalized religion and liked to tweak the pomposity of church rituals. Ernest Samuels, *Henry Adams: The Middle Years* (1958; New York: History Book Club, 2003), 278; see also Kaledin, *The Education of Mrs. Henry Adams*, 32–33.

34. HA to John Hay, June 11, 1886, San Francisco, in *HA Letters*.

35. Adams had known La Farge since the early 1870s, when both were teaching at Harvard University, and possibly even earlier. La Farge was appointed a university lecturer in art composition at Harvard in 1871–72. The two men had overlapping circles of friends, including John Bancroft, with whom Adams traveled in Germany in 1859 and who was a Newport neighbor of La Farge's in 1860. James L. Yarnall, *John La Farge: A Biographical and Critical Study* (London: Ashgate, 2012), 54, 137. Helene Barbara Kallman Weinberg, "The Decorative Work of John La Farge" (Ph.D. diss., Columbia University, 1972), 128n1.

36. Lawrence W. Chisolm, *Fenollosa: The Far East and American Culture* (New Haven: Yale University Press, 1963), 61–63.

37. For references to the monument as a Buddha figure, see diary entries for April 29 and December 10, 1888, in *HA Letters*.

2. THE MILMORES AND THE SPHINX

1. For the sphinx's journey to the cemetery, see "Mount Auburn Cemetery," *Boston Evening Transcript*, August 16, 1872, 2. The granite block from which it was carved measured 15 by 8 feet.

2. The essential source on Bigelow and the creation and evolution of Mount Auburn has been Blanche Linden-Ward, *Silent City on a Hill: Landscapes of Memory and Boston's Mount Auburn Cemetery* (Columbus: Ohio State University Press, 1989). An expanded edition has since been published: Blanche M. G. Linden, *Silent City on a Hill: Picturesque Landscapes of Memory and Boston's Mount Auburn Cemetery* (Amherst: University of Massachusetts Press, 2007). Bigelow and the sphinx are also treated in Joy Giguere, *Characteristically American: Memorial Architecture, National Identity, and the Egyptian Revival*, forthcoming from the University of Tennessee Press.

3. See Jacob Bigelow, *An Account of the Sphinx at Mount Auburn* (Boston: Little, Brown, and Co., 1872), 13–14.

4. Ibid. On the need for a good death, see Drew Gilpin Faust, *This Republic of Suffering: Death and the American Civil War* (New York: Alfred A. Knopf, 2008). Bigelow apparently referred Milmore, among other things, to sphinxes pictured in an eighteenth-century travel book about Egypt and to a print of a restored avenue of sphinxes that served as the frontispiece to his own 1842 volume, *The Useful Arts Considered in Connexion with the Applications of Science* (New York: Harper & Brothers Publishers).

5. On Bigelow's blindness, see Linden-Ward, *Silent City on a Hill*, 293–94, and George E. Ellis, *Memoir of Jacob Bigelow, M.D., LL.D.* (Cambridge, Mass.: John Wilson & Son, 1880), 71.

6. "Art," *Atlantic Monthly* 31, no. 183 (January 1873): 116.

7. Quoted in Frank Foxcroft, "Mount Auburn," *New England Magazine* 20, no. 4 (June 1896): 428.

8. On French's visit to the Sphinx, see diary extracts, French Family Papers, Library of Congress.

9. Marian Hooper Adams to her father, Robert Hooper, from Paris, April 20, 1873, in Thoron, *The Letters of Mrs. Henry Adams*, 93.

10. For the Daniel Chester French quotes, see French's letter to A[deline] A[dams], February 7, 1931, as cited in "Milmore, Martin," in *Dictionary of American Biography* (New York: Charles Scribner's Sons), 7:18.

11. Roxbury, a fast-growing independent city, was annexed by Boston in 1868.

12. Milmore's drawing (preserved by the headmaster with a chemical spray) and those by two other students were still there when the Brimmer free elementary school was closed in 1911 for conversion into a boys' trade school. See "Milmore's Youthful Blackboard Sketch Is in Jeopardy from Brimmer School Dismantling," *Christian Science Monitor*, May 27, 1911, 4.

13. *American Architect and Building News* 19, no. 527 (January 30, 1886): 49.

14. Thomas Ball, *My Three Score Years and Ten: An Autobiography*, 2nd ed. (Boston: Roberts Brothers, 1892), 223–24. "Martin Milmore, Sculptor," obituary, *Boston Daily Globe*, July 22, 1883, 6.

15. "Problems of Sculpture," *Boston Evening Transcript*, April 7, 1862, sec. 2, 5.

16. See "The Sanitary Fair," November 23, 1864, 2; "Sculpture," April 23, 1864, 2; "Milmore," November 23, 1864, 2; "What Shall I Buy for a Christmas Gift?" and "Phosphor," December 6, 1864, 1, 2; and De Vries, Ibarra & Co. ad, December 9, 1864, 3, all in the *Boston Evening Transcript*. Articles on artists from the *Evening Transcript* were among those compiled from nineteenth-century sources by Colonel Merl M. Moore Jr., now on file in the Smithsonian American Art Museum/National Portrait Gallery Library, Smithsonian Institution. See also Jan Seidler and Kathryn Greenthal, *The Sublime and the Beautiful: Images of Women in American Sculpture, 1840–1930* (Boston: Museum of Fine Arts, Boston, 1979), 19.

17. On the Horticulture Hall sculptures, see Ball, *My Three Score Years and Ten*, 236; "Martin Milmore," letter to the editors, *New York Evening Post*, August 7, 1866, 1; as well as reports in the *Boston Evening Transcript*, April 20, May 15, May 30, and June 1, 1866, all on page 2, and June 6, 1866, 3. James and Joseph had established a sculpture business together as "J & J Milmore."

18. On Emerson's sitting, see Irving H. Bartlett, ed., "The Philosopher and the Activist: New Letters from Emerson to Wendell Phillips," *New England Quarterly*, June 1899, 293–95. Milmore's 1865 bust of Charles Sumner in neoclassical garb was especially well received for its "spirited" and "lifelike" appearance and won a gold medal at the 1869 exhibition of the Massachusetts Charitable Mechanic Association. "Massachusetts Charitable Mechanic Association," *Boston Evening Transcript*, October 27, 1869, 1.

19. For the quote, see "The Bronze Statue of a Union Soldier," *Boston Evening Transcript*, February 18, 1868, 2.

20. The Milmore brothers made Civil War soldier statues or portrait statues for at least ten cities in New England and Pennsylvania as well as a six-foot-long *Weeping Lion* (1871) at Colby College in Waterville, Maine, commemorating students and alumni who died in the Civil War. This may have influenced Bigelow in his commission for the monumental sphinx. Bigelow had been inspired by examples such as the colossal dying lion designed by Bertel Thorvaldsen that was carved into a cliff at Lucerne, Switzerland, in memory of Swiss royal guards killed in the French Revolution. On Milmore, see Chandler Rathfon Post, "Martin Milmore," in *Art Studies, Medieval, Renaissance and Modern*, vol. 3 (Cambridge, Mass.: Harvard University Press, 1925), 41–60.

21. It is likely that the three Milmore brothers who worked as sculptors (the fourth brother, Charles, was listed in the city directory as a carpenter) made grave markers or monuments in their early years, since that was the stonecutters' bread and butter. One of Martin's earliest works, for example, was a bas-relief at Mount Auburn of the Universalist minister Thomas Whittemore (ca. 1862). He is also believed to have sculpted a life-size dog dated 1866 at the Wingate gravesite there, honoring two young brothers.

22. "Death of James Milmore," *Evening Transcript*, December 27, 1872, 1. According to his death certificate, he died of Bright's disease. His occupation was listed as "sculptor." Martin and Joseph purchased the cemetery lot for $1,200 in 1877, according to the deed.

23. *American Architect and Building News* 19, no. 527 (January 30, 1886): 49.

24. The city council chose Milmore's revised $75,000 proposal for a thirteen-foot statue of the Genius of America atop a tall column, with figures representing the Soldier, Sailor, History, and Peace at the base and female allegorical figures above. The monument was dedicated on September 17, 1877, with a grand procession, fireworks display, and banquets, and described in the next day's *Boston Morning Journal*. The *New York Evening*

Post reported, however, that Milmore's mother was injured at the dedication when a platform fell, causing her to break a hip; *Evening Post*, September 25, 1877, 2. The monument became a model for other large group war memorials across the country; see Peggy McDowell, "Martin Milmore's Soldiers' and Sailors' Monument in the Boston Common: Formulating Conventionalism in Design and Symbolism," *Journal of American Culture* 11, no. 1 (Spring 1988): 63–85.

25. "I have engaged to pay Martin Milmore the artist $2500 to make a marble monument and set it on my lot at Mount Auburn. The angel's face to be a likeness of my deceased daughter's face, Maria Frances Coppenhagen" (1838–1869); quote from the will of Mehitable Coppenhagen, dated March 24, 1871, as cited by Ernest Rohdenburg III in "A Bid for Immortality: The Sculpture and Life of Martin Milmore" (accessed October 27, 2000), at www.antiquesamerica.com/features/elibrary/printabble.cfm?ArticleNo=550.

26. Lorado Taft, *The History of American Sculpture* (New York: Macmillan Co., 1903), 253. A failure for Milmore was his model for an equestrian statue of Robert Gould Shaw, which he exhibited at the Massachusetts Charitable Mechanic Association in 1874. A New York critic said it had "hardly a redeemable feature to raise it above the baldest mediocrity"; see E. M., "Art in Boston," *New York Evening Post*, September 21, 1874, 2. Shaw and his troops would eventually be memorialized in Boston instead with a high-relief monument by Augustus Saint-Gaudens, who practiced a more modern French-influenced brand of sculpture.

27. Milmore was an officer of the Boston Art Club and won prizes from the Mechanic Association; see *Boston Evening Transcript*, February 20, 1880, 1. He left no significant body of correspondence. His busts were shown regularly at the Doll & Richards art gallery in Boston. A number of reductions of his busts and statues were marketed in Parian ware for small prices, available for home settings. Lithographs of the Sumner bust and of the Soldiers and Sailors monuments were also sold. All of Milmore's known commissions are in Massachusetts, New York State, Pennsylvania, New Hampshire, and Maine.

28. October 9, 1872, passport application in the Colonel Merl M. Moore Jr. Papers, American Art Museum/National Portrait Gallery Library, Smithsonian Institution.

29. See *Boston Directory*, 1871 and 1883. On his engagement, see "Milmore, Martin," in *National Cyclopaedia of American Biography* (New York: James T. White & Company, 1900), 8:291.

30. According to an obituary in the *Boston Evening Transcript*, he suffered "a chronic affection [*sic*] of the liver." His last work, a bust of Daniel Webster commissioned for the New Hampshire statehouse, was left in clay for Joseph to finish.

31. "Martin Milmore's Funeral," *Boston Daily Globe*, July 24, 1883, 5; "Martin Milmore Buried," *New York Times*, July 25, 1883, 2. The Reverend Father O'Toole and other priests presided.

32. Joseph Milmore and lawyer James Bailey Richardson were named co-executors in the January 1882 will and instructed to sell three lots of property remaining in the estate to cover the costs of erecting the cemetery monument. "The Sculptor Milmore's Will," *New York Times*, August 2, 1883, 5. Probate Court, Suffolk County, records, No. 69830, November 1883.

33. "Martin Milmore's Money," *Boston Daily Globe*, September 14, 1884, 2. For Mrs. Hanley's death notice, see "Obituary Notes," *New York Times*, March 9, 1909, 9.

34. Forest Lawn Cemetery interment records state that Sarah Milmore died on May 31, 1884. Joseph had made a number of copies of Martin's designs over the years as well as his own work, including a marble statue of Lord Dufferin in Montreal (ca. 1878), of which a bronze version was commissioned for London's Hyde Park, and the newspapers reported that he was commissioned to make a grave statue for department store mogul A. T. Stewart.

35. Joseph's death on January 10, 1886, was reported on the front page of the *Globe*, attesting to his final celebrity in Boston. "The deceased, although eccentric in some respects," the newspaper reported, "was a man of marked ability in his profession, and of warm and generous impulses"; "Joseph Milmore Dead," *Boston Globe*, January 16, 1886, 1.

36. His body was placed in a receiving vault until September 4, 1886, when memorial services were held at Forest Hills Cemetery.

37. "Milmore's Will to Be Contested," *New York Times*, February 20, 1886, 3.

38. "The Artist Milmore's Widow," *New York Times*, February 21, 1886, 5.

39. "The Will of Joseph Milmore," *Boston Evening Transcript*, January 10, 1888, 1. Mary Milmore agreed to give Charles $1,000 in cash and deeds to several houses,

40. "Joseph Milmore's Will," *Boston Daily Globe*, February 19, 1886, 4.

1. On the sea voyage, see Francis Boott, *Recollections of Francis Boott for His Grandson F.B.D.* (Boston: Southgate Press, 1912), 58–59, and passenger list of the ship *Sophia Walker*, bound for Genoa, *Boston Daily Evening Transcript*, September 27, 1847. For details of the Bootts' biography, see Carol M. Osborne, "Lizzie Boott at Bellosguardo," in *The Italian Presence in American Art, 1860–1920*, ed. Irma B. Jaffe (New York: Fordham University Press, 1992), 188–99; and Michael P. Vargas, *Elizabeth Boott Duveneck: Her Life and Times* (Santa Clara, Calif.: Triton Museum of Art, 1979).

2. For the "produced" quote, see Henry James, "Notes of a Son and Brother," in *Henry James: Autobiography*, ed. Frederick W. Dupee (New York: Criterion Books, 1956), 520.

3. See Alta Macadam, *Americans in Florence: A Complete Guide to the City and the Places Associated with Americans Past and Present* (Florence: Giunti Guide, 2003). Boott, *Recollections of Francis Boott*, 66.

4. Boott at first published his songs under the name "Telford"; see *Boston Globe*, March 6, 1904, 42, which reported that his best-known song was "Here's a Health to King Charles." For their intersections with the Shaws in Europe, see Boott, *Recollections of Francis Boott*, including 69–71. A number of Boott's compositions are to songs speaking of the heart seeking solace or the impossibility of forgetting loss; see, for example, "The Mind Has a Thousand Eyes, the Heart but One."

5. William James to Henry Bowditch, August 12, 1869, in *The Letters of William James*, ed. Henry James (1920; repr., New York: Kraus Reprint Co., 1969), 155. Henry corresponded more than eighty times with Lizzie over the course of her life. He is said to have partially modeled Adam and Maggie Verver in *The Golden Bowl* (1904) on the Bootts and made their villa the setting for his *Portrait of a Lady*.

6. Hunt had studied with Couture and recommended him as a teacher. Henry James wrote about the exhibition at the Boston Art Club in the *Nation*, June 3, 1875, where he famously called Duveneck "an unsuspected man of genius."

7. Frank Duveneck's oil painting, *Francis Boott*, 1881, is now in the Cincinnati Art Museum.

8. On Elizabeth Boott's exhibitions, see, for example, "Art and Artists," *Boston Daily Globe*, November 19, 1882, 3, "The Exhibition of Misses Boott and Dixwell" at Chase's Gallery, in which Boott's "vigorous" oil painting technique is admired. See also reviews in the *Boston Evening Transcript* on November 25, 1882 (where her painting of a gypsy was called "curiously unfeminine to come from the hand of a woman"); October 22, 1883; February 5 and 11, 1884; and April 30, 1885. Boott showed sixty-six paintings at Doll & Richards gallery in Boston in 1884.

9. Henry James to Charles Eliot Norton, March 31, 1880, Florence, and to Mrs. Henry James Sr., March 16, 1881, Genoa, in *Henry James Letters*, vol. 2, *1875–1883*, ed. Leon Edel (Cambridge, Mass.: Belknap Press of Harvard University Press, 1975), 280, 349; and James to Henrietta Reubell, March 11, 1886, in Edel, *Henry James Letters, 1883–1895*, 117. James mentioned that he himself had "no less than three Boots on my wall" and worried that Lizzie would not be able to maintain her career. At the time of the Boston Art Club show in 1875, a *New York Evening Post* account on July 29 described Duveneck as "the young Western artist," another indication that he was an outsider. On James and Duveneck, see Mahonri Sharp Young, "Duveneck and Henry James: A Study in Contrasts," *Apollo* 92 (September 1970): 210–17.

10. Josephine Duveneck, *Frank Duveneck: Painter-Teacher* (San Francisco: John Howell Books, 1970), 115: "Since Duveneck understood no French, Lizzie had to prod him to say 'oui.'" On the premarital agreement by which Duveneck relinquished "any claim to Lizzie's estate should she predecease him," see Carol M. Osborne, "Frank Duveneck & Elizabeth Boott Duveneck: An American Romance," essay for an exhibition at Owen Gallery, New York, 1996, www.tfaoi.com/aa/2aa/2aa572.htm.

11. Elizabeth Boott to the Richard Morris Hunt class, July 22, 1879, part of a letter to "Dear Friends" in several installments beginning June 22, 1879, Archives of American Art, Smithsonian Institution, reel 1097 (original letters, Cincinnati Historical Society). Lizzie called Duveneck "Herr Professor" in this letter, written while she was studying with him in Bavaria.

12. Ibid.

13. A July 27, 1875, passport application lists Duveneck's height, eye color, and other descriptive information; a copy is in the artists' files, Cincinnati Art Museum. "He was a real swell, swinging a cane and tossing a Munich cape back from his shoulders," Clement Barnhorn is quoted as saying in Duveneck, *Frank Duveneck, Painter-Teacher*, 55.

14. His name may also have been an allusion to Frank Boott, Lizzie's brother who had died in infancy in 1845, and of course to Frank Duveneck. Henry James once jestingly called Lizzie "the queen of the Franks"; James to Francis Boott, May 25, [1886,] in Edel, *Henry James Letters, 1883–1895*, 120.

15. Elizabeth Boott Duveneck, March 13, 1888, quoted in Duveneck, *Frank Duveneck, Painter-Teacher*, 120. Lois Dinnerstein in "From Private Grief to Public Monument: The Funeral Effigy of Elizabeth Boott Duveneck," in Jaffe, *The Italian Presence in American Art, 1860–1920*, 200–213, raises the possibility that Lizzie's death was a suicide, based on a phrase used by Alice James, as did Jean Strouse in *Alice James: A Biography* (Boston: Houghton Mifflin, 1980), 270. But other responses from friends and family members to her death do not support their awareness of such a self-destructive event. Constance Woolson, for example, wrote Francis Boott on September 15, [1888], "In all your grief and loneliness, it must still be a pleasure to remember how happy her life was during these last two years . . . I think she was one of the happiest wives I have ever known"; quoted in Osborne, "Lizzie Boott at Bellosguardo," 198. Lizzie's own ebullient letters from her early marriage and the birth of Frank Jr. also argue against the notion of her having become suicidal.

16. Frank Duveneck to brother Charles Duveneck, March 23, 1888, Frank and Elizabeth Duveneck Papers, Archives of American Art, Smithsonian Institution, reel 1150.

17. Ibid.

18. See Luigi Santini, "The Protestant Cemetery of Florence: Called the English Cemetery," www.florin.ms/cemetery.html. After Elizabeth's burial, other artists and writers, including Thomas Ball, were interred on the hillside there.

19. For the James quote, see Duveneck, *Frank Duveneck, Painter-Teacher*, 121. Elizabeth's nanny, Ann Shenstone, placed at the foot of the grave "a little round marble stone marked in loving & reverent memory from her old nurse"; letter from Ella [Lyman], December 21, 1894, in Duveneck Papers, reel 1097.

20. "Frankie" was raised by his great-uncle Arthur Theodore Lyman (1832–1915), the half brother of Elizabeth's mother, and his wife, Ella Bancroft Lowell Lyman (1837–1894), who had had seven children of their own. The youngest, Robert, was nine when Frank arrived. Lyman, who headed textile manufacturing businesses, was also an adviser to major cultural institutions such as Harvard University and the Boston Athenaeum. Duveneck painted his portrait in 1893. See "Death of Arthur T. Lyman," *New York Times*, October 25, 1915; Samuel A. Eliot, *Biographical History of Massachusetts: Biographies and Autobiographies of the Leading Men in the State*, vol. 7 (Boston: Massachusetts Biographical Society, 1917); and Historic New England, Lyman Estate History, www.historicnewengland.org/historic-properties/homes/lyman-estate/lyman-estate-history/. The Lymans had a home on Beacon Street in Boston and a summer estate called the Vale in Waltham, Massachusetts. Duveneck visited regularly, but, according to Josephine Duveneck, Frankie's wife, the son never saw his Duveneck grandmother and had no relationship with Duveneck's family in Covington, making his first visit there only after Francis Boott's death. See Duveneck, *Frank Duveneck, Painter-Teacher*, 154, and Josephine Duveneck, *Life on Two Levels: An Autobiography* (Los Altos, Calif.: William Kaufmann, 1978), 83–86.

21. Henry James to Henriette Reubell, April 1, 1888, in Edel, *Henry James Letters, 1883–1895*, 230–31.

22. Duveneck, *Frank Duveneck, Painter-Teacher*, 125, quotes an August 22, 1888, journal entry by Mrs. Lyman.

23. F. Boott, *Miserere for Four Voices* (Boston: O. Ditson & Co., 1888; No. 3606 Oliver Ditson Company's Sacred Selections); a copy is in the collection of the Loeb Music Library, Harvard College. *Miserere* was Gregorio Allegri's 1630s masterpiece, sung at the Sistine Chapel.

24. "The Fine Arts," *Boston Evening Transcript*, April 21, 1888, 10.

25. After his wife's death, Duveneck returned first to Boston, then Cincinnati, spending summers in Gloucester, Massachusetts, to be near his son, and frequently traveling abroad. The drawing is in the collection of the Cincinnati Art Museum, the gift of Frank Duveneck. "He showed us the drawing taken of dear Lizzie after she died by his friend Mr. Ritter," Ella Lyman wrote in her journal, August 22, 1888, as quoted in Duveneck, *Frank Duveneck, Painter-Teacher*, 124.

26. On Story's life and career, see Mary E. Phillips, *Reminiscences of William Wetmore Story, the American Sculptor and Author* (Chicago: Rand, McNally & Co., 1897); the biography by Henry James, *William Wetmore Story and His Friends*, 2 vols. (Boston: Houghton, Mifflin & Co, 1903); and Jan Seidler Ramirez's biographical essay in Kathryn Greenthal, Paula Kozol, and Jan Seidler-Ramirez, *American Figurative Sculpture in the Museum of Fine Arts, Boston* (Boston: Museum of Fine Arts, Boston, 1986), 107–9. The Harry E. Ransom Humanities Research Center, University of Texas, Austin, holds a major collection of Story papers. For "born by mistake," see M. E. W. Sherwood, "William Wetmore Story," *New York Times*, April 2, 1898, book review sec., 230.

27. Phillips, *Reminiscences of William Wetmore Story*, 276.

28. James, *William Wetmore Story and His Friends*, 2:76–77.

29. Marian Hooper Adams to Robert Hooper, Paris, April 20, 1873, in Thoron, *The Letters of Mrs. Henry Adams*, 94–95.

30. "I Am Weary of Rowing," sheet music, Oliver Ditson & Co., 1857, music by F. Boott, words by W. W. Story. Boott also composed music for Story's "Garden of Roses" published in 1863 (see Figure 8); "I walked in the garden of roses with thee, In the garden where never again we shall be, And thy ghost in the garden is all that I see, For thou comest never, oh! Never. . . . Alone in the garden I cry in my pain."

31. See Annette Blaugrund, *Paris 1889: American Artists at the Universal Exposition* (New York: Harry N. Abrams, 1989), 23–24.

32. For "my life, my joy," see James, *William Wetmore Story and His Friends*, 2:316. On the fainting episode, see Sherwood, "William Wetmore Story."

33. Phillips, *Reminiscences of William Wetmore Story*, 277.

34. "Mrs. W. W. Story's Funeral: A Large and Sorrowful Gathering at the American Church in Rome," *New York Herald*, January 12, 1894.

35. "Obituary Notice of My Dear Wife: A Sculptor's Wife, the Contribution of an Able Helpmate to a World-Wide Fame," *Boston Evening Transcript*, April 20, 1894.

36. W. W. Story to "My Dear Julian," January 25, 1894, Rome, Harry Ransom Humanities Research Center. My thanks to Kathleen Lawrence for sharing her research on the Story materials in Austin.

37. William Vance, *America's Rome*, vol. 2, *Catholic and Contemporary Rome* (New Haven: Yale University Press, 1989), 211.

38. Phillips, *Reminiscences of William Wetmore Story*, 287.

39. James, *William Wetmore Story and His Friends*, 2:324.

40. Henry James to Francis Boott, October 11, [1895], in *Henry James Letters*, vol. 4, *1895–1916*, ed. Leon Edel (Cambridge, Mass.: Belknap Press of Harvard University Press, 1984), 23.

41. On the church, see Vance, *Catholic and Contemporary Rome*, 268–69.

4. EMOTIONAL REGULATION

1. Samuels, *Henry Adams: The Middle Years*, 281, also states that Adams came down to dinner that day wearing a bright red tie (thus flouting mourning dress traditions for men to wear black ties). Chalfant, *Better in Darkness*, 842n6, says, however, that he was never able to substantiate the story of the red tie.

2. Philippe Ariès, *Western Attitudes toward Death from the Middle Ages to the Present* (Baltimore: Johns Hopkins Press, 1974), 85–90. Martha V. Pike and Janice Gray Armstrong, *A Time to Mourn: Expressions of Grief in Nineteenth Century America* (Stony Brook, N.Y.: The Museums at Stony Brook, 1980), 11. Thoron, *The Letters of Mrs. Henry Adams*, 272n1, states that the Hoopers had inherited a "stoical custom" from their grandfather William Sturgis that "discouraged conventional outward signs of mourning."

3. Advertisements for stores featuring mourning garments could be found in publications such as *Godey's Lady's Book and Magazine* in the 1860s; see Faust, *This Republic of Suffering*, 152. Karen Halttunen, *Confidence Men and Painted Women: A Study of Middle-Class Culture in America, 1830–1870* (New Haven: Yale University Press, 1982), 124.

4. Embalming was developed, for example, to enable the transport of soldiers' bodies home from distant battle sites. David Charles Sloane, *The Last Great Necessity: Cemeteries in American History* (Baltimore: Johns Hopkins University Press, 1991), 119–20. Marian Adams left a $40,000 estate. For the undertaker's payment, see inventory of the estate of Marian Adams by Edward W. Hooper, executor, May 26, 1890, Probate Court, Boston; archives of the Massachusetts Supreme Judicial Court, Boston.

5. The first national meeting of funeral directors was held in 1882 in Rochester, New York. The funeral director "moved in the direction of being a seller of personal services. The new role involved him closely with the bereaved, which he now conceived of as distraught human beings rather than as customers for his wakes." Robert W. Habenstein and William M. Lamers, *The History of American Funeral Directing* (Milwaukee: Bulfin Printers, 1955), 475–77.

6. Florence Howe Hall, *Social Customs* (Boston: Estes and Lauriat, 1887), 256. Florence Howe Hall, *The Correct Thing in Good Society* (Boston: Estes and Lauriat, 1888), 202. The author was the daughter of Julia Ward Howe, who wrote "The Battle Hymn of the Republic," and a descendant of one of the framers of the U.S. Constitution.

7. John Kasson, *Rudeness & Civility: Manners in Nineteenth-Century Urban America* (New York: Hill and Wang, 1990) describes authors and audiences for such guides and their discussions of "feeling rules"; see esp. chapters 2 and 5, quote at page 5.

8. *Decorum: A Practical Treatise on Etiquette and Dress of the Best American Society* (New York: Union Publishing House, 1880), 254, 256.

9. Blanche M. G. Linden, *Spring Grove: Celebrating 150 Years* (Cincinnati: Cincinnati Historical Society, 1995), 93.

10. Sloane, "Retreat from Sentimentality," chap. five in *The Last Great Necessity*, 99–127.

11. Charles Darwin, *The Expression of the Emotion in Man and Animals* (London: John Murray, 1872), chap. 7.

12. Daughter Alice Longworth regretted that "he never even mentioned my mother to me." See *Mrs. L: Conversations with Alice Longworth* (Garden City, N.Y.: Doubleday & Company, 1981), 4. Kasson, *Rudeness & Civility*, 180, refers to "deep acting" based on habitual emotional management to achieve polished social performances.

13. *Decorum*, 260.

14. Rose E. Cleveland et al., *Our Society: A Complete Treatise of the Usages That Govern the Most Refined Homes and Social Circles* (Detroit: Darling Publishing Co., 1893), 289, 296.

15. Halttunen, *Confidence Men and Painted Women*, 132.

16. Hall, *Social Customs*, 264; Hall, *The Correct Thing in Good Society*, 208. By 1924 Margaret Emerson Bailey wrote in *A Book of Manners: Present-Day Customs and the Courtesies of Social Intercourse* (New York: McCall's Magazine, 1924), 28: "Many persons do not put on mourning even for the closest kin, the idea being that by appearing in somber garments they inflict their sorrow on the notice of a world which is quite uninterested."

17. In Massachusetts, for example, the life expectancy of a white male born in 1850 was calculated at just 38.3 years, while by 1920 it was 54.1 years. Nationwide figures are not available before 1900. Expectation of life at birth nationwide was 48.2 years for a white male in 1900–1902, compared with 56.3 years for the period 1919–21, according to Census statistics. See charts B126–135 and B116–125, U.S. Department of Commerce, *Historical Statistics of the United States: Colonial Times to 1970* (White Plains, N.Y.: Kraus International Publications, 1989), 1:56.

18. On the special fears of Bostonians, see, for example, Vincent J. Cannato, "Immigration and the Brahmins," *Humanities*, May–June 2009, 12–17.

19. See "Irish Wakes," on the Irish Apostolate website, http://usairish.org/pastoral-care/irish-rituals/ (accessed February 2014), and in Sean Connolly, ed., *Oxford Companion to Irish History* (New York: Oxford University Press, 2007). The casket could have been uncovered or covered by a nicely ornamented black cloth called a pall. It was unlikely that anyone but the priest(s) and perhaps altar boys would have received communion, given the requirement for fasting beforehand, which was not practiced when a wake was held. My thanks to Mariann McCormally and Stephen F. Obarski for their assistance in understanding what a Catholic requiem Mass might have included at the turn of the century.

20. "Wm. H. Vanderbilt Dead," *New York Sun*, December 9, 1885, 1; "Mr. Vanderbilt's Funeral," *New-York Daily Tribune*, December 11, 1885.

21. *Mourning Glory: An Exhibition on Nineteenth-Century Customs and Attitudes toward Death and Dying* (Wilmington, Del.: Eleutherian Mills-Hagley Foundation, 1980), intro. by Mary Durham-Johnson, 3. Elaine Nichols, ed., *The Last Miles of the Way: African-American Homegoing Traditions, 1890–Present* (Columbia, S.C.: South Carolina State Museum, 1989), 24–29. Karla F. C. Holloway has noted that African Americans, especially vulnerable to early death due to low income and lack of equal access to the best diet, housing, and medical care, often practiced expressive funerals and retained a sense of the presence of haunts and spirits; Holloway, *Passed On: African American Mourning Stories; A Memorial* (Durham, N.C.: Duke University Press, 2002).

22. Adams gave friends Rebecca Dodge and Elizabeth Cameron, a senator's wife who became his emotional confidante, gifts of his dead wife's jewelry; see Chalfant, *Better in Darkness*, 506–7.

23. Sigmund Freud, *Mourning and Melancholia*, 1917, republished in revised form in *The Standard Edition of the Complete Psychological Works of Sigmund Freud*, trans. James Strachey with Anna Freud (London: Hogarth Press and Institute of Psycho-Analysis, 1914–16), vol. 14, 245–58. On the comparison with slides, see James E. B. Breslin, book review, *New York Times*, July 24, 1994. On prolonged grief disorder, see Fran Schumer, "After a Death, the Pain That Doesn't Go Away," *New York Times*, September 29, 2009, D1, D6.

1. William Walton, "A Higher Quality in Funerary Monuments," *American Architect* 100, no. 1854 (July 5, 1911).

2. Writers of fiction have also addressed the issue. Marguerite Yourcenar, in her novel *Memoirs of Hadrian*, for example, described how the Roman emperor had animals killed to see if he could observe their spirits departing the body.

3. For Raboteau's comments and others, see Robert J. Kastenbaum, *Death: A Personal Understanding* (Annenberg Media, Sleeping Giant Productions, 1999), video 1, "What Is Death?" The course is based on Kastenbaum's classic textbook, *Death, Society, and Human Experience*, 10th ed. (Boston: Allyn & Bacon, 2009), see esp. chap. 2.

4. Hall, *Social Customs*, 255.

5. Sherwood, *Manners and Social Usages*, 188.

6. Despair was associated with Sloth, denoting an unease of mind and failure to fully accept God's order of things.

7. Halttunen, *Confidence Men and Painted Women*, 125–26. The ideas of eighteenth-century scholar Emanuel Swedenborg, who postulated a heaven not far removed from earth that corresponded to the beauty of nature, proved influential.

8. For "dogged optimism," see Linden-Ward, *Silent City on a Hill*, 322.

9. The same firms, like the large Memorial Card Company of Philadelphia, might sell "Hail Mary" prayer cards for their Catholic clientele; see advertisement, Memorial Card Co. of Philadelphia, from the Joseph Downs Collection of Manuscripts and Printed Ephemera, Winterthur Library, Winterthur, Delaware.

10. C. A. Belin to Mrs. du Pont, April 12, 1880, Box 79, Series E, group 9, Mrs. Samuel Francis du Pont, Hagley Museum and Library, Wilmington, Delaware.

11. Jane Stanford to Bishop and Mrs. Newman, 1893, n.d.; Jane Stanford to Susan M. Harvey, July 15, 1893, on black-bordered stationery, Stanford Family Papers, Stanford University Archives. The statue at Stanford University was designed by Larkin Mead and dated 1899.

12. Hall's sermon quoted in Garver, *Edward H. Hall, An Address Given in the Church of the Second Parish*.

13. James De Normandie, *Address Delivered on February 25th, 1912, at the Funeral of Edward H. Hall, D.D., Minister of the First Parish, Cambridge, from 1882 to 1893* (Cambridge, Mass.: First Parish, 1912).

14. Adams, *The Education of Henry Adams*, 1:35–36. According to James Freeman Clarke's *Manual of Unitarian Belief* (Boston: Unitarian Sunday-School Society, 1884), Lesson 9:61, "Unitarians believe that the future life will be a continuation of the present life, with opportunity for further growth and development. They think that every man will go 'to his place,' the place where he belongs, the place where it is best for him to be. Jesus says, 'In my Father's house are many mansions; if it were not so I would have told you' (John 14.2)."

15. John Hay to Henry Adams, December 9, 1885, in *HA Letters*.

16. See, for example, T. J. Jackson Lears, *No Place of Grace: Antimodernism and the Transformation of American Culture, 1880–1920* (New York: Pantheon Books, 1981), which develops the theme of openness to a therapeutic culture drawing from many sources among those seeking meaning in this period.

17. Phillips Brooks to sister-in-law "Lizzie" Brooks, January 30, 1883. Brooks traveled to India from December 1882 to March 1883, visiting temples and other tourist sites, including the Bo tree where Buddhism began. "India has interested me intensely," he wrote Herr von Bunsen on January 28, 1883. "I long to see Christianity come here, not merely for what it will do for India, but for what India will do for it. Here it must find again the lost oriental side of its brain and heart." Alexander V. G. Allen, *Life and Letters of Phillips Brooks* (New York: E. P. Dutton, 1900), 2:392–93.

18. Carl T. Jackson, *The Oriental Religions and American Thought* (Westport, Conn.: Greenwood Press, 1981), 143.

19. See Alan Chong and Noriko Murai, eds., *Journeys East: Isabella Stewart Gardner and Asia* (Boston: Isabella Stewart Gardner Museum, 2009) for Gardner's journal describing their journey; for the quote, see Chong's "Introduction," 18–19.

20. Frances Snow Compton [Henry Adams], *Esther: A Novel* (New York: Henry Holt and Co., 1884). The chief character is caught between religion (the Episcopal minister) and science, each presented as a form of profound mystery; she cannot accept either as providing the answer she requires after her father's death. Clarence King told John Hay in a letter of July 4, 1886, that in *Esther* Adams had "exposed his wife's religious experiences and as it were made of her a clinical subject vis-à-vis of religion." Clarence King Papers, 1877–1934, Massachusetts Historical Society.

21. See Kastenbaum, *Death, Society, and Human Experience*, 526.

22. William James, *The Varieties of Religious Experience: A Study in Human Nature* (1902; repr., New York: Modern Library Edition, 1994), 184, 175.

23. Ibid., 196. The book is based on the Gifford lecture series James gave in Edinburgh in 1901–2. Biographer Robert D. Richardson called it "the founding text" in his *William James: In the Maelstrom of American Modernism* (Boston: Houghton Mifflin Company, 2006), 5.

24. William James, "The Confidences of a Psychical Researcher," *American Magazine* 68 (October 1909): 580. Deborah Blum's *Ghost Hunters: William James and the Search for Scientific Proof of Life after Death* (New York: Penguin Press, 2006) recounts this lifelong quest by James and others to keep an open mind toward the evidence.

25. Compton, *Esther*, 87. In a letter dated March 20, [1881], Clover tells her father that Mrs. Baird Smith "is delighted with two books of Howells which I had sent her—Foregone Conclusions and Undiscovered Country"; see Thoron, *The Letters of Mrs. Henry Adams*, 278,

26. William James, *The Will to Believe and Other Essays in Popular Philosophy* (New York: Longmans, Green, and Co., 1912), 51, 54.

27. Conrad Wright, an expert on the history of the American Unitarian church, commented, "Whatever might have been said positively, it is clear that any Protestant evangelical or Catholic fear that suicide was a barrier to eternal salvation would be rejected." Letter to author, August 2, 1994.

28. George Upton, "The Facts about Suicide," *New York Independent*, April 7, 1904, 763–65.

29. The lecture, entitled "Is Life Worth Living?" was delivered at the Harvard YMCA in April 1895; Richardson, *William James*, 356; James, *The Will to Believe*, 35–55, 58–61.

30. Kathleen Pyne, *Art and the Higher Life: Painting and Evolutionary Thought in Late Nineteenth-Century America* (Austin: University of Texas Press, 1996), 20. Herbert Spencer, *First Principles* (New York: A. L. Burt, 1880); *First Principles* was published in 1863 in Britain and underwent multiple revisions and editions.

31. Saint-Gaudens to Rose Nichols, September 23, 1898, quoted in Rose Nichols, ed., "Familiar Letters of Augustus Saint-Gaudens," *McClure's Magazine*, November 1908, 3.

32. "Walt Whitman Laid at Rest," *New York Times*, March 31, 1892, 3.

33. In the Middle Ages a "wonder experience" meant an encounter with an object that was singular and significant, according to scholar Caroline Walker Bynum; in later times it might describe an event so extraordinary it could not be explained by the laws of nature. See Bynum, *Metamorphosis and Identity* (New York: Zone Books, 2001), chap. 1, 37–75; also Penelope Curtis, *Wonder—Painted Sculpture from Medieval England* (Leeds, U.K.: Henry Moore Institute, 2002), 13–15.

34. Kastenbaum, *Death, Society, and Human Experience*, 48.

6. LANDSCAPES OF SENSATION

1. Adams purchased lots 202 and 203 in Section E, a grassy expansion section of Rock Creek Cemetery, on December 12, 1885, for $400, according to Ledger Lot Book, 1872–89, Rock Creek Cemetery archives. "Generally a family would buy one lot," general manager David Downes said in an interview in 1994. "At that time, there probably were 10 burial sites for one lot." Adams purchased two more lots on March 28, 1887.

2. Chalfant, *Better in Darkness*, 506, cites this as a tradition of the Sturgis family. It also fits within an "earth to earth" burial campaign in England in the last quarter of the nineteenth century to let the body mingle with the earth; see Sherwood, *Manners and Social Usages*, 188. A "disintegrating coffin" of light permeable material, such as wicker or lattice-work, open at the top, was marketed by several British firms after 1875. In some such interments, the body was laid on a bed of ferns or mosses and covered with herbaceous material, aromatic or flowering plants; Julian Litten, *The English Way of Death* (London: Robert Hale, 1992), 117.

3. According to an accounting of Marian Adams's estate filed with the Probate Court in Boston, $12 was paid out on December 28 for "Head stone for grave." The estate also repaid Henry Adams $411.50 for the money he spent on the cemetery lots plus "expenses." Account of the executor, Edward Hooper, January 31, 1890, in case No. 74682, Suffolk County Probate Court.

4. The outer boxes made of cheap wood protected the beautifully varnished or cloth-covered casket at the time of burial; see Virginia Russell Remsberg, "From Coffin-Making to Undertaking: The Rise of the Funeral Directing Industry in the 1880s" (Master's thesis, University of Delaware, 1992), 62. In the last quarter of the nineteenth century, metallic "caskets" modeled after precious jewel cases made their debut on the U.S.

market. See *Mourning Glory*, 8, and Habenstein and Lamers, *The History of American Funeral Directing*, 171, 273, 400–402.

5. "Vale! Vanderbilt. Sudden Death of the Richest Man in the World," *Washington Critic*, December 9, 1885, 1.

6. On cremation, see Sloane, *The Last Great Necessity*, 142–45, and Habenstein and Lamers, *The History of American Funeral Directing*, 453–57.

7. Katherine Verdery, *The Political Lives of Dead Bodies* (New York: Columbia University, 1999), 17, 32–33.

8. On invoking the dead but signaling that they have departed forever, see Charlotte Stanford, "The Body at the Funeral: Imagery and Commemoration at Notre-Dame, Paris, about 1304–18," *Art Bulletin* 89, no. 4 (December 2007): 665.

9. Charles Francis Adams II spoke of "wind and driving rain" at the cemetery in his "Memorabilia," May 3, 1891, Charles Francis Adams II Papers, Massachusetts Historical Society. Cemetery records show that Mrs. Adams was not actually buried until December 11; her body apparently was placed in a holding vault at nearby Oak Hill Cemetery in the interim.

10. Ellen Gurney to Elizabeth Cabot, January 1, 1886, or December 31, 1885. As quoted in Kaledin, *The Education of Mrs. Henry Adams*, 223–24, and Chalfant, *Better in Darkness*, 503–4.

11. See Marian Hooper Adams to Robert Hooper, December 1 and 10, 1878, Adams Family Papers, Massachusetts Historical Society. The grave digger had come to America decades earlier as a page to a ballerina named Fanny Elssler, and before that had lived with an upper-crust London family, he told them, taking on his current profession only in the United States. Elssler visited the United States from 1840 to 1842, according to *Appleton's Cyclopaedia of American Biography*.

12. Marian Adams to Pater (Robert Hooper), February 19, 1882, in Thoron, *The Letters of Mrs. Henry Adams*, 349.

13. Marc Friedlander et al., eds., *Diary of Charles Francis Adams* (Cambridge, Mass.: Belknap Press of Harvard University Press, 1986), 7:400.

14. See Linden-Ward, *Silent City on a Hill*, 171.

15. Jacob Bigelow, *A History of the Cemetery of Mount Auburn* (Boston: J. Munroe and Co., 1860), 170. Bigelow's son, Henry Jacob Bigelow, later married William Sturgis's daughter, Susan. The Sturgises apparently rejected ostentation and developed a tradition at Mount Auburn of modest white marble gravestones inscribed only with the initials of the deceased. Henry Adams may at first have placed a similar stone on Clover's grave in Washington.

16. An act authorizing the incorporation of a Rural Cemetery Association passed the New York State Legislature in 1847.

17. Angels and female mourning figures sometimes appear in nearly equal numbers. The variety of angels found in rural cemeteries is described by Elisabeth L. Roark in "The Annexation of Heaven: The Angelic Monument in the American Rural Cemetery" (Master's thesis, University of Pittsburgh, 1984).

18. As one of his first important projects, the young sculptor would design a statue there of Justice Story to record his participation. Linden-Ward describes Justice Story's important role in the development of the cemetery in *Silent City on a Hill*, 130–32. For the address, see also *Sweet Auburn*, Fall–Winter 2011, 9.

19. See, for example, Edward Casey, "How to Get from Space to Place in a Fairly Short Stretch of Time," in *Senses of Place*, ed. S. Feld and K. Basso (Santa Fe: School of American Research Press, 1997), 19.

20. On Bigelow, see Linden-Ward, *Silent City on a Hill*, esp. 258–94.

21. Ibid., 291. Sphinxes had existed in U.S. cemeteries before the Civil War. David Lawler, one of the founders of Spring Grove Cemetery in Cincinnati, had a bluestone sphinx installed there in 1850, commemorating his parents. Linden-Ward has speculated that Bigelow was also influenced by a small Civil War painting by Elihu Vedder entitled *The Questioner of the Sphinx* (1863, Museum of Fine Arts, Boston), then in a private collection in Boston; Linden-Ward, *Silent City on a Hill*, 290–91. Bigelow, *An Account of the Sphinx of Mount Auburn*, 9, 10, 13.

22. *Regulations of the Laurel Hill Cemetery, on the River Schuylkill, near Philadelphia* (Philadelphia: John C. Clark, 1840). Some rules, such as restrictions on Sunday visits, might have been adopted to discourage immigrants or low-income visitors deemed to be using the grounds in alien or disrespectful ways.

23. Halttunen, *Confidence Men and Painted Women*, 127. Sloane, *The Last Great Necessity*, 115.

24. The German quotation is from scene 19 of Goethe's *Faust*. The Massachusetts Historical Society holds two prints of this image; only one has the inscription.

25. Saint-Gaudens served on a panel of experts advising the U.S. Senate Committee on the District of Columbia, and his comments were incorporated in its report on park and cemetery planning, report no. 166, 57th Congress, 1st session. See Charles Moore, ed., *The Improvement of the Park System of the District of Columbia* (Washington: Government Printing Office, 1902), 58–59.

26. By the turn of the century, the "modern" idea is a modest stone marker that does not stand high enough above the grass to break the continuity of the lawn; see Suzanne S. Ridlen, "Funerary Art in the 1890s: A Reflection of Culture," *Pioneer America Society Transactions* 6 (1983): 27–35. The landscape aesthetics were of lesser importance in much of the rural South or the West, which featured different kinds of landscapes. Decoration could be a source of local pride, with distinctive ethnic features. Catholics and Jews more often buried their dead in cemeteries reserved for their faith; Eileen Wilson Coffman, "Silent Sentinels: Funerary Monuments Designed and Executed by Louis Comfort Tiffany and Tiffany Studios" (Master's thesis, Southern Methodist University, 1995), 146, 152.

27. See, for example, *Annual Reports of the Trustees of the Wood-Lawn Cemetery to the Lot-Owners for the Year 1867* (New York: Office of the Wood-Lawn Cemetery, 1868), esp. 16. Prepared by R. E. K. Whiting, superintendent, Woodlawn Cemetery archives, Bronx, New York.

28. While iron fences and hedges had been encouraged to mark the boundaries of family cemetery plots in the 1840s, these enclosures elicited widespread criticism among the post–Civil War generation. Not only did they create maintenance costs, but they were deemed antithetical to the basic tenets of American democracy in that they perpetuated class divisions and exclusivism as well as conflicting with the emerging interest in unbroken lawn vistas, according to *Mourning Glory*, 9.

29. Adolph Strauch, *Spring Grove Cemetery: Its History and Improvement with Observations on Ancient and Modern Places of Sepulture* (Cincinnati: Robert Clarke & Co., 1869), 23.

30. Ibid., 56.

31. Ridlen comments on the "breakdown of kinship emphasis" and "paternal bias" in "Funerary Art in the 1890s," 35.

32. See "President's Address" by Ossian C. Simonds, superintendent of Graceland Cemetery, Chicago, during the association's 1896 convention in St. Louis. *Modern Cemeteries: A Selection of Papers Read before the Annual Meetings of the Association of American Cemetery Superintendents, 1887–1897* (Chicago: Association of American Cemetery Superintendents, 1898), 166–70.

33. "Cemetery Superintendents in Annual Convention," *Monumental News* 14 (October 1902): 590–91.

34. Mariana Van Rensselaer, *Art Out-of-Doors* (New York: Charles Scribner's Sons, 1903), 236.

35. Rex McGuinn makes similar parallels for the elegy in his "Discourtesy of Death: The Elegy in the Twentieth Century" (Ph.D. diss., University of North Carolina at Chapel Hill, 1980), 284, 290.

36. While Mount Auburn had been formed as a private association, Forest Hills Cemetery in Roxbury, Massachusetts, was intended to be a more democratic space established by the city. As a municipal cemetery, it at first offered free spaces to the indigent. Spaces were more reasonably priced than in Mount Auburn, ultimately attracting the well-to-do and merchant classes, and after the Civil War Forest Hills also became a private nonprofit corporation. *Forest Hills Cemetery: Its Establishment, Progress, Scenery, Monuments, Etc.* (Roxbury, Mass.: John Backup, 1855), 11–12. Many cemeteries continued to be racially segregated into the second half of the twentieth century. Rock Creek Cemetery adopted a policy allowing interments of blacks only in the 1960s; see "Cemetery Race Policy Reviewed," *Washington Post*, April 5, 1964, and "Interment for All Faiths Approved by Rock Creek," *Washington Post*, April 14, 1964.

37. J. H. Griffith, "Cremation, the Lawn Plan, and the Granite Industry," *Monumental News* 14 (October 1902): 639.

38. Fanny Copley Seavey, "The Cemetery as a Work of Art," in *Modern Cemeteries*, 180.

39. Ibid.

40. Van Rensselaer, *Art Out-of-Doors*, 235.

41. Ibid., 237–39.

42. James J. Farrell, *Inventing the American Way of Death, 1830–1920* (Philadelphia: Temple University Press, 1980), 126.

43. Pyne refers to a "unified therapeutic environment" and design as an agent of progress in her important *Art and the Higher Life*, 40, 44.

7. THERAPEUTIC BEAUTY

1. Gurney, who had introduced Henry Adams to Marian Hooper, died September 12, 1886.

2. HA to Anne Palmer Fell, December 5, 1886, Massachusetts Historical Society. Fell had informed Adams that she had named her new baby daughter after Marian; see Dykstra, *Clover Adams*, 212.

3. As a historian Adams was aware that he could shape his own legacy, and he carefully destroyed his earlier diaries and some of his correspondence. He also selectively destroyed some correspondence coming to him and instructed others, such as his friend Elizabeth Cameron, about preservation of his letters. See diary entries September 16 and September 30, 1888, in *HA Letters*.

4. The exact date of the initial discussions is not known. Adams mentioned seeing Saint-Gaudens and other friends in New York in 1886 as he was departing for Japan. He had made up his mind to proceed with an elaborate memorial by March 1887, when he purchased two more lots at Rock Creek Cemetery, doubling the size of his already substantial plot. Adams purchased lots number 204 and 205 in Section E for $400 on March 28, 1887; "Deed No. 612," Lot Ledger Book, Rock Creek Cemetery archives, entry 351. For complete accounts, see Cynthia Mills, "The Adams Memorial and American Funerary Sculpture, 1891–1927" (Ph.D. diss., University of Maryland at College Park, 1996); Joyce Karen Schiller, "The Artistic Collaboration between Augustus Saint-Gaudens and Stanford White" (Ph.D. diss., Washington University in St. Louis, 1997); Lois G. Marcus, "Studies in Nineteenth-Century American Sculpture: Augustus Saint-Gaudens (1848–1907)" (Ph.D. diss., Graduate Center, City University of New York, 1979), and John Dryfhout, *The Work of Augustus Saint-Gaudens* (Hanover, N.H.: University Press of New England, 1982), 189–93.

5. HA to Elizabeth Cameron, April 19, 1903, section quoted is April 21 in *HA Letters*.

6. Henry J. Duffy, "American Collectors and the Patronage of Augustus Saint-Gaudens," in *Augustus Saint-Gaudens, 1848–1907: A Master of American Sculpture* (Paris: Somogy, Éditions d'Art, 1999), 56.

7. Diary entry, May 3, 1891, Charles Francis Adams II Papers, Massachusetts Historical Society.

8. C. Lewis Hind, *Augustus Saint-Gaudens* (New York: International Studio, John Lane Co., 1908), xxx.

9. Duffy, "American Collectors and the Patronage of Augustus Saint-Gaudens," 49.

10. This is the formula that Adams passed on to other patrons, such as Clara Hay, who came to him later for advice. See Epilogue.

11. Michael Richman, in the introduction to his *Daniel Chester French: An American Sculptor* (New York: Metropolitan Museum of Art, 1976), notes that a sculptor expected four or five reviews by a patron during the production of a statue.

12. Arlie Russell Hochschild, *The Managed Heart: Commercialization of Human Feeling*, 20th anniversary ed. (Berkeley: University of California Press, 2003), see 33, 35–36 for "deep acting."

13. Homer Saint-Gaudens, ed., *The Reminiscences of Augustus Saint-Gaudens* (New York: Century Co., 1913), 1:129 for the quote and 1:285 on the sculptor's reaction to his father's death. (Hereafter cited as *Reminiscences*.)

14. Ibid., 2:203.

15. Ibid., 2:60.

16. Quoted in James Earle Fraser unpublished autobiography, Saint-Gaudens Papers, Dartmouth College.

17. On artistic deference masking a form of resistance or rebelliousness, see Susan Rather, "Contrary Stuart," *American Art* 24, no. 1 (Spring 2010): 66–93, esp. 78.

18. "Highest Art Appreciated Here," *New York Times*, April 5, 1908, SM 3.

19. Saint-Gaudens met La Farge in the 1870s, possibly through David Maitland Armstrong. La Farge oversaw the execution of numerous decorative projects for which he hired artists. Saint-Gaudens painted the St. James figure at Trinity Church in 1876 as an assistant to La Farge and worked on the St. Thomas angels in 1877 and the King Tomb in 1877–78.

20. Duffy, "American Collectors and the Patronage of Augustus Saint-Gaudens," 57n17. For the Saint-Gaudens quote, see *Reminiscences*, 1:161.

21. M. V. Cousin, *Lectures on the True, the Beautiful, and the Good*, trans. O. W. Wright (New York: Appleton, 1857), 162–63.

22. The bas-relief at St. Thomas, completed in a project arranged by La Farge, was destroyed in a fire in 1905, shortly before Saint-Gaudens's death.

23. Two plaster sketch models at the Saint-Gaudens National Historic Site and several photographs are all that remain of the Morgan tomb. See Duffy, "Angels," in *Augustus Saint-Gaudens*, 112–13. On the Morgan tomb project, see "A Cemetery Fire," *Hartford Daily Courant*, August 23, 1884, 2; correspondence and photos, reel 46, microfilm edition of the Saint-Gaudens Papers, Dartmouth College; Louise Hall Tharp, *Saint-Gaudens and the Gilded Era* (Boston: Little, Brown and Company, 1969), 179–82; *Reminiscences*, 1:179, 220–25, 272–73; and "Great Art Work Lost," *Hartford Courant*, November 2, 1913, A3.

24. *Amor Caritas* was reproduced, in reduced form, many times. The Morgan angel also was used for the John Hudson Hale Tomb, Sleepy Hollow Cemetery, Tarrytown, New York, ca. 1898, and the Maria Mitchell

Memorial in a Philadelphia church; see Thayer Tolles, *Augustus Saint-Gaudens in the Metropolitan Museum of Art* (New York: Metropolitan Museum of Art, 2009), 40, 42.

25. Fish had first approached sculptor Erastus Dow Palmer about his commission; Palmer, citing poor health, recommended Saint-Gaudens in a letter to the patron on January 6, 1887. Fish and Saint-Gaudens discussed photographs and portraits of the women and the degree of likeness achieved in letters exchanged on June 14, 1889, May 18, 1890, September 2, 1890, and September 4, 1890; Hamilton Fish Papers, Library of Congress. The Fish Papers contain extensive correspondence on the commission.

26. Saint-Gaudens to Hamilton Fish, February 20, 1891, Hamilton Fish Papers.

27. Homer Saint-Gaudens, in *Reminiscences*, 1:108, describes how Saint-Gaudens at first modeled the figures kneeling and included an infant, which Fish wanted removed, then later began the revised standing version. The final Fish cemetery monument was not installed in the cemetery until late 1891, months after the Adams Memorial. The 1887 Fish contract states the main elements of the projected monument: "two life size figures, in a general way representative, one of his wife, Mrs. Fish, and the other of his daughter, Mrs. d'Hauteville," with a "bronze cross to be likewise executed according to Mr. St Gaudens design." Saint-Gaudens Papers, Dartmouth College. A separate contract with Stanford White was prepared for the setting, and it appears that White ultimately designed the cross; see Lawrence Grant White, *Sketches and Designs by Stanford White* (New York: Architectural Book Publishing Co., 1920), 11. Fish died September 6, 1893.

28. Adams's niece wrote that he "seized the new abstraction [nirvana] and returned [from Japan] with it, resolved to have the idea embodied in a Western form of expression, that the Western world might understand and be consoled by it as he had been." Henry Adams, *Letters to a Niece and Prayer to the Virgin of Chartres, by Henry Adams, with a Niece's Memories by Mabel La Farge* (Boston: Houghton Mifflin Co., 1920), 9.

29. *Boyd's Directory of the District of Columbia*, 1890, 956.

8. MAKING THE ADAMS MEMORIAL

1. A number of photographs of Saint-Gaudens's sketches were contained in a large scrapbook, which survived the fires of 1904 and 1944; see John Dryfhout to Richard Wunder, March 23, 1967, Eduard Pausch curatorial file, Smithsonian American Art Museum. Photos of these survive in the Saint-Gaudens Papers, Dartmouth College.

2. Another surviving drawing proposes a bas-relief of two standing figures on the upper half of a vertical block of stone, with a cornice above. The two figures might also stand for an idea Adams later included in his poem "Buddha and Brahma." It says, in part, "But we, who cannot fly the world, must seek / To live two separate lives; one, in the world . . . / The other in ourselves, behind a veil." Adams sent the poem to John Hay, April 26, 1895 in *HA Letters*.

3. Saint-Gaudens to HA, September 11, 1887, Windsor, Vermont, Henry Adams Papers, microfilm edition, Massachusetts Historical Society (hereafter HA microfilm).

4. White to HA, January 9, 1888, HA microfilm.

5. *Reminiscences*, 1:356, 359.

6. Homer Saint-Gaudens said his father wrote only one sentence about the Adams Memorial in his original "Reminiscences of an Idiot": "Following the [*Puritan* monument to Deacon Samuel] 'Chapin' on the scaffolding was the figure in Rock Creek Cemetery which I modeled for Mr. Henry Adams." But he wrote "Amplify" in the margin. In trying to fill in what happened, the son relied heavily on letters loaned to him by Adams. Homer discussed the Socrates sketch and objections to it in a draft of the *Reminiscences* and in the article "Augustus Saint-Gaudens Established," *Century Magazine* 78 (June 1909): 220. It was not mentioned in the final text for the book published in October 1913, although the photograph of the Socrates clay sketch was retained. The reference to Flanagan's modeling for the monument was also deleted from both the *Century* article and the book. Homer Saint-Gaudens may have excised these parts in consideration of Adams's distaste for any mention of suicide or to a specific model. Drafts of *Reminiscences* are in the Saint-Gaudens Papers, Dartmouth College.

7. See *Grave Stele of a Seated Woman*, Cypriot limestone, ca. 400–350 B.C., purchased by subscription 1874–76 (74.51.2485); and an example acquired in the twentieth century, *Fragment of a Grave Stele with a Seated Woman*, mid-fourth century B.C., Greek marble found in Attica before 1827, purchased in 1948 (48.11.4); both in the Metropolitan Museum of Art, New York.

8. Flanagan to Richard Watson Gilder, March 1908, box 15, folder 51, Richard Watson Gilder Papers, Manuscript Division, New York Public Library.

9. Gustav Kobbé, "Mystery of Saint Gaudens' Masterpiece Revealed by John La Farge," *New York Herald*, January 16, 1910, magazine sec., 11.

10. Ibid. La Farge sent a correction to the *New York Herald* pointing out that he was not at the critical meeting between Saint-Gaudens as Kobbé had stated. "Mr. Adams alone suggested to Saint-Gaudens the meaning and the pose," he added. "Mr. La Farge Explains," letter dated January 21, 1910, in *New York Herald*, January 26, 1910.

11. Flanagan to Richard Watson Gilder, March 1908, Gilder Papers, New York Public Library. It is uncertain, however, whether Flanagan (1865–1952) was working for Saint-Gaudens early enough to have been present for initial meetings. The crucial meeting probably occurred in January 1888 when Adams visited Saint-Gaudens's New York studio, for Saint-Gaudens wrote Adams on January 25, 1888: "The reason I have not sent you the photographs sooner is the idiot who posed so finely as Budha before you not getting the negatives printed." On November 5, 1888, Saint-Gaudens could write Adams, "I have commenced on your work." He asked him to send back "the photographs that I took of my boy" in January.

12. See John Milton, "Il Penseroso," in *Milton: Poems* (London: Penguin Books, 1953), 45–50. Many American artists had addressed the theme. Thomas Cole painted an *Il Penseroso* and *Allegro* set in the Italian countryside in the 1840s. Hiram Powers completed a standing *Penserosa*, with proper left hand held to a face tilted slightly upward, in the 1850s and made a bust, *Il Penseroso*; Joseph Mozier's *Il Penseroso*, with a similar gesture and the name inscribed on the base, was exhibited at the 1876 world's fair in Philadelphia. Ideal "Penserosa" or "Penseroso" busts were also done by Launt Thompson, Joel Hart, and William Rinehart, among others, before the centennial. Adams was fascinated with Michelangelo's memorial to Lorenzo de' Medici in Florence, widely known as "Il Penserioso." In May 1899 he wrote niece Louisa Hooper that he was visiting Florence "solely to look once more at the Medici figures," including the "Lorenzo, pondering over it, but not seeing either Hope or Consolation or Faith"—conventional categories for funerary sculpture.

13. Outside of his funerary work, his major commission in this vein had been *Silence*, an early marble figure of a woman, holding a rose in one hand and a finger of the other hand to her mouth. It was created for a Masonic lodge in Utica, New York, and he later expressed dissatisfaction with it. See Dryfhout, *The Work of Augustus Saint-Gaudens*, 75.

14. HA diary entry, April 29, 1888, in *HA Letters*.

15. In an entry in his diary, September 30, 1888, Adams wrote: "Have sold at a sacrifice of two thirds all the railroad stock I still own, and am beginning to provide twenty thousand dollars for St. Gaudens and Stanford White," in *HA Letters*. White at first acted as an intermediary in the matter, writing Adams on August 13, 1888: "Unless some definite time and price is set, I think he [Saint-Gaudens] will always look upon the thing as a matter half of art and half of friendship, to be begun when he is in the mood." And on October 2, 1888: "He [Saint-Gaudens] told me that he would rather make the matter a work of love than have you think he was in any way charging you an excessive price, and yet he was in such a position he could not attempt work . . . unless at some profit." HA microfilm.

16. On September 2, 1888, White sent Adams a copy of the Hamilton Fish contract as a possible model for an agreement with Saint-Gaudens. Saint-Gaudens sent Adams a draft contract October 11. On December 11, 1888, Saint-Gaudens sent the countersigned agreement back to Adams with a "memorandum" [bill] for his preliminary work; HA microfilm. A copy of the contract can be found in the Saint-Gaudens Papers, Dartmouth College, in papers not microfilmed.

17. HA diary entry for Sunday, December 10, 1888, in *HA Letters*.

18. Saint-Gaudens to HA, January 3, 1889, HA microfilm. Another set of photographs had changed hands as the work got under way and the pace seemed to quicken. On meeting with La Farge, see Saint-Gaudens to HA, March 21, 1889, HA microfilm.

19. In a letter now lost, Adams wrote to La Farge of his concerns. La Farge in his response tried to soothe Adams's frayed nerves and offered to pass on information from the artist on the progress of the project. See, for example, La Farge to HA, July, August 14, and September 29, 1889, La Farge Family Papers, Manuscripts and Archives, Yale University Library.

20. In January 1888 Saint-Gaudens wrote Adams about a "stunning scheme" White had proposed. By June 11, 1888, White was receiving a bid from the American Marble Co. in Marietta, Georgia, for the stone work, although he advised the company that the large upright stone "may be delayed . . . on account of the sculpture to go on it, and it may be somewhat altered in form." White wrote Adams on August 9, 1888, in a similar vein; White Letterpress Books, Department of Drawings & Archives, Avery Architectural & Fine Arts Library, Columbia University. Adams noted in his diary for August 26, 1888, that he had finalized a contract with White for the stone work in *HA Letters*.

21. Kirk Savage, "The Obsolescence of Sculpture," *American Art* 24, no. 1 (Spring 2010): 12.

22. These ideas are developed in Schiller, "The Artistic Collaboration between Augustus Saint-Gaudens and Stanford White."

23. White also informed Adams that Flanagan had completed a model for the folded wings that would demarcate the ends of the seat. "I am quite proud of the result—it is an owls wing (sleep)—and we invited in one of natures own make to help us." White to HA, May 29, 1889, HA microfilm.

24. White to HA, May 31, 1889, HA microfilm. White wrote the firm several angry letters calling this "a complete and unpleasant surprise to me," and stating, "The whole scheme of the monument and the sculpture . . . contemplates a green monument." White to American Marble Co., May 31, June 13, and June 25, 1889, White Letterpress Books.

25. White wrote Adams October 26, 1889: "It looks very much as if we would have to give up their stone, in which case I should advise returning to our original idea of a rosy porphyry or granite"; White Letterpress Books. The green marble, mined in smaller blocks, was used primarily as a decorative stone for such purposes as ornamental mantels.

26. The trip to Paris occurred not long after Saint-Gaudens's most recent project, the figure of James McCosh, was installed at Princeton. Saint-Gaudens had told Adams he would return to active work on his tomb sculpture after the McCosh project was completed; Saint-Gaudens to HA, March 21, 1889. HA microfilm. For "the best modern French sculptors," see William Walton, *Chefs-d'oeuvre de l'exposition universelle* (Paris: Barrie Frères; Philadelphia: George Barrie, 1889), part 9, 35.

27. The marble monument, first exhibited at the 1885 Salon, was designed for the tomb of Mme Charles Ferry at Parnay (Maine-et-Loire). The replica shown in 1889 was given to the Luxembourg Museum and is now in the Musée d'Orsay. The sculpture was hailed by writer Henry Havard as a masterpiece of its type: graceful, grand and yet meditative—a charming, poetic figure coming to rest after a life of joy and sorrow. See color plate, Walton, *Chefs-d'oeuvre de l'exposition universelle*. At the fair, *Le Souvenir* was displayed in the central rotunda, the Gallery of Fine Art.

28. Saint-Gaudens did not display any of his work in Paris in 1889, but he loaned to the U.S. fine arts exhibition the portrait Kenyon Cox had made of him in 1887. After the fair, he wrote Mariana Griswold Van Rensselaer of the "wonderful fête success of the exposition." But he added, "About the art, my impressions are too complex and result in so much vanity that I'll modestly refrain." *Reminiscences* 1:326.

29. White to HA, October 26, 1888, White Letterpress Books.

30. Lewis Iselin, a sculptor-conservator who supervised the making of a 1967 cast from the Adams monument, speculated that after changes and rearrangements to the drapery were made, Saint-Gaudens patted the wet clay with burlap. The warp and woof of the burlap are sometimes in relief and sometimes in intaglio; Lewis Iselin, "The Adams Memorial: A Reproduction," Saint-Gaudens National Historic Site, Cornish, New Hampshire, copy in the Adams Memorial curatorial file, Smithsonian American Art Museum. Saint-Gaudens describes using a similar method in a letter of September 5, 1905, to Abbott Thayer, Saint-Gaudens Papers, Dartmouth College. Bronzes from the 1967 plaster cast for the Saint-Gaudens National Historic Site at Cornish were made for both Cornish and the Smithsonian American Art Museum.

31. *Reminiscences*, 1:335–36.

32. Saint-Gaudens to HA, February 21 and April 23, 1890, HA microfilm.

33. Saint-Gaudens to HA, May 6, 1890, HA microfilm.

34. HA to Elizabeth Cameron, February 6, 1891, HA microfilm.

35. Saint-Gaudens to HA, May 16, 1890, HA microfilm. Saint-Gaudens added, "La Farge saw it the other day and told me he would give you his impression." In a May 18, 1890, letter to Adams, La Farge indicated that John Hay also saw it at about this time. "I think that the thing is fine," La Farge declared, but said he was not sure how Adams would feel.

36. La Farge apparently visited Adams later in May to personally discuss his perceptions. La Farge to HA, May 18, 1890, La Farge Family Papers, Yale University Library. La Farge to HA, May 22, 1890, HA microfilm. While La Farge wrote Adams favorably of the sculpture, he was less pleased with the architectural setting. La Farge held a grudge against White's architectural firm, McKim, Mead & White, for not commissioning work from him, and he may have swayed Adams's attitude toward White. The tension between La Farge and White erupted nearly twenty years later when La Farge "set off a bomb" with remarks he made while accepting a medal of honor from the Architectural League of New York. La Farge was quoted as telling the assembled audience, "this recognition from the architects comes very late in life," when it no longer could be useful to his career, and complained that

for twenty-two years "McKim, Mead & White never gave me any work. I don't know why." "Late for a Medal, Says John La Farge," *New York Times*, January 30, 1909, 1. Adams wrote Richard Watson Gilder on February 2, 1909, "Poor dear La Farge has, indeed, at last got in his little knife on Stanford," in *HA Letters*.

37. Directing his lawyer to file suit over import fees on some statuettes in 1889, White wrote, "I brought over some copies of antique statuettes. You know the character of work that I do with St. Gaudens, sculpture and architecture together, and I use these models in my work. I entered them as 'tools of trade' and the Treasury Dept. refuses to allow them. . . . Now this is a trivial matter but at the same time, it contains the kernel of the business." White to lawyer Charles C. Beaman, October 30, 1889, White Letterpress Books. On White's career, see Wayne Craven, *Stanford White: Decorator in Opulence and Dealer in Antiquities* (New York: Columbia University Press, 2005).

38. White's life and philosophy are described in Paul R. Baker, *Stanny: The Gilded Life of Stanford White* (New York: Free Press, 1989), and Lawrence Grant White, *Sketches and Designs by Stanford White* (New York: Architectural Book Publishing Co., 1920). White's personal ideas about grave decoration may be seen in the tombstone he designed for his father's grave in Rosedale Cemetery, East Orange, New Jersey. It is a beautifully ornamented marble tablet with a shaped cornice on which are carved an open book and wings. The inscription, "THE RIGHT AND SLEEP," makes clear that the wings stand for sleep in White's funerary iconography.

39. White to Saint-Gaudens, February 4, 1890, White Letterpress Books.

40. White to Norcross Brothers, April 30, 1890, and White to Saint-Gaudens, May 12, 1890, White Letterpress Books. A similar circle appeared years later in Alexander Stirling Calder's Henry C. Lea Memorial in Philadelphia's Laurel Hill Cemetery, a seated figure of History with a great laurel wreath behind, completed by 1912.

41. Honorific, upright torches are used on Saint-Gaudens's Whistler Memorial, 1906–7, for West Point.

42. Saint-Gaudens to HA, February 21, 1890, HA microfilm.

43. "His range of friendships was vast, and his capacity for friendship was remarkable. He cherished friendships and worked tirelessly and indulgently to maintain and strengthen them. . . . He was, his friend Royal Cortissoz wrote, 'a very prince of friends.'" Baker, *Stanny*, ix.

44. White to HA, June 24, 1889 [*sic*]. A copy is retained in the White Letterpress Books. If this letter was sent as written, Adams made a point of destroying it, for it does not remain in his papers with other letters he received from White.

45. White to Adams, July 7, 1890, White Letterpress Books and HA microfilm.

46. White to Norcross Brothers, July 27, 1890, White Letterpress Books.

47. In the present arrangement, there would not be room to place a circle above the figure's head. Apparently the capstone was not originally included or an additional capstone was considered later. On January 1, 1893, Saint-Gaudens wrote Adams asking for a photo of the memorial, because "I want to settle the top of the monument." White followed up on January 6, 1893, saying that Saint-Gaudens had insisted that he "arrange the capping of the slab behind the Nirvana" before a planned trip to Europe that month. White wondered, however, whether Adams really wished the addition. HA microfilm. No further correspondence on this issue survives, but the capstone with its small band of egg-and-dart and wheat-sheaf ornament, foreseen in the earlier McKim, Mead & White renderings, does.

48. Adams forbade his literary executor from including illustrations in his *Education*, commenting, "I have always tried to follow the rule of making the reader think only of the text." HA to Henry Cabot Lodge, March 1, 1916 in *HA Letters*.

49. White to Saint-Gaudens, December 10, 1890, White Letterpress Books.

50. The granite was used for the Bunker Hill Monument in the 1820s. Its purity of color and durability made it costly to quarry, so its greatest use was ornamental. See ads for Quincy Granite, *Monumental News* 24 (February 1912): 187, and (March 1912): 226. Saint-Gaudens decided to have the rock rubbed to darken it rather than have it polished, wishing to retain its naturalistic quality. See Saint-Gaudens to White, undated handwritten note, folder 9:5(s), box SW9, Stanford White personal correspondence, Avery Drawings & Archives, Columbia University; and White to J. F. Manning, April 1891, White Letterpress Books.

51. HA to John Hay, June 21, 1891, Fiji, in *HA Letters*. Adams's niece wrote that he began the trip "overtaxed and overstrained by sorrow, as well as by his efforts to surmount it." Adams, *Letters to a Niece*, 9.

52. Cameron had encouraged Adams to take the South Seas journey and during a brief reunion in London afterward apparently held off his advances. One look at their relationship is Ernest Samuels, "Henry Adams and the Gossip Mills," in *Essays in American and English Literature Presented to Bruce Robert McElderry, Jr.*, ed. Max F. Schulz, William Darby Templeman, and Charles Reid Metzger (Athens: Ohio University Press, 1967), 59–75.

53. HA to Cameron, February 6, 1891, Papeete, Tahiti, in *HA Letters*.

54. HA to Theodore Dwight, February 10, 1891, Papeete in *HA Letters*.

55. M. J. Fitzgerald for Norcross Bros. to Stanford White, February 28, 1889, Box SW9, White personal correspondence, Avery Drawings & Archives.

56. Saint-Gaudens to HA, March 13, 1891, HA microfilm. White sent Adams a report that "all accounts . . . are settled in full" on April 22, 1891, after he and Saint-Gaudens made an inspection visit to the cemetery. White Letterpress Books.

57. Cameron to HA, serial letter beginning March 9, 1891, HA microfilm.

58. John Hay to HA, March 25, 1891, in *Letters of John Hay and Extracts from Diary* (1908; repr., New York: Gordian Press, 1969).

59. Hay's description "gave me a regular old-fashioned fit of tears," HA wrote Elizabeth Cameron in a serial letter beginning May 17, 1891, section quoted is Monday, June 1, HA to Saint-Gaudens, June 23, 1891, Siwa, Fiji, in *HA Letters*.

60. John Hay to HA, June 4, 1891, HA microfilm.

61. Adams, *The Education of Henry Adams*, 2:105–6.

9. DEATH AND THE SCULPTOR

1. A copy of the memorandum of agreement between James B. Richardson and Daniel Chester French, dated December 9, 1889, can be found in the Fairmount Park Art Association Papers, Historical Society of Pennsylvania (#2045), box 10, folder 2, attached to a letter dated January 13, 1893, from French to Charles H. Howell. There is no record of any preliminary meetings between Joseph's widow, Mary Longfellow Milmore, and Daniel Chester French (hereafter DCF).

2. "I have not the contract by me to refer to, but there were almost no specifications in it as I remember, Judge Richardson leaving everything to me," French later recalled; DCF to Oscar Milmore, August 4, 1914, Daniel Chester French Papers, Library of Congress (hereafter French Papers-LC). A report in the Chicago *Graphic*, February 27, 1892, which discusses the casting of the statue in some depth, says, "The sculptor was permitted to choose his own subject and to treat it in his own way."

3. DCF to William M. R. French, February 27, 1889, French Papers-LC.

4. Margaret French Cresson, *Journey into Fame: The Life of Daniel Chester French* (Cambridge, Mass.: Harvard University Press, 1947), 167–68.

5. "Monthly Record of American Art," *Magazine of Art* 112 (July 1889): xxviii.

6. DCF's biological mother, Anne Richardson French, died when he was six. His father, Henry Flagg French, married his second wife, Pamela Prentiss, in 1859.

7. Michael Richman, "The Man Who Made John Harvard," *Harvard Magazine*, September–October 1977, 48.

8. See Cresson, *Journey into Fame*, 142–47, on the state of Pamela Prentiss French after the death of her husband Henry Flagg French (1813–1885), 142. See letter from Harris Preston, London, December 1st(?), 1885.

9. "Dan signed up for Mercié's sculpture class several evenings a week." Cresson, *Journey into Fame*, 145.

10. "Dan found French more difficult than Italian and he was always a little timorous about using what little he did know. But Pamela spoke easily and was never held back by timidity." Ibid., 145.

11. William Wetmore Story, *Reports of the U.S. Commissioners to the Paris Universal Exposition* (Washington, D.C., 1878), 2:11–14.

12. Saint-Gaudens wrote the Gallaudet Monument Committee that he had not intended his letter on behalf of a M. Ballin to be "prejudicial to Mr. French's interests." Undated letter, ca. 1884, French Papers-LC.

13. On the Gallaudet sculpture, see Richman, *Daniel Chester French*, 63–68. For the DCF quote, see Mary French, *Memories of a Sculptor's Wife* (Boston: Houghton Mifflin Company, 1928), 154.

14. On French's biography, in addition to family memoirs, see Greenthal et al., *American Figurative Sculpture in the Museum of Fine Arts, Boston*, 250–53; Thayer Tolles, *American Sculpture in the Metropolitan Museum of Art*, vol. 1, *A Catalogue of Works by Artists Born before 1865* (New York: Metropolitan Museum of Art, 1999); Richman, *Daniel Chester French*; Richman, "The Early Career of Daniel Chester French, 1869–1891" (Ph.D. diss., University of Delaware, 1974); and Adeline Adams, *Daniel Chester French—Sculptor* (Boston: Houghton Mifflin Company, 1932).

15. DCF to William M. R. French, September 2, 1889, French Papers-LC.

16. Ball to DCF, April 26, 1877, Wendell Collection, Houghton Library, Harvard, as cited in Richman, *Daniel Chester French*, 20n28.

17. "All the work . . . shall be done in an artistic manner, and with such inscriptions on the base as to names &c as may be required," the contract added. French later sent a copy of his agreement with James B. Richardson, dated December 9, 1889, to a colleague as an example of a "satisfactory" contract that could be the model for another project. See DCF to Charles H. Howell, January 13, 1893, Fairmount Park Art Association Papers, Historical Society of Pennsylvania.

18. Cresson, *Journey into Fame*, 109. French, *Memories of a Sculptor's Wife*, 43.

19. Sarita Brady to DFC, October 19, 1881, French Papers-LC.

20. Ministers from St. Paul's Episcopal Church, Concord, spoke at his funeral in his studio. French was married at home, not in a church, and there is no mention of a minister presiding at the wedding ceremony.

21. DCF to Ball, February 11, 1891, French Papers-LC.

22. William Brewster to DCF, July 2, 1883, French Papers-LC. French made a relief portrait of his sister Sarah "Sallie" Bartlett as a final tribute of his affection.

23. DCF to Brewster, October 5, 1890, William Brewster Papers, Museum of Comparative Zoology, Harvard University. French sent Brewster a photo of the monument on May 24, 1892, so that "you may see what use I made of the wings that you were kind enough to send me. I hope they will meet your approval in general even if you cannot decide at a glance which genus or species of angel in particular they belong to." He introduced Abbott Handerson Thayer to Brewster; DCF to Brewster May 24, 1892, William Brewster Papers.

24. Thayer to the curator of the Smith College Art Gallery, [1912], typescript, Nelson C. White Papers, Archives of American Art, Smithsonian Institution.

25. Roark, "The Annexation of Heaven," quote at 12. See also Roark's "Embodying Immortality: Angels in America's Rural Garden Cemetery, 1850–1900," *Markers: Journal of the Association of Gravestone Studies* 24 (2007): 56–111.

26. The angel is dedicated to Maria Frances Coppenhagen (1838–1869), one of six children of the German-born Arnold Coppenhagen. Chandler Post later called it "the acme" of the artist's capability "in spiritual expression," demonstrating Milmore's ability to conceive an ideal female form "with a real and personal content." Post, "Martin Milmore," in *Art Studies, Medieval, Renaissance and Modern*, 59.

27. In the Chickering monument, the angel holds a torch pointed downward in one hand and lifts the veil covering the eyes of a kneeling Faith, who clutches a cross to her breast. Below a female genius of music is carved in relief holding a laurel wreath in one hand and lyre with broken strings in the other. See "Thomas Ball's Last Work," *Boston Daily Globe*, June 27, 1873, 2. French also certainly knew of Saint-Gaudens's lost Morgan tomb project, one of whose angels had been reproduced on the title page of Mariana Griswold Van Rensselaer's *Book of American Figure Painters* (1886). French's brother, William, had begun his career as a landscape architect and civil engineer, and in that capacity worked on a number of cemetery projects with designer H. W. S. Cleveland, including Evergreen Cemetery in Dunn County, Wisconsin.

28. See Cresson, *Journey into Fame*, 143, about visits to British artists' studios. Also see John William Waterhouse's painting *Sleep and Her Half-Brother Death* (1874).

29. See undated French-language newspaper clippings, 1892 scrapbook, French Papers-LC.

30. See Jane Dillenberger, "Between Faith and Doubt: Subjects for Meditation," in *Perceptions and Evocations: The Art of Elihu Vedder*, Joshua Taylor et al. (Washington, D.C.: Smithsonian Institution Press, 1979), 142, and Richard Murray, http://americanart.si.edu/exhibitions/online/vedder/rubaiyatmain.html. Vedder's image also appeared as a painting in two instances and in other forms.

31. Kastenbaum, *Death, Society, and Human Experience*, 55.

32. DCF to Ruckstuhl, *The Art World*, New York, October 10, 1917. French said he learned of the Greek quotation from classics scholar Harriet Fenton, who visited his family's home in Concord when he was a youth. Years later he asked her for the source, but she said she had forgotten it. DCF to Rev. Elwood Worcester of Emmanuel Church, Boston, June 9, 1927, French Papers-LC.

33. Paul Gardella, *American Angels: Useful Spirits in the Material World* (Lawrence: University Press of Kansas, 2007), 12.

34. Roark, "Annexation of Heaven," 19.

35. At the same time, Gardella noted, angels, which had previously been predominantly depicted as male or androgynous figures, began being interpreted as female guardians. Gardella, *American Angels*, 74–75, 69, for *The Gates Ajar*, and 85 for the gender shift of the angels. For an example of the serialization and mention of the Angel of Death in *The Gates Ajar*, see "Our Boys and Girls: As Allegory—the Silver Thread of Love," *Los Angeles Times*, April 15, 1889, 7.

36. Kastenbaum, *Death, Society and Human Experience*, 446–47, also talks about the longtime desire to see life as a "journey." Thomas R. Cole, *The Journey of Life: A Cultural History of Aging in America* (New York: Cambridge University Press, 1992). Constantino Brumidi's 1865 fresco in the Capitol dome is entitled *The Apotheosis of Washington*.

37. For critical mention of the parallel with Lefebvre, see undated French-language newspaper clippings, 1892 scrapbook, French Papers-LC.

38. "Summer in Rome," *Daily Evening Transcript*, August 25, 1876, 4.

39. DCF wrote to Mrs. G. R. Streeter, Hammond, Indiana, on March 6, 1914: "The sphinx in the relief of 'Death and the Sculptor' was introduced because of the significance of the sphinx which is usually interpreted as mystery. In this case the mystery of life and of death. It was a coincidence that Martin Milmore, in whose memory the relief was made, sculptured for a Soldier's monument in Mount Auburn Cemetery in Cambridge a colossal sphinx which some regarded as his best work." French Papers-LC. He also noted in a letter to Adeline Adams, February 7, 1931, "He [Milmore] had already made a war memorial in the form of a sphinx which was created in Mt. Auburn Cemetery in Cambridge." French Papers-LC.

40. Thomas Brown, *The Public Art of Civil War Commemoration: A Brief History with Documents* (Boston: Bedford/St. Martins, 2004), 5; David Blight, *Race and Reunion: The Civil War in American Memory* (Cambridge, Mass.: Harvard University Press, 2001), 164, 181.

41. DCF to John M. Goetchius, December 28, 1926, French Papers-LC.

42. Faust, *This Republic of Suffering*.

43. Scrapbook 29 #253, French Papers-LC. In the sketch, the sphinx is still in its earlier form, facing forward and incomplete.

44. Taft, *The History of American Sculpture*, 320.

45. For instances of the sphinx in popular culture, see "Spectres on the Stage," *Boston Daily Globe*, September 14, 1884, 9; "A Startling Stage Sensation" and "The Stage in New York," *Boston Daily Globe*, July 3 and September 23, 1874; and "An Optical Illusion," *Boston Daily Globe*, May 28, 1888. *Scribner's Magazine*, December 1875, opens with a sphinx, taken from the first plate of Charles Stuart Welles's *Tour of the Nile*.

46. See Scott C. Allan, "Interrogating Gustave Moreau's Sphinx: Myth as Artistic Metaphor in the 1864 Salon," *Nineteenth-Century Art Worldwide* 7, no. 1 (Spring 2008), www.19thc-artworldwide.org/spring08/39-spring08/spring08article/110-interrogating-gustave-moreaus-sphinx-myth-as-artistic-metaphor-at-the-1864-salon.

47. For "privileged insight," see Kastenbaum, *Death, Society, and Human Experience*, 87.

48. Contract with E. Gruet Jeune, Fonderie de Bronze d'Art, 44 bis, avenue de Châtillon, Paris, December 8, 1891, for 10,000 francs, the model to be delivered to his studio and the bronze "soit à l'atelier soit au Salon." French Papers-LC. The Milmore monument was the only sculpture French had cast outside the United States, suggesting that he recognized its importance for his career. He also mentioned a significant savings that made up for the cost of shipping and duties.

49. French wrote his brother on November 29, 1891, "I am finishing the Milmore. I shall not model the sculptor over as I expected to. It is a better figure than I thought and I shall content myself with remodeling the head and hands." French Papers-LC.

50. DCF to William M. R. French, January 5, 1892, French Papers-LC.

51. DCF to Anne Keyes in Chicago, May 17, 1892, French Papers-LC.

52. Thomas Ball, *My Fourscore Years* (Los Angeles: Trecavalli Press, 1993), includes on 34 the text of his letter to DCF on March 23, 1894.

53. For "ten stroke," see DCF to William M. R. French, February 3, 1893, New York, French Papers-LC. DCF also wrote on November 18, 1892, to Pamela Prentiss French: "I have had a great time getting the Milmore bronze set up in the new gallery of the Fine Arts Society for the Soc. Am. Artist's exhibition. The doors were too small to admit it and the architect had them enlarged and then the chandaliers [*sic*] were too low and they had to be taken down and I have done little else in the last week, but attend to the thing."

54. It was also exhibited at the Art Institute of Chicago in 1893. It was installed in the cemetery in August 1893, according to Richman, *Daniel Chester French*, 75. An 1893 installation was confirmed by Pamela Narbeth Mellberg, archivist for Forest Hills Cemetery, letter to the author, August 11, 2005.

55. DCF wrote to Charles Hutchinson, president of the Art Institute of Chicago, on September 28, 1894, that the original bronze of "Death and the Sculptor" might come on to the market, and asked if the museum would want it for $12,000 to $15,000, AIC archives, Hutchinson file. DCF wrote his brother, William M. R. French, on

October 28, 1894, that he had "failed to come to an understanding with Judge Richardson about the Milmore." French Papers-LC.

56. French asked the Milmore family's consent for the four casts for U.S. museums and added, "I am wavering about sending one to London." DCF to William M. R. French, January 22, 1894, New York, French Papers-LC.

10. DUVENECK'S LADY

1. Leon Edel, *Henry James: The Middle Years, 1882–1895* (Philadelphia: Lippincott, 1962), 248, provided this description of a period visitor's perception.

2. The inscription reads: "Elizabeth Boott Duveneck / Born in Boston U.S. April 13th A.D. 1846 / Died in Paris March 22D A.D. 1888."

3. Elaine Scarry, *On Beauty and Being Just* (Princeton: Princeton University Press, 1999), 29, 58, 62.

4. Duveneck, *Frank Duveneck, Painter-Teacher*, 144.

5. In ibid., 163, author Josephine Duveneck, who was Frank Duveneck's daughter-in-law, states that the artist returned to the church at the end of his life. "There was a little ceremony in his hospital room," she writes, "and his sister joined at the same time. I think Duveneck felt that this might represent consolation for her, whose whole purpose in life would be lost in his going." His sister survived him by only a few days, however.

6. "An Artist's Grief: How It Finds Expression in Cold Bronze," *Cincinnati Times Star*, July 7, 1891.

7. "Shake off this downy sleep, death's counterfeit!" Macduff says, for example, in William Shakespeare's *Macbeth*, act 2, scene 3.

8. Gisants were created in the medieval and Renaissance periods, and a revival occurred in the nineteenth century. Scholars have cited Jacopo della Quercia's fifteenth-century tomb of Ilaria del Carretto in Lucca, which had been admired by John Ruskin and Edith Wharton and reproduced in casts in Florence and in prints, as a precedent for the Boott tomb; see Dinnerstein, "From Private Grief to Public Monument," 206. For nineteenth-century French examples such as Henri Chapu's model for the tomb of the duchess of Orléans and others at Dreux, see Antoinette le Normand-Romain, *Mémoire de marbre: La sculpture funéraire en France, 1804–1914* (Paris: Bibliothèque Historique de la Ville de Paris, 1995).

9. Dinnerstein, "From Private Grief to Public Monument," 204, suggests that Browning's tomb in Florence might have inspired a desire by Francis Boott to support a similar one for his daughter.

10. James to Boott, July 14, [1893], in Edel, *Henry James Letters, 1883–1895*, 417–18.

11. The bronze at Elizabeth Boott Duveneck's gravesite was cast in 1892. For the marble version, see Greenthal et al., *American Figurative Sculpture in the Museum of Fine Arts, Boston*, 209–13. Duveneck told others that he sank into despair after touching up the features of Lizzie's face on the marble monument; he feared he might have ruined the stonework prepared by Italian workmen, but found later that he had not; see accounts by Howard Walker and Julius Rolshoven as cited in Duveneck, *Frank Duveneck, Painter-Teacher*, 127, and in Mary Alexander, "Cincinnati Artist Returns to Place Where He Painted Many Noted Canvases," July 9, 1925, clipping, Duveneck scrapbook, Cincinnati Art Museum archives. William Couper, Thomas Ball's son-in-law and eventual partner, arranged for the block of marble.

12. Duveneck gave the marble to the Museum of Fine Arts, Boston in 1912 after Francis Boott's death. Boott may also have contributed financial support to the casting of the original cemetery bronze.

13. Henry Lee to Francis Boott, March 12, 1895, Frank Duveneck Papers, Archives of American Art, Smithsonian Institution, Washington, D.C. (hereafter Duveneck Papers, AAA).

14. Extract from Ella's letter [presumably Ella Lyman], September 1891, Duveneck Papers, AAA.

15. Duveneck, *Frank Duveneck, Painter-Teacher*, 127. After Lizzie's death, Francis Boott lived with his sister in Cambridge, Massachusetts, near William James, with whom he shared a close friendship. When Boott passed away in 1904, James wrote the address for a memorial service held for him; see ibid., 125. A music competition at Harvard University was endowed in Boott's honor. Boott's own remains were cremated and buried at Mount Auburn Cemetery beneath a simple marker; see "Funeral of Francis Boott," *Boston Daily Globe*, March 4, 1904, 5; and Boott, *Recollections of Francis Boott*, 57–58. Although a number of sources state that his wife, Elizabeth Lyman Boott, who died in 1846, and their infant son Frank, who was born in 1845 and only lived a few months, were buried at Mount Auburn, the cemetery has no record of their gravesite.

16. Taft, *The History of American Sculpture*, 526.

17. The cast that Duveneck gave to the Cincinnati Art Museum is usually considered the original plaster. Duveneck gave the Metropolitan Museum of Art in New York a plaster, cast from the Cincinnati version, in 1917, and the Metropolitan had it cast in bronze in 1927 by Gorham Manufacturing Company. The Metropolitan then donated its plaster (no longer extant) to the University of Nebraska at Lincoln. At least three other known plasters are believed to be no longer extant: a plaster made in 1898 for the Art Institute of Chicago from the Boston marble, and plasters at the Pennsylvania Academy of the Fine Arts and the San Francisco Art Association. The Yale University Art Gallery owns a plaster (1990.17.1) of "unknown provenance." Paula B. Freedman, *A Checklist of American Sculpture at Yale University* (New Haven: Yale University Art Gallery, 1992), 59.

18. On Burd, see Constance M. Vecchione, "Memorial Art in North American Churches, Eighteenth and Nineteenth Centuries: Some Sources, Styles, and Implications" (Ph.D. diss., University of Delaware, 1968), figs. 85 a, b. The sculpture of Robert E. Lee, designed by Edward Valentine, was completed in 1875. Similarly, Elizabet Ney designed a gisant of General Albert Sidney Johnston, a Texas war hero. It was completed in 1903 and placed in an Austin cemetery, where it rests inside an iron enclosure in the form of a Gothic chapel. Moses Ezekiel designed two figures at Cornell, Mrs. Andrew Dickson White (1889) and Jennie McGraw Fiske (1908). See Ezekiel, *Memoirs from the Baths of Diocletian*, ed. Joseph Gutmann and Stanley F. Chyet (Detroit: Wayne State University Press, 1975), 411, figs. 62, 63, 65.

19. See, for example, the effigies of Dr. Morgan Dix by Isidore Konti in Trinity Church, New York; Bishop Horatio Potter by Konti and Henry Codman Potter by James Earl Fraser, both in the Cathedral of St. John the Divine, New York; and Father Brown by J. Massey Rhind in the Church of St. Mary the Virgin, New York, as cited in Francis Hamilton, "Contemporary Tomb Figures," *International Studio*, October 1925, 23–27. Also see Bela Pratt's recumbent effigy of Bishop Henry A. Neely created for the Episcopal Cathedral of St. Luke in Portland, Maine, 1904; *Monumental News*, 1905, 739–40. See Diana Strazdes, "Tomb Effigy of Elizabeth Boott Duveneck," in *The Lure of Italy: American Artists and the Italian Experience, 1760–1914*, ed. Theodore E. Stebbins Jr. (Boston: Museum of Fine Arts, Boston, 1992), 371.

20. See Sadakichi Hartmann, "Ecclesiastical Sculpture in America," *Catholic World* 77, no. 462 (September 1903): 760–67, and "Ecclesiastical Statuary," *Monumental News* 13, no. 9 (September 1901): 511.

21. DCF to Duveneck, August 4, 1895; DCF to Frank B. Duveneck, March 25, 1926; both in French Papers-LC.

22. Duveneck to Francis Boott, December 20, 1896, Duveneck Papers, AAA. Duveneck did work together with Barnhorn on two commissions for portrait sculptures for Harvard University, a bust of president Charles W. Eliot and a bronze seated portrait of Ralph Waldo Emerson.

23. For the quote, see Henry Turner Bailey, "The Lenten Season, 1910," typed transcript in Duveneck scrapbook, Cincinnati Art Museum archives. Two of Duveneck's oil studies for the mural's composition and another for the Crucifixion are in the museum's collection. Sketches in a decorative frame are also in the Good Samaritan Hospital, Cincinnati, where Duveneck was cared for during his final illness.

24. "Notables at Funeral of Duveneck," clippings, Duveneck Papers, AAA, reel 1151, frames 726–28. The Cincinnati Art Museum installed a memorial display: a portrait of the artist, surrounded by his paintings and directly facing its plaster cast of his monument to Lizzie.

25. Royal Cortissoz, *American Artists* (New York: Charles Scribner's Sons, 1923), 160.

26. On the Mother of God Cemetery memorial, see Mary L. Alexander, "Work of Two Masters Are Reflected in This Memorial," May 13[?], 1926, clipping, artist files, Cincinnati Art Museum. Gatherings continue each Memorial Day, according to the Cincinnati Art Club website, www.cincinnatiartclub.com/20301.html#duveneck.

27. The inscription on the Crucifixion is in German: "Ich bin du Auferstehung / und das leben ++ Jon 11–25" (I am the resurrection and the life). Barnhorn, who traveled in Italy and studied in Paris for five years after working with Duveneck on his wife's memorial, spent his remaining career in Cincinnati, sculpting and teaching. When a retrospective exhibition was held in 1934, Cincinnati newspapers declared him the greatest ecclesiastical sculptor of his era. He made a number of other cemetery memorials, including the Burkhardt Memorial in Cincinnati's Spring Grove Cemetery, also known as *Grief* (1908). See Mary Alexander, "The Week in Art Circles," *Cincinnati Enquirer*, January 14, 1934, 8; Mary Sayre Haverstock et al., *Artists in Ohio, 1787–1900* (Kent, Ohio: Kent State University Press, 2000), 49–50; *Retrospective Exhibition of Sculpture by Clement Barnhorn, January 16–February 11, 1934* (Cincinnati: Cincinnati Art Museum, 1934); and artist's file, Cincinnati Art Museum.

28. The bulk of the rest of his estate, including his interest in his late wife's fortune, was left to his two grandsons, and other amounts to siblings, nephews, and nieces. See "Duveneck Will Is Copied," clipping, Frank Duveneck Papers, AAA, reel 1151, frame 774.

29. *Frank Duveneck, 1848–1919*, Cincinnati Museum Association, 1919.

1. From 1903 to 1931 French played an influential role at the Metropolitan Museum of Art, which with its Rogers Fund began to acquire contemporary sculpture; Thayer Tolles, "A History of the Metropolitan Museum's American Sculpture Collection," in *American Sculpture in the Metropolitan Museum of Art*, xvi–xxii.

2. A version of the head from the Adams monument was apparently exhibited briefly in New York in 1900 as *Nirvana*; see *Catalogue of Works by Members, Students and Instructors of the Art Students' League of New York* (American Fine Arts Society, May 10–19, 1900), no. 503, where it was listed as "loaned by Mrs. Tonetti" (Mary Lawrence Tonetti, who had been a student and assistant to Saint-Gaudens). A photograph of the Adams Memorial was shown at the 1898 Champs-de-Mars Salon as part of the major Paris display of Saint-Gaudens's body of work, and other photos circulated in the media. The closing date for the blockbuster Saint-Gaudens memorial exhibition was extended twice, and the catalogue was reprinted twice. Saint-Gaudens had had a regular interaction with the Metropolitan over the years, contributing some objects, memorializing fellow artists, and using the collection as a resource; see Tolles, *Augustus Saint-Gaudens in the Metropolitan Museum*, 50–54.

3. On February 1, 1908, at the end of a second trial, Thaw was found not guilty by reason of insanity and committed to a mental institution.

4. *Reminiscences*, 2:354–55.

5. The death mask, held by the Saint-Gaudens National Historic Site in Cornish, has been exhibited publicly only once, in a show entitled *Augustus Saint-Gaudens: A Personal Retrospective* in 2007 at the Saint-Gaudens National Historic Site Picture Gallery, according to curator Henry Duffy.

6. See "Funeral Services Held over the Ashes of Saint Gaudens," *Boston Herald*, August 8, 1907. Lydia Parrish's account of the service is described by Burke Wilkinson in his *Uncommon Clay: The Life and Works of Augustus Saint Gaudens* (San Diego: Harcourt Brace Jovanovich, 1985), which cites "Mrs. Parrish's unpublished diary, courtesy of the late Maxfield Parrish, Jr." The Stevenson prayer was included on the St. Giles monument in Edinburgh, Scotland.

7. Saint-Gaudens's ashes had initially been placed in a brick vault in nearby Ascutney Cemetery in Windsor, Vermont. The temple was originally designed by Henry Hering as the central stage piece of the pageant; it was carved in marble in 1914 from a design by William M. Kendall of McKim, Mead & White. Other family members are also buried there, including Augusta, their son, Homer, and Augustus's brother Louis. On the pageant, see Henry Duffy, "A Masque of 'Ours' or the Gods and the Golden Bowl," *Friends of the Saint-Gaudens Memorial Newsletter*, Spring 2005, 1–5. On the tomb, see Dryfhout, *The Work of Augustus Saint-Gaudens*, 312.

8. This line is used in Franz Liszt's *Trois odes funèbres*.

9. George B. McClellan, "Augustus Saint-Gaudens," *Putnam's & the Reader* 4 (August 1908): 569–73.

10. Adams also later consented to Mrs. Saint-Gaudens's request that a bronze head of the Adams Memorial in her possession, fashioned from the original plaster, be included in further retrospectives in other cities. Saint-Gaudens gave a bronze version of the head to his architect friend Daniel Burnham; see Cynthia Mills, "Casting Shadows: The Adams Memorial and Its Doubles," *American Art* 14, no. 2 (Summer 2000): 6–9. On other heads, realized or proposed, see Mills, "The Adams Memorial and American Funerary Sculpture, 1891–1927," 210–17 and 248–51nn4, 15, 18.

11. Edward Robinson to HA, November 5, 1907, HA microfilm. HA to Robinson, January 22, 1908, in *HA Letters*. *Catalogue of a Memorial Exhibition of the Works of Augustus Saint-Gaudens* (New York: Metropolitan Museum of Art, 1908), no. 64.

12. See Royal Cortissoz, "Art Exhibitions: The Works of Augustus Saint-Gaudens at the Museum," *New York Tribune*, March 3, 1908; and Glenn Brown, *Memories* (Washington, D.C.: W. J. Roberts Co., 1931), 504–5, 543–44.

13. The *Washington Herald* ran massive coverage of the exhibition opening and disagreed with Cortissoz about the effect of the white plaster, which it called even "more impressive than the original" bronze. "The reproduction in plaster has a touch of mystic lightness that really seems to add to its beauties." "Bears Native Stamp," *Washington Herald*, December 16, 1908, 9. The sculpture was "given a room to itself, secluded and set off as nearly as possible as it is in Rock Creek Cemetery" in the later retrospective at the Art Institute of Chicago; "Saint-Gaudens Memorial Exhibit in Chicago," *Monumental News* 21 (September 1909): 681.

14. John Dryfhout to curator Richard Wunder, March 23, 1967, curatorial file, Smithsonian American Art Museum, Washington, D.C.

15. Near the end of his life, French played a key role in commissioning a gilded bronze cast of the Duveneck tomb for the Metropolitan's permanent collection.

16. *An Exhibition of American Sculpture, March 1918* (New York: Metropolitan Museum of Art, 1918), cat. nos. 22, 26, 80, 81.

17. "Exhibitions of Art in Great Variety: Art at Home and Abroad, *New York Times*, March 17, 1918, 88.

18. Adeline Adams, "Contemporary American Sculpture," *Bulletin of The Metropolitan Museum of Art* 13, no. 4 (April 1918): 81–82.

19. Hamilton, "Contemporary Tomb Figures," 26.

20. A 1919 cast was commissioned of the *Amor Caritas*. French helped to influence the acquisition of a number of Saint-Gaudens's works, with his last acquisition being Saint-Gaudens's *Diana*; Tolles, *Augustus Saint-Gaudens in the Metropolitan Museum of Art*, 57–58.

21. Frank Duveneck's "very beautiful and sensitive" memorial "makes one wish that your father had done more in sculpture," French commented in a letter to the artist's son, Frank Boott Duveneck, April 24, 1926, Duveneck Papers, AAA.

22. DCF to Abbott Handerson Thayer, March 27, 1916, Abbott Handerson Thayer Correspondence, Archives of American Art, Smithsonian Institution.

23. "Notables at Bier of Daniel C. French," *New York Times*, October 12, 1931, 20. Richman, *Daniel Chester French*, 205.The working model of *The Genius of Creation* remained in the studio after it was made in 1914. For an account of a memorial exhibition of DCF's work held in 1932 at Grand Central Galleries, see "Art in Review/ Memorial Exhibition of Work by Daniel Chester French," *New York Times*, June 8, 1932, 22.

24. William M. R. French is buried in Mount Greenwood Cemetery, Chicago. DCF was at his bedside when he died in 1914. See "French Funeral Set for Tomorrow," *Chicago Daily Tribune*, June 4, 1914, 2. "Will," as his brother called him, was remembered for having popularized art in Chicago through the Art Institute, which he had led from its inception.

25. See *Catalogue of the Exhibition of the National Sculpture Society under the Auspices of the Municipal Art Society of Baltimore*, April 4 to April 26, 1908.

26. "For Better Types of War Monuments: Address before Convention of American Federation of Arts by Adeline Adams," *Monumental News* 30 (November 1918): 482.

12. PUBLIC SORROW

1. "Death Mask of Gen. Grant Completed," *New York Times*, January 6, 1896. The mask was taken in 1885.

2. "The McKinley Death Mask," *New York Times*, November 19, 1901. For the payment to Pausch, see "Fees for McKinley Doctors," *New York Times*, March 11, 1909, 6.

3. Pausch's business stationery included the heading at upper left: Eduard L.A. Pausch, / (maker of President McKinley death mask.) / Figure and Ornamental / .. Sculptor .. / Plaster models and casts / of all descriptions." At upper right it listed studios in Buffalo, New York, and Westerly, Rhode Island. See Pausch to Edwin Elwell, August 11, 1903, Elwell Collection of American Sculptors' Letters, Thomas R. Watson Library, The Metropolitan Museum of Art.

4. One such bronze cast of the Lincoln life mask taken by Leonard Volk is now in the collection of the Metropolitan Museum of Art. Masks of several individuals remain in the collection of the Saint-Gaudens estate, according to curator Henry Duffy, who has found evidence that Saint-Gaudens and artist Will Low also took a death mask of General Sherman in New York.

5. Eduard L. A. Pausch to Edwin Elwell, July 15, 1903, Elwell Collection of American Sculptors' Letters. Pausch, who had lived in Connecticut and in Westerly, Rhode Island, settled in Buffalo after the fair.

6. These films, re-created from paper prints deposited with the U.S. Copyright Office, are available today via the Library of Congress American Memory project online or the library's Motion Picture & Television Reading Room. The Edison Company's Edwin S. Porter later filmed a dramatic reenactment of the execution of Leon Czolgosz. See Charles Musser, *Before the Nickelodeon: Edwin S. Porter and the Edison Manufacturing Company* (Berkeley: University of California Press, 1991), 184–90.

7. Roxanne Nilan, "The Life & Times of a Victorian Lady: Jane Lathrop Stanford," *Sandstone & Tile* (Stanford Historical Society) 21, no. 3 (Summer 1997): 3–14.

8. See "The Cemetery Robbery," *New York Times*, November 9, 1878, A1, and daily front-page articles on the break-in at St. Mark's Church graveyard through November 21.

9. See Barbara Lanctot, *A Walk Through Graceland Cemetery* (Chicago: Chicago Architecture Foundation, 1988), 52–53.

10. Ibid., 18. The Pullman monument was designed by Solon Spencer Bemen, the architect of the company town of Pullman.

11. "Jay Gould's Body at Rest: Placed in the Mausoleum at Woodlawn Yesterday," *New York Times*, December 7, 1892.

12. "The Mackay Mausoleum," *Los Angeles Times*, February 17, 1896, 8.

13. "Will of H. A. Lozier: Cleveland Man Who Died Here Suddenly Left over $1,000,000," *New York Times*, June 19, 1903, 9.

14. Van Rensselaer, *Art Out-of-Doors*, 237–39.

15. Moore, *The Improvement of the Park System of the District of Columbia*, 57–59.

16. Mark Bennitt, ed., *History of the Louisiana Purchase Exposition* (St. Louis: Universal Exposition Publishing Co., 1905), 717–18, 720.

17. Mark Twain (Samuel Clemens), *The Adventures of Tom Sawyer* (1884) and *Adventures of Huckleberry Finn* (1885).

18. See, for example, "Hypocrite," *New York Times*, June 7, 1887, 4; and "Vaudeville," *New York Times*, March 28, 1909, 8.

19. "Puns on Tombstones," *New York Times*, August 27, 1899, 21.

20. On changing attitudes about inscriptions, see Arthur W. Brayley, *History of the Granite Industry of New England* (Boston: National Association of Granite Industries of the United States, 1913), 127–31.

21. Michael Leja, *Looking Askance: Skepticism and American Art from Eakins to Duchamp* (Berkeley: University of California Press, 2004), 1.

22. Augustus Saint-Gaudens to Norman Hapgood, May 24, 1906, Saint-Gaudens Papers, Dartmouth College.

23. Boris Emmet and John E. Jueck, *Catalogues and Counters: A History of Sears Roebuck and Company* (Chicago: University of Chicago Press, 1950). Sears Roebuck & Co., *Tombstones and Monuments* (Chicago: Sears Roebuck & Co., 1902), 1.

24. *Tombstones and Monuments*, 15, 38, 50. On marketing, see Susan Strasser, *Satisfaction Guaranteed: The Makings of the American Mass Market* (New York: Pantheon Books, 1989).

25. *Tombstones and Monuments*, 62. Sears sent letters to undertakers urging them to keep the firm's catalogue on hand and suggest its value; see "Firm Changes and Other Trade News," *Monumental News* 29, no. 6 (June 1917): 346.

26. "Thinks Tombstone Too Costly," *New York Times*, July 13, 1899, 4.

27. Charles Bianchi & Sons advertisement, *Granite, Marble and Bronze* 23, no. 6 (June 1913): 21.

28. See undated catalogue, *Memorials: The Smith Granite Company, Westerly, Rhode Island*.

29. For a good listing, see Brayley, *History of the Granite Industry of New England*.

30. "Firm Changes and Other Trade News."

31. *Out-of-Door Memorials: Mausoleums, Tombs, Headstones, and All Forms of Mortuary Monuments* (New York: Tiffany Glass & Decorating Company, 1898), n.p.; *Tiffany Studios Memorials in Glass and Stone* (New York: Tiffany Studios, 1913), n.p.

32. *Out-of-Door Memorials*, n.p.

33. Ibid.

34. Coffman, "Silent Sentinels," 184.

35. Ibid. catalogues his memorials.

36. Of course, Tiffany had long been making stained-glass windows, and many were adapted for mausoleums or chapels. The windows were the topic of Elizabeth de Rosa, "Louis Comfort Tiffany and the Development of Religious Landscape Memorial Windows" (Ph.D. diss., Columbia University, 1995).

37. *Tiffany Studios Memorials in Glass and Stone*, n.p.

38. Coffman, "Silent Sentinels," 141.

39. See, for example, *Tiffany Studios Memorials in Glass and Stone*, n.p.

40. On the Rabboni sculpture, see Mills, "The Adams Memorial and American Funerary Sculpture," 308–20.

41. "The ability to produce, to perceive, to discern, and to appreciate authentic art became one mark of an authentic self," writes Barry Shank, "a self that signaled its coherence and integrity at least in part through cultural habits, beliefs, and behaviors that were meant to . . . indicate a cultural superiority that was predicated on this self's ability to rise above the desires and tastes produced in mass culture and . . . [remain] untouched by economic determinations." Shank, "Subject, Commodity, Marketplace: The American Artists Group and the Mass Production of Distinction," *Radical History Review* 76 (Winter 2000): 25–26.

1. Saint-Gaudens's Lincoln, Shaw, and Sherman Memorials topped the list; see "The Best Art in America," *Art and Progress* 4 (June 1913): 1007–9; and "Our Greatest Monuments," *Monumental News* 25 (August 1913): 549.

2. Lorado Taft, "Daniel Chester French, Sculptor," *Brush and Pencil* 5, no. 4 (January 1900): 151.

3. "Boston Public Monuments (Continued)," *Monumental News* 25, no. 7 (July 1913): 491.

4. On Clemens's print, see Albert Bigelow Paine, *Mark Twain*, 4 vols. (1912; repr., New York: Chelsea House, 1980), 3:1351. For the Thistle prints, see *Thistle Publications: Office Catalogue of Works of Art Reproduced from Eleven Leading Galleries of the United States and Many Private Collections* (Detroit: Detroit Publishing Co., 1912).

5. See, for example, Curtis & Cameron, *The Copley Prints* (Boston, 1902).

6. "The Convention of Cemetery Superintendents, Washington D.C.," *Monumental News* 17 (November 1905): 752–54. For the delegates' schedule, see Association of American Cemetery Superintendents, *Proceedings of the Association of American Cemetery Superintendents* (Park and Cemetery Press, 1905), 49.

7. "It Shocks the Rector: Henry Adams Places a Figure of Despair over the Grave of His Wife," *Boston Herald*, July 9, 1891.

8. HA to Richard Watson Gilder, October 14, 1896, and HA to Homer Saint-Gaudens, January 24, 1908, in *HA Letters*. There have been many reports that Samuel Clemens coined the name "Grief." That claim has never been documented, though Clemens did visit the memorial in 1906.

9. HA to Elizabeth Cameron, April 16, 1900 in *HA Letters*.

10. See Jane Aser, ed., *The Ladies and Gentlemen's Etiquette Book of the Best Society* (London: S. Low, Son & Co., 1881), 40, 46, 88.

11. John E. Monk, "Sculpture, Romance, Gossip," *Albany Evening Journal*, August 8, 1907.

12. HA to Edward Robinson, November 6, 1907 in *HA Letters*.

13. Augusta Saint-Gaudens to HA, November 11, 1908, HA microfilm.

14. Brewster to Augusta Saint-Gaudens, December 17, 1908, HA microfilm.

15. On Agnus, see *Baltimore: Its History and Its People* (New York: Lewis Historical Publishing Co., 1912), 81–84; "Gen. Felix Agnus Dies at Age of 86 at His Home," *Baltimore Sun*, October 31, 1925, 26; *National Cyclopaedia of American Biography* (New York: James T. White & Co., 1898) s.v. "Agnus, Felix," 1:200; and Dawn F. Thomas, *The Green Spring Valley: Its History and Heritage* (Baltimore: Maryland Historical Society, 1978), 1:133–36.

16. Brewster to Augusta Saint-Gaudens, December 21 and 23, 1908, Saint-Gaudens Papers, Dartmouth College. Brewster asked McKim, Mead & White to obtain estimates for the stone work for a duplicate monument.

17. "Sculptors Indignant," *New York Tribune*, February 6, 1909, 14. This account of the Agnus Memorial was first published in Mills, "Casting Shadows."

18. For correspondence with Adams on the copyright issue, see Brewster to HA, January 30, February 5, 17, and 20, 1909, HA microfilm; and Brewster to Augusta Saint-Gaudens, February 19 and 26, 1909, Saint-Gaudens Papers, Dartmouth College. The design was registered with the U.S. Copyright Office in Washington, D.C., in the name of Augusta Saint-Gaudens on January 16, 1909.

19. The suit named J. Frank Salter of New London, Connecticut, doing business as John Salter & Son in Groton. See "Among the Sculptors," *Monumental News* 22 (November 1910): 805. The portrait of Agnus appears to have been made by Henry Baerer.

20. See Study Commission on Maryland Folklife, *Final Report of the Study Commission on Maryland Folklore* (Bethesda, Md., 1970), 16; and George C. Carey, *Maryland Folklore* (Centreville, Md.: Tidewater Publishers, 1989), 93–97. Baltimore newspaper articles have included "Teenagers' Visits Irk Cemetery Officials," *Evening Sun*, January 16, 1950; "Black Aggie: Legend Grows around Cemetery Statue," *Evening Sun*, September 7, 1966, C1; and "Black Aggie Gone, not Forgotten," *Evening Sun*, September 16, 1976, C1.

21. The 2,400-pound sculpture, shipped to Washington in 1967, was assigned accession number 1967.139, the gift of Louise Leser, in the Eduard Pausch curatorial file at the Smithsonian American Art Museum. General Services Administrator Terence C. Golden first considered placing it in one of the Blair House gardens. On the GSA installation and adjacent historic buildings, see Daniel B. Krinsley, "An Unexpected Rendezvous at the Cosmos Club on Lafayette Square," *Cosmos: Journal of the Cosmos Club of Washington, D.C.*, 1998, 107–20.

22. According to the cemetery lot and grave index, Charles E. Meding acquired the lot on July 24, 1906. Son Charles Meding Jr., twenty-seven years old, died in 1906, and the father died in October 1918. My thanks to Rosemary Lanes of Princeton Art Services for pointing out this monument and to Paterson historian Howard Lanza for discussing it with me.

23. At age eighty, he returned to the Beverly Farms, Massachusetts, summer home he and Clover had built. Afterward he began speaking about Clover with Aileen Tone, a young woman who served as his companion in his last years, according to Harold Dean Cater, *Henry Adams and His Friends: A Collection of His Unpublished Letters* (Boston: Houghton Mifflin Co., 1947), cii. Cater interviewed Tone, who said Adams told her, "My child, you have broken a silence of thirty years" after she asked him about Clover.

24. HA to Moreton Frewen, July 2, 1913 in *HA Letters*.

25. The plaster of the Adams Memorial remaining from the casting process burned in a fire at Cornish, but later casts of the head survived because Saint-Gaudens had made one as a gift for his friend Daniel Burnham and it was recast by Augusta Saint-Gaudens. Mrs. Saint-Gaudens had the head in her possession copyrighted on November 4, 1908; see Copyright Office records, Library of Congress. After the Black Aggie debacle, a casting of the whole figure in the cemetery was permitted in the late 1960s so that one could be displayed at Cornish and another at the Smithsonian to replace the pirated copy. The bronze in Cornish is displayed outside in a landscaped setting, and the one at the Smithsonian American Art Museum against a photographic backdrop of a cemetery.

26. See Sarah Burns, "Populist versus Plutocratic Aesthetics," in *Inventing the American Artist: Art & Culture in Gilded Age America* (New Haven: Yale University Press, 1996), esp. 300–304.

27. Helen B. Emerson, "Daniel Chester French," *New England Magazine*, n.s., 16, no. 3 (May 1897).

28. "Daniel Chester French, Sculptor," *Munsey's Magazine* 19, no. 2 (May 1898): quotes at 235–36, with engraving of Milmore, 234.

29. Charles Caffin, *American Masters of Sculpture* (Garden City, N.Y.: Doubleday, Page & Company, 1913), 62.

30. The Metropolitan Museum of Art formally accepted the marble sculpture in 1926. A copy of the Wachs poem is included in the museum's curatorial file.

31. Preston Remington, "The Angel of Death and the Sculptor," *Metropolitan Museum of Art Bulletin*, July 1926, 162.

32. Lorado Taft, *Brush and Pencil* 5, no. 4 (January 1900): 151.

33. Adams, *Daniel Chester French, Sculptor*, 27.

34. Baldwin & More advertisement, *Monumental News* 21, no. 9 (September 1909): 728. The Kavanagh advertisement appeared in *Monumental News* on several occasions, including 23, no. 12 (December 1911): 922.

35. DCF to Ralph H. Jones Company, attention Earl R. Trangmar, French Papers-LC.

36. Walton, "A Higher Quality in Funerary Monuments," second page of article.

37. See undated newspaper advertisement beginning, "Genoa may have its Campo Santo—but the Nation's Capital has its Rock Creek Cemetery," vertical files, Historical Society of the District of Columbia. The ad appears to be from the *Evening Star* sometime after March 1941. Also *Rock Creek Cemetery*, 1933 promotional brochure.

38. Washingtoniana collection, Martin Luther King Library, Washington, D.C.

39. DCF to Oscar Milmore, August 4, 1914, perhaps a draft of an unsent letter because a different letter was sent on August 5: "It is true that Judge Richardson was not satisfied with the stone work, but in view of the fact that the expenses of the monument, not counting my own time as anything whatever, were almost equal to the whole sum that I received for it, he finally accepted it. Later, at my own expense, as I knew that the work was not standing as the architect and contractor assured me it would, I made a new top, and made other changes, for it." The August 5 letter suggested that arrangements could be made for the Milmores to retain ownership if the monument were moved. DCF to Oscar Milmore, August 4 and 5, 1914, French Papers-LC.

40. The November 1, 1943, date is listed on lot cards in the Forest Hill Cemetery archives. The bodies of the Milmores were also moved to the new site.

14. AFTERLIVES

1. The monument was mentioned frequently after Story's death on October 7, 1895, when it was pictured in *Cosmopolitan* magazine.

2. Jane Stanford (hereafter JS) to May (Mrs. Mark) Hopkins, February 25, 1884, Stanford Family Papers, Special Collections and University Archives, Stanford University Libraries, Stanford, Calif. (hereafter Stanford Papers).

3. Leland Stanford Jr., born in 1868, died on March 13, 1884, at age fifteen years ten months.

4. "The Stanford Mausoleum," *Los Angeles Times*, April 19, 1888, 6.

5. "The Stanford Tomb," article from the *San Francisco Chronicle* reprinted in *Scientific American, Architects and Builders Edition*, May 1889, 75. Stanford had originally included $100,000 in his will for erection of the mausoleum, but that clause was deleted before his death since the mausoleum had already been completed.

6. Robert Caterson monument company catalogue, Woodlawn Cemetery Archives, the Bronx, New York.

7. "The Stanford Mausoleum," *Los Angeles Times*, April 19, 1888, 6.

8. For the quote about the death mask, see Couper to JS, August 12, 1890, Stanford Papers. The death mask, cast in plaster from a wax facial mold, is in the Stanford University Archive, L44.2.1998.

9. Couper to JS, September 9, 1891, Stanford Papers. Couper sent the bill of lading for the shipment to San Francisco by way of New York on September 25, 1891. He first sent a photo of a small model so that "you may see the character of the Sphinx I propose to make," July 17, 1890. Carol M. Osborne, *Museum Builders in the West: The Stanfords as Collectors and Patrons of Art, 1870–1906* (Stanford, Calif.: Stanford University Museum of Art, 1986), 58. JS later traveled to Egypt to visit the source of their inspiration.

10. For "our loved one," see, for example, JS to Andrew D. White, May 19, 1901, Stanford Papers.

11. JS to May Hopkins and Mrs. Park, May 15, 1889, Stanford Papers.

12. On their vision for the university, see O. L. Elliott, *Stanford University: The First Twenty-Five Years* (Stanford, Calif.: Stanford University Press, 1937), 11–12, and Gunther W. Nagel, *Iron Will: The Life and Letters of Jane Stanford* (Stanford, Calif.: Stanford Alumni Association, Stanford, Calif., rev. ed. 1985), 41.

13. The painting by Astley David Montague Cooper, *Mrs. Stanford's Jewel Collection*, 1898, is in the collection of the Iris & B. Gerald Cantor Center for Visual Arts at Stanford University.

14. JS to David Starr Jordan, September 5, 1899, Stanford Papers. "I realize fully at this late day that education of the brain is not all that God exacts from us. The soul life and high moral sense must be awakened and book learning is not all that is required," she wrote David Charles Gardner on February 26, 1904; quoted in Nagel, *Iron Will*, 186.

15. Robert C. Gregg et al., *Stanford Memorial Church: Glory of Angels* (Stanford, Calif.: Stanford Alumni Association, 1995).

16. JS to Andrew White, May 19, 1901, Stanford Papers. "On the 21st of June Mr. Stanford will have been gone from earth-life eight years." Another inscription in the church states, "Earth grants joys that are great; but transplant such joys to Heaven . . . and they grow to a magnitude beyond the comprehension of earth mind." The Larkin Mead statue was first placed in a prominent position on the campus and only later moved near the mausoleum.

17. Nagel, *Iron Will*, 120.

18. JS to May Hopkins, talking about next Saturday, March 9, box 3, folder 18, Stanford Papers.

19. See Gregg et al., *Stanford Memorial Church* for details of church decoration.

20. JS to Mrs. David Starr Jordan, wife of the university president: "I am sending my comforters . . . these books I now dare to send. My secret long cherished loving words that led me to love God as I never loved him before. He called my dear ones from earth life to Heaven . . . Dec. 6, 1901." Inscription, Stanford archives. Ernest Warburton Shurtleff, *The Shadow of the Angel* (Boston: L. Prang & Company, ca. 1895).

21. Shurtleff, *Shadow of the Angel*, 1, 3.

22. This is just one of a number of paintings commissioned before and after his death. See also Félix Chary's *Leland Stanford Jr., Aged 15 Years*, 1884, with a broken column, in the Cantor Center at Stanford University.

23. Miles Orvell, *The Real Thing: Imitation and Authenticity in American Culture, 1880–1940* (Chapel Hill: University of North Carolina Press, 1989), xv.

24. Osborne, *Museum Builders in the West*, 39.

25. JS to Andrew White, May 19, 1901, Stanford Papers. The statues of the apostles were destroyed in the 1906 earthquake and were not replaced.

26. JS to Mrs. David Starr Jordan, March 25, 1899, Stanford Papers.

27. *San Francisco Chronicle*, April 4, 1899, 10. The newspaper said he had lived principally with Mrs. Stanford during his illness.

28. See "Beautiful Statue of the 'Angel of Grief' on the Stanford Campus," *Sunday Examiner Magazine*, March 10, 1901, n.p. Rita Jamison, "The Many Sorrows of an Angel," *Sandstone & Tile* (Stanford Historical Society), 18, no. 3 (Summer 1994): 5.

29. JS to Susan M. Harvey, July 15, 1893, on black-bordered paper, Stanford Papers. "Alone! All alone! My acheing bleeding heart cries, but I look afar and see the joy beyond in the Fairer Land, Father and Son together." For "lonely bleeding bruised one," see JS to Bishop and Mrs. Newman, 1893, n.d., Stanford Papers.

30. "Beautiful Statue of the 'Angel of Grief.'"

31. See "Originality in Monuments," *Monumental News* 13 (July 1901): 394.

32. She had bought sculptural works by the Americans Randolph Rogers, Hiram Powers, and Joseph Mozier as well as by contemporary Italians.

33. Just before her death in Hawaii, Mrs. Stanford claimed that she had been poisoned. The possibility that she died of poisoning has been seriously discussed; see, for example, Robert W. P. Cutler, *The Mysterious Death of Jane Stanford* (Stanford, Calif.: Stanford University Press, 2003).

34. Osborne, *Museum Builders in the West*, 40–41. Underwood & Underwood issued a stereograph of the ruined Stanford angel after the earthquake.

35. On Teich, see Texas State Historical Association, *Handbook of Texas Online*, www.tshaonline.org/handbook /online/articles/fte05. On his angel in Scottsville, Texas, see Carol Morris Little, *A Comprehensive Guide to Outdoor Sculpture in Texas* (Austin: University of Texas Press, 1996), 411. The reproduction is in Frank Teich, *Miscellaneous Memorials We Executed and Erected*, a promotional and sales catalogue of Teich's Studio of Memorial Art, Llano, 1926, Archives, Llano County Historical Museum, Llano, Texas.

36. "Peter Youree," entry in *A Dictionary of Louisiana Biography*, ed. Glenn R. Conrad, 2 vols. (New Orleans: Louisiana Historical Society, 1988), 2:868. Mrs. Youree's family was from Scottsville.

37. Suzanne Turner et al., *Houston's Silent Garden: Glenwood Cemetery, 1871–2009* (College Station: Texas A&M University Press, 2010), 158.

38. The Hooper replica, apparently made by the Boston firm of Kavanagh Brothers, was prominently pictured by photographer Harry A. Bliss in his influential *Memorial Art, Ancient and Modern* (Buffalo, N.Y.: Harry A. Bliss, 1912). While Bliss did not recognize its connection with Story's creation in Italy, he called it a representation of "Grief," saying, "Grief could hardly receive a more appropriate interpretation than is shown in the beautiful kneeling figure of the Hooper memorial, its face buried in its arms." In modern times, the Hingham Cemetery adopted a side view of the monument on its stationery.

39. Such angels are found in, among other locales, Dallas's Grove Hill Cemetery; Calvary Cemetery in Grayson County, Texas; Green-Wood and Woodlawn cemeteries in New York City; Holy Sepulchre Cemetery in Rochester, N.Y.; Cypress Lawn Memorial Park in Colma, Calif.; Calvary Cemetery in St. Louis; Oakland Cemetery in Little Rock, Ark.; Chapel of the Chimes in Hayward, Calif.; Friendship Cemetery in Columbus, Miss.; and Highland Cemetery, Covington, Ky.

40. See, for example, Evanescence ("Odes of Ecstasy"), Nightwish ("Once"), and the Tea Party ("The Edges of Twilight").

41. William Wetmore Story, *The Proportions of the Human Figure* (London: Chapman and Hall, 1866), 42.

42. Lilian Whiting, *Italy, the Magic Land* (Boston: Little, Brown, and Company, 1910), 217–18. William H. Gerdts, "American Memorial Sculpture and the Protestant Cemetery in Rome," in Jaffe, *The Italian Presence in American Art*, 145.

43. William Wetmore Story, "Under the Rose," *Boston Daily Globe*, September 1, 1896, 6.

44. Mrs. Cresson to Fletcher, May 4, 1956; Chesterwood Archives, Stockbridge, Massachusetts. Her count seems exaggerated. According to Richman, *Daniel Chester French*, 79n23, the version at the Art Institute of Chicago was destroyed in 1949. The Boston version went to the Metropolitan Museum of Art as a model for carving in marble, then to the Corcoran Gallery of Art in Washington, D.C., in 1926. The version in St. Louis was broken up in 1945, and a similar fate apparently met a cast on loan to the Carnegie Institute in Pittsburgh, but no record exists of when that plaster was destroyed. DCF also wrote of arranging a model for a Concord, Massachusetts, school.

45. Casts in Chicago, Philadelphia, San Francisco, and Lincoln, Nebraska, are no longer extant.

46. See Metropolitan Museum of Art, Special Committee to Enlarge Collection of Casts, Report of Committee to Members and Subscribers, February 1, 1892, which includes the text of "Why the Metropolitan Museum Should Contain a Full Collection of Casts," a statement published by the committee in March 1891. Metropolitan Museum of Art Publications, accessible at http://cdm16028.contentdm.oclc.org/cdm/ref/collection/p15324coll10/ id/2273. The period after completion of the Adams and Milmore Memorials was the height of cast collection in new American museums.

47. See Alan Wallach, "The American Cast Museum: An Episode in the History of the Institutional Definition of Art," in *Exhibiting Contradictions: Essays on the Art Museum in the United States* (Amherst: University of Massachusetts Press, 1998), 38–56.

EPILOGUE

1. HA to Florence Boardman Keep, November 27, 1911, in *HA Letters*. Mrs. Keep sought Adams's advice about memorialization after the death of her husband, Frederic, in June 1911.

2. *Reminiscences*, 2:354.

3. Background and analysis by Homer Saint-Gaudens in *Reminiscences*, 2:323.

4. Ibid., 2:354.

5. On the Baker monument, see also Dryfhout, *The Work of Augustus Saint-Gaudens*, 301.

6. Sources on Baker's life and philosophy include: Albert Bigelow Paine, *George Fisher Baker: A Biography* (New York: Knickerbocker Press, 1920); entry by N. S. B. Gras in *Dictionary of American Biography*, supplement 1:44–45.; *National Cyclopaedia* 23:75–76; and interview by Georgette Carneal, *New York World*, August 12, 1923. Also see obituary, "George F. Baker, 91, Dies Suddenly of Pneumonia; Dean of Nation's Bankers," *New York Times*, May 3, 1931, A1, 28. Paine, *George Fisher Baker*, 149, 168–69.

7. See Kathleen McCarthy, *Noblesse Oblige: Charity & Cultural Philanthropy in Chicago, 1849–1929* (Chicago: University of Chicago Press, 1982), 61–62.

8. See Lawrence W. Levine, *Highbrow/Lowbrow: The Emergence of Cultural Hierarchy in America* (Cambridge, Mass.: Harvard University Press, 1988), 9.

9. On the Hubbard Memorial, see Cynthia Mills, "Dying Well in Montpelier: The Story of the Hubbard Memorial," *Vermont History* 68, nos. 1–2 (Winter–Spring 2000): 35–57.

10. Advertisement by Gorham Galleries, *Arts and Decoration* 7 (March 1917): 277.

11. "The New Mien of Grief," *Literary Digest* 52 (February 5, 1916): 292.

12. Sloane, *The Last Great Necessity*, 159–90.

13. Adeline Adams, *The Spirit of American Sculpture* (New York: National Sculpture Society, 1923), 55–56. I rely here on the ideas about the waning of Beaux-Arts sculpture in America by Daniel Robbins in his essay "Statues to Sculpture: From the Nineties to the Thirties," in *200 Years of American Sculpture* (New York: Whitney Museum of American Art, 1976), 113–59.

14. Michele H. Bogart, *Public Sculpture and the Civic Ideal in New York City, 1890–1930* (Chicago: University of Chicago Press, 1989); Robbins, "Statues to Sculpture."

15. Robbins, "Statues to Sculpture," including 137–38.

16. A number of sculptors had worked on military cemeteries abroad as well. Manship, for example, was chosen by the American Battle Monuments Commission to create monuments following both world wars. They are located respectively in the American Cemetery at Thiaucourt, France, and the military cemetery at Anzio, Italy. Sculptors provided bronze doors for mausoleums as at New York's Woodlawn Cemetery. Many of these artists were immigrants, and monuments in the interwar period were an eclectic mix.

17. Augustus Lukeman, "A Sculptor Talks about Cemeteries." *American Cemetery* 6 (July 1934): 7–9. I am indebted to Blanche Linden for pointing out this article.

18. Edward F. Bergman, *Woodlawn Remembered: Cemetery of American History* (Utica, N.Y.: North Country Books, 1988), 4–5. Russell Lynes, *An Intimate Portrait of the Good Old Modern* (New York: Atheneum, 1973), 119–20.

19. H. V. Marrot, *The Life and Letters of John Galsworthy* (New York: Charles Scribner's Sons, 1936), 339–40, 473, 503.

20. Lorena Hitchcock, *Eleanor Roosevelt: Reluctant First Lady* (New York: Dodd, Mead & Company, 1962), 89–92. See Philip Hamburger, "Mrs. Roosevelt, Eight Feet Tall," *New Yorker*, October 24, 1994, 54–60.

21. Alexander Woollcott, *When Rome Burns* (New York: Viking Press, 1934), 303–6.

22. Charles Constable, ed., *The Letters between Bernard Berenson and Charles Henry Coster* (Florence: Leo S. Olschki, 1993), 254.

SELECT
BIBLIOGRAPHY

ARCHIVAL MATERIALS

Adams Family Papers, Massachusetts Historical Society, Boston.

Charles Francis Adams II Papers, Massachusetts Historical Society, Boston.

Henry Adams Papers, Microfilm Edition, from the collections of the Massachusetts Historical Society, Boston; the Houghton Library at Harvard University, Cambridge, Massachusetts, and the John Hay Library at Brown University, Providence, Rhode Island.

William Brewster Papers, Museum of Comparative Zoology, Harvard University, Cambridge, Massachusetts.

Chesterwood Archives, Chapin Library of Rare Books, Williams College, Williamstown, Massachusetts.

Joseph Downs Collection of Manuscripts and Printed Ephemera, Winterthur Library, Winterthur, Delaware.

Druid Ridge Cemetery Archive, Pikesville, Maryland.

Hamilton Fish Papers, Library of Congress, Washington, D.C.

Forest Hills Cemetery Archive, Boston.

Daniel Chester French Papers, Library of Congress, Washington, D.C.

Frank Duveneck and Elizabeth Boott Duveneck Papers, Archives of American Art, Smithsonian Institution, Washington, D.C.

McKim, Meade and White Architectural Records, Prints and Photography Division, New-York Historical Society, New York, New York.

Metropolitan Museum of Art curatorial files, New York, New York.

Rock Creek Cemetery Archives, Washington, D.C.

Augustus Saint-Gaudens Papers, Rauner Special Collections Library, Dartmouth College, Hanover, New Hampshire.

The Mary R. Schiff Library and Archives, Cincinnati Art Museum, Ohio.

Smithsonian American Art Museum curatorial files, Washington, D.C.

Jane Stanford Papers, Special Collections and University Archives, Stanford University Libraries, California.

Washingtoniana Collection, Martin Luther King Library, Washington, D.C.

Stanford White letterpress books and personal papers, Department of Drawings & Archives, Avery Architectural & Fine Arts Library, Columbia University, New York, New York.

PUBLICATIONS

Adams, Henry. *The Education of Henry Adams*. Boston: Massachusetts Historical Society, 1918. Reprint, New York: Time, 1964.

———. *Letters to a Niece and Prayer to the Virgin of Chartres, by Henry Adams, with a Niece's Memories by Mabel La Farge*. Boston: Houghton Mifflin Co., 1920.

Ariès, Philippe. *Western Attitudes toward Death from the Middle Ages to the Present*. Baltimore: Johns Hopkins Press, 1974.

Augustus Saint-Gaudens, 1848–1907: A Master of American Sculpture. Paris: Somogy, Éditions d'Art, 1999.

Baker, Paul R. *Stanny: The Gilded Life of Stanford White*. New York: Free Press, 1989.

Ball, Thomas. *My Three Score Years and Ten: An Autobiography*. 2nd ed. Boston: Roberts Brothers, 1892.

Bigelow, Jacob. *An Account of the Sphinx at Mount Auburn*. Boston: Little, Brown and Co., 1872.

———. *A History of the Cemetery of Mount Auburn*. Boston: J. Munroe and Co., 1860.

Bliss, Harry A. *Memorial Art, Ancient and Modern*. Buffalo, N.Y.: Harry A. Bliss, 1912.

Bogart, Michelle. *Public Sculpture and the Civic Ideal in New York City, 1890–1930*. Chicago: University of Chicago Press, 1989.

Boott, Francis. *Recollections of Francis Boott for His Grandson F.B.D.* Boston: Southgate Press, 1912.

Burns, Sarah. *Inventing the American Artist: Art & Culture in Gilded Age America*. New Haven: Yale University Press, 1996.

Bynum, Caroline Walker. *Metamorphosis and Identity*. New York: Zone Books, 2001.

Catalogue of a Memorial Exhibition of the Works of Augustus Saint-Gaudens. New York: Metropolitan Museum of Art, 1908.

Cater, Harold Dean. *Henry Adams and His Friends: A Collection of His Unpublished Letters*. Boston: Houghton Mifflin Co., 1947.

Chalfant, Edward. *Better in Darkness: A Biography of Henry Adams; His Second Life, 1862–1891*. Hamden, Conn.: Archon Books, 1994.

Coffman, Eileen Wilson. "Silent Sentinels: Funerary Monuments Designed and Executed by Louis Comfort Tiffany and Tiffany Studios." Master's thesis, Southern Methodist University, 1995.

Cresson, Margaret French. *Journey into Fame: The Life of Daniel Chester French*. Cambridge, Mass.: Harvard University Press, 1947.

Darwin, Charles. *The Expression of the Emotion in Man and Animals*. London: John Murray, 1872.

Decorum: A Practical Treatise on Etiquette and Dress of the Best American Society. New York: Union Publishing House, 1880.

Dryfhout, John H. *The Work of Augustus Saint-Gaudens*. Hanover, N.H.: University Press of New England, 1982.

Duveneck, Josephine W. *Frank Duveneck, Painter-Teacher*. San Francisco: John Howell Books, 1970.

Dykstra, Natalie. *Clover Adams: A Gilded and Heartbreaking Life*. Boston: Houghton Mifflin Harcourt, 2012.

Edel, Leon, ed. *Henry James Letters*. 4 vols. Cambridge, Mass.: Belknap Press of Harvard University Press, 1974–84.

Faust, Drew Gilpin. *This Republic of Suffering: Death and the American Civil War*. New York: Alfred A. Knopf, 2008.

French, Mary. *Memories of a Sculptor's Wife*. Boston: Houghton Mifflin Company, 1928.

Gardella, Paul. *American Angels: Useful Spirits in the Material World*. Lawrence: University Press of Kansas, 2007.

Garver, Austin S. *Edward H. Hall: An Address Given in the Church of the Second Parish, Worcester, 14 April 1912*. Worcester, Mass., 1913.

Greenthal, Kathryn, Paula Kozol, and Jan Seidler Ramirez. *American Figurative Sculpture in the Museum of Fine Arts, Boston*. Boston: Museum of Fine Arts, 1986.

Habenstein, Robert W., and William M. Lamers. *The History of American Funeral Directing*. Rev. ed. Milwaukee: Bulfin Printers, 1962.

Hall, Florence Howe. *The Correct Thing in Good Society*. Boston: Estes and Lariat, 1888.

———. *Social Customs*. Boston: Estes and Lauriat, 1887.

Halttunen, Karen. *Confidence Men and Painted Women: A Study of Middle-Class Culture in America, 1830–1870*. New Haven: Yale University Press, 1982.

Hamilton, Francis. "Contemporary Tomb Figures." *International Studio*, October 1925, 23–27.

Hind, Charles Lewis. *Augustus Saint-Gaudens*. New York: International Studio, John Lane Co., 1908.

Hochschild, Arlie Russell. *The Managed Heart: Commercialization of Human Feeling*. 1983. 20th anniversary ed. Berkeley: University of California Press, 2003.

Jaffe, Irma B., ed. *The Italian Presence in American Art, 1860–1920*. New York: Fordham University Press, 1991.

James, Henry. *William Wetmore Story and His Friends*. 2 vols. Boston: Houghton, Mifflin & Co., 1903.

James, William. *The Varieties of Religious Experience: A Study in Human Nature*. 1902. New York: Modern Library Edition, 1994.

Kaledin, Eugenia. *The Education of Mrs. Henry Adams*. 1981. Amherst, Mass.: University of Massachusetts Press, 1994.

Kasson, John. *Rudeness & Civility: Manners in Nineteenth-Century Urban America*. New York: Hill and Wang, 1990.

Kasson, Joy S. *Marble Queens and Captives: Women in Nineteenth-Century American Sculpture*. New Haven: Yale University Press, 1990.

Kastenbaum, Robert J. *Death, Society, and Human Experience*. 1977. 10th ed. Boston: Allyn & Bacon, 2009.

Kobbé, Gustav. "Mystery of Saint Gaudens' Masterpiece Revealed by John La Farge." *New York Herald*, January 16, 1910, magazine sec., 11.

Laderman, Gary. *The Sacred Remains: American Attitudes toward Death, 1799–1883.* New Haven: Yale University Press, 1996.

Lears, T. J. Jackson. *No Place of Grace: Antimodernism and the Transformation of American Culture, 1880–1920.* New York: Pantheon Books, 1981.

Leja, Michael. *Looking Askance: Skepticism and American Art from Eakins to Duchamp.* Berkeley: University of California Press, 2004.

Le Normand-Romain, Antoinette. *Mémoire de marbre: La sculpture funéraire in France, 1804–1914.* Paris: Bibliothèque Historique de la Ville de Paris, 1995.

Levenson, J. C. *Supplement to the Letters of Henry Adams.* 2 vols. Boston: Massachusetts Historical Society, 1989.

Levenson, J. C., Ernest Samuels, Charles Vandersee, and Viola H. Winner, eds. *The Letters of Henry Adams.* 6 vols. Cambridge, Mass.: Belknap Press of Harvard University Press, 1982–89.

Levine, Lawrence W. *Highbrow/Lowbrow: The Emergence of Cultural Hierarchy in America.* Cambridge, Mass.: Harvard University Press, 1988.

Linden, Blanche M. G. *Spring Grove: Celebrating 150 Years.* Cincinnati, Ohio: Cincinnati Historical Society, 1995.

Linden-Ward, Blanche. *Silent City on the Hill: Landscapes of Memory and Boston's Mount Auburn Cemetery.* Columbus: Ohio State University Press, 1989.

Marcus, Lois G. "Studies in Nineteenth-Century American Sculpture: Augustus Saint-Gaudens (1848–1907)." 2 vols. Ph.D. diss., City University of New York, 1979.

McDowell, Peggy, and Richard E. Meyer. *Revival Styles in American Memorial Art.* Bowling Green, Ohio: Bowling Green State University Press, 1994.

Migeon, Gaston, "Le Sculpteur Augustin Saint-Gaudens." *Art et Décoration* 5 (February 1899): 43–49.

Mills, Cynthia. "The Adams Memorial and American Funerary Sculpture, 1891–1927." Ph.D. diss., University of Maryland at College Park, 1996.

———. "Casting Shadows: The Adams Memorial and Its Doubles." *American Art* 14, no. 2 (Summer 2000): 2–25.

———. "Dying Well in Montpelier: The Story of the Hubbard Memorial." *Vermont History* 68, nos. 1–2 (Winter–Spring 2000): 35–57.

Modern Cemeteries: A Selection of Papers Read before the Annual Meetings of the Association of American Cemetery Superintendents, 1887–1897. Chicago: Association of American Cemetery Superintendents, 1898.

Mourning Glory: An Exhibition on Nineteenth-Century Customs and Attitudes toward Death and Dying. Wilmington, Del.: Eleutherian Mills-Hagley Foundation, 1980.

"Mr. La Farge Explains," letter dated January 21, 1910. *New York Herald*, January 26, 1910.

Nagel, Gunther W. *Iron Will: The Life and Letters of Jane Stanford.* Stanford, Calif.: Stanford Alumni Association, 1975. Rev. ed. 1985.

Orvell, Miles. *The Real Thing: Imitation and Authenticity in American Culture, 1880–1940.* Chapel Hill: University of North Carolina Press, 1989.

Osborne, Carol M. "Frank Duveneck & Elizabeth Boott Duveneck: An American Romance." Catalogue of an exhibition at Owen Gallery, New York, 1996, www.tfaoi.com/aa/2aa/2aa572.htm.

———. *Museum Builders in the West: The Stanfords as Collectors and Patrons of Art, 1870–1906.* Stanford, Calif.: Stanford University Museum of Art, 1986.

O'Toole, Patricia. *The Five of Hearts: An Intimate Portrait of Henry Adams and His Friends, 1880–1918.* New York: Clarkson Potter, 1990.

Out-of-Door Memorials: Mausoleums, Tombs, Headstones, and All Forms of Mortuary Monuments. New York: Tiffany Glass & Decorating Company, 1898.

Phillips, Mary E. *Reminiscences of William Wetmore Story, the American Sculptor and Author.* Chicago: Rand, McNally & Co., 1897.

Pike, Martha V., and Janis Gray Armstrong. *A Time to Mourn: Expressions of Grief in Nineteenth Century America.* Stony Brook, N.Y.: Museums at Stony Brook, 1980.

Richardson, Robert D. *William James: In the Maelstrom of American Modernism.* Boston: Houghton Mifflin Company, 2006.

Richman, Michael. *Daniel Chester French: An American Sculptor.* New York: Metropolitan Museum of Art, 1976.

———. "The Early Career of Daniel Chester French, 1869–1891." Ph.D. diss., University of Delaware, 1974.

———. "The Early Public Sculpture of Daniel Chester French." *American Art Journal* 4 (1972): 97–115.

Ridlen, Suzanne S. "Funerary Art in the 1890s: A Reflection of Culture." *Pioneer America Society Transactions* 6 (1983): 27–35.

Roark, Elisabeth L. "The Annexation of Heaven: The Angelic Monument in the American Rural Cemetery." Master's thesis, University of Pittsburgh, 1984.

———. "Embodying Immortality: Angels in America's Rural Garden Cemetery, 1850–1900." *Markers: Journal of the Association of Gravestone Studies* 24 (2007): 56–111.

Saint-Gaudens, Homer, ed. *The Reminiscences of Augustus Saint-Gaudens.* 2 vols. New York: Century Co., 1913. Reprint. New York: Garland Publishing Inc., 1976.

Samuels, Ernest. *Henry Adams: The Middle Years.* 1958. New York: History Book Club, 2003.

Schiller, Joyce Karen. "The Artistic Collaboration of Augustus Saint-Gaudens and Stanford White." Ph.D. diss., Washington University, 1997.

Sears Roebuck & Co. *Tombstones and Monuments.* Chicago: Sears Roebuck & Co., 1902.

Sherwood, Mary Elizabeth. *Manners and Social Usages.* New York: Harper & Brothers, 1887.

Shurtleff, Ernest Warburton. *The Shadow of the Angel.* Boston: L. Prang & Company, ca. 1895.

Sloane, David Charles. *The Last Great Necessity: Cemeteries in American History.* Baltimore: Johns Hopkins University Press, 1991.

Taft, Lorado. *The History of American Sculpture.* New York: Macmillan Co., 1903.

Tharp, Louise Hall. *Saint-Gaudens and the Gilded Era.* Boston: Little, Brown, 1969.

Thoron, Ward, ed. *The Letters of Mrs. Henry Adams: 1865–1883.* Boston: Little, Brown and Co., 1936.

Tiffany Studios Memorials in Glass and Stone. New York: Tiffany Studios, 1913.

Tolles, Thayer. *Augustus Saint-Gaudens in the Metropolitan Museum of Art.* New York: Metropolitan Museum of Art, 2009.

———, ed. *American Sculpture in the Metropolitan Museum of Art.* 2 vols. New York: Metropolitan Museum of Art, 1999, 2001.

200 Years of American Sculpture. New York: Whitney Museum of American Art, 1976.

Vance, William L. *America's Rome.* Vol. 2. *Catholic and Contemporary Rome.* New Haven: Yale University Press, 1989.

Vandersee, Charles. "The Mutual Awareness of Mark Twain and Henry Adams." *English Language Notes* 5 (June 1968): 285–92.

Van Rensselaer, Mariana. *Art Out-of-Doors.* New York: C. Scribner's Sons, 1903.

Vargas, Michael P., *Elizabeth Boott Duveneck: Her Life and Times.* Santa Clara, Calif.: Triton Museum of Art, 1979.

Wallach, Alan. *Exhibiting Contradictions: Essays on the Art Museum in the United States.* Amherst: University of Massachusetts Press, 1998.

Walton, William. *Chefs-d'oeuvre de l'exposition universelle.* Paris: Barrie Frères; Philadelphia: George Barrie, 1889.

———. "A Higher Quality in Funerary Monuments." *American Architect* 100, no. 1854 (July 5, 1911).

Wells, Richard A. *Manners, Culture and Dress of the Best American Society.* Springfield, Mass.: King, Richardson & Son, 1890.

Wilkinson, Burke. *Uncommon Clay: The Life and Works of Augustus Saint Gaudens.* San Diego: Harcourt Brace Jovanovich, 1985.

Yarnall, James L. *John La Farge: A Biographical and Critical Study.* London: Ashgate, 2012.

FREQUENTLY CITED NEWSPAPERS AND JOURNALS

American Architect and Building News

Baltimore *Evening News*; *Evening Sun*; and *News American*

Boston *Globe*; *Herald;* and *Evening Transcript*

Monumental News

New York *Daily Tribune*; *Evening Post; Times*; and *World*

Washington *Critic*; *Herald*; *Post*; and *Evening Star*

INDEX